Monster | B E A U T Y

University of California Press Berkeley Los Angeles London

Monster | BEAUTY

Building the Body of Love

JOANNA FRUEH

The following chapters are revised versions of materials
published elsewhere: chapter 1: "Monster/Beauty: Midlife
Bodybuilding as Aesthetic Discipline," in Kathleen Wood-
ward, *Figuring Age: Women, Bodies, Generations*
(Bloomington: Indiana University Press, 1998); chapter 3:
"Building the Body of Love," in *Expanding Circles: Women,
Art, and Community*, ed. Betty Ann Brown (N.Y.: Midmarch
Arts Press, 1996); chapter 9: "Dressing Aphrodite,"
in *n. paradoxa* 1 (1998): 49–60.

Excerpt from "I Am Not a Bunny" reprinted by permission
of Marnie Weber. Excerpt from "The Ship Song," by Nick
Cave, reprinted by permission of Windswept Pacific Songs
on behalf of Mute Song, Ltd.

Student materials excerpted in chapters 4 and 8 appear
here with permission.

University of California Press
Berkeley and Los Angeles, California

University of California Press, Ltd.
London, England

Library of Congress Cataloging-in-Publication Data

Frueh, Joanna.
Monster/beauty : building the body of love / Joanna Frueh.
p . cm.
Includes bibliographical references and index.
ISBN 0-520-22113-3 (cloth : alk. paper)—
ISBN 0-520-22114-1 (pbk. : alk. paper)
1. Feminine beauty (Aesthetics). 2. Body image.
3. Frueh, Joanna. I. Title.
HQ1219.F78 2001
305.4—dc21
00-021024

Manufactured in Canada
10 09 08 07 06 05 04 03 02 01
10 9 8 7 6 5 4 3 2 1
The paper used in this publication meets the minimum
requirements of ANSI/NISO Z39.48-1992 (R 1997)
(*Permanence of Paper*). ∞

To Aphrodite

Aphrodite of Knidos,
Colonna type, Roman copy.
Rome, Vatican 812.

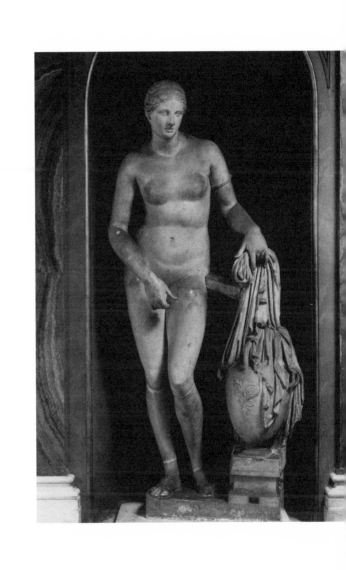

Contents

Acknowledgments

Florence and Erne Frueh, my parents, have educated my aesthetic/
erotic intelligence throughout my life. In Mom's glamorous force field
I learned the meanings of red lipstick. Dad, without his knowing it,
taught me to be a gardener.

Russell Dudley's gifts and skills as an artist and a critic make him a
master at knowing how to create and to keep creating himself erotically
and aesthetically. Russell is my husband, and his corporeal wit and
adventurousness, his devastatingly morbid sense of humor, his precise
and pungent assessments of sights or events on the street, in the moun-
tains and desert, on television, and in books, art magazines, and our
backyard infuse the everyday with monster/beauty, a term that totally
becomes him. As the collaborator on the photographs in this book, he
educated me in fearlessness and fragility.

Peggy Doogan once said, after returning home from a visit with Rus-
sell and me, that it was "a heart massage." During the decade and a half
that we have been friends, she is a heart massage for me. Chapter 13 in
this book would probably not have been written had she not invited me
to participate in "Censorship: For Shame," a 1998 College Art Associa-
tion session chaired by her for which I wrote the essay.

Sarah Lewis continues to provide the comforts of home whenever I'm in New York.

Claire Prussian, Edith Altman, and Andrea Inselmann assure me, in their longtime friendship, that loving relationships between women of different ages build and sustain monster/beauty. Claire and Edith are more than ten years older than I am, and Andrea is more than ten years younger.

Carolee Schneemann's aphroditean wisdom astonishes and inspires me.

Johanna Burton deepens my wonder in the erotics of pedagogy. Conversation with her is fast and full of delight.

Robyn Warhol read the manuscript of *Monster/Beauty* with a loving thoughtfulness whose detail helped me to understand the book in ways that I hadn't seen and to avoid discordant statements.

Joan Hawkins's insights after reading the manuscript eased my fears: I felt graceful standing on academic limbs.

Leslie Heywood's scholarship on women's bodybuilding has given me much to think about, as have conversations with her about both bodybuilding and beauty. A bodybuilder as well as a literary and cultural critic, Leslie is often less positive than I am about the transformative cultural power of bodybuilding for women.

Maria-Elena Buszek's work on the feminist viability of pinups helped me to develop my discussion about midlife women bodybuilders as pinups.

Chris Reed's acceptance of my proposal for a 1996 College Art Association conference session chaired by him, titled "Sexuality and Pedagogy," was the beginning of "Pleasure and Pedagogy," part 2 of this book.

The bodybuilders I interviewed for chapters 1 and 2 were generous with their time, experiences, and opinions. Looking at these women, talking with them, and, in a couple of cases, benefiting from one or two training sessions with them have all enlightened my passionate understanding of big female muscle.

Laurie Fierstein is the midlife bodybuilder without whose rich assistance I would not have understood women's bodybuilding from the position of the bodybuilder herself. Laurie made possible my interviews with other bodybuilders, and her critical contemplativeness about gender and the allures and terrors of female hypermuscularity opened avenues for me to investigate, as did her extensive knowledge about the bodybuilding world.

Al Thomas, a longtime bodybuilding philosopher, was one of the people to whom Laurie introduced me. Al is a marvel. He thinks about bodybuilding as no one else does, and that difference is invaluably unique.

Steve Wennerstrom, who has an encyclopedic knowledge of the history of women's bodybuilding, was another person to whom Laurie introduced me. Time and again Steve's knowledge and contacts have eased my initiation into the mysteries of the bodybuilding subculture.

John Scott's kindness and sensitivity and his love of bodybuilding helped me in the early 1980s to develop my own muscle. John owned Iron Unlimited, a gym in Tucson. He was my first bodybuilding guide, and Iron Unlimited was a joy to work out in.

Lisette Thran, my aesthetician, has applied her many skills—from the touch of learned fingers to the relaxation of laughter—to my skin and soul.

Jacob Abraham, my hairdresser for many years in Reno, entertained me with his biting humor while trimming my bangs to perfection.

Ági Brooks and Betsey Johnson design clothes that give me great pleasure in my daily life. Brooks's elegant daywear recalls styles from the 1940s. Teaching in a skirt, blouse, or jacket of hers, I feel both the fluidity of my movements and my shoulders' strength. Only recently have I begun to wear Betsey Johnson dresses to school. With their obvious, even trashy sexiness and their silliness clinging to me, I cannot hide either my body's contours or my sense of fun. Liliana Casabal, who owns Morgane Le Fay, fashions dresses of fabrics that shine like fairy-tale costumes and often feel and look like gossamer. I have worn her inventions for two performances, both of which appear in this book—chapters 9 and 13. Her dresses alter my comportment when I put them on.

Peter Fox designs high-heeled shoes that are gorgeous, sophisticated, sensual, and comfortable. They are monster/beauty shoes par excellence, highly articulated in shape and material. They are a pleasure to wear during performances and for special occasions.

In autumn 1996 the University of Nevada, Reno, provided me with a sabbatical, during which time I read works by and about Sade and began research on chocolate—a theme that occurs in chapter 13, in which I write about Sade, and a subject that will be a major focus in my next book.

Students I have taught at the University of Nevada, Reno, at Oberlin

College, at the University of Arizona, and at Rochester Institute of Technology have provoked me—to different kinds and degrees of love and frustration—enough times that I could no longer keep from writing about pedagogical realities that teachers and students know and care about but rarely put into print.

Andrea Gardella, an art history major at the University of Nevada, Reno, assisted flawlessly in preparing the *Monster/Beauty* manuscript for publication.

Naomi Schneider's intelligence is an astringent pleasure that keeps me alert and laughing during conversations in person, and as I was writing *Monster/Beauty* I could not have wanted a more encouraging editor: she is delicate and subtle, honest and daring, a true monster/beauty.

Nola Burger's design enhances my words and ideas.

Alice Falk deftly copyedited the manuscript, and Rachel Berchten and her assistant, Lynn Meinhardt, scrupulously tended its production into an elegant book.

MY BODY, MY BEAUTY

I have never been pretty as a picture. Though I, like many women and fewer men, have tried to be. I've attempted to keep my body from changing, from growing or performing in recalcitrant, untidy, and irregular directions. I've labored and paid to be beautiful according to an ideal designed in Western culture, adherence to which requires that one must stay still, as if posing always for a photograph. Even the moving figures, the beauty celebrities on film and videotape, fix themselves in our minds as paralytically perfect images, their bodies erotically deactivated, immobilized and silenced, like still photographic subjects, into aesthetic melancholy.

I began shaving my legs when I was eleven, perhaps younger. Dark and abundant hair from thigh to ankle has been a beauty bane for most of my life. The perfect feminine picture should radiate animal magnetism through her beauty, but she must not be too animal. She must not exhibit a brute body reminiscent of beasts. Only recently have the leg hair and my anxiety about it lessened. I have plucked and bleached my facial hair—on my chin and jaw, above my lips—for almost as long as I have been shaving my legs. The sides of my

cheeks were hairy, too, and my mother took me to an electrologist in order not only to rectify my appearance but also to assuage my shame about it.

This is a narcissist's tale and it is an act of love. It is not a confession. Victims confess, to crimes and faults. Narcissism can be self-love that is not deleterious neurosis.

We might understand the narcissist as the primary figure in a contemporary critique of fitness: self-care and -development will protect an individual from aging, construed as a naturally de-aestheticizing and de-eroticizing process; fitness disciplines isolate us in our own obsessional anguish about loss—of beauty and youth, and of life itself. The fitness narcissist works against mortality, as impossible a task as producing, in actuality, a perfect picture of her body. However, another kind of narcissist, while living within the bombardment of fitness's demands and promises, tries not to run scared from herself. Simplistic popularizations of self-loving techniques, in which the word *self-esteem* becomes a cliché, manifest people's yearning for self-love that operates not only in one's isolated behalf but also relationally—in intimate and everyday social situations. Self-love comes from aesthetic/erotic attentiveness, and many of us are at a loss when it comes to trusting and working with our own aesthetic/erotic capacity in order to know, in soul-and-mind-inseparable-from-body, the beauty of the following complex: self-consciousness, self-pride, self-pleasure, and self-love.[1] For how does one live within yet live against a society in which the perfect picture of beauty thrives?

Here I am, red lips wanting to kiss you all up and down your spine, red lips wondering and working out an answer.

I like to experience the sensual dimensionality that is a human being's beauty. I am interested in the aesthetic/erotic field that people create for themselves and inhabit, the field that they in fact are. Beauty as only and simply a visual feature—a still picture—is erotically devoid, a failure of love; and that kind of beauty resonates with the aesthetic melancholy that I earlier mentioned, because, as art historian Francette Pacteau writes in *The Symptom of Beauty* (1994), ideal beauty "entails the loss of corporeal subjectivity."[2] In contrast, and in eros, monster/beauty is the flawed and touchable, touching and smellable, vocal and mobile body that, by exceeding the merely visual, manifests a highly articulated sensual presence. Ideal beauty attracts, whereas monster/beauty very likely

attracts and repulses simultaneously. Although media invest ideal beauty with sexual charisma, which may lure an observer into love of the beautiful body, it is monster/beauty that is the body of love.

My luxuriantly wavy hair always gives me pleasure, and I don't fuss with it. I wash it and let it air dry. But a precise cut is essential, especially since much of my life I've worn French bangs, whose severe glamour requires a meticulous stylist.

I file my nails short and carefully arc them. As a child I polished them red, and as a teenager I liked the glow that buffing gave. For decades, anything more of a manicure than filing has seemed like too much work. Red lips have taken the place of red nails—I love hot flings of color—and in my mid-forties I took to using lip pencil, which creates a clean and sexy contour and, applied all over the mouth, provides a base that enriches the lipstick color laid over it. Painted lips are such a pleasure. Their lined and saturated surface is so neatly sensuous. (Flings of color must be carefully executed.)

From around ten to forty my facial skin was an inadequate complexion. As a preteen and adolescent I used over-the-counter topical products, and a dermatologist removed pus from deep inflammations that were contaminating my feminine well-being: sweet beauty, even enhanced by the contradiction of femme fatale seductiveness, does not erupt; beauty rationalizes and regulates a human body's chemistry. Alluring though I sensed I was, my skin was wilder than I felt that I could be.

Discussing beauty is taboo. It is a sacred and forbidden subject, because female beauty as it has been constructed in Western culture is a paradox— necessary for women yet impossible to achieve. Naomi Wolf asserts on the first page of her 1991 best-seller *The Beauty Myth* that many so-called liberated women are "ashamed to admit that such trivial concerns—to do with physical appearance, bodies, faces, hair, clothes—matter so much."[3] In their introduction to *Face Value* (1984), co-authors Robin Tolmach Lakoff and Raquel L. Scherr reveal their doubts, as serious feminist scholars, about writing a book focusing on beauty: it might be trivial and frivolous, "insulting to a woman," unsuitable for cultural and political critique; and it might show them to be "members of a small cult of diehard neurotics."[4] What they discovered, however, was that beauty fascinated and pained other women as much as it did themselves, and they realized that they had entered taboo territory.

· · ·

When I was forty an artist whose no-nonsense political paintings and draw-
ings I much admired surprised me by saying, "You look like a model, but
your face is too expressive." I think she said that my quirky, emphatic facial
expressions "twisted" my features away from prettiness. I get bug-eyed when
I'm delighted to see someone, I sneer good-humoredly in conversation with
friends, and my face is very mobile. I scrunch up my nose, narrow my eyes,
bare my teeth, raise my eyebrows, spread my large mouth in wide smiles that
round to extremes the flesh of my cheeks. I distort the shapes of prescribed
beauty into the different and more generous proportions of monster/beauty.
As I write this, the artist's words remind me that emotion and intellect pervert
a pretty picture by wresting an individual from the dubious legitimacy of
purely visual beauty. Within the beauty ideal, regular features and, as one
ages, "good genes" will promote one's approximation to perfection. Without
discounting these aspects and pretending that they never play any part in
monster/beauty, I contend that monster/beauty is a sensuous, alluring
dimensionality that exceeds both luck and the purely visual.

Lakoff and Scherr affirm that beauty is the "last taboo," not discussed by
friends or by feminist scholars. While feminists had broached "other
taboos—masturbation, menstruation, things too unspeakable to contem-
plate until recently," beauty remained an anguish and obsession, a pleasure
and a fantasy that "neither feminists nor any other woman could admit to
openly."[5] I do not consider the narratives of confession and transformation
in fashion magazines, such as the February 1998 *Vogue* story by a thirty-
six-year-old woman about her Botox treatment for a "brow . . . indelibly
etched with squint and frown lines," to be daring explorations of the
beauty problem.[6] Rather, they reinforce the beauty ideal and often, more
particularly, its ageism. Popular confession-and-transformation narratives
may give the impression of open speech but are simply anecdotal com-
monplaces, for they lack a complex presentation of the beauty problem
and models of contestation that are also models of joy.

The taboo lives, as is clear not only in Wolf's fairly recent book but
also in the words of a beauty who is an acquaintance of mine, a scholar
and professor in her early thirties who describes herself as the "blonde,
blue-eyed, Roman-nosed Caucasian ideal" and who wishes to remain
anonymous. I believe that her words ring true for beauties and nonbeau-
ties alike. She writes me, in e-mails dated January 26 and 27, 1998—from
which I quote throughout this introduction—that beauty is "something I

have always wanted to talk about but didn't dare. . . . Anyone who says beauty isn't still the main (though not the only) avenue for a modicum of power in this culture for women is full of shit!!! And so it controls us, and so we feel ashamed of it if we have some degree of it, so it gets treated in ways that are negative as well as positive." The blonde scholar's final comment touches on the taboo's paradoxical nature, which Lakoff and Scherr try to tease apart in chapter 2 of *Face Value*. Simultaneous "sinking and swimming" is artist Martha Rosler's description of the contradictory feelings that arise in women over their practice, or nonpractice, of conforming to beauty ideology.[7] The beauty swims because she looks so good, and she sinks because she must work hard to maintain the status that her appearance has achieved for her seemingly effortless conformity to pretty picturehood. Individual beauty labor garners both attention and damnation. The nonbeauty sinks because she fails at supreme femininity, yet she swims because in her appearance she has resisted the impracticable model. When beauty is a standard of success rather than a variety of pleasures, everyone sinks and pleasure itself drowns in the tortured apparatus of effort, competitiveness, impossibility, and failure.

Monster/beauty encompasses a variety of pleasures, which may include the regular and harmonious features that tend to signal ideal or conventional beauty. Such features, however, are not the basis of the alluring aesthetic/erotic field that is monster/beauty. Aesthetic/erotic wit, a decisive way of dressing oneself in the sensuality and beauty of Aphrodite, proceeds from the corporeal subjectivity and agency that define monster/beauty.

A midlife scholar describes my beauty to me. I've asked her to do this because she's piqued my curiosity and vanity by telling me that I'm conventionally and unconventionally beautiful.

> Regular features do seem to me associated with what is generally considered beautiful. However, striking looks, like your very large and luminous eyes, can also be marks of beauty. The ways that you seem to me conventionally attractive are that you are slender but have sexy curves . . . , have a harmonious face, and have shiny, wavy hair. What is unconventional is how dramatic your features and gestures are: big and passionate looking. While your facial features harmonize with each other they also stand out and draw attention. You move forcefully and with a lot of purpose. You project self-confidence.[8]

Wendy Chapkis begins *Beauty Secrets,* published in 1986, with an account of traumas due to her mustache and ends her three-page introduction with a poignant declaration that I take as a manifesto and a call to action, which is speech:

> But going beyond private solutions means breaking the silence. And I still don't think my problem should matter. It shouldn't matter enough to tell. It shouldn't matter so much that I could be so afraid to tell.
>
> And yet I know that there can be no truly empowering conclusions until our beauty secrets are shared.[9]

Throughout Chapkis's book women tell their beauty secrets, about disability, aging, fat, compulsive eating, mastectomy, acne, sex change surgery, dark skin devaluing them aesthetically because of the blonde ideal, clothing and makeup choices that give them pleasure. For Lakoff and Scherr, Wolf, and Pacteau, as well as for Chapkis, their own experiences as women and feminists who live under the sign of the beauty ideal motivated them to write their beauty books, even though the personal appears very little—the most in Chapkis, the least in Pacteau. I attribute this absence to a particular aspect of the taboo. As the blonde scholar writes to me, "None of this is permissible public speech." That is true whether the would-be speaker does or does not resemble the perfect picture.

In my twenties, volcanic skin displays generally subsided, but large pores and cheek scars, the visible memory of severe breakouts, diverged from the poreless, unblemished skin of wonder-femmes of beauty ideology and supposed reality. Late in that decade of my life I briefly dated a man who told me that we had similar skin—with oily, big pores. This identification with features that I found troubling and defeminizing appalled me, especially because not once had Steve complimented my appearance or said anything meaningful about it. Clearly, his comment was insightful, but it conveyed no sensual identification that connected our imperfect but perhaps desirable skins, desirable as part of two complex aesthetic/erotic fields. All I felt was my own ugliness, which had taken a specific form: it consisted of looking not only like a man but like a man who believed he was unattractive or, at best, ordinary. Beauty ideology enforces sexual difference, and I had failed to be clearly female.

Popular beauty literature often designates *large pores* as *enlarged pores,* and in my youth I was well aware of the latter designation. The former term characterizes a state (of ugliness), a finished picture that nonethe-

less holds a promise: by using toners or glycolic acid creams of reversal, a woman can manage bodily processes so that the visible outcome of her beauty labor is the creation of a prettier picture—a static picture. Every action within the economy of beauty attempts to make stasis possible. The phrase *enlarged pores* suggests a process (of becoming ugly), and it contains the possibility of increase, of greater ugliness. A woman's enlarged pores signify unmanageable change.

Fashion magazine interviews with beauty icons offer descriptions of unmadeup and flawless skin that have both struck and stricken me through the years.[10] I felt inadmissible to an implicit meritocracy of beauty.[11] At first I believed the adjectives—unmadeup and flawless; then I questioned their factuality. Sheer foundations are now available, and they create an even skin tone without dense coverage; often I can't tell whether or not someone is wearing foundation. Also, in the past decade my own skin has become a very satisfying complexion, and I see many women of different ages whose skin is lovely, so the concept of flawlessness mystifies me. (Aestheticians, trained in the beautification of skin, distinguish between *skin* and *complexion*. The latter exhibits clarity and beauty; the former is a covering.) My grandmother Ida's skin was its most beautiful when she was in her eighties, and she wore no foundation—only, occasionally, a light pink lipstick. *Flawlessness* feels like an exaggeration of attractiveness or glamour, an overstatement meant, not necessarily deliberately, to inflate an actual woman's appearance into the iconic power she bears as a representation of beauty.

I'm visiting a city where I used to teach, and as I leave a vintage clothing store a former student, whom I had barely known, calls my name. Her greeting includes, "You look perfect." I laugh and respond, "Hardly." While that may be read as rejection of a compliment, inability to accept let alone enjoy my beauty, the response comes from my disbelief in the reality of bodily perfection, of the perfect picture in real life.

Whenever I've walked past fashion shoots in New York—one starred Patti Hansen, a celebrated model of the moment—the words "I look as good as that" have immediately come into my head. Women's comparative looking at one another is almost impossible to avoid in many public and social situations, and fashion shoots are no exception. I'm complicit. As dictated by beauty ideology, I surveil members of my sex. At the same time, I depart from its dictate that I, as everywoman, am inadequate, for the models do not look any more

perfect to me than I do in makeup. They look conventionally attractive, never fascinating. If I were inclined to stop and watch a fashion shoot, it would be to see how conventional beauty performs for the camera. "I look as good as that" is probably defensive, but beneath the words is my pride in being more striking than the standard.

For a while when I was attending Sarah Lawrence College, the model Penelope Tree was also a student. I remember staring at her in the dining hall lunch line, noticing her pimples, her wonderfully wide face, her being no more ordinary, strange, or beautiful than the rest of us in the room, although she was taller than most of us and exceptionally thin. I liked the human dimension of her. It was a relief. And that this glamorous, high-fashion beauty is constructed became evident to me.

People have compared me to perfectly constructed beauties. Two months before my fiftieth birthday and near the beginning of my first meeting with a fellow art historian, she offers, out of the blue but as if she's been trying to place me, "I know who you look like! Winona Ryder." Throughout my forties and into my fifties students and acquaintances have told me I look like the fifties porn star Betty Page. My bangs resemble hers, as they did when I was a child in the decade of her porn ascendancy, but I know that the bangs alone are an insufficient sign of our similar attractiveness. Something more than hairstyle and features, than slender curves and distinctive colors—dark hair, light skin, red lips—designate me "sexy" like the porn star. My similarity to her is monster/beauty, an aesthetic/erotic aptitude, fleshed out and inspirited with the essence of Aphrodite.

"I am not, in my view, in any way what one would abstractly describe as beautiful because of my weight and the irregularity of my features," a scholar who is an acquaintance e-mails me on August 16, 1997. "Yet, I have so much success with men. I want to theorize that in a way that isn't bragging about it, just trying to understand it. Men often tell me that they are attracted to me because they can tell that I like sex, that I am not trying to 'tease' and then reject and mock them, but that when I give them attention I really 'mean it.' That may be the beginning of allure." I would say that her erotic confidence and comfortableness, her aphroditean monster/beauty, are the allure.

I'm sitting by myself at a conference, enjoying a moment alone over lunch. From behind, a woman asks, "Joanna, can I sit with you?" I barely know her. We met the previous year, and we know one another's writing

more than we know one another. Live, she fascinates me. We talk for way too short a time—I want more of her—and find seats together at a session. I'm excited to be in her aesthetic/erotic field. Hours later, after attending different sessions, we are in the same auditorium. She is diagonally several rows in back of me. I look at her when she asks questions of the speakers, and I want to keep looking at her long after she has spoken. I force myself not to look her way. She is astoundingly sexy, and I want to be able to absorb her soul-and-mind-inseparable-from-body by looking at her and hearing her at the same time. Her aesthetic/erotic field most embraces me when I can see her expressive face and body and feel myself to be a part of her words as I watch her lips shape them. She is not conventionally beautiful. Gangly thinness, a sweater and pants that cover what a beauty might want to reveal, no makeup, lank brown hair: these visual cues say nothing of her radiant spirit and intellect, their generosity and erotic compassion that tell me she is monster/beauty, Aphrodite's daughter. A friend says later about our aphroditean kin, "We're all in love" with her.

Venus Verticordia, changer of hearts, look me straight in the eye, then hug me, then look me in the eye again. Tell me stories about your ancestor, Aphrodite, our mother of eros, whose child—his name, his works and play— have usurped Aphrodite's authority.

Aphrodite, full of grace long before the birth of Mary, sometimes I fear I've lost you in the slim pickings of sex-goddess incarnations who slightly reflect your radiance so wayward from the ironic lucidity I see in perfect pictures.

Venus Verticordia grieves: our mother Aphrodite, a wide-ranging aphrodisiac, an erotic pharmacopeia, is stripped down to one simple, insufficiently effective drug. Aphrodisiac: mistaken for merely a substance to ingest.

Aphrodite, you stimulate me in intricately erotic ways. You arouse the pleasure I feel in my own beauty. Erotic: you mothered the meaning of this word, whose profundity is minimized by the synonym sexy—*a useful colloquialism, shorthand for aphrodisiac.*

Monster mother, huge in the ability to praise yourself, I can look at you anytime I see myself.

Over a decade ago I began to make a point of thanking people when they complimented me on my appearance. Women, considered beautiful or

otherwise, rarely accept compliments. We act mystified or dismissive, or we seem to have heard nothing. "You look gorgeous," I told the blonde scholar after seeing a photograph of her. We had never met, and have still only seen one another in pictures. She didn't respond to my comment; when I mentioned her silence months later, she revealed, "I think I've only talked about it [being beautiful] explicitly, 'owned up to it,' so to speak, with a couple of people. Mostly . . . when people have said something about it, I tend to ignore it, and act like the beauty is utterly unimportant and isn't something I should be proud of or put any stock in because it has no 'real' value." If the beautiful woman values her beauty by clearly enjoying it, she may appear arrogant; so she chooses aloofness and denial, which lead to shame.

Aphrodite, save me from the self-contempt elicited by approximating the ideal beauty. She is a fluffcake and a stalker who has betrayed monster/beauty, the pleasurable corporeality that is your domain.

Aphrodite, help me to build the body of love.

I am a skeptic and a believer, a laborer and a sybarite, a fool and a wise-woman. Facials, first at Georgette Klinger Salon in Chicago when I was thirty-two—I would make appointments with Bella when I visited from Oberlin, Ohio, where I was living—then periodically in Tucson, St. Louis, and Rochester, New York, the cities to which I moved, or at Georgette Klinger in New York, and now monthly in Reno, where I've lived for a decade; treatment products from one company and another, Neutrogena (modestly priced) to René Guinot (expensive); Kyolic garlic capsules, Chinese herbs; happiness in love: all have regulated and boosted my feminine well-being.

Regulation—the management of beauty discomforts or the aesthetic/cosmetic maintenance of one's body—is not necessarily evil. As a technique of stasis, it is absurd and pointless, aimed at producing the desired and ever-deferred end point of ideal beauty; but sometimes regulation produces aesthetic/erotic comfort, a necessary balance that lessens painful obsessiveness or that permits a woman to finally understand, with joy, that she is beautiful. This does not mean that she has become a picture. Rather, it means that she has discovered monster/beauty by learning to build the body of love.

AESTHETIC/EROTIC SELF-CREATION

This book presents a theory and some practices of aesthetic/erotic self-creation by developing beauty as showiness that emerges from intimacy with one's aesthetic/erotic capacity rather than as the hopeless pursuit of perfect appearance. I define *monster/beauty* as an extremely articulated sensuous presence, image, or situation in which the aesthetic and the erotic are inseparable. Monster/beauty is a condition, and it can also describe an individual. Because extremity is immoderation—deviation from convention in behavior, appearance, or representation—and starkly different from standard cultural expectations for particular groups of people, monster/beauty departs radically from normative, ideal representations of beauty. Monster/beauty eroticizes the midlife female body, develops love between women, embraces without degrading or aggrandizing bodies that differ from one's own in age, race, sex, and shape. Monster/beauty is artifice, pleasure/discipline, cultural invention, and it is extravagant and generous: it is female hypermuscularity, the mother's eros, aphroditean radiance, the female professor's pleasure in her pedagogical-scopophilic power.

In *Monster/Beauty* I continue to develop ideas addressed in *Erotic Faculties* about the erotic, beauty, older women, sex, and pleasure by offering models for aesthetic/erotic self-creation: I revise traditional models, such as Aphrodite; challenge stagnant types, such as the nurturing or male-imitating female professor; celebrate a body of repulsion and allure, the female bodybuilder; and rethink the vampire, creating a figure who enlivens—eroticizes—the living. I develop models of agency for people who wish to be erotic subjects and objects: that is, who wish to enjoy themselves and to be enjoyed. They become the body of love.

Monster/Beauty considers the body as aphrodisiac in its representation and daily practices. Aphrodisiac capacity, which I discuss at length in chapter 9, is inseparable from daily practices, from the self-maintenance that can be minimal or, as with monster/beauty, highly articulated. One builds aesthetic/erotic capacity by educating and caring for one's body/mind with much deliberation and exertion, through ornamentation or weight training, perfume and makeup, identifying with the erotic sustenance of the mother's body, and enjoying one's own embedded gestures and vocal inflections. Daily efforts and pleasures build the body of love.

Monster/beauty is insistently and even defiantly fabricated. Individual monster/beauties do turn themselves into objects of pleasure, for both themselves and others. But monster/beauty is not solely a decorative or sex object, as ideal beauty tends to be. Monster/beauty does not stop at being a pretty picture, if indeed that is even a passing goal. Camera-ready beauty tames the aesthetic/erotic life out of the palpable and imperfect body, which, because it can only approximate perfect beauty, always signifies the "personal failure" that Chapkis relates to women's inadequacy conditioning: "no woman is allowed to say or to believe 'I'm beautiful.' "[12] The pretty picture is an impasse to richer ideas, experiences, and practices of bodily beauty, which may be activated by the visual but which the purely visual also always keeps at bay. For ideal beauty operates through distance and monster/beauty through intimacy.

People talk about their own and others' illnesses more freely than they are able to speak about their own and other people's beauty. They brag about sex, turning acts into escapades and adventures, and they reminisce about delectable meals. In these ways, they try to share organs, skin, and senses, because people want to be intimate with one another's bodies. They are searching for an erotics of intimacy.

I don't want to hold still. I would rather be talking together than scrutinizing your appearance, assessing how beautiful you look, as if I were a connoisseur of corpses. I would rather we embrace one embedded gesture after another of each other's. I would love our words to couple while our fluctuating looks and scents are doing the same. I want to smell you, pungent and pronounced just under my nose; or sweat or perfume drifting toward me then surrounding me as we sit in a caressing breeze, five feet apart. I would rather be fucking you than imagining how good it might be from staring at a crisp image of you in a magazine.

Russell, monster/beauty, after we share embedded gestures that lead to orgasm, you're thirsty. You walk to your kitchen for milk, while I lie in your bed, enjoying a rear view: your confident posture and light steps; your broad lats and shoulders; your high, round buttocks, so like mine, but smaller; your finely textured skin; your graceful energy as you lift the milk carton to your lips and drink. As you return to me, your beauty amazes my soul-and-mind-inseparable-from-body. I love your sparkling green eyes, your extravagantly curly hair, and the creaminess of your skin. You are a revelation.

Almost ten years later you're washing dishes in our kitchen. You wear your usual worn jeans and T-shirt. You are as creamy, strong, and elegant as ever.

I stand near you and my eyes fix on your forearms as your strong sweat and sweet, warm voice impel me closer, as much as the muscles and tendons that focus my vision of you at this moment. The smell, the sound, and the sight of you impel me to say, "I want to fuck you."

People are trying to make aesthetic sense of themselves. An erotics of distance, which is all that the beauty ideal offers, makes this effort a joke, because an erotics of distance and an aesthetics of deprivation and despair walk hand in hand.

Monster/beauty destabilizes both the image and ideology of female beauty, and my desire to witness the body of beauty change from impossible ideal to achievable reality motivates the writing of *Monster/Beauty*. A large part of that desire concerns the perception and representation of older women. The blonde scholar, who reveals to me that aging "is now one of [her] biggest fears," urges me "to be brave and to say it—yes I was/am beautiful, and it has done these things for me, and it has done these things to me, and be unflinching in what it has done." She broods, "Beautiful women are the ones everyone hates because everyone wants it, so if you are beautiful, as I am, as I know you are, . . . you are expected to spend your whole life pretending you are not beautiful, being vigilantly modest. . . . You can never have joy in your own beauty, and when you most have it is when you most have to try to counteract it or you are accused of egotism, self-absorption and vanity." Her conflicting delight in her beauty and desperation about its assumed demise well up: "And then, the culture makes you absolutely panic about losing it!!!!!!" I am not in a panic, but I'm deeply concerned: do people think I'm beautiful? even though I'm a midlife woman? *Even though* profoundly motivates my writing. I do not want to lose what I am, which is not a simple beauty but rather monster/beauty. I care a great deal for and about my looks, notwithstanding my knowing that simple appearance is only one aspect of monster/beauty, which, unlike beauty, a possession one *has*, energizes one's looks into part of an aesthetic/erotic field that one *is*.

I have never felt hated for my beauty, perhaps because hairiness and acne galore kept me from ever feeling perfect, so that I did not comport myself, move and speak, with the confidence of a beauty. Unlike the blonde and beautiful scholar, who was very aware of her beauty and its powers in adolescence, I did not know, unequivocally, that I am beautiful until I was almost the age that she is as I write this.

Although I earlier criticized the moving figures of beauty celebrities in films and videos, it was while watching myself on a videotape that I recognized my own monster/beauty. I was thirty-two and had recorded a rehearsal of my first performance art piece. Grimaces, snarls, laughs, gleaming and swinging hair, a mellow and melodic voice, and a robust slender body energized with eros, with strong and graceful pleasure in itself, jolted me out of a lifelong unwillingness and inability to testify to my attractiveness. Because I was watching myself and not looking at some celebrity, I observed and felt what I saw with intimate attentiveness and knowledge: I recognized my skill at aesthetic self-preparation—the punctuation of dark bangs and red lips against light skin, the close fit of a sleeveless T-shirt baring my substantial upper arms, the casual polish of black pedal pushers, naked calves and ankles, and white jazz shoes—and the demand for perfection did not enter my mind to negate the revelation of pleasure in myself.

Sometimes, thinking about beauty and eros, I wonder if I'm a fool to believe that monster/beauty does not wither if one constructs oneself within its generous embrace. My monster/beauty has seduced men and women, drawn lovers-to-be toward me, and intimidated people so that they treat me as if I'm unapproachable. Monster/beauty helps students in my classes and audiences at my performances to pay attention. I believe in monster/beauty's vitality because I know that contemporary Western culture *constructs* women's aging as a dreaded, painful loss, a time when beauty, which can be possessed only by the young, is irretrievable. However, *having beauty* and *being monster/beauty* differ greatly. *Having beauty* determines the value of fading pictures, whereas the body of love that is monster/beauty is not a picture to be admired or feared. It is neither perfected nor ultimate in any way.

I am forty-seven, and a twenty-three-year-old male student tells me at an art opening, "You're a beautiful woman." I am forty-eight, and an extremely sexy male artist, with whom I have never spoken, sits down at a restaurant table next to me in order to begin a conversation and says, "I just bought your book. You look hot on the cover." I am fifty, and a former student, now around twenty-eight, asks me for a hug at a public event. His voice and demeanor indicate sexual more than friendly desire.

As I write this introduction, I have just turned fifty. I am a white middle-class woman who has researched and written about women's aging.[13]

Many women fifty and over say they feel that people no longer *see* them, but we must understand this crucial aspect of women's aging as only one significant element in the aesthetic/erotic disappearance that cultural forces—entertainment media, the fashion and cosmetic surgery industries, a long Western history and tradition of young, white, blonde, slim, and unblemished beauty—impose on women. Western culture constructs female aging as diminishment; so an ad in the February 1998 *Vogue*, for Estée Lauder's product called Diminish, especially caught my eye and left me feeling very melancholy. The ad reads, "You'll love what you don't see," and advises, "Use Diminish nightly and see lines and wrinkles become less apparent. Age spots seem to fade. Your skin will glow again." *Diminish* is the most prominent word in the ad. (The product name isn't always the largest word in fashion magazine advertising copy. Often the company name or the product's benefits are stressed.) Aging itself must become less apparent, must fade, so that a glowing quality—the radiance that we come to believe is and thus enact as the possession of youth alone—may return. The ad subtly encourages women's participation in their cultural diminishment in every respect, except as a cohort of consumers.

I visit my parents after not seeing them for several months. I'd recently intensified aspects of my midlife bodybuilding, working out more concentratedly and creatively than before, and show up in a tank top and jeans. My shoulder and back muscles, my larger delts and lats, create the illusion of a smaller waist. Dad observes, "You look bigger and smaller." I thank him and silently respond with delight to his first adjective. Like women I know and read about, I don't want to be told that I look fat, but unlike many of them, neither do I want to be seen as little. My father's bigger *and* smaller *conveyed what I considered to be attractive changes in my shape. Larger muscle resulted in an attitude and comportment shift: I felt larger, stood and moved with a greater sense of sovereignty over myself and in relation to the space around me, which resonated in my aesthetic/erotic field.*[14]

Johanna, my friend and surrogate daughter, tells me, many times, that I look littler than when she has last seen me. She intends a compliment, but it always takes me aback because I don't feel little. I never have.

I overhear a saleswoman at a local boutique complimenting a customer with "You're so tiny." My reaction is alert anxiousness. I'm hoping that the same remark doesn't come my way, because my response would be politeness

rather than my honest thoughts about the power that the diminutive wields over women. Monster/Beauty *redresses women's bodily dominion.*

I am five feet, four and a half inches tall, with a small waist and small breasts, broad shoulders, thick biceps, and thighs and calves bigger than my husband's. I carry more weight than a scale can measure. It is the aesthetically activated mass and spirit of monster/beauty; and it is erotic weight, which permeates Monster/Beauty.

At forty-six a friend of mine said she was beginning to witness her invisibility: men weren't looking at her anymore and she wasn't feeling desirable. While heterosexual women's investment in engaging men's sexualized looking as part of their pleasure in daily life might be critiqued for displaying a lack of autonomy in beauty, serious discussions about beauty cannot afford to dismiss the comfort and excitement that such erotic—not simply visual—relations provide. Aesthetic/erotic self-creation is a relational as well as a private pleasure, a fact that *Monster/Beauty* consistently addresses.

I feel desirable and desired. That reality and that feeling mark me, and it is difficult to address them publicly or, sometimes, to fully enjoy them whether in public or in private. It is difficult to proudly and graciously accept a compliment about one's attractiveness, let alone speak about it in positive or negative terms, or to acknowledge one's own beauty to oneself or in the presence of others.

Throughout *Monster/Beauty* parts of my discussion of everyday practices are significantly based in personal experience—not only mine but also that of subjects I interview and friends and lovers. My experiences situate the author of this book for the reader as they also establish the necessity of speaking about beauty, of beauty speaking for herself. As serious feminist studies of beauty either state or suggest, women's telling of their experiences is necessity. It need not be vanity. The personal has become much used in humanities scholarship, and it is a controversial and hotly debated subject. While the personal is useful in scholarship that treats identity, and personal narrative makes clear the subjectivity of scholarship, those employing such narratives have been accused of self-absorption, self-indulgence, and narcissism.[15] Without a resonant basis in the personal my argument in behalf of beauty as possible, as doable, would languish in the realm of theory—which, though necessary, is

removed from the everyday. Aesthetic/erotic self-creation as practice requires grounding in actual people's disciplines, loves, and daily lives. I theorize lived experience—bodybuilding, lovemaking, teaching, dressing. In *Monster/Beauty* lived experience encompasses the recognition that human beings and their bodies are culturally marked in ways that can be transformed by putting the knowledge gained through theorizing into practice.

Monster/Beauty also distills experience in poetic developments of ideas. I used this technique in *Erotic Faculties,* and it remains an unusual one in critical writing. African American and Latina feminist writers and poets who have produced significant but not high academic theory, such as Audre Lorde and Gloria Anzaldúa, have recognized the importance of poetry as a means for elucidating women's lives. Lorde's defense of poetry as "disciplined attention" and "a vital necessity" for women's existence in "Poetry Is Not a Luxury" supports my use of lived experience and reinforces my belief that poetry can be a vital tool for scholars who are intellectually invested both in social change and in the value of simultaneous thinking and feeling. Lorde critiques the "white fathers [who] told us: I think, therefore I am." Against this conditioned acceptability of being, she posits the "Black mother within each of us—the poet—[who] whispers in our dreams: I feel, therefore I can be free."[16] By interweaving poetry with theory and the personal, scholars can sharpen and reveal experience and provide a language "to express and charter" the desire and demand for freedom.[17] They can create lexicons of pleasure.[18]

FEMINIST CRITIQUES OF PERFECT, VISIBLE BEAUTY

I have already mentioned and quoted from Robin Tolmach Lakoff and Raquel L. Scherr's *Face Value,* Wendy Chapkis's *Beauty Secrets,* Naomi Wolf's *Beauty Myth,* and Francette Pacteau's *Symptom of Beauty.* These books are the foundation of a serious critique of beauty and they point to roads that scholars might journey, to practices that people might pursue, and to perceptions that their readers might alter in order to open the narrow parameters and expand the current content of bodily beauty, in which perfection and visibility are primary. Below, to clarify monster/beauty I discuss some of the authors' salient points regarding these constituents of ideal beauty. While beauty has been an implied or tangential

aspect of numerous feminist discussions, only the authors listed above have dared to write entire books that theorize beauty.[19] Una Stannard's "Mask of Beauty," published in one of the earliest second-wave feminist anthologies, *Woman in Sexist Society* (1971), provides (along with sections in Germaine Greer's *Female Eunuch* and Shulamith Firestone's *Dialectic of Sex*, both published in 1970) one of the first contemporary feminist analyses of bodily beauty as a problem for women.[20] A subject that has given rise to only four books in three decades of feminist politics, practice, and theory might appear to be unimportant. But the paucity of writing instead underscores these authors' daring, because beauty is at once so painful and precious a subject—taboo, as I earlier pointed out. *Monster/Beauty* would not have been possible without the insight, bravery, revelations, and analyses that I find in the four feminist books on beauty. I use them as inspirations and touchstones, regardless of any disagreements I have with them. The books give me courage and urge me to speak about beauty in ways as yet unspoken.

Monster/beauty lurks within the feminist critique of beauty just as it underlies problems and definitions of beauty, which the authors analyze as a representation of a perfection that women pursue as if it were possible to achieve. The feminist challenge to the discursive reality of beauty that informs women's bodily practices and displeasures with themselves revolves around issues of control, management, transformation toward the improvements that will produce perfection, and auto-surveillance and its concomitant comparative and competitive surveillance of other women. Each writer personally responds to the issues that she critiques. Chapkis, as we have seen, struggles over her mustache.[21] Wolf reveals her teenage anorexia.[22] Scherr has been in conflict with the "dark self" of Jewish-Mexican difference from blonde beauty. Lakoff offers a self-assessment: "strikingly homely."[23] The seemingly simple statements in Pacteau's introduction are loaded, requiring exploration in the form of a book-length scholarly effort: "This essay is an attempt to talk about the problem of beauty—which is at one and the same time a theoretical problem, and an everyday problem for me as a woman," and "My own experience as a (White, European) woman in contemporary Western culture . . . is often one of distress at the impossibility of beauty."[24]

Monstrousness is an unnamed and implicit feminine condition at the heart of each author's explicit or implicit self-critique or -revelation.[25] The Western tradition is populated by terrifically exciting female mon-

sters, whose threat to men or male dominance is so great that they must be killed: Tiamat, the Sphinx, Medusa. Woman has been constructed as a hormonal and a sexual monster whose physical attractions lure man into the *vagina dentata*, where he will be emasculated; whose femininity must be controlled through the administration of estrogen and progesterone and through dieting, the constriction of appetite. Female monsters in film can be mothers whose protectiveness of their spawn and whose procreative powers are both deadly to the human species—witness female villainy in the *Alien* films.[26]

Chapkis, Pacteau, Wolf, and Lakoff and Scherr have each felt like a monster; each has suffered because of this feeling and has addressed other women's inescapable suffering, whether her methodology includes theoretical, statistical, historical, sociological, art-historical, autobiographical, or popular-cultural material. The following amusing yet poignant analogy from Pacteau asserts how global and deeply impacted women's suffering is: "Freud observed that no man escapes castration anxiety; . . . it seems to me that, at least within the so-called developed Western world in which I am situated, no woman escapes 'beauty.' "[27] I join the five authors in their suffering as implicit monsters: my hairiness and acne; my teenage name for my body from crotch to knees, "Elephant Thighs"; my lower belly—which I discover as a lovely curve of a little girl belly in photographs of me in a bathing suit at age six—extending beyond the exacting flatness of contemporary perfection. Like other women, Raquel, Francette, Naomi, Robin, Wendy, and I are monsters because we are anomalies in relation to the sameness dictated by the beauty ideal, not because we are deformed or hideous.

Depending on the individual who experiences monster/beauty, it may be grotesque—the "misshapen" female bodybuilder who develops hypermuscularity, the younger man's lust for a midlife woman, a person's very investment in her aesthetic/erotic well-being, or a woman's declared love for her mother's or a surrogate mother's body, which the daughter perceives as a source of eros and beauty. Monster/beauty's perceived grotesqueness, based in taboo and the unconventional, differs from the grotesquely—abjectly—attractive body that has become the star of a late 1990s low-life aesthetic.[28] Nor does monster/beauty satisfy a Sadeian or Bataillean erotics of horror based in an aesthetics of disgust. The modern erotics of damage, which I critique in chapter 13, enters some contemporary women artists' self-portrayals as mon-

strous—excessively confrontational and, for many, difficult to visually enjoy. Obvious examples are Cindy Sherman's *Disasters* and *Fairy Tales*, Orlan's operating room documentation of her cosmetic surgeries, Jo Spence's photographs of her midlife body after breast cancer surgeries, and Hannah Wilke's photographs that show weight gain and hair loss from cancer treatments, drawings composed of the artist's own hair, and watercolors of her hand pierced by an IV needle. In these works physical transformation as violence predominates. Critical elaborations of this phenomenon might consider violence to women as a social reality or might frame such self-figurations as protests against the aestheticized female body in both high art and popular culture. My book, however, elaborates the monster as essential to a condition that neither uses nor suggests disease, breakdown, mutilation, or the hospital. While monster/ beauty may thus seem utopian, its exotic relation to the perfect appearance of ideal beauty makes the monster/beauty bizarre, incongruous, eccentric, strange, or ridiculous. More important, monster/beauty destabilizes both the image and the ideology of female beauty.

Women may be monster/beauties if we consciously depart from the idea that beauty is dependent on looks alone and instead create ourselves as aesthetic/erotic fields of simultaneously concentrated and resonant sensuousness. Doing so, we may begin to—or we may even finally— forget the anguishing "split between the dream [of beauty] and the observed physical reality" of ourselves.[29] I am not suggesting that we forget the historical reality of that split or its effects on the bodies or the unconscious of women. Rather, because monster/beauty is a far more pleasurable condition than is the split state that stirs self-condemnation, I hope for our bodies themselves to forget the pain of beauty as a promise and an abstraction, so that joy, excitement, pleasure, humor, and comfort can fill us and pervade our aesthetic/erotic fields. As monster/beauties we can be hyperbolic, heretical, and heroic bodies, as are the body-builder, the mother and the stepmother, the teacher, the vampire, and the goddess Aphrodite. We can take pleasure in our beauty and be self-consciously erotic, while also understanding that the whole enterprise of aesthetic/erotic artifice is, to some degree, ridiculous.

The vampire laughs at her evening attire and fangs. Naked, in front of a full-length mirror, Sade's Mme. Duclos smirks at the spider veins on her thighs while admiring her breasts, so loved by the marquis himself. Aphrodite

shakes her head in disbelief at the intimidation her appearance seems to provoke.

In an essay that was published six years after *Beauty Secrets,* Chapkis herself appears as monster/beauty, and her mustache, bleached and framing a lipsticked mouth, is one of the highlights of what she calls the "very best dyke drag."[30] (I quote the passage in chapter 6.) Chapkis is full of pride in her sensuousness and its effect—she is lecturing to students. In *Beauty Secrets* she critiques and envies the celebratory, eroticized, and public display of men's shaving paraphernalia and asks the reader to "imagine a similar celebration of a woman plucking her eyebrows, shaving her armpits or waxing her upper lip." Only "after" shots—the pretty pictures—are permissible in advertisements, she asserts, because " 'before' scenes apparently would be too shocking."[31] Monsters shock, and so can monster/beauty. Chapkis heroically emphasizes her mustache by letting readers know that she has one and that she bleaches it—so the reader imagines the "before" shot to be dark and thick—and by celebrating its beauty in print. Although blondeness allows mustaches to disappear, to imitate an ideal, Chapkis has both playfully challenged and loved blondeness, which is an idealization that I confront and honor in chapter 10.

Monster/beauty can reconcile a woman to her frustratingly real body so that she can stop playing the losing game that is a central focus of the feminist critique. Chapkis and the four other authors examining beauty have understood that personal bodily beauty is always deferred because it is always frustrated by the ideal and ideology of beauty as a pretty picture. None is antibeauty, but they agree that the beauty game exerts control such that women assume a passive position—I'll play and try to be beautiful, or I won't play and I'll be ugly. Roberta Seid's affirmation of beauty accurately expresses a feminist position that exists within a severe challenge to the pretty picture: "It would be a bleak world if we did not celebrate beauty and if we did not encourage the imagination and play involved in bedecking ourselves and molding our own images."[32] Either way, the game is a condition of one's female existence, and one is playing whether or not one is trying to win. If a woman is successful—she never really wins—then all that she achieves is passive power, and it will die along with her youth.

Each author except Pacteau urges women to invent new beauties, new images, new ways to see their bodies, to please themselves, and to love

what they see. Pacteau indicates, in her concluding chapter, that women's self-display, their being *captivated by* rather than being solely *captives of* creating themselves as images, deserves investigation. I would like to hope that she will offer a way out. But she presents a fraught rather than sunny future. Women needn't "relinquish all autonomy," yet they would be wise "to refuse the choice between two forms of reductionism: on the one hand, the delusory voluntarism of total liberty; on the other hand, the petrifying hopelessness of total determinism."[33] She offers no practical advice, and her epilogue casts further doubt on the possibility of women's stepping out of the mise-en-scène of beauty that she has analyzed in chapter after chapter—even with the help of one another. The epilogue is a less than one-page narrative by artist Mary Kelly from her 1985 installation *Corpus*. Two women, who are meeting after having met only once before, stand before one another having attempted to replicate the other's earlier dress. Each had admired the other's very different style and had wanted to please her. If the reader has absorbed the rest of Pacteau's book, she will understand that each woman's pleasure derives from the desire to please, from a sense of inadequacy in her own self-fashioning, and from the hope of gaining approval from the object of her admiration. Captivated by one another, the women cannot leave the staging of beauty. Each, in Pacteau's words from her conclusion, words that resonate when we read Kelly's narrative, is "alien to [her]self, can only be in an image: a 'beautiful work' formed in the gaze of another, and in the guise of another." And as an image she will always fail, as the end of Kelly's story makes clear: " 'See these boots,' I ask, 'HAVE I SUCCEEDED?' 'Well, ALMOST,' she laughs."[34]

The feminist critique focuses on visual beauty and advocates women's *seeing* themselves differently through personal, cultural, and artistic invention. Becoming *visibly* different from normative beauty will prove women's powers in self-love and social transformation. The feminist critique is also filled with analyses and sentiments about Western culture's formation of woman's beauty almost exclusively as a visual ideal, which so distills the body from the living reality of gestures, scents, and voice that such beauty, fashioned and then read as plenitude and perfection, requires corporeal dearth if not absence. Thus, the critique simultaneously maintains and challenges the visual.

Pacteau returns over and over to the irony of the beauty's decorporealized body, an irony because the culture's aesthetic/erotic focus is on

the visible. Her book analyzes the "absence of the 'real' woman that is the necessary support of the attribution of beauty."[35] The beautiful woman as a pretty picture, she argues, is a symptom of male psychology: it "seduces by offering a coherence and a unity that is foreign to the existential body. The fascination with this disembodied ideality is contingent upon the disavowal of one's own corporeality in the real—a disavowal which supports the anticipation of an ever-deferred more 'perfect' body." When, as she claims, the "material body dissolves into . . . abstraction," then great bodily satisfaction and delight—paradise—are out of reach; and if beauty evacuates the woman, then beauty is a killer and beauty lifeless.[36] Superior to the world and a paragon of virtue—she eats little and submits to the rigors of beauty dogma—the beauty belongs in the paradise that is the dwelling of the righteous after death.

This paradisiacal beauty, a "petrified image," a corpse of sorts, is less than flat.[37] She is dead(ening), an unerotic ideal in Seid's estimation: "When the body has been efficiently reduced to a flat surface, it offers no softness, no warmth, no tenderness, no mysteries—qualities once integral to images of sexuality. Our erotic ideal has become as hard and unyielding, perhaps, as the love relationships that dominate social life."[38] In her preface Wolf posits, against a bonily hard anorectic icon that damages girls' capacity for embodied pleasure, an imagined health that is a "full spectrum" of images "in which young girls could find a thousand wild and tantalizing visions of possible futures." She returns to those possibilities in her conclusion, proposing a new visibility whose terms would allow women to actually win at beauty. The winner "calls herself beautiful and challenges the world to truly see her." *The Beauty Myth*'s last sentence stresses the visual: "What *will* we see?" asks Wolf.[39] These final words may be read as figurative, but within the framework of her polemic we are pushed to take them literally.

Janet, a student in a performance art course I taught in the mid-1980s, faces the class to deliver a piece about looking and being looked at. She wears one of the fifties dresses that many of us have admired on her outside of school. The sky-blue satin complements her thick and almost coarse blonde hair. The cocktail dress shows her off: a scoop neck and tight belt emphasize large breasts and a proportionately small waist; the skirt flares around her bare legs. I remember glitter—rhinestones—and vampish high heels. Robust and awesomely sensuous, Janet, who was in her early twenties, sat and stared at us. In all the power of her young,

blonde, but not ideally slender beauty, she was trembling as she engaged each of us, singly, eye to eye, for as long as we could bear it. This was never more than a minute or so, often just a matter of several seconds, and the looking was devastatingly erotic and intimate. I shared her combined nervousness and excitement at the experience of observation. It cut through the objectification and enigma that pretty pictures produce. In the flesh, monster/beauty demystifies woman's reduction to image. What *did* I see? Not an image of beauty but the "body of content" that is monster/beauty.[40] Not only Janet's, but also my own.

Feminist encouragement of women to find better ways to represent ourselves suggests that visibility, on women's own terms, means power. But the body of content, a recurring theme in this book, exceeds the visual; and basing political as well as personal power in visible beauty—even expanded, "wild and tantalizing" versions—is problematic. In 1975, in "Visual Pleasure and Narrative Cinema," Laura Mulvey called for the ruin of (male) visual pleasure, which fetishizes the ideally—cinematically— beautiful female face and body through the male gaze. It is this male gaze that creates the petrified picture of woman. Theories of the male gaze's construction of visual pleasure dominated feminist and art theory in the 1980s and were a significant aspect of the problematizing of female pleasure, visual and otherwise. More recently some theorists, such as Lorraine Gamman, Margaret Marshment, and Teresa de Lauretis, have been revising gaze theory, opening up avenues of visual pleasure for women.[41] Yet when visual pleasure as an essential aspect of women's beautifying themselves mixes with issues of self-representation and of social and political visibility, beauty is clearly as troubled a way as ever through which to gain power.

Philosopher Susan Bordo reminds us that body practices such as dieting and weight training, which promise beauty as an outcome, are likely both productive and counterproductive. They may reproduce conventional feminine behavior, pleasing the eye by disciplining the body. Still, she acknowledges that body disciplines may indeed liberate women from "gender normalization."[42] The woman who is a beautiful sight partakes of spectacle in contradictory ways. As a monster/beauty she is unusual, even daring or ridiculous looking. She is midlife bodybuilder Diana Dennis in pinup gear; professor Jane Gallop in a dramatic red suit; my mother naked, leaping like a ballerina; the vampiric terror who sucks the blood out of the pretty picture in order to transmogrify it, to enliven

dead images with new blood. However, as imitations of ideal beauty, women may be pathetic "consumer[s] of illusion," a phrase Guy Debord uses in his damning critique of commodity spectacle to describe passive victims of a world "mediated by images."[43] Such women identify with the celebrity beauty, a commodity spectacle who is the illusion of feminine perfection. In Debord's terms, the woman who aspires to commodity spectacle can only be banally artificial—a "falsification of life," of truly fleshly desire and satisfaction.[44] Such a woman desires appearances, wants herself to become an abstract value: beauty. She is the ineffectual spectator whose identification—a superficial intimacy—with the spectacle is pitifully and bitterly ironic. For spectator and spectacle never merge, and desiring spectators unite only in their separateness from one another. Isolation disempowers the would-be spectacle. Sight deceives, asserts Debord. So the woman who wishes to be seen as a spectacle has been deceived by its ubiquity, its "monopolization of the realm of appearances," into believing that emulation will boost her own ever-inadequate visibility.[45]

Visibility does bring attention, and it is politically appealing because those who are seen get a chance to be heard. In the late 1960s the women's movement brought women's bodies, frustrations, intellect, and savvy into the limelight. From the sexual revolution to the academy's questioning of canons to the establishment of women in positions of professional authority, visibility for women has resulted in greater personal and professional confidence and power. At the same time, increased visibility generated the insidious 1980s barrage of news stories, films, and TV shows that Susan Faludi unremittingly documents in *Backlash: The Undeclared War against American Women* (1991). She asserts that perpetrators of the backlash, who included the fashion and beauty industries, tried to convince women that feminism was their enemy. Wolf claims in *The Beauty Myth* (published the same year) that "beauty backlash arose specifically to hypnotize women into political paralysis."[46] Women's political, professional, and sexual power so threatened the social order, according to her, that women had to be put back in their place—the feminized house and prison of beauty, where "wild" bodies and ideas could be domesticated and surveilled.

Performance studies scholar Peggy Phelan articulates ways in which visibility "is a trap . . . ; it summons surveillance . . . ; it provokes voyeurism, fetishism."[47] The spectacle, whether beauty, anorectic, or

"fatty," is fetishized into an icon to fault, chastise, or shame women; and the marketers' gaze fixates on those in all three categories, who are visible in politically new formations due to women's enhanced public presence. Phelan suggests that "Visibility politics are compatible with capitalism's relentless appetite for new markets."[48] Beauty, exhaustively sold to women, becomes the price exacted for just a little liberation from gender norms.

Monster/Beauty develops new modes of beauty that *are* visual. I agree with Phelan that "visual representation is 'not all,' " because it marks a loss, in commodity culture, of the underasserted senses.[49] For Pacteau, sight misrecognizes the beauty: she is the mother, perfectly inviting and comforting in a "sartorial skin" that is evidence of human beings' " 'sublimation' of touching into looking."[50] Monster/beauty reverses that process with a palpability essential to touch's existence and operation. But I cannot betray the monster's visual plenty through some theoretical sleight of hand. The monster's purpose has been to show and be shown. *Monster* derives from the Latin *monstrare*, "to show"; and within the Western tradition, monsters are meant to be shown as warnings that visibly reveal unreason.[51] *Monster* also derives from the Latin *monstrum*, "divine portent of misfortune." The monster defies expectation, and therefore I use it as a symbol and agent of change. Monster/ beauty heralds misfortune to beauty and its particular rationalizing of the human body into measurements, such as 36–24–36—the mantra of perfection in my adolescence—height and weight charts, or the French Renaissance *blason anatomique* analyzed by Pacteau. Monster/beauty deviates from the beauty ideal in which form, inflexibly ordered, is content; for monster/beauty shows off the more fully sensuous and intelligent content of soul-and-mind-inseparable-from-body.

PLEASURE IN THE PROSAIC

"Pursue pleasure," Wolf exhorts, as a way for women to claim beauty for themselves.[52] Good enough idea, though it pretty much remains a slogan, along with others that advocate an end to the self-inflicted pain that women endure in order to achieve beauty. She makes pleasure— playfulness, choice, and self-love—a clear antidote to pain; yet without a substantial exploration of pleasure, she leaves me with the feeling that pleasure is something giddy and that it can be willed. I am at least as firm

as Wolf in advocating pleasure as a basis for change, and I believe that pleasure is feasible and necessary momentum in the process, not just a goal. But pleasure as one's general state of being, as a prosaic—here I mean daily, not banal—reality, is not within everyone's easy reach or even realm of belief. Pleasure, for many people, does require pursuit—trying, striving, seeking.

Pleasure is an ultimate antidote that detoxifies women's bodies both of intimates' criticisms and of the medical and beauty industries' poisons that provide false comfort. Women in their twenties tell me that their thighs jiggle, their buttocks are huge, their stretch marks horrify them, and they dread growing older; and their parents and lovers reinforce the women's belief in their ugliness, which becomes heartbreaking commitment to self-abnegation, to their inability to be goddesses of perfection. I listen to midlife women grappling with cultural imperatives to undergo cosmetic surgery and hormone replacement therapy, to continue to atone for being female. "Under a patriarchal regime," states philosopher and psychoanalyst Luce Irigaray, "religion is expressed by rites of *sacrifice and atonement*."[53] The idea of sacrifice for beauty runs throughout Wolf's book, and the chapter titled "Religion" impresses upon the reader the momentousness of what would seem to be a most trivial secular devotion: looking divine.

> *Victim:* a person killed as a sacrifice to a god in a religious rite
>
> *Women:* immolated on the altar of Dionysus, victims not of divine but of daily frenzies, the beatings and rapes, the anti-abortionists' verbal and physical attacks, the wild martyring of themselves for one after another vision of an Aphrodite they have never invented
>
> *Victim:* a hormonal horror possessed by estrogen, which, when she becomes postreproductive, the medical profession must replace in order to maintain her derangement, her feminine essence and excess that drive her to the edge for beauty
>
> *Woman:* immolated in the orthodoxy of hormonal biologism
>
> *Victim:* delirious from lack of pleasure

Representation impinges on pleasurable everyday practices, making them or individual experience untrustworthy as sites of cultural transformation, according to many feminist theorists: women cannot represent

themselves, nor can they experience their own desire. Film theorist Mary
Ann Doane explains: "the representations of the cinema and the repre-
sentations provided by psychoanalysis of female subjectivity coincide.
For each system specifies that the woman's relation to desire is difficult if
not impossible. Paradoxically, her only access is the desire to desire."[54]
Feminist theorists' recognition of the need for a revolution in the sym-
bolic order, in representation, led many in the 1980s away from writing
(as) real bodies or from writing or trusting experiential pleasure. A poli-
tics of experience, equated by some theorists with 1970s activist femi-
nism, which in the United States often grew out of consciousness-
raising groups in which women spoke of their own experiences, was
called naive. In 1983 Jane Gallop wrote about such naiveté in an article
about Irigaray.[55] In *Sexual/Textual Politics* (1985) Toril Moi discusses
Irigaray's analysis of woman's lack of access to the pleasure of self-
representation.[56] In *The Bonds of Love* (1988) Jessica Benjamin asserts,
"Insofar as a woman's desire pulls her toward surrender and self-denial,
she often chooses to curb it altogether" and, concerning self-representation,
"the element of agency will not be restored to woman by aestheticizing
her body—that has already been done in spades."[57] Much of 1980s femi-
nist theory problematized woman's desire and experience to such a
degree that beauty could easily be construed as complicity with man's
desire, as was pleasure—if indeed pleasure (her own pleasure) was even
possible.

If, as a site of visual pleasure, a woman is only a reflective Other who,
as Phelan claims, "cannot be seen,"[58] then how is she to establish her own
aesthetic/erotic pleasure? Chapkis offers a strategy, "defiant pride in
challenging convention"; and her chapter "Toward a More Colorful
Revolution" includes testimonials of pleasure.[59] A seventy-nine-year-old
woman enjoys brightly colored contemporary fashions and believes that
old women should "take pleasure in dressing up at our age." A black
woman adopted by a white family—"my natural mother was a white
Dutch woman impregnated by a man from Ghana"—relates her fear
about encouraging the "stereotype of the hot Black woman who is good
in bed" if she were to wear the very short skirts that she herself has
made. Finally, she wears them "on the streets" so that she would not be
like a "lot of women [who] do their utmost to be good rather than fol-
lowing their own fantasies." A longtime feminist who likes makeup and
dressing theatrically ruminates about the talent, skill, time, and, "most

important of all, . . . self-confidence" necessary for "matching what you think you are inside with what you want to look like outside."[60] The women's stories are positive, hopeful, and inspiring, and Chapkis frames them within a picture of necessary social change: women must recognize and contest the sources and maintenance mechanisms of "our sense of inadequacy."[61] Individual boldness and defiance are significant, because they bolster one's self-respect; yet daring aesthetic/erotic self-creations, identified as or reduced to only individual acts, may be seen as dismissible eccentricities unless we organize our thinking to consider them as part of a larger restructuring of beauty performed, enjoyed, and labored on by a community of monster/beauties.

Individual pleasure is difficult to find. Several years ago a student who knew that I was thinking critically about pleasure gave me an exercise, a photocopied sheet titled "Find Out What Would Give You Pleasure," that she had found in an empty classroom. The addressee is advised to make lists of pleasures—current, onetime, and untried—that seem appealing. Some suggestions appear as activities for morning, afternoon, or evening. The bottom of the page reads, "You now have the possibility of waking up each morning with something to look forward to immediately and again later in the day and of finishing off the day with the knowledge you can have some pleasures in life if you'll take them. Make it a reality by giving yourself some joy at least three times a day." The exercise seems directed toward women because many of the activities bear female associations: crocheting, telephoning a friend, watering plants, buying black satin sheets, visiting. All the others are gender neutral.[62] Although pleasure in the prosaic matters is indeed the focus— riding river rapids is the only anomaly in this regard—it must be pursued, because pleasure is not habitual. Also, it can be made to seem like a chore: the two sections of the exercise are headed "Activity 19A" and "Activity 19B."

In a realm of eros worlds apart from Activities 19A and 19B, the marquis de Sade's novels, the relation between people and pleasure is no less hapless and disconnected. Sade's libertines are forever exclaiming that their sexual pleasure has never been so good. Such hyperbole suggests that pleasure is an ultimate experience; yet one can repeat it many times. His characters' self-observations epitomize what appear to be common feelings about pleasure: it comes and goes, it is extreme. That pleasure might be fairly constant in some people's lives seems

absurd, for wouldn't it then be boring, indicative of inertia or stagnation, or even delusional?

For someone reading a review of performance artist Penny Arcade's *Bad Reputation* in the May 1997 *New Art Examiner,* a response to the question "delusional?" could easily be "yes." Reviewer Ed Rubin compares Arcade to Piaf, displaying "suffering at its most artistic." Recountings of rapes (her own and other women's), manifesting "visceral anguish" by eating then vomiting twelve raw eggs, and exploring "society's tendency to blame the victim" leave Rubin "speechless" at one more "dazzling" piece by Arcade, whose career of almost three decades is marked by her "confessional," "vulnerable," "in-your-face" content.[63] *Bad Reputation,* like Sue Williams's ribald painted attacks on men's violence to women; Cindy Sherman's dismembered and truncated bodies, constructed of prostheses; and Kiki Smith's sculptural exposures of fleshly fragility, reports aesthetically on painful social and corporeal facts and receives praise for doing so.

In contrast, a major art magazine feature on Carolee Schneemann's 1996 retrospective exhibition—her career, like Arcade's, was then about thirty years long—is at best ambivalent about Schneemann's engagement in pleasure. "The Arrogance of Pleasure" is the title of Nancy Princenthal's October 1997 *Art in America* review. Schneemann is best known for work that features her own beautiful body as a site of pleasure. Indeed, in Princenthal's article, Schneemann is a "pioneer of freewheeling body art" and one of "several groundbreaking feminist artists" who dared to present herself as sexual subject and object, or in Schneemann's words, as "an image and an image-maker." Although Princenthal affirms Schneemann's importance within both contemporary and feminist art, she seems leery of the artist's most praiseworthy achievements; while recognizing "the merits of its still stunning boldness and joyousness, and above all its pride," its "shapeless, shameless celebration of pleasure, unqualified by irony, ambiguity, danger or past pain" seems to her "difficult" and "embarrassing."[64] Apparently, pleasure must have a point—perhaps orgasm, or a reward, such as a bowl of chocolate ice cream at the end of the day, for a task well done.

Princenthal suggests that Schneemann was ahead of her time in the mid-1960s, "creating performances and installations definitely not meant for the faint-hearted."[65] The reviewer treats erotic pleasure as if it were an aggressor; but it is "damage," as Schneemann asserted when I asked

about her response to the review—specifically the notion of pleasure as arrogance—that truly threatens human being.[66] Schneemann compassionately acknowledged the very real sources and consequences of social and psychic damage, and she said, too, that it is always women who are labeled shameless. In chapter 13, where I discuss shame and the erotics of damage, I also point out the difference between the shameless and the unashamed soul-and-mind-inseparable-from-body. Neither indecent, impudent, immodest, nor brazen, Schneemann's pleasure is unashamed. It only appears arrogant in an art world that likes its pleasures cut by irony, ambiguity, danger, or past pain, that elevates an abject or grotesque aesthetic, so that an aesthetic of unadulterated pleasure in an aphroditean body is "too much" because it is more than many of us can imagine to be possible for ourselves.[67]

I am for an aimless pleasure, like a stroll in a familiar city, like swinging my arms for the hell of it. I am for shapeless joys, chocolate melting in my mouth, listening to a voice I love saying anything at all. These unforced moments shape soul-and-mind-inseparable-from-body into monster/beauty. Leisured pleasure, given a chance to become habit, is a foundation for building the body of love.

When damage exceeds pleasure as a primary mode of existence, pleasure stigmatizes the body. Lack of aesthetic/erotic failure is the "arrogance" that marks the body of pleasure as dismissible. Pleasure permits and exudes self-validation, but, as Princenthal's reservations indicate, the body of pleasure, though powerful, cannot be granted outright authority.

The "GLAM Manifesto," authored by two undergraduate art students, is a paean to the authority of the body of pleasure built through aesthetic/erotic self-creation. Julia Steinmetz and Jessica Peterson, founders of the GLAM Dyke Rescue Unit, handed out their manifesto at the Style Conference held at Bowling Green State University in 1997. The wryly written, theoretically informed broadside gives serious practical advice about how to intrusively trouble the "gender, class, and sexual signifiers" of popular culture, fashion, and the capitalist system in order to construct oneself in a "sexy, positive and self-respectful way."[68] GLAM is work, is chosen, and is irreverent, self-conscious, and nonconforming, and it is meant for everyday use. GLAM queens, dykes, and princesses do not aspire to be spectacles by arranging appropriately mixed consumer items. Rather, they become spectacles by skillfully mis-

matching normative codes of commodities and behaviors. Steinmetz and Peterson display an implicit understanding of the feminist analysis of beauty's formulation as class-based in two senses. Beauties exist in a class by themselves; and beauty is closely related to wealth—a point made clear by Lakoff and Scherr in their discussion of *Vogue,* a society magazine that early in the twentieth century featured photographs of moneyed women but post-Depression began to show beauty as a "commodity in and of itself," as exemplified by the professional beauty who necessarily promoted a high-class aura and expensive clothing.[69] GLAM practitioners joyfully flaunt their deviance from *Vogue*'s prettily ordered "classy" picture by being "actively beautiful."[70]

This kind of agency plus the habit of leisure may rescue people from damage as well as from the unpleasurable labor, the tedious to punishing practices, that the feminist critique decries. Wolf is especially relentless as she details physical and political effects of anorexic starvation and tortures of cosmetic surgery. In a chapter titled "Violence," surgeons "invade" women's healthy bodies, "atrocities" flourish, and "mangling" and "mutilations" are perpetrated in the search for perfect breasts and faces.[71] Women's hunger, not their fat, is the latent content within self-punishing efforts to be thin. Female fat is the surface moral and aesthetic issue; but as Bordo asserts in *Unbearable Weight* in chapters on hunger, thinness, and anorexia, which were first drafted or published in the late 1980s, "Mythological, artistic, polemical, and scientific discourses from many cultures and eras certainly suggest the symbolic potency of female hunger as a cultural metaphor for unleashed female power and desire."[72] The "beauty" of diet labor is that it "reduces" women's appetite and energy for, in Bordo's words, "inner development and social achievement." Anxious and passive: this is the body/mind produced by eating restrictions, and it manifests what Bordo calls a "psychopathology as the crystallization of culture."[73] Or the effects of "beautifuckation."

Beautifuckation was the title of another of Janet's performances. Her props were grooming tools; she was naked beneath an open robe, and I remember her shaving her legs and clipping her pubic hair. This was sexy, funny, and horrifying all at once. Preceding publication of *Beauty Secrets,* with its envious yet severe comments about the celebratory media representation of male grooming rituals, Janet heroicized and condemned beauty maintenance as something that fucks over women. Her authoritative performance as a body of pleasure—plump, self-

loving, wonderfully aphrodisiac—leads me to think that the process of beautifuckation, of tending oneself into fuckability, helps to build the body of love. Janet was a substantial, very material body, but the beauty ideal, with its demand that women suppress their appetites for fulfillment outside of the pretty picture, produces desire for a nonbody. Beautifuck-ation procedures may entail getting rid of one's body—literally, through dieting or liposuction, and figuratively, through surgical alterations—in order to become "superior to the world."[74] But monster/beauty is in and of the world, taking up space, casting a shadow, dirtying the virtues of sexual difference in appearance, of age-appropriate behavior and cos-tume, of the blonde bunny goddess whose deification I debunk in chap-ter 10. Monster/beauty is not an answer to compulsive behaviors, but it *is* an appetite for pleasure and an investment in pleasure.

While bodybuilders' grueling workouts may proceed from fat- and age-fearing self-punishment, from desire for strength and protective armor, they may at the same time be rooted in the pleasure of intense training and of changing the body's shapes and comportment. Bordo's keen insight is helpful in thinking about the contradictory nature of beautifuckation: "I view our bodies as sites of struggle, where we must *work* to keep our daily practices in the service of resistance to gender domination, not in the service of docility and gender normalization. This work requires, I believe, a determinedly skeptical attitude toward the routes of seeming liberation and pleasure offered by our culture."[75] Ready-made formulas such as dieting, exercising, eating five or more fruits and vegetables a day, balancing one's psyche through meditation, or alleviating emotional venom sound like parts of a sane routine. Or perhaps it's just a boring routine that desensitizes us to pleasure. *Monster/ Beauty* speaks strongly in behalf of susceptibility to pleasure.

People's erotic ease in their bodies is a dream of mine that impels me to write poetically—and some might think utopically—about midlife bodybuilders, mothers and daughters, and older women and younger men. When I say in chapter 1 that bodybuilders Emilia Altomare, Christa Bauch, Diana Dennis, Laurie Fierstein, and Linda Wood-Hoyte manifest "paradise now," I wish to foster the delight that we are able to feel in ourselves, a delight that comes, in part, from our confidence to create ourselves as the "stuff of erotic fantasy" that Chapkis suggests is an important part of personal beauty.[76] I wish also to eradicate beauty ago-nies and ironies that revolve around the decorporealized "body" of the

beauty. My wish is unforced. It grows out of inclinations, intuitions, and feelings that, through analysis and articulation in critical and poetic language, appear to be strategic. I do not think of my motivation for writing in those terms; but if *Monster/Beauty* suggests to the reader that pleasure is a strategy for well-being, then I am for that plan of action.

In the Name of Monster/Beauty

I'm a standup nightmare, a blistering perfume
I'm offering salvation when I glide into your room
I'm a folktale told at midnight, a young girl's freshest dream
I'm Aphrodite's long-lost child and just like her I gleam

Hey! My name is Legion. Hey! My name is Truce
Hey! My name is Sleepless Nights when I am on the loose
In hearts that tried disowning me and eyes that tend to see
Visions like they're pictures to scan on your TV

Hey! My name is Tenderly. Hey! My name is Cute
I am full of flesh and hair and plenty queer, to boot
I love chocolate, I love sun, I'm beauty and the beast
I'm an invitation to your own erotic feast

NOTES

1. Elaine Scarry's *On Beauty and Being Just* (Princeton: Princeton University Press, 1999) provides a rich ground for thinking about the pursuit of one's own beauty as a way to achieve self-love. When she argues that "the very symmetry of beauty . . . leads us to, or somehow assists us in discovering, the symmetry that eventually comes into place in the realm of justice" (97), and that "Beauty seems to place requirements on us for attending to the aliveness . . . of our world, and for entering into its protection" (90), I begin to think that the self-love discovered through our own aesthetic/erotic self-creation is a kind of justice toward ourselves, a kind of aliveness that engenders the desire to care for—protect—our own and others' well-being.
2. Francette Pacteau, *The Symptom of Beauty* (Cambridge, Mass.: Harvard University Press, 1994), 95.
3. Naomi Wolf, *The Beauty Myth: How Images of Beauty Are Used against Women* (New York: Anchor Books, 1992), 9.
4. Robin Tolmach Lakoff and Raquel L. Scherr, *Face Value: The Politics of Beauty* (Boston: Routledge and Kegan Paul, 1984), 15.

5. Ibid., 14–15.

6. Elizabeth Hayt, "Pretty Poison," *Vogue*, February 1998, 160. Hayt explains that "Botox, the latest craze among cosmetic dermatologists and plastic surgeons, does, indeed, come from Botulinum Toxin Type A, a neuromuscular blocking agent that, when ingested in large doses, causes food poisoning, leading to complete paralysis, respiratory failure, and death. . . . Right now, . . . tens of thousands of Americans are receiving Botox injections to smooth facial lines." She also calls Botox "a fin de siècle miracle against aging."

7. Martha Rosler, *Vital Statistics of a Citizen, Simply Obtained*, 40 min., Art Metropole, Toronto, 1977, videocassette.

8. E-mail, August 24, 1997. The writer wishes to remain anonymous.

9. Wendy Chapkis, *Beauty Secrets: Women and the Politics of Appearance* (Boston: South End Press, 1986), 3.

10. *Flawless skin* is one of many phrases in the beauty jargon of hope. Makeup artist Laura Mercier makes it clear that flawless skin is a constructed look: "My whole career I've been obsessed with trying to make the complexion flawless." Several products in her own makeup line create what she calls "the flawless finish." Mercier is quoted in Amy Astley, "Artistic License," *Vogue*, February 1998, 238.

11. In an article on Ossie Clark, "*the* swinging London designer" of the sixties, Hamish Bowles designates Clark a formative member of a "meritocracy of talent and looks" that included Mary Quant, Mick Jagger, Jean Shrimpton, David Bailey, the Beatles, and Richard Lester. See "Ossie Clark, 1942–1996," *Vogue*, November 1996, 142.

12. Chapkis, *Beauty Secrets*, 6.

13. See Joanna Frueh, "Visible Difference: Women Artists and Aging," in *New Feminist Criticism: Art, Identity, Action*, ed. Joanna Frueh, Cassandra L. Langer, and Arlene Raven (New York: HarperCollins, 1994), 264–88, and "Polymorphous Perversities: Female Pleasures and the Postmenopausal Artist," in *Erotic Faculties* (Berkeley: University of California Press, 1996), 81–112.

14. In "Ghettos of Obscurity: Individual Sovereignty and the Struggle for Recognition in Female Bodybuilding," in *Picturing the Modern Amazon*, ed. Joanna Frueh, Laurie Fierstein, and Judith Stein (New York: Rizzoli, 2000), 72–85, Leslie Heywood thinks both positively and critically about women's corporeal sovereignty in relation to female bodybuilding.

15. For pros and cons on the personal in scholarship, see "Forum," a series of twenty-six statements, in *PMLA* 3, no. 5 (October 1996): 1146–69.

16. Audre Lorde, "Poetry Is Not a Luxury," in *Sister Outsider: Essays and Speeches* (Trumansburg, N.Y.: Crossing Press, 1984), 37, 38 (earlier version published as "Poems Are Not Luxuries," *Chrysalis: A Magazine of Woman's Culture*, no. 3 [1977]: 8).

17. Ibid., 38.

18. I hope that I'm contributing to Susan Gubar's "more mirthful lexicons[—] . . . delicious linguistic practices . . . that . . . can heal feminist discourse" of its "debilitating rhetorics of critical election, abjection, and obscurantism." See Gubar, "What Ails Feminist Criticism?" *Critical Inquiry* 24, no. 4 (summer 1998): 902.

19. Noliwe M. Rooks, *Hair Raising: Beauty, Culture, and African American Women* (New Brunswick, N.J.: Rutgers University Press, 1996), discusses beauty as an issue of race and class from historical and political perspectives. As is true of the authors more focused on beauty per se, Rooks is concerned with women's self-representation and -definition and their fears of physical imperfection. Nancy Etcoff's position in *Survival of the Prettiest: The Science of Beauty* (New York: Doubleday, 1999) goes against the grain of feminists' assertions that beauty is a myth and a cultural construct. She argues that human beings' beauty is a biological adaptation, a "core reality" (233).

20. Una Stannard, "The Mask of Beauty," in *Woman in Sexist Society: Studies in Power and Powerlessness*, ed. Vivian Gornick and Barbara K. Moran (New York: Basic Books, 1971), 187–203; Germaine Greer, *The Female Eunuch* (London: MacGibbon and Kee, 1970), 33–38, 55–63, 259–62; and Shulamith Firestone, *The Dialectic of Sex: The Case for Feminist Revolution* (New York: William Morrow, 1970), 171–75.

21. A recent issue of *She*, an Irish fashion magazine, includes a feature on women who "are flaunting their facial hair." Four women, photographed by Trish Morrissey, reveal their facial hair traumas and reconciliations. See Sophie Davies, "The Gender Agenda," *She*, February 1998, 41–44.

22. Wolf, *Beauty Myth*, 201–8.

23. Lakoff and Scherr, *Face Value*, 3, 12.

24. Pacteau, *Symptom of Beauty*, 15, 19.

25. In *Hair Raising* Rooks discusses turn-of-the-century beauty advertisements that "relied heavily on 'before' and 'after' photographs that promised to change African American women from beasts into close approximations of white women, or beauties" (119). Rooks's discussion throughout *Hair Raising* implicitly conjures up the African American woman as a monster if she does not approximate whiteness with her hair texture.

26. Gail Vines, *Raging Hormones: Do They Rule Our Lives?* (Berkeley: University of California Press, 1993), challenges the notion that women are hormonal "monsters" whose biology needs to be medically controlled. Susan Bordo, *Unbearable Weight: Feminism, Western Culture, and the Body* (Berkeley: University of California Press, 1993), 154, explains that the anorexic syndrome manifests "deep fear of 'the Female,' with all its more nightmarish archetypal associations of voracious hungers and sexual insatiability." Barbara Creed, *The Monstrous Feminine: Film, Feminism, Psychoanalysis* (London: Routledge, 1993), considers, among other subjects, the monstrous mother. The *Alien* series, all Twentieth Century Fox films, comprises *Alien* (1979, dir. Ridley Scott), *Aliens* (1986, dir. James Cameron), *Alien³* (1992, dir. David Fincher), and *Alien: Resurrection* (1997, dir. Jean-Pierre Jeunet).

27. Pacteau, *Symptom of Beauty*, 14.

28. Mary Russo's "Female Grotesques: Carnival and Theory," in *The Female Grotesque: Risk, Excess, and Modernity* (New York: Routledge, 1994), 53–73, is a classic feminist consideration of the female grotesque. Julia Kristeva's *Powers of Horror: An Essay on Abjection*, trans. Leon S. Roudiez (New York: Columbia University Press, 1982), became the foundation for scholars' and artists' think-

ing and projects about abjection. See below, chapter 3, note 7, for documentation of Kristeva's influence. Much of the November 1997 *New Art Examiner* is devoted to the low-life aesthetic, which I discuss in chapter 13.

29. Lakoff and Scherr, *Face Value*, 9.

30. Wendy Chapkis, "Explicit Instruction: Talking Sex in the Classroom," in *Tilting the Tower: Lesbians, Teaching, Queer Subjects,* ed. Linda Garber (New York: Routledge, 1994), 14.

31. Chapkis, *Beauty Secrets*, 6.

32. Roberta Seid, "Too 'Close to the Bone': The Historical Context for Women's Obsession with Slenderness," in *Feminist Perspectives on Eating Disorders,* ed. Patricia Fallon, Melanie A. Katzman, and Susan C. Wooley (New York: Guilford Press, 1994), 13.

33. Pacteau, *Symptom of Beauty*, 183–84.

34. Ibid., 186, 197. "Capital letters signify red highlights in the original text" (197).

35. Ibid., 12.

36. Ibid., 189, 91. Pacteau writes, "In an essay of 1979, examining the status of all the 'Lauras' of fifteenth-century poetry, Mario Pozzi has traced what may be called the 'evacuation' of the woman to the level of the poetic discourse itself" (26).

37. Ibid., 108.

38. Seid, "Too 'Close to the Bone,' " 13.

39. Wolf, *Beauty Myth*, 2, 290–91.

40. "Body of content" was a phrase used by bodybuilding philosopher Al Thomas in a conversation with me in May 1995.

41. Lorraine Gamman and Margaret Marshment, eds., *The Female Gaze: Women as Viewers of Popular Culture* (Seattle: Real Comet Press, 1989); Teresa de Lauretis, *The Practice of Love: Lesbian Sexuality and Perverse Desire* (Bloomington: Indiana University Press, 1994).

42. Bordo, *Unbearable Weight*, 184.

43. Guy Debord, *The Society of the Spectacle*, trans. Donald Nicholson-Smith (New York: Zone Books, 1994), 12, 32 (originally published as *La société du spectacle* [Paris: Buchet-Chastel, 1967]).

44. Ibid., 45.

45. Ibid., 15.

46. Wolf, *Beauty Myth*, 7. See Susan Faludi, *Backlash: The Undeclared War against American Women* (New York: Crown, 1991).

47. Peggy Phelan, *Unmarked: The Politics of Performance* (London: Routledge, 1993), 6.

48. Ibid., 11.

49. Ibid., 32.

50. Pacteau, *Symptom of Beauty*, 157, 158.

51. Marie-Hélène Huet, *Monstrous Imagination* (Cambridge, Mass.: Harvard University Press, 1993), 6, briefly discusses Western traditions that connect the monster with ideas of warning and showing.

52. Wolf, *Beauty Myth*, 291.

53. Luce Irigaray, *Sexes and Genealogies*, trans. Gillian C. Gill (New York: Columbia University Press, 1993), 190 (emphasis hers).

54. Mary Ann Doane, *The Desire to Desire: The Woman's Film of the 1940s* (Bloomington: Indiana University Press, 1987), 9.

55. Jane Gallop, "Quand nos lèvres s'écrivent: Irigaray's Body Politic," *Romanic Review* 74, no. 1 (January 1983): 77–78, 83.

56. Toril Moi, *Sexual/Textual Politics: Feminist Literary Theory* (London: Methuen, 1985), 135.

57. Jessica Benjamin, "Woman's Desire," chap. 3 of *The Bonds of Love: Psychoanalysis, Feminism, and the Problem of Domination* (New York: Pantheon, 1988), 90, 124.

58. Phelan, *Unmarked*, 6.

59. Chapkis, *Beauty Secrets*, 174; see her chap. 5 (170–93).

60. Ibid., 180, 186, 189, 193.

61. Ibid., 174.

62. The other activities are trying caviar, gardening, bowling, reading in bed, putting up a shelf, browsing in a bookstore, roller-skating, riding river rapids, writing poetry, lingering over a newspaper, and reading mail.

63. Ed Rubin, "Penny Arcade," *New Art Examiner* 24, no. 8 (May 1997): 51.

64. Nancy Princenthal, "The Arrogance of Pleasure," *Art in America* 85, no. 10 (October 1997): 106, 108.

65. Ibid., 106.

66. I asked the question during an interview of Schneemann by David Levi Strauss at the Subject to Desire: Refiguring the Body conference, the State University of New York at New Paltz, November 8, 1997.

67. Bordo, *Unbearable Weight*, 160–63, is insightful about woman being "too much" within a Western "gender/power axis."

68. Julia Steinmetz and Jessica Peterson, "GLAM Manifesto" (1997). Steinmetz and Peterson were students at Carleton College.

69. Lakoff and Scherr, *Face Value*, 80.

70. Steinmetz and Peterson use the phrase "actively beautiful" in "GLAM Manifesto."

71. Wolf, *Beauty Myth*, 238–39, 242–43.

72. Bordo, *Unbearable Weight*, 116. On women, weight, hunger, and food restriction, see Joan Brumberg, *Fasting Girls: The Emergence of Anorexia Nervosa as a Modern Disease* (Cambridge, Mass.: Harvard University Press, 1988); Kim Chernin, *The Obsession: Reflections on the Tyranny of Slenderness* (New York: Harper and Row, 1981) and *The Hungry Self: Women, Eating, and Identity* (New York: Harper and Row, 1985); Laura Kipnis, "Life in the Fat Lane," in *Bound and Gagged: Pornography and the Politics of Fantasy in America* (New York: Grove Press, 1996), 93–121; and Susie Orbach, *Fat Is a Feminist Issue: The Anti-Diet Guide to Permanent Weight Loss* (New York: Berkley Books, 1972).

73. Bordo, *Unbearable Weight*, 160. "Psychopathology as the Crystallization of Culture" is the subtitle of her chapter titled "Anorexia Nervosa."

74. Debord, *Society of the Spectacle*, 22.

75. Bordo, *Unbearable Weight*, 184.

76. Chapkis, *Beauty Secrets*, 7, admits that feminists "are beginning to suspect that while a genderless sisterhood may have made for wholesome family relations, it may not be the stuff of erotic fantasy."

APHRODITE'S GARDEN

Photographs by Russell Dudley and Joanna Frueh

As Russell's and my garden came into bloom in May 1999 we began pho-
tographing "Aphrodite's Garden." In June we completed the project.
Like other sections of *Monster/Beauty*, "Aphrodite's Garden" is personal
and scholarly, and the author makes herself known in an aesthetic/erotic
manner.

Gardens, gardening, and flowers make numerous appearances in
Monster/Beauty, as does Aphrodite, to whom I dedicate the book. In the
Graeco-Roman period Aphrodite's sculpted presence existed in gardens,
and in Pompeii she was their protector.

I provided the context and concepts for the images, and Russell pro-
vided the fine-tuned sense of prosaic aesthetics that characterizes his own
sculptures, photographs, and installations. Rich in humble relationship
with real objects and places, Russell's photographs often look like intoxi-
cated snapshots. They are extreme—their swooning permeability to the
impact of actual surfaces and atmospheres, their often minimalist plain-
ness. One sees, too, sentimentality and intimacy, which are elements
apparent in my work as well. All of the above are qualities I wanted in
"Aphrodite's Garden," so while I was asking Russell to portray me as the
aphrodisiac body I discuss throughout the book, to see me, his wife, his

prosaic partner, as an aesthetically/erotically created image, I was also anticipating that the images would look simultaneously momentous and trivial or even ludicrous—me, a real, everyday human being, as both monument and pinup. In monster/beauty one sees the result of building the body in various ways—through physical disciplines, adornments, love; one sees an articulation of pleasure and, sometimes, of the silliness of the whole enterprise of seriously creating a highly formulated aesthetic/erotic field.

Achieving the monumental and the trivial necessitated mixing figures borrowed from art history and popular culture, such as the Aphrodite of Rhodes, a Rossetti face in the midst of flowers, or a prone nymphette in short shorts, camisole, and high-heeled Mary Janes. Although my appearance as famous female nudes and as Rossetti's "Aphrodite" of precisely delineated red lips and luminous, large eyes reminds the observer that artists strictly design their subjects as beauties, neither the construction of female beauty through the artifice of artworks nor the dismantling of that beauty is the focus of "Aphrodite's Garden." However, a process similar to what it takes for that dismantling is at work: defamiliarizing the familiar through a consciously strange and close association with it. *Idiosyncrasy* is a word that Russell applies to engagingly curious and provocative artworks. Russell is good at defamiliarizing the familiar through his idiosyncratic use of materials and images. He has fashioned huge sculptures of plywood shards, golden walls to climb on; he has created a strangely prickly heaven from 10,000 transparent pushpins—hung overhead, like a cloud, after he melted them with a tea candle and fused the pins together thick end to thick end, then stuck the sharp, heated points of yet other pins into the cooled-off units; he built a trailer that serves as a pinhole projector and hand-polished its steel exterior to a reflective gleam, creating a fluid and luminous skin. Russell, like Caravaggio and Watteau, knows the boldly erotic sweetness of light.

This knowledge of his creates a photogenic monster/beauty. Photogenic: produced by light. Radiant Aphrodite, a photogenic beauty.

Russell's photographs discover the value of scenes and objects so ordinary that they are almost unreadable, because people do not have or make the time to be attentive to the visual details of their daily lives: a hand holds a saw, birds decorate a fake Navajo rug, a bruised and swollen knee becomes an elegantly queasy abstraction. His photographs, in general and in "Aphrodite's Garden," offer an erotic—which is a deeply

attentive—connection with the prosaic, a physical and perceptual con-
centration that Russell, as a rock climber, brings to bear in relation to
rock. He moves as if he were dancing, creates an aesthetic/erotic rela-
tion. He and rock assimilate into one another. *Assimilate*, from Latin
ad + similare, "to make similar." His attraction and attachment to the
physical produce an understanding of it that exceeds the physical dimen-
sion while incorporating it. This ability belongs to a prosaic aesthetics,
which is the creation of an ardent, gentle force field that permits one to
assimilate with one's everyday environment in ways that enhance both
its and one's own beauty.

In the creation of a prosaic aesthetics, one might assimilate with
Aphrodite. Apparently, everyday Greek and Roman women experienced
Aphrodite—a statue in their homes, shrines, and gardens—as sister and
friend. If she can be this today, then she is a woman's complement, not
the implicit critic of a woman's imperfections. Aphrodite Concordia.

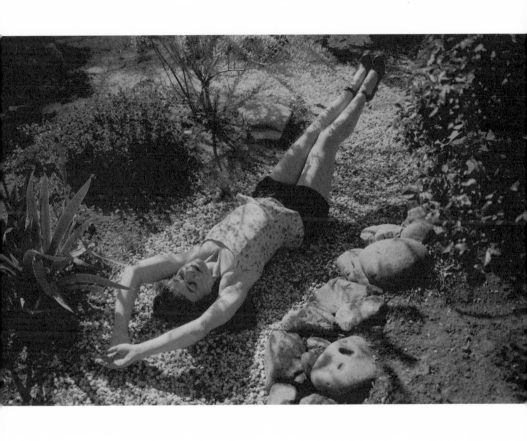

The Force of Little Girls.

Above:
Monna Pomona (after a
Rossetti watercolor of 1847).

Opposite:
Rhodian Aphrodite.

Two Golden Roses —
Florence and Erne.

Charismatic Decorum.

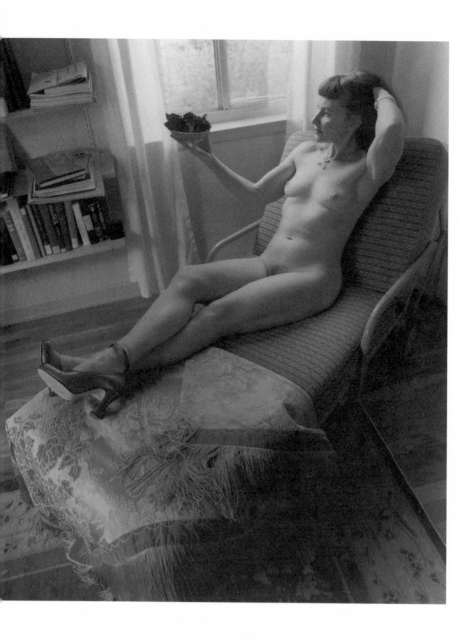

Reclining Venus
with Bowl of Roses.

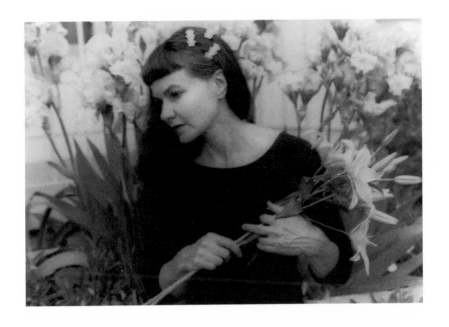

The Blessed Damozel (after
a Rossetti oil dated 1875–78).

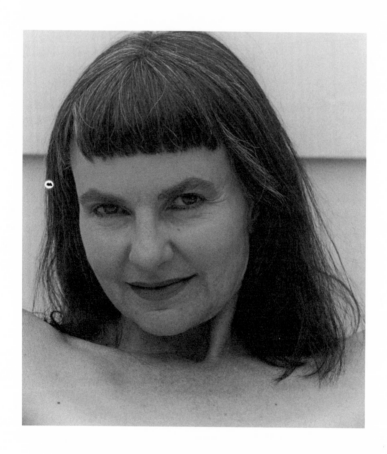

Ambrosial Aura.

Comportment of the Undead.

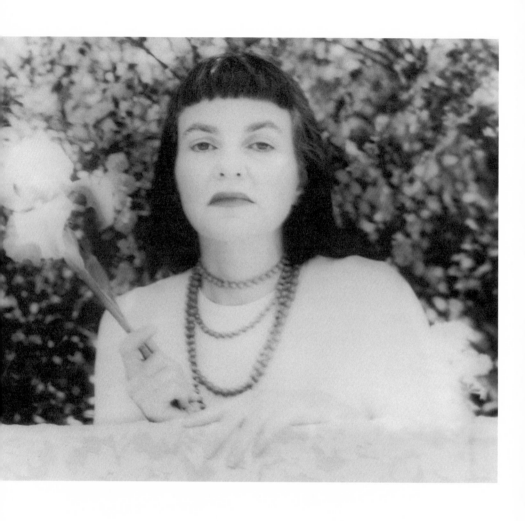

Regina Cordium
(after a Rossetti oil of 1866).

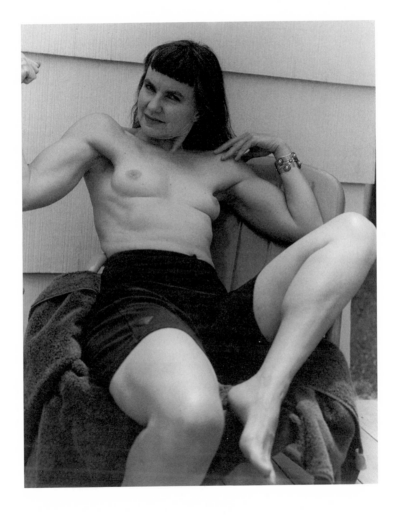

The Implicit Reach of Petals.

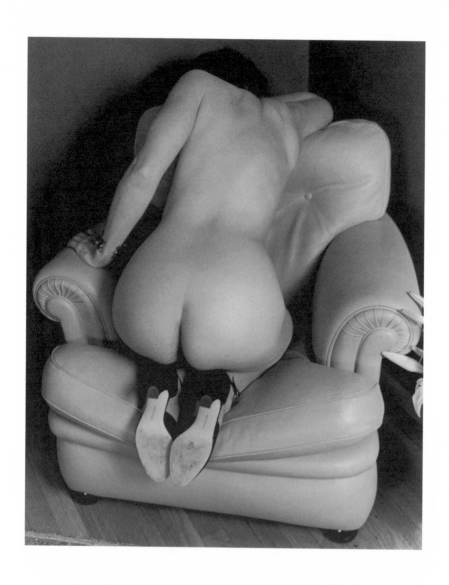

Aphrodite Salacia/
Aphrodite Amazonia.

Erotic WEIGHT

One

APHRODISIA AND EROTOGENESIS

"She's an abomination," said the owner of a fashionable New York gym chain in 1995 about a bodybuilder in her early forties. "I could love them all," wrote semiotician Marshall Blonsky about the twenty-seven body-builders in *Evolution F,* a 1995 performance that included three women in their forties and one each in her fifties and sixties.[1] These two statements bracket the extremity of response to an aesthetic spectacle that is not just the female bodybuilder but also, more complexly, her older incarnation.

A bodybuilder friend of mine in her forties used to train herself and others at this voguish gym and reported the owner's remark to me. She told me she thinks the "abomination" was so labeled because of her stu-pendous shoulder and biceps development. A risky body, such as hers and my friend's, a risk-taking soul-and-mind-inseparable-from-body, inspires hatred and disgust as well as stimulating erotic and aesthetic pleasure.

The bodybuilder's aesthetic and erotic overarticulation provokes dis-comfort and lust. Whether the bodybuilder has created a sculpted form that merely exceeds a normative (relatively flaccid) appearance or one that is hypermuscular, the deliberately built older female body violates categories; it is uncategorizable according to binary laws. Illicit and

anomalous, the midlife bodybuilder speaks the paradox of pleasure that is monster/beauty. Her immoderate appearance ruins and increases visual pleasure. She is an erotic assault on the prevailing erotophobia regarding older women because by literally bringing them into being she brings into consciousness supposed oppositions and dissonances: youth and age, the feminine and the masculine, touchability and dominatrix toughness. She is the sign and embodiment of confusions and dilemmas. A comic body based in hyperbole, she is a joke: on "feminine forever," because she crosses genders, anatomies, and generations;[2] on the arche-typal crone, the wise soul in a withered body; on sex myth, which requires the respectable invisibility and matronly spread-and-shrivel of older women. The midlife bodybuilder is a cliché that shatters clichés, a nude who is also an actual woman, a purposive exerciser whose "pur-poseless" muscles expose the workings of eros as an aesthetic discipline.[3] She is the return of the repressed—older women's erotic agency and urgency—and she is proof that an older woman can be an aphrodisiac body, sensually gratifying to herself and others, sexually and aestheti-cally arresting. She can be the subject of erotogenesis.

THE ANAPHRODISIAC BODY

Myths of so-called graceful aging and acceptance of reality—submission to time and gravity—construct an anaphrodisiac body for the older woman. These myths essentialize her body by relegating her to a no-body. She may gain wisdom by modeling herself after the crone arche-type or simply by living as long as she has, but she loses her body, the corporeal and carnal vitality and presence wrongly associated only with younger women.

Freud wrote, "Dirt is matter in the wrong place."[4] This definition applies to the older female body in its conventional contemporary con-figuration of de-forming matter or verging-on-formless matter: time has polluted the older female, and dirt manifests itself as sagging flesh and atrophy. A statement by artist Joan Semmel, who is now in her late sixties and who has worked out regularly, serves as counterpoise to Freud's: "the human body is always sensual no matter what age, twenty or fifty."[5] Semmel's words suggest that age cannot separate flesh and the senses, because sensuality is an essential element of bodily existence. Surely sen-

suality performs the pleasures of firm, proportionate shape. Yet sensuality just as readily can perform what writer Yukio Mishima called the "narcissism" of a "bulging belly or a flat chest with protruding ribs"[6]—irregularities of droop that display eating as overconsumption and as fat that grows through lack of movement, atrophic midlife softness that (supposedly) distances caressability because observers fear the anaphrodisiac body's imagined stagnant innards that warn of the imaginer's own degeneration.

The anaphrodisiac older female body is more irregular than a younger female body, which itself is more chaotic and "abnormal" than a male body. Surveying art history, Lynda Nead argues that "the formless female body has to be contained within boundaries, conventions and poses" and that this has been the work of the female nude.[7] In the West, artists have idealized and romanticized women's bodies into predictable patterns in which youth and shapeliness signify allure and the decency of regularity, permitting viewers the relief of not having to look literally or figuratively at what culture assumes to be human beings' natural state of defectiveness. Kenneth Clark, whose study *The Nude* remains the most inclusive consideration of the subject, asserts that the nude is art's answer to "the humiliating *im*perfection to which our species is usually condemned."[8] In effect, he accepts the body as death trap, a loser's habitat. Because some younger women appear to be flawless, they escape the humiliation of imperfection; but as Clark sees it, humiliation is the general human aesthetic condition. Humiliation increases with age, which brings one loss of physical strength and, for women, the end of reproductivity. Reproductivity not only symbolizes but also has come to embody fuckability. The postreproductive body is unfuckable—erotically taboo—because it is not a potential site of male fertility/creativity: it is a tomb for men who seek immortality rather than the pleasures enjoyed by two mortals.

As Clark so bluntly puts it, "on the whole there are more women whose bodies look like a potato than like the Knidian Aphrodite. The shape to which the female body tends to return is one that emphasizes its biological functions." According to Clark, Praxiteles' Knidia (ca. 350 B.C.E.) purified the "bulging statuettes from paleolithic caves," tuberous forms whose creators emphasized breasts, hips, and belly.[9] Representing beauty, sex, and fertility to the Greeks, the Knidia became the model for the female nude. Most women, unable to compete with the classical god-

dess and her descendants, are reversions; and atavism, for Clark, is ugly. In his terms, the older female body could only be emphatically, and naturally, tuberous, with its presumably pendulous breasts and enlarged abdomen ironically stressing "biological functions" near or at an end.

The older female nude is an oxymoron if not a virtual impossibility. The tradition of both the female and male nude almost exclusively represents a young body. The Resting Hercules, heroic and ideally robust, is a mature body without an ancient Greek female equivalent. Ripe like a fruit, in bloom like a flower:[10] the female nude, in Clark's terms, is supremely clean for it is free of disharmonious development. Disharmony is a sign of the anaphrodisiac body, which is not merely unshapely; it is misshapen as well. For the Greeks, youth was the prerequisite essence of the nude because youth meant reproductive potency.

Clark assumes the existence of natural bodies on which natural events and forces operate. It matters little whether this body is called "potato-like" or "matronly." Within this system of values, the "natural" older female body lacks proportion and harmony. It is seen as men's flabby sister, thanks to the erroneous notion that the "natural" male body is hard. The "natural" older female body is also younger women's feeble grandmother, because, "naturally," young women are powerful—sexually and alluringly visible. The midlife body, an incarnation of the myth of the natural body that manifests in reality as a self-fulfilling prophecy, is, like other conventional constructions of the female body, "easy to be intimate with."[11] Smooth skin, slender physique, and high round breasts typify the look of desirability, of potential sexual intimacy. Wrinkles, gray hair, and untoned muscle characterize the conventional figure of the grandmother, whose body welcomes familial embraces and provides (sterilized) nurturance and warmth safe from sex. Inviting sex (whether loving or violent) and providing emotional and physical nourishments are all-too-familiar attributes of femaleness. But wrinkles, gray hair, and untoned muscle describe the hag as well as the grandmother. The hag, mean and hideous, is not a body that supplies intimacy, yet it is as formulaic and as familiar as the body of the sexpot, the grandmother, and the midlife matron. The supposedly chaotic older body, with its erratic contours and unpredictable menopausal organs, enforces the formula both as expectation and as reality.

A mid-forties professor said to her introductory nutrition class of almost two hundred students that because she was now in midlife she could look

"like this, matronly." In a lecture on ideal weight she was suggesting that because one's weight generally increases with age, people will not judge harshly an older body carrying more pounds and girth than a younger one. At least one student, twenty-three years old, heard her instructor's remark as an apologetic rationalization for becoming heavy and for apparently not putting to use the wealth of information on nutrition that haunted and impressed the younger woman.[12]

Several years ago a longtime feminist artist then in her early sixties was wounded and astonished when, on two social occasions, groups of her feminist artist friends (in their forties, fifties, and sixties) verbally attacked her for not looking her age. The artist bodybuilds, and she told me, "I've worked hard to keep my body in shape, and women of my generation, and some younger, view me with suspicion, as if I've had massive plastic surgery or done something unnatural. They say, 'Oh, that's just the way you are—good genes.' They don't see my going to the gym as a discipline." The artist understands her bodybuilding as not solely a matter of appearance. Bodybuilding is the use of weight resistance to shape and strengthen the body—and the mind and soul. Some bodybuilders and outside observers make a distinction between bodybuilding and weight training: the former is more rigorous and produces bigger muscles. However, Lenda Murray—six-time Ms. Olympia, and thus six-time winner of one of the main international professional bodybuilding competitions—asserted, when I interviewed her July 6, 1998, "People don't understand, it's like playing basketball. When people go out into their yard to play basketball, they don't say that it's not basketball—it's basketball. When you pick up weights, it's bodybuilding. You are working on your body."

The feminist artist told me that her friends asked "how I had so much energy, and as I continue to keep in shape, they can't move with as much flexibility. They have an obvious physical slowed-downness and self-consciousness—a feeling that they're losing their attractiveness. They seem to lack critical self-evaluation and knowledge of the connection between cause and effect. I love the experimentation with my body. Younger people today, who are thirty to forty-five, say, 'If you can do it, I can.' "[13] Backstage at *Evolution F*, I saw a competitive bodybuilder in her early thirties ask the artist her age. When she answered, "Sixty-three," the younger woman's eyes widened and she said, "I thought you were much younger."

We mistake attractiveness and energy—aesthetic vitality—for youthfulness. We are amazed by older women looking younger than their years. Our vocabulary is wickedly wrong; the notion of looking and feeling "young" undercuts the conscious creation of beauty and makes its possession possible only to younger people or, supposedly, their imitators. The feminist artist and other older bodybuilders who exhibit aphrodisiac beauty, who incarnate monster/beauty through aesthetic discipline, do not imitate youth any more than do women who wear makeup.[14] Imitation is useless because exact correspondence is impossible: *youthful* is not the same as *young;* youthful is the aesthete's halfway house; youthful is a sort-of state, not one of intriguing liminality; youthful is the matron's readjustment to society's age dread, her redemption after falling into the wayward gracelessness of midlife.

Beauty is not natural to anyone, for people create or negate their beauty by exercising—or not exercising—aesthetic energy. For the midlife bodybuilder, this creation is supremely conscious. Her exercise of pleasure creates a monster who performs a beauty that sins against the vacuous glamour that is the prettiness of "young." The midlife bodybuilder's glamour is, in part, the provocation of her years. Glamour is her accumulation of charisma: her aging, her experience, and her aesthetic/erotic work on her body, which give it character and expressiveness and which kill conventional beauty. In Diderot's words, conventional beauty, which art and culture at large have constructed as the only beauty available to women, is "a face"—and I would add *body*—"of a young woman . . . , innocent, naive, still without expression."[15]

The matron, like the bodybuilder, is neither an innocent nor inexpressive body, but cultural pathology has negated her possible beauties. I sound harsh about the matron, but her figure is so often a prototype of submission and anaphrodisia. Germaine Greer writes in *The Change* that women should enjoy becoming the invisible matron, whose interior life allows her to "gaze outward" and see beauty, to "at last transcend the body that was what other people principally valued her for." The matron's "invisibility" releases her from the "fretful struggle to *be* beautiful." According to Greer, a woman must move from incessantly laboring to be an object of desire to understanding that "beauty is not to be found in objects of desire but in those things that exist beyond desire."[16] Such is the aphrodisiac—the erotogenic—body, whose bodybuilder creator, at best, has made herself *out of* her interior life, her aesthetic concentration. This kind of concentration and its product are being experi-

enced as pleasure. Concentration and its product are comfortableness, clarity, and groundedness, and they are related to Greer's "calm and indifference," which she calls "a desirable condition."[17] The hypermuscular midlife bodybuilder deviates spectacularly from the matron model, and the less monumentally developed midlife bodybuilder deviates as well: through monster/beauty discipline, both become visible in a way that is attractive to some observers. It is the bodybuilder's being as supreme aesthete/"abomination" and as felt by the observer, rather than the bodybuilder's outer beauty, that is her more complex allure.

Writing about feminist artist Mary Kelly's *Interim*, an extensive 1990 installation that investigated the subjectivity of becoming a midlife woman, art historian Norman Bryson takes on a funereal tone: "no social agencies step forward, like suitors, to claim the woman of middle age; time no longer urges, it hangs heavy. Identification enters on a period of vacuum and dearth. What is striking now is the stark condition of need for identification."[18] Time, hanging heavy, claims the midlife body, enervating it, degenerating it from lassitude to sluggishness so that *it* hangs heavy. Time matronizes the body; and because society offers so few aesthetic models or archetypes for the midlife woman, she is left, if she wishes to be an aphrodisiac body, to identify with youthfulness. As Margaret Morganroth Gullette has argued in *Reinterpreting Menopause*, culturally constructed decline pits midlife women against their younger selves. Gullette's essay and many others in the anthology present midlife as a time for women to critically examine the cultural construction of menopause and to rethink models and explanations of menopause in order to combat them and, even, to live it, in Fiona Mackie's words, as a "joyous transition."[19] Various contributors assert that power and potential—economic, spiritual, political, bodily—are, and should be, midlife women's reality. In numerous ways, the bodybuilder is a model of particular powers and potentials.

Midlife women could stand wooing, out of the closet of time that is the death trap of the anaphrodisiac body. Herbert Marcuse's discussion of time in *Eros and Civilization* is useful for understanding both aesthetic concentration—timelessness—and the anaphrodisiac death trap.

> Timelessness is the ideal of pleasure. . . . The flux of time is society's
> most natural ally in maintaining law and order, conformity, and the
> institutions that relegate freedom to a perpetual utopia[.] . . . Whether
> death is feared as constant threat, or glorified as supreme sacrifice, or
> accepted as fate, the education for consent to death introduces an ele-

ment of surrender into life from the beginning—surrender and sub-
mission. It stifles "utopian" efforts. The powers that be have a deep
affinity to death; death is a token of unfreedom, of defeat.[20]

The "natural" body of the matron figure consents to the death of aphro-
disia, whereas the aphrodisiac body, created in the timelessness of aes-
thetic concentration, may appear relatively ageless. Bodybuilders wrin-
kle, like everyone else. That their "bodies know no age, or refuse to
reveal the process of aging," that they grow younger with time, is a
fable.[21] But as bodybuilding philosopher and doyen Al Thomas told me
in a 1996 letter, the "only 'organ' (apart from the liver) that is available
for endless regeneration is muscle." Thomas, a great lover of muscle,
wrote too that "there is no age at which well-developed (well-trained)
muscle becomes something other than (anything other than) beautiful."
Intense training, Thomas believes, creates the "sort of muscle which
(however covered with a bit of wrinkling or flab) is erotic and eroticized
and arousing, no less in an old woman than in a young woman or girl.
FAR more. Far more to be cherished." Aesthetic concentration has cre-
ated a woman whose allure is not only in her muscle but also in her
agency; for she has *chosen* shape, strength, and development. Her appear-
ance displays them, and so does her being when she is a body of content.

In general, the body of content and conventional beauty are not one
and the same. For good reason, feminists have critiqued women's long-
ing to be beautiful, because, as Francette Pacteau elaborates in her psy-
choanalytic analysis of conventional female beauty, it is a symptom of
patriarchal psychology. In *The Symptom of Beauty* she notes that the cov-
ers of *Spare Rib* magazine in the 1970s were meant to depict "real
women."[22] *Spare Rib* was a significant indicator of contemporary femi-
nist stands in Great Britain, and its covers thus forced women photogra-
phers to confront a profound task and determine "what does a 'real'
woman look like?" Pacteau answers her own question with an anecdote:
"as a photographer friend of mine remarked, the answer provided by
Spare Rib was that a real woman was 'middle-aged and very badly lit.' "[23]
If we turn with the same question to the older woman who works her
body, we may construct her as pathetic, as straining for youth, and as
fanatical—attempting in all cases to counteract "reality" and to fulfill
male desire. Inventing or naming a feminist model or image of female
physical appearance is a difficult task.

After thirty years feminists have given up their attempts to proscribe the details of women's appearance. The reasons for ending the proscriptions are many and varied, and they include public interest in high fashion and supermodels, women's wanting to "look good" in professional positions, postmodern theorists arguing the performativity of gender, the popularity of Madonna's extremely sexualized style, the booming cosmetic surgery business, and sophisticated feminist theory about beauty and the gaze.

I didn't shave my legs for a while in 1970 during my first year of graduate school; I wanted to make a feminist statement that other women were making, too. I've rarely worn a bra since high school, but not as a feminist statement. I'm most comfortable without one. I've never given up makeup. I began to play with lipstick in my childhood. I love seeing the beautiful colors on my mouth, and they've become richer, more saturated, as I get older.

The problem of naming or creating a feminist model of a "real" woman who is not a "symptom of beauty" remains. The *Spare Rib* story suggests, despite its tongue-in-cheek tone, that real women are not or ought not to be glamorous. The beauty and fashion industries create the desire to be photogenic, to conform to the glamour that photographic illusions can design. *Spare Rib* did not comply. Decades later we are still searching for a range of noncomplicitous models of real women and of feminist beauty. I posit the erotogenic as an antidote to the photogenic and as a feminist model of beauty, rooted in aphrodisiac capacity and not simplistically reliant on appearance. The older aphrodisiac body does not strain for glamour that is only artifice, and it is not rabid with longing for youth.

My friend Helen, a midlife woman who, until recently, was director of the campus women's center, spoke with me about a former faculty member at our school whom I did not know; she had been a midlife bodybuilder. Helen said that the bodybuilder looked sexy and great. "It's shameful to older women to feel and be sexual," Helen added regretfully. We agreed that the older sexy or erotic body is an embarrassment, stigmatized by hostility and at times uncomfortable to its bearer, that these kinds of appearance or presence embody a femininity that a woman is "naturally" losing as she leaves behind reproductivity; she still wants to fascinate and seduce others with her own nakedness. The erotic body is a

richer complex of elements than the sexy body, but neither is appropriate to midlife.

The midlife female bodybuilder, like both her younger and male counterparts, becomes, in philosopher Alphonso Lingis's terms, a "carnal orchid" and a "showy sex-organ."[24] Her obvious carnality intensifies suspicions about bodybuilders in general: they are self-glorifying exhibitionists—"ostentatious sex symbols," offers Lingis, with "fixated libidinal compulsions."[25] The midlife bodybuilder is an indiscreet physique, always calling attention to itself in a denial of reality (a transcendence of culturally constructed female midlife?). Also, an older woman's built body intimidates and provokes envy, a friend confided. She was in her early forties and her body had recently changed considerably because she had given birth to her first child. Intellectually, my friend was extremely curious about her "new" body, but she was at times upset with its appearance.

Helen referred to Lillian Robinson's commenting, in her review of two feminist studies of sex in the *Women's Review of Books*, on her own "sexual isolation" as a fifty-three-old heterosexual. "I am celibate and ashamed," she writes, "ashamed of my involuntary condition and ashamed that it is involuntary."[26] That the sexual isolation of older women is perpetuated by feminist ageism is apparent from Lynne Segal's *Straight Sex*, one of the books that Robinson reviews positively, though it gave her an uncomfortable feeling that " 'real' heterosexual feminists—under fifty, under forty, maybe— . . . are the ones expected to be sexual subjects," along with, perhaps, "some others still hanging in there (by our silver threads?), albeit potentially frustrated by the joint operation of sexism and ageism that is our personal problem." Robinson feels "that the desire that inhabits me is a disease."[27] The desire expressed in an aesthetically shaped older body, worked as a labor of love/play, is not fanaticism understood as desperate stalling of age. The bodybuilding fanatic does go beyond what is reasonable; she is unreasonably enthusiastic, unreasonably erotic, for she builds a body of pleasure, not only desire. Muscle as shape and strength is attainable relatively easily, whereas the high-fashion height, slenderness, and flawless skin of the runway model or the sexpot curves and luxuriant hair of the porn icon are not.

"You're strong, " says Russell to me.

"Your shoulders are awesome, " remarks a young male student to me after a spring 1999 session of our nineteenth-century art class. We both work out at

the school gym; and we compare notes for a few minutes, before leaving the classroom separately, about shoulder exercises we like.

"You have a sculpted body," my friend Robyn compliments me.

These experiences—and those of the artist in her sixties who body-builds—indicate that everyday midlife women who bodybuild can create, in the words of bodybuilder and literary critic Leslie Heywood, female embodiment "based in a power rather than a fragility aesthetic."[28] Heywood holds out this hope in an essay published in 1997, in which she is also very critical of female bodybuilders' sexualized photographic representation and their imitation of masculinity. More recently, however, she has argued that the female bodybuilder may be participating in "third-wave gender activism."[29] Seen in this light, the midlife body can express capacity rather than loss. This body can be art, and it can manifest intention and action operating in the practitioner's behalf. The lover initiates herself into art. She is the agent of her own pleasure, which is her capacity to commit to potentials of her strength and size, to the embodiment that reflects the mental concentration of "I can." "I can" proceeds from "I will," for the midlife bodybuilder who initiates herself into aesthetic/erotic self-creation and is then intent on developing it exerts her will to pleasure.[30] She need not replicate the stressed and obsessive dieting and training regimens of competitive bodybuilders, especially professionals. Competitors work to achieve as perfect a body as possible, but the noncompetitor can work with and enjoy both the building and the release of libidinal force.[31]

The runway model and the porn icon symbolize youth itself and create longing. In addition, for the older woman, they represent loss. The midlife fanatic, who asserts her will against the expectation, even the demand, that she become the formulaic matron, draws on the energy of the "tabooed logic" of eros and therefore appears unreasonable.[32] Bordo's descriptions of bodybuilding in *Unbearable Weight* illustrate this judgment. An academic acquaintance paraphrased Bordo's words to me, and I reread them: "adversarial relationship to the body," "compulsive," "perfection," "tightly managed," "disdain for material limits and the concomitant intoxication with freedom, change, and self-determination," "*control* . . . total mastery of the body."[33] For most bodybuilders, precompetition dieting is management-cum-punishment, comparable, they tell me, to anorexic starvation. Like many other women, bodybuilders are not always satisfied with their appearance, so they obsess about control.[34]

Bordo effectively analyzes the simultaneously productive and coun-terproductive elements of body disciplines that promise pleasure, beauty, and freedom. Yet her chiefly negative take on bodybuilding misses the important point of *aesthetic* control, which is a process and experience of sensuous embodiment and which particularly benefits older women. Granted, I speak about bodybuilding as a practitioner who perceives and interprets its best aspects, whereas Bordo and Nead present its worst fea-tures and speak, to my knowledge, as nonpractitioners. (Bordo did, one summer, engage in "a little bit of casual weight-training," at which time she came to understand its "attractions" in terms of "the hard and impenetrable.")[35] Also, neither considers the midlife bodybuilder as embodying different needs and pleasures than does her younger counter-part. Both Nead and Bordo posit the female bodybuilder as a contempo-rary icon of fit femininity who imposes imperatives of perfection on her-self and impossible achievements of appearance on others.[36]

Perfection and aphrodisiac beauty are not equivalents. The latter is creatable—and odd. Think of Frida Kahlo and Louise Nevelson. They styled themselves through the ornaments of clothing, jewelry, and makeup. The primary self-styling mode of the bodybuilder is the artist's basic, intuitive, and sensual shaping of matter into form. Bodybuilding has been conventionally described as the molding of the clay of the body and as the dexterous sculpting and chiseling of the body, metaphors that trivi-alize the aesthetic process as it has been exercised by women bodybuilders I have interviewed. They see these metaphors as either altogether inaccu-rate or imprecisely used. The bodybuilder as midlife monster/beauty is bizarrerie, a form of deviant content; like all exercisers, she has worked from the inside out. Molding and chiseling shape materials from the out-side, and the latter is a subtractive sculptural process. Resistance exercise as aesthetic practice is simultaneously additive and subtractive control that requires intuitive looseness as part of the discipline.

My forty-eight-year-old bodybuilder friend tells me as she trains me, "Don't count reps. Don't count sets. What does your body care about numbers? Eight? Ten? Use your intuition."

The matron model assumes that women have no control over their bod-ies or that women cannot or will not assert it. Damning management, as Bordo and Nead do, refutes another model—one making fitness an imperative—but also segues into acceptance of matronhood, whose

loose flesh becomes the contrary of taut bodies built by the tight control of fear. Let us expand both models, and say that the matron may affirm the pleasures of literally and figuratively hanging loose, while the midlife bodybuilder may assert the necessary looseness of artistic process, which makes work fun and the aesthetic erotic.

Loose women lay bare flesh that once hesitated to love itself. Dimpled or solid, but never rock, they are bulkier than normal. They do not fit the excess-free zone.[37] *They bulge into corners and across intersections. They project pleasure. Burly girls throw their weight around for the hell of it, in the buoyancy of eros.*

EROTOGENESIS

I think, all too often, about the lament of an artist in her fifties whose work has been instrumental in the formulation of a feminist visual erotics. She said to me several years ago, "There is not an erotics for older women. You're out of the game."[38] Personal shame, determined by cultural shame, is part of what redistributes, inhibits, and makes older women's erotic flair and flesh invisible.

I think, too, of my bodybuilder friend who, in response to society's matronizing of women, has protested, "What are you supposed to do? Shrivel up and die?" Her body reads as aphrodisiac pleasure to me—the opulent forms, the sweaty ecstasies of gym time; she tells me, "I feel horniest working out." I identify: always, and especially after I've performed an exercise with heavier weight or more repetitions than usual, I catch myself swaggering to the drinking fountain, radiating sex.

Voluptuousness is extreme comfortableness in one's body/being. Bodily ease, which is an erotic condition, is "naturally" rare in adults. Bodily ease characterizes children's more than adults' bodies, for adults must work at flexibility. The bodybuilder's contours, posture, muscle, and strength—and often flexibility—project her body/being as an instrument and a site of pleasure. Pleasure supports and strengthens eros. If, as Marcuse argues, the "erotic aim of sustaining the entire body as subject-object of pleasure calls for the continual refinement of the organism, . . . the growth of its sensuousness,"[39] then the bodybuilder's developing and refining of her body can be self-affirming rather than simply self-glorifying or -punishing. Comfortableness in one's body/being

may strike some as a luxury—of time, energy, and money. But erotic well-being is not a luxury; it sustains a human being, it is not dessert.[40] Erotic well-being includes elements of self-celebration, a lust for oneself that, while it cannot cancel out an observer's objectifying gaze, focuses a primary aspect of the midlife bodybuilder's attention on her own pleasure. Here lust means enthusiasm and appetite for one's own lusciousness.[41]

Shame obviates lust. Shame lives in powerfully erotic, beautifully powerful bodies. Many hypermuscular female bodybuilders wear only large, body-obscuring clothing on the street because their bodies have frequently provoked verbal abuse. Even in the gym when she was training us, my friend never removed her sweatshirt, and I could feel her self-consciousness when she took off her sweatpants and revealed her legs in tights. When she does reveal her body, her forearms rivet me with their shapely strength and severity. One day I watched her perform 315-pound squats, which moved me to tears. Immediately before squatting, her short legs, voluptuously thighed and calved, elicited from me the passionate compliment, "Your legs are beautiful." I said that because I wished to acknowledge an erotic moment, and I said that to counter her shame.

I love her, this monster/beauty: how do I console or cajole her adequately when she tells me the following story, whose quasi-humorous yet debasing content addresses her body as come-on, dare, and degradation and provokes the public shame she feels that her physique brings her?

> I was wearing tights, heeled boots, and a short, leather jacket and was walking along Broadway late in the afternoon after an art opening. A minivan slowed down and started following me. It was filled with teenage boys who were making comments about me. Then one stuck his head out the window and asked, "Will you whip me?" I was angry. What a predictable response.

My friend's beauty is bizarre and it always shows itself, whatever her state of dress or undress. Pacteau notes that Baudelaire "spoke of *bizarrerie* as the condition of beauty, rhetorically asking: 'try to conceive of a beauty that would be commonplace!' "[42] The matron is commonplace, which is one reason that she does not generally excite whipping fantasies or photographers' aesthetic or soft porn gaze.

Some feminists have argued that female display always dehumanizes a woman, whether she is an object of dirty pleasures who arouses sexual

desire or an object of supremely clean enjoyment who stirs aesthetic feeling. The aphrodisiac body, especially when clothed in (almost) nudity, the way we see or imagine the bodybuilder, provokes both responses. Deliberate and cognizant self-display is perhaps more problematic to feminists than innocent exhibition, because the subject knows that she may be fulfilling someone else's desires.

But art is paradoxical, and often the contradictions in art objects captivate us: Frida Kahlo's stunning self-martyrdoms; Eva Hesse's sagging, tangled, agonizing visceral equivalents; the midlife woman's monstrous beauty of solid form incongruous with age, of motivations for display too easily perceived as repellent, undignified, ridiculous, or immature. Some may even read the midlife monster/beauty bodybuilder as an undeserving—because not young—subject who has gratified herself.

Pacteau makes beauty a hopeless pursuit. She argues that "the pleasure afforded by self-display arises from the subject's identification with the gaze of the other: the subject sees itself, as a picture."[43] Art critic Dave Hickey insists instead that beauty, as art, is a rhetoric, that it has an agenda.[44] The bodybuilder's agenda is to show the bizarre—because apparently unbelievable—spectacle of midlife eros.

The beauty of the bodybuilder, her eros, derives from bodily mastery and awareness. Michel Foucault has explained the process this way:

> Mastery and awareness of one's own body can be acquired only through the effect of an investment of power in the body: gymnastics, exercises, muscle-building, nudism, glorification of the body beautiful[.] . . . But once power produces this effect, there inevitably emerge the responding claims and affirmations, those of one's own body against power, . . . of pleasure against the moral norms of sexuality, . . . decency.[45]

The body that lusts for itself does not lose itself and refuses to be expelled from the paradise of eros. More prosaically, this body looks good naked. Consider an ad for one of David Barton's gyms that has no image, only words: "Look better naked." It may be taken as an admonishment to achieve something impossible, as a snotty, imperious comment that invites rejection, as an unsurprising acknowledgment that everyone is embarrassed by his or her body or hates it, as a possible means to better sex—or as a suggestion that anyone can be a nude, clothed and confident in the beauty of his or her own skin, like Aphrodite.[46]

*God knew better than Adam and Eve, who were beautiful in the garden,
beautiful in their nakedness. But when they knew too much, they knew that
they were naked, and God expelled them. Erotic shame and oblivion ensued.*

We know that we are naked.

*Today's bodybuilders know that they can look better naked. These words
made flesh can reinstate the body in paradise.*

The erotic requires a connection in which the gaze of another is
essential and not necessarily alienating: *I feel pleasure because you feel
pleasure in my pleasure. You mirror my pleasure in myself.* This look does
not separate a woman from herself, does not necessarily make her into an
image, isolate her into a picture useful only as someone else's masturba-
tory tool. The erotic gaze derives from mother's and infant's mutually
loving looks, which can be a model of the freedom to look with love and
pleasure at another human being and, through that erotic interaction, to
look at oneself similarly.

Older women are not supposed to show off their bodies, but the mon-
ster's purpose is to show and be shown. In her extravagant body, devel-
oped beyond the de-eroticized rationality of the body of the matron, the
midlife bodybuilder is a prophetic vision not only of the body's power
against the powers that be but also of the horror of difference and the
paradox of pleasure: self-display as erotic agency and engagement and as
a persuasion to self-pleasure, different from because not simply the self-
estrangement of needy exhibition; age as the beauty of well-defined
curves, which disrupts the notion that attractive roundness belongs only
to the reproductively sexy bodies of younger women;[47] eros in the wrong
body; the shock of muscle where there should be flab, of stereotyped
masculinity where there should be naturally aging femininity. Monster/
beauty: a feminist nude. Monster/beauty: doom to maturity as ripe, then
rotten.

Webster's New World Dictionary defines *matron:* a woman "who has a
mature appearance or manner." *Mature* means "developed," which in
turn implies sedateness, decorum, self-respect. The bodybuilder is also
dignified and mature, in heretical ways. She exemplifies what Jan Todd, a
historian and the strongest woman in the world in 1977, calls Majestic
Womanhood: a nineteenth-century ideal of physical strength and size,
independence, and intelligence produced by advocates of purposive exer-
cise in opposition to the ideology of True Womanhood, which supported
women's weakness and passivity.[48] The matron model corresponds to

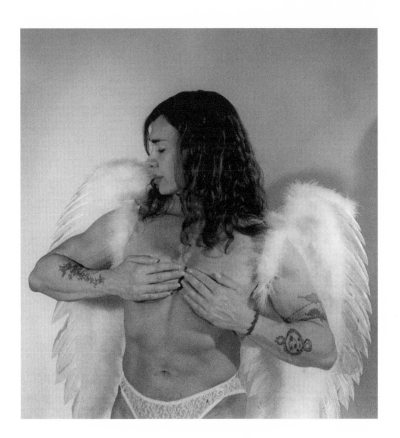

Emilia Altomare. Photograph:
Sarah Van Ouwerkerk.

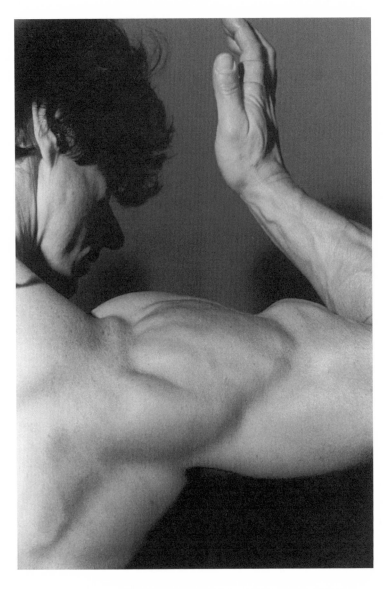

Christa Bauch. Photograph:
Sarah Van Ouwerkerk.

True Womanhood, and her *developed* body is the fullness of flab. The midlife bodybuilder's maturity also takes up space. The bigger and stronger she becomes, the more abundantly, showily *developed* she is.

Just as nineteenth-century masculinists feared manly women and the unsexing of women achieved through means that included purposive exercise and art making, so today women and men, many feminists included, derogate female bodybuilders for looking like men. Bordo, for example, writes that the "new 'power look' of female body-building . . . encourages women to develop the same hulklike, triangular shape that has been the norm for male body-builders."[49] Her point that contemporary fitness and weight loss regimes produce a masculine body is well-taken: "successful" women must reject softness, equated with the (non-liberated) mother's body. However, a hulk is large, heavy, clumsy, and slow; and many female bodybuilders, including Emilia Altomare in her forties and Linda Wood-Hoyte in her fifties, are graceful, sleek, and, like Diana Dennis in her forties, extremely flexible. The triangular shape of male bodybuilders replicates an ideal female form of large chest, small waist and hips, and round buttocks. In *Foreign Bodies*, a study of bodily pleasure, pain, and competencies, Lingis speaks of bodybuilders' "hermaphrodite muscles," an accurate description of bodybuilders of both sexes.[50] But I would add that the hermaphroditic body is other than strictly male and female; it is an unnamed sex, just as the midlife bodybuilder may be, on sight, an undesignatable age.[51]

Older women's distinct muscles create equivocation. Equivocation is erotic essence, part of the paradox of (aesthetic) pleasure. In *Libido* Lingis asks, "Is it not the indecisive and equivocal carnality, rather than the splendor of proportions not yet disfigured by the fatigue of years, that makes youth troubling?"[52] Because she is bizarrely unfatigued in flesh, the midlife bodybuilder radiates a carnality whose sex and age seem vacillating and inconclusive. Her strong and shapely hypersexuality troubles time itself as a tyrant who demands "reasonable"— unerotic—aging.

The matron, a model of sedate inactivity, is the embodiment of the sedation of eros, of giving in to the natural death trap of an aging body. The cultivation of the aesthetic of youthful prettiness in the midlife body, in contrast, neutralizes time by inhibiting the living, acting, developing body. "Life Begins at Forty," *Playboy*'s February 1995 cover story, features this surrender to prettiness by the feminine subject who, to quote

Iris Young, "posits her motion as the motion that is *looked at*," as "shape and flesh" to be enjoyed with someone else's purposes in mind "rather than as a living manifestation of action and intention."[53]

Victoria Jacobs poses on Playboy's *cover. Emphatically sultry in her huge black hair and a tiny, white, satiny slip, she holds a valentine against her upper thigh.*

Blonde and smiling Ginny Einsohn stands invitingly in a doorway. She is dressed in a transparent gold mesh negligee and gold slippers laced from her ankles to the bottoms of her calves.

Patricia Marquis kneels on a chair at a vanity. Her pose emphasizes her buttocks.[54]

Jo More reclines in black and metallic lingerie and jet stockings, legs above her head, as she faces the viewer.

Jerilyn Walter lies in a brass bed. A pearl dog collar decorates her neck, and she cups her breasts, pushing up each one. Her bikini line is visible. So are her labia.

These youthful women in their forties may be enjoying their bodies as much as the observer is. The poser's and the observer's pleasure can both be served at once, so the problem is not necessarily with pleasures and gazes. The problem is that cultural representations peculiarly disembody both the midlife pinup and the matron. The pinup often exhibits inactivity more than capacity, which, ironically, corresponds to the matron's projection of body experience. The matron's gardening and the pinup's lounging do not convey dynamic bodily capacity. Unlike the midlife bodybuilders whose bodies represent intention, action, and, in the words of the artist mentioned earlier who bodybuilds in her mid-sixties, "experimentation," the bodies of these "fabulous" forty-year-olds lounge around—these women are aging "like wine, not vinegar"[55]—and only time will tell the quality of their genes, gourmet good or otherwise.

The midlife bodybuilder is also an epicurean spectacle, but she projects a different state of being than the no-effort fantasy bodies of soft porn. Matron, *Playboy* ingenue at forty, and bodybuilder may all love their bodies, just as everyone does, to varying degrees at various times. Yet the bodybuilder's love, rooted tremendously in capacity—pleasurable work and strength, confidence in body that can translate, as Young says she intuits, into confidence "about our cognitive and leadership abilities"[56]—is narcissism as contemplation, physical education as erotic and spiritual education.

All too often, contemporary cultural critics see the gym as a site of one-dimensional Foucauldian discipline, like a barracks, school, or prison. Gym as labor camp, producing the culturally submissive body, the desperate midlife youth-seeker. The bodybuilder does, with martial determination, protect herself against the Paleolithic bulbousness that Clark and other art historians interpret as fat (not strength) and against the flabbily middle-aged and marginal Silenus, so empathetically painted by Rubens as flesh, that substance made female in Western art.[57] One midlife bodybuilder, however, calls the gym "heaven"; another, Laurie Fierstein, says that if working out isn't fun, it isn't creative.[58] Training can be the same kind of experience that art making is. The bodybuilder's concentration, which simultaneously creates strength and shape, disproves the idea that bodybuilding is a mindless routine, such as three sets of ten reps per each designated body part during every gym stint.[59]

Talking at home about gym time with Reed, a friend of my husband's who, like him, is athletic and concentrates on rock climbing, I say, "I do sit-ups very slowly. You always see people doing them fast, and doing a lot, like a hundred." Reed laughs because he knows this performance of abs exercises is typical. I continue, "My friend said to do few reps, so that I feel them and think about my muscles intensively. She said, 'You're always in your mind anyway, so this should be easy.'" Reed says, "You can do one, two a minute." I smile, thinking about the excruciating pleasure that I'm not yet ready to initiate, and say, "I haven't done that, but slow is erotic. So is not counting reps and sets." Reed says, "That's not most people's attitude. It's get in, ten reps here, eight reps there, get out, you're done."

Heartless labor.

Sounds like bad sex to me.

Looking at herself in the mirror as she trains can heighten a bodybuilder's muscular and aesthetic concentration, a self-contemplation whose erotic rootedness and energy signify narcissism as connection rather than isolation or withdrawal. This aesthetic/erotic focus is related to Marcuse's idea that Narcissus's "life is that of *beauty,* and his existence is *contemplation.*"[60] Creating monster/beauty, the midlife bodybuilder is both grounded and fluid. She may enjoy being observed, but she escapes such observation, her own included, into an interiority that is tissue- and soul-deep: the barbell presses her feet to the floor as she curls the bar to develop her biceps; the barbell forces her back and shoulders to the

bench as she presses the bar above her chest to strengthen her pecs; the bodybuilder's swagger balances her from mind to torso to footsteps. (Perhaps precompetition dieting is less the anorectic's starvation and more the monk's fast.)[61]

At its best, bodybuilding disciplines a woman to live with the ground, to feel it throughout all her body at once as she struts to the drinking fountain or from the parking lot to her office; and bodybuilding simultaneously disciplines one to glide through space. Grounded and gliding, the bodybuilder can achieve clarity. Such was Mishima's perception when he wrote as a midlife bodybuilder, "I had begun to believe that it was the muscles—powerful, statically so well organized and so silent—that were the true source of the clarity of my consciousness."[62] Connected, grounded, gliding, and clear, the midlife female bodybuilder, a feminist nude, is, like the nudes of Western art, an expressive body. She expresses not only a state of being but also being itself. Being is a state of gratification.[63]

Young points out that in some activities, "of which dancing is paradigmatic, . . . the 'I' shifts from the eyes to the region of the trunk. In this orientation . . . we experience ourselves in greater sensory continuity with the surroundings."[64] Such thinking supports the idea that narcissism can be connection. When the bodybuilder's eros contemplates itself, she experiences Lingis's "lust lustful with regard to itself"; and she is also expanding with the pleasure in what Marcuse has called a "libidinal cathexis of the ego (one's own body) [that] may become the source and reservoir for a new libidinal cathexis of the objective world—transforming this world into a new mode of being."[65] Aphrodisiac being can become a new reality principle.

Training can be work as play, not heartless labor. The midlife female bodybuilder develops a body that works well—at libidinal play. One may agree with Leslie Heywood and with Norman Bryson that bodybuilding for men signifies a contemporary crisis in masculinity: Bryson uses Arnold Schwarzenegger to exemplify the effort and sweat necessary to produce the "masculine masquerade."[66] But the midlife female bodybuilder, even when hypermuscular, is a phenomenon whose richness—in both representation and reality—cannot be reduced to speculations and arguments about her gender, about her striving to be the masculine ideal by laboring in the gym in the same way that the masculine ideal strains to strengthen itself even as it atrophies.

A model of aesthetic/erotic self-creation, the midlife bodybuilder provides images and practices of living aesthetically. Time disappears and pleasure follows when one is living aesthetically. Quoting Kant, Marcuse calls the aesthetic attitude "purposiveness without purpose" and "lawfulness without law."[67] Today's sports audience expects muscle to perform—in a game, a competition, some display of prowess. In these terms, the bodybuilder's aesthetic expertise has no value: her muscles are gratuitous, dysfunctional, purposeless. In these terms, bodybuilding, purposive though it is, is a waste of time because it is nonproductive, just as art is nonproductive. But nonproductivity—*being* as one trains, one's *being* as a body—distinguishes eros as it does the aesthetic. We are comfortable with the muscular body that does something, for it enacts the performance principle, whose laws are utility, acquisition, competitiveness, and domination. Crushing pleasure, it generates economically useful products rather than aesthetic/erotic citizens: narcissists, contemplators of beauty, and Aphrodites, agents of their own pleasure.

The midlife bodybuilders I interviewed began the discipline in their thirties and did so on their own. Women who take up bodybuilding in their early twenties often act at the instigation of their bodybuilder boyfriends, who then become Pygmalions and Svengalis. For Altomare, Fierstein, and other bodybuilders, the gym has been and continues to be a pleasure zone that provides "challenge," "sensual transformation," strength, and development and that creates bodies of content, in whose "sacr[a] . . . thought has become living cells."[68] Thought, the concentration of Narcissus, is made visible in the midlife body. Thought as physical education, educating the body in eros.

I perform calf raises, seated rows, squats, and military presses more slowly than most people and linger, "wasting time," longer between sets than many experts recommend. This leisure is time to feel my muscles swelling. I love to swell like that, in a sacral joy that shapes an intellectual and psychic as well as a physical swagger. Swell and swagger: the words "erection," "phallic," and "masculine" don't apply here.

The "pump" is a pleasurable feeling brought about when a muscle is filled with blood and is short of oxygen. Muscles are engorged, like cocks about to come: that's the bodybuilding cliché. This priapic-muscular equation unrealistically masculinizes the pleasure of swellings and erections: during sexual arousal, a woman's nipples become erect and her clitoris and labia swell. We are habituated to perceive muscle as male, mon-

umentalizing it into phallic power: as if gender, in the extreme of hyper-masculinity, needs to be bolstered or protected, and as if bodily bigness that is firm to hard can only be male.[69] Lingis writes beautifully and sensitively about bodybuilding, though I do not always agree with him. A case in point is his comparison of bodybuilders, posing in competitions, to erect penises; he describes them as "whole anatomies pumped like priapic erections."[70] Dieting reduces body fat and brings out vascularity, which seems to legitimize the penis metaphor. (Yet dieting itself, for bodybuilders, crosses gender.)[71] But when we ascribe male and phallic metaphors to female bodies, we may be simply maintaining gender's rigid grip on our imaginations and behaviors.

Lingis describes bodybuilders "contracting poses and shifting with held violence from one pose to the next with the vaginal contractions of labor pains."[72] His metaphors, applied to "whole anatomies" rather than to men or women, seem to expand gender, unlocking masculinity from the male and femininity from the female. Yet the male metaphor figures as being, whereas the female metaphor figures as pain. Masculinity is a state of achievement; femininity is involuntary corporeal process. Masculinity presumably feels good; femininity hurts.

I could adjust the involuntary aspect of this problematic gender asymmetry. I could say that a woman can control her vaginal contractions for her own and her lover's pleasure during heterosexual intercourse; that her vagina and vulva are slick during these contractions; that bodybuilders, oiled when they pose, flex like lovemaking vaginas and exhibit the slickness of aroused female sexual organs. But as much as I enjoy my metaphor, I have just played into the gender maintenance game. "Aroused" may be a better way to understand "swell" and "swagger," which are conditions that need not be gendered. Wanting to revamp representations and discourses about masculinity, Bordo suggests that we "allow the imagination to play with the figure of the *aroused* penis—aroused (as in a state of *feeling*), rather than 'erect' (as in a state of accomplishment and readiness to perform)."[73] Arousal can be any person's, any body's pleasure.

Writing about Ingres's *Grande Odalisque,* Bryson concludes that her body is pleasure; it is "a radical disruption of the standard and homogeneous image of woman, in a self-dissolving and self-unraveling movement of what Barthes used to call *jouissance.*"[74] A body that is sex-dissolving and sex-unraveling. The *Grande Odalisque* was a body of content for nineteenth-century critics, who saw her physique as pleasure

and horror, as purest form and deformed, as sensually beautiful and as bizarrerie—as, according to art historian Carol Ockman in *Ingres's Eroticized Bodies,* destabilizing the categories of masculine and feminine.[75] In an orgasmic body, the *Grande Odalisque*'s and the midlife bodybuilder's, the undoing of discrete anatomies, the separated sexes, produces monster/beauty integrity. Pacteau writes that "beauty resides in the *integrity* of the body"; she notes the derivation of *integrity* from Latin *integer,* "intact," and from the root *tangere,* "to touch."[76] Orgasm can be the beauty of integrity, not as melting, dismemberment, parts felt separately from other parts.

Lingis asks, "Does not the orgasmic body figure as a body decomposed, dismembered, dissolute . . . ? Is it not a breaking down into a mass of exposed organs, secretions, striated muscles, systems turning into pulp and susceptibility?"[77] The penis becomes "dismembered" in the vagina, "cut off" visually from the rest of a man's body, depending on the physical length of thrusts and the position of bodies. The penis "dissolves," detumesces, in the female saline and mucosal genital secretions, in a sexual solution. The male "breaks down" as he comes, his penis and perhaps his entire body going limp. He becomes "pulp," looking soft and juicy all over—from sweat—and because the skin of his penis is moist with his own and his lover's cum. He exhibits utmost susceptibility, for his exposed organ, his penis, has changed form, "decomposing" from erection to a soft, still very sensitive tissue. This is one kind of orgasmic body and being. There are many.

An orgasmic body and being different from the one in Lingis's description might "figure as a body" continually remembering itself. Acute local pleasures—a kissed toe, a back of the knee caressed by three fingers, a cervix under the pressure of a penis, chest prickling to the graze of a two-day-old beard—accentuate awareness of anatomical details, which are galvanized as a global sensation when luxuriously hard thrusts of a penis in a vagina centralize these specific pleasures in the vulval-vaginal area. Aphrodisiac beauty is coming together, all parts organized for and resonant with erotic leisure. This leisure is a condition and process through which one discovers orgasmic being.

Counting reps is measuring productivity. Counting makes one tense, expectant, and takes one away from pleasure. A woman counting in the gym is like a man thinking about a golf game or a cold shower while fucking so that he will not come too fast. Protection from pleasure. Thought becomes the living cells of disengagement. A reason for being in the gym is to come and to come

and come, to swell again and again. Orgasm, *from Greek* orgaō, *"to swell with lust."*

Thomas believes that fulfillment "is not an idea, but in carnal thingness, in body," and that women's "complaint should be of de-objectification," for woman has been reduced to a "manipulatable abstraction."[78] Woman as object *is* an abstraction—the matron's flab, the midlife ingenue's flatteringly lit figure. The object is useful for sexual fantasy and fashion layouts, for deliberately political picturing, and for more intellectual mindplay. The object is a picture obviously lacking carnal thingness. Thingness for Thomas is not objectification but rather an actual body's meaning created through thought made physical.

Visual pattern, force field, holy middle, flux of muscular transformations, viable vehicle of lust, *ecorché* and Aphrodite, hair "dyed and fried" or going gray,[79] the midlife bodybuilder is a creation not a picture, an abundance not a lack, a fulfillment ready to be more fulfilled. She is Emilia Altomare, Christa Bauch, Diana Dennis, Laurie Fierstein, Linda Wood-Hoyte. Paradise now.

NOTES

This chapter is an expanded version of "Monster/Beauty: Midlife Bodybuilding as Aesthetic Discipline," a performance I presented at the Women and Aging: Bodies, Cultures, Generations conference organized by the Center for Twentieth Century Studies, University of Wisconsin at Milwaukee, April 1996. I thank center director Kathleen Woodward for her comments and suggestions made as she edited the shorter piece for publication in her collection *Figuring Age: Women, Bodies, Generations* (Bloomington: Indiana University Press, 1999), 212–26.

1. Both the bodybuilder who heard and told me what this gym owner said and the gym owner must remain anonymous. Marshall Blonsky's 1996 essay "I Could Love Them All" to date has been published only in a Portuguese translation as "Hipermulheres," *Mais!* January 21, 1996. I was one of the women in her forties who participated—speaking, not flexing—in *Evolution F: A Surreal Spectacle of Female Muscle*, which was organized by bodybuilder Laurie Fierstein.

2. Robert A. Wilson, *Feminine Forever* (New York: M. Evans, 1966), advocates estrogen replacement therapy for menopausal women so that they can stay feminine forever.

3. In my essay "The Real Nude," in *Picturing the Modern Amazon*, ed. Joanna Frueh, Laurie Fierstein, and Judith Stein (New York: Rizzoli, 2000), 34–47, I

argue that despite art historians' conceptualization of the nude as an abstraction, the female bodybuilder is a real nude.

4. Freud is quoted in Francette Pacteau, *The Symptom of Beauty* (Cambridge, Mass.: Harvard University Press, 1994), 94.

5. Joan Semmel, *Joan Semmel: A Passion for Painting*, dir. and prod. Paul Tschinkel, Inner-Tube Video, New York, 1995, videocassette.

6. Yukio Mishima, *Sun and Steel*, trans. John Bester (Tokyo: Kodansha International, 1970), 15.

7. Lynda Nead, *The Female Nude: Art, Obscenity, and Sexuality* (London: Routledge, 1992), 11.

8. Kenneth Clark, *The Nude: A Study in Ideal Form* (Princeton: Princeton University Press, 1956), 341.

9. Ibid., 93, 71.

10. For fruit and flower metaphors used of the female nude, see ibid., 106, 111, 115, 124, 128.

11. A student, Grady Schieve, made this comment about women's bodies in my course "Monster/Beauty," spring 1995.

12. The student, who wishes to remain anonymous, heard this remark in spring semester 1996.

13. The artist, who wishes to remain anonymous, spoke with me by telephone, March 21, 1996.

14. Charles Baudelaire, "The Painter of Modern Life" (1859), in *The Painter of Modern Life and Other Essays*, ed. and trans. Jonathan Mayne (London: Phaidon, 1964), 33–34, asserts that "face-painting" should not be used for "entering into competition with youth." Baudelaire understands makeup to be a kind of monster/beauty. The often-used colors red and black, for instance, "represent life, a supernatural and excessive life."

15. Diderot is quoted in Pacteau, *Symptom of Beauty*, 111.

16. Germaine Greer, *The Change: Women, Aging, and the Menopause* (New York: Alfred A. Knopf, 1992), 378, 377.

17. Ibid., 378.

18. Norman Bryson, "Interim and Identification," in *Interim*, exhib. cat. (New York: New Museum of Contemporary Art, 1990), 27.

19. Margaret Morganroth Gullette, "Menopause as Magic Marker: Discursive Consolidation in the United States and Strategies for Cultural Combat," and Fiona Mackie, "The Left Hand of the Goddess: The Silencing of Menopause as a Bodily Experience of Transition," both in *Reinterpreting Menopause: Cultural and Philosophical Issues*, ed. Paul A. Komesaroff, Philipa Rothfield, and Jeanne Daly (New York: Routledge, 1997), 176–99, 21 (quotation).

20. Herbert Marcuse, *Eros and Civilization: A Philosophical Inquiry into Freud* (Boston: Beacon Press, 1966), 231, 236.

21. Jonathan Goldberg, "Recalling Totalities: The Mirrored Stages of Arnold Schwarzenegger," in *Building Bodies*, ed. Pamela L. Moore (New Brunswick, N.J.: Rutgers University Press, 1997), 221.

22. Pacteau, *Symptom of Beauty*, 13.

23. Ibid.

24. Alphonso Lingis, *Foreign Bodies* (New York: Routledge, 1994), ix.

25. Ibid., 34.

26. Lillian S. Robinson, "Doing What Comes Socio-Culturally," *Women's Review of Books*, 12, no. 7 (April 1995): 11.

27. Ibid., 12, 11.

28. Leslie Heywood, "Masculinity Vanishing: Bodybuilding and Contemporary Culture," in Moore, *Building Bodies*, 182.

29. Leslie Heywood, *Bodymakers: A Cultural Anatomy of Women's Body Building* (New Brunswick, N.J.: Rutgers University Press, 1998), 57.

30. Iris Marion Young, *Throwing Like a Girl and Other Essays in Feminist Philosophy and Social Theory* (Bloomington: Indiana University Press, 1990), 148, writes, "Typically, the feminine body underuses its real capacity, both as the potentiality of its size and strength and as real skills and coordination that are available to it. Feminine bodily existence is an inhibited intentionality, which simultaneously reaches toward a projected end with an 'I can' and withholds its full bodily commitment to that end in a self-imposed 'I cannot.'"

31. Discussions about bodybuilding and the perfect body appear in Leslee A. Fisher, "'Building One's Self Up': Bodybuilding and the Construction of Identity among Professional Female Bodybuilders," in P. Moore, *Building Bodies*, 153–54; and in Stephen D. Moore, *God's Gym: Divine Male Bodies of the Bible* (New York: Routledge, 1996), 77–82.

32. See Marcuse, *Eros and Civilization*, 185.

33. Susan Bordo, *Unbearable Weight: Feminism, Western Culture, and the Body* (Berkeley: University of California Press, 1993), 151, 152, 211–12, 246, 301.

34. Anne Bolin, "Flex Appeal, Food, and Fat: Competitive Bodybuilding, Gender, and Diet," in P. Moore, *Building Bodies*, 201–2, asserts that the bodybuilder's precontest dieting is not a "starvation diet in which one experiences nutritional deprivation." The bodybuilder eats several small meals daily, so "food is his or her friend; that is not true for the anorexic. . . . For the most part, except for the week or two prior to competition when some of the depletion and dehydration strategies are employed, bodybuilders are practicing good nutrition."

35. Bordo describes her experience in "Reading the Male Body," in P. Moore, *Building Bodies*, 60–61.

36. See Bordo, *Unbearable Weight*, 151, 211–12, and Nead, *Female Nude*, 8–10.

37. Bordo, *Unbearable Weight*, 191, uses the term "excess-free"; Nead, *Female Nude*, 10–11, discusses fat as excess.

38. The artist, who wishes to remain anonymous, made this remark in a telephone conversation with me, June 1993.

39. Marcuse, *Eros and Civilization*, 212.

40. Erotic well-being provides a kind of "social security," as I argue in "The Erotic as Social Security," *Art Journal* 53, no. 1 (spring 1994): 66–72.

41. Alphonso Lingis, *Libido: The French Existential Theories* (Bloomington: Indiana University Press, 1985), 34, asks, "Might not pleasure's incessant movement of self-affirmation have an affective and not objectifying form—self-affirmation as adhesion to self, itself pleasurable—a lust lusting with regard to itself?"

42. Pacteau, *Symptom of Beauty*, 138.

43. Ibid., 149.

44. Dave Hickey, "Enter the Dragon: On the Vernacular of Beauty," in *The Invisible Dragon: Four Essays on Beauty* (Los Angeles: Art Issues Press, 1993), 11–24.

45. Michel Foucault, "Body/Power," trans. Colin Gordon, in *Power/Knowledge: Selected Interviews and Other Writings, 1972–1977*, ed. Colin Gordon (New York: Pantheon, 1980), 56.

46. I saw the ad in the program for *Celebration of the Most Awesome Female Muscle in the World*, a bodybuilding performance organized by Laurie Fierstein in 1993.

47. Natalie Angier, *Woman: An Intimate Geography* (Boston: Houghton Mifflin, 1999), 139–41, associates the attractiveness of rounded muscles, breasts, and faces with human beings' attraction to the shape and meaning of spheres.

48. Jan Todd, "Majestic Womanhood vs. 'Baby Faced Dolls': The Debate over Women's Exercise," in *Physical Culture and the Body Beautiful: Purposive Exercise in the Lives of American Women, 1800–1870* (Macon, Ga.: Mercer University Press, 1998), 11–30. In a June 1977 powerlifting contest in Stephenville Crossing, Newfoundland, Todd raised 441 pounds in a dead lift, 176.4 pounds in the bench press, and 424.4 pounds in the squat. The total of 1,041.8 pounds was approximately 100 pounds more than any women had ever lifted before in competition.

49. Bordo, *Unbearable Weight*, 179.

50. Lingis, *Foreign Bodies*, 42.

51. I stick with the "undesignatable age" description even though a student in one of my classes, viewing a slide of midlife bodybuilder Christa Bauch, said that she looked like she was in her forties. He was correct. For Scott, Bauch's face indicated her age.

52. Lingis, *Libido*, 62.

53. Young, *Throwing Like a Girl*, 150, 155.

54. Marquis is a black woman. In chapter 10, I discuss the European sexualization of black women's buttocks.

55. "Life Begins at Forty," *Playboy*, February 1995, 125.

56. Young, *Throwing Like a Girl*, 156.

57. Svetlana Alpers, "Creativity in the Flesh: The 'Drunken Silenus,'" in *The Making of Rubens* (New Haven: Yale University Press, 1995), 101–57, makes an exquisite case for the complexity of Rubens's gender embodiment in his painting. Irving Lavin, "Preface: The Body Artist," in Frueh, Fierstein, and Stein, *Picturing the Modern Amazon*, provocatively asks, "Was the model for the Venus of Willendorf a 'bodybuilder'? What were her designs? How did she achieve those extravagant shapes, and what did they mean to her?" (8).

58. I interviewed Laurie Fierstein and the other bodybuilder, who wishes to remain anonymous, in May 1995. Fierstein has said to me that the fun, the pleasure of the process, derives from doing, whereas often the fun or pleasure of the result derives from others' reactions.

59. In contrast, Alan M. Klein, *Little Big Men: Bodybuilding Subculture and Gender Construction* (Albany: State University of New York Press, 1993), 41, suggests that the "oft-overlooked seduction of weight training lies in the very mindlessness of the routine, which is as compelling as the physical alteration."

60. Marcuse, *Eros and Civilization*, 171.

61. Fisher, " 'Building One's Self Up,' " 153, interviewed a professional woman bodybuilder who revealed, "The hard part is the diet, but in a way, it's like a monk fasting."

62. Mishima, *Sun and Steel*, 44; he is here relating his passion for fencing after having built his muscles. Yet the muscles themselves are the source of his clarity.

63. Marcuse, *Eros and Civilization*, 125, 166, writes, "Being is essentially the striving for pleasure" and "Being is experienced as gratification."

64. Young, *Throwing Like a Girl*, 165.

65. Lingis, *Libido*, 34; Marcuse, *Eros and Civilization*, 169.

66. Heywood, "Masculinity Vanishing," 170–72, and Norman Bryson, "Géricault and Masculinity," in *Visual Culture: Images and Interpretations*, ed. Norman Bryson, Michael Ann Holly, and Keith Moxey (Hanover, N.H.: University Press of New England, 1994), 235.

67. Marcuse, *Eros and Civilization*, 177.

68. The term "challenge" was used by a bodybuilder who wishes to remain anonymous and "sensual transformation" by Fierstein, in separate conversations with me in May 1995. Al Thomas, "Some Thoughts on Spirit: Its Source and 'Uses' in the Best of Games," *Iron Game History* 4, no. 2 (October 1995): 16, meditates on the bodybuilder, in whose "sacrum . . . thought has become living cells."

69. S. Moore, *God's Gym*, 86–91, 108–17, deals with bigness in sections titled "Gigantic God" and "Colossal Christ." Goldberg, "Recalling Totalities," 221, considers more mundane aspects of bigness and male bodybuilding.

70. Lingis, *Foreign Bodies*, 30.

71. Bolin, "Flex Appeal, Food, and Fat," 201, argues that female and male bodybuilders "pursue the same diet. Differences between the sexes on the diet were regarded as differences of degree, not kind."

72. Lingis, *Foreign Bodies*, 30.

73. Bordo, "Reading the Male Body," 63.

74. Norman Bryson, *Tradition and Desire: From David to Delacroix* (New York: Cambridge University Press, 1984), 137.

75. Carol Ockman, "This Flatulent Hand: Nineteenth-Century Criticism," in *Ingres's Eroticized Bodies: Retracing the Serpentine Line* (New Haven: Yale University Press, 1995), 84–109.

76. Pacteau, *Symptom of Beauty*, 85.

77. Lingis, *Libido*, 55–56.

78. Al Thomas, "Some Notes toward an Aesthetics of Body for the Modern Woman," *Compass*, spring 1972, 4–5. Thomas wrote the essay in 1968.

79. "Dyed and fried" is Fierstein's phrase (conversation with author, May 1995).

Two

HYPERMUSCULAR PERFORMANCE

The hypermuscular midlife bodybuilder is a pinup. She is an antithesis of the matron figure, or the midlife woman represented in corporeal deterioration; in performances and photographs, the midlife bodybuilder generally appears in the sexualized poses, costumes, makeup, and hairstyles or wigs—the femininity—of her younger counterparts. Midlife muscles perform in the conventionally eroticized fashion that contemporary culture has demanded of the monstrously strong woman. This representation eases viewers' discomfort over women who supposedly look like men, by diminishing the women's physical, aesthetic, and erotic power with an ill-fitting gender uniform. The midlife bodybuilder disciplines herself out of one gender construction only to be entrapped by another.

Yet because representation is multivalent and malleable—in both cultural practice and in individuals' minds and hearts—the feminine pinup performance of female muscle also boosts that muscle's aesthetic and erotic power. While such performances by younger and older bodies share many meanings, the meanings shift when associated with the midlife bodybuilder. Matron, crone, and grandmother figures usually de-eroticize the midlife woman by divesting her of aesthetic/erotic pleasure in her own body and in her role as an object of others' visual and sexual

pleasure. These common figures deprive her of desire, desirability, and activity based in her sexual agency and beauty.

The pinup is an image of dual pleasure in its function of subject/object: the pinup's attractiveness gives pleasure to the viewer; and especially in recent feminist reclamations of the pinup, but also in earlier twentieth-century "proto-feminist" images, the pinup's self-confident allure signals pleasure in herself.[1] Performances by midlife bodybuilders challenge the multiform representation of older women's lack of aesthetic and erotic glamour and agency. Focusing on these performances— by Emilia Altomare, Christa Bauch, Diana Dennis, Laurie Fierstein, and Linda Wood-Hoyte—and their relation to the pinup genre, to feminist body and performance art work, and to gender issues that circulate around women's bodybuilding, I hope to justify the value of hypermuscular performance for a midlife erotics, despite bodybuilders' apparent investment in conventional sexual spectacle.[2]

ACTIVATING EROS

"I feel that I must have sex at least nine times a week, that's the bare minimum, and it must be exciting and of reasonable duration. I talk to women our age who say they have sex four times a year and are comfortable with that." A woman in her forties, a heterosexual who exercises sexual agency with younger men, recently told me this. Her insistence on having sex that is good for her in quality, duration, and frequency, her difference from many midlife women—her sexual urgency—that nevertheless exemplifies some midlife women's experience, should not be reduced to indictment: she is a "sexual addict," in "psychobabble" terms;[3] she is defensive about aging and desirability; she is covering up her passive, subordinate sexual relations with men, as much feminist theorizing about heterosexuality might suggest. This woman's active and particular midlife sexuality has been silenced both by such feminist theorizing and by a larger cultural discourse that ages women out of their sexual pleasure as subjects and objects.

An older woman carries erotic weight. She is evidence of Aphrodite's discipline, which is to build the body of love.

One of Aphrodite's ancient postures is the "pudica." Pudica means "modesty," and the goddess bends forward slightly and flexes both arms—one to

cover her breasts, the other her crotch. The gesture simultaneously, purpose-fully, draws attention to those eroticized parts, the surfaces of maternal and reproductive organs.

Always Aphrodite, beyond reproductivity, flexes for a different purpose. She works with gravity to reshape its demands, moves heavy weight, labors under pressure to become invisible, is in resistance training through repeated acts of self-attentiveness that articulate a statement of being; eroticism and visibility uniting in her capacity to be a spectacle, a sight for sore eyes sick of women as waifs, twigs, and mysteries, a beauty for eyes bored by the moronic appeal of young parts; the graceful strut stating that she keeps coming into her own, which is the pleasure, the home of her own body.

When an older woman flexes, she swells with lust in Aphrodite's orgasm. I am an athlete, she thinks as she observes herself between sets, I am training in orgasm.

The erotic athlete develops the stamina to know and satisfy her own plea-sure. She exercises orgasmic capacity, enables herself to come in public. Shred-ding standards of decency, which is invisibility for older women, Always Aphrodite revels in indecent exposure, the naked splendor and unpredictabil-ity of an older woman muscled beyond comparison to men.

Challenging the idea that menopause ages women, Margaret Morganroth Gullette argues that "menopause discourse" is the culprit and that women must use "conscious resistance" in order to combat the words and images that produce women's "complicity" and "vulnerability." Baby boomers' entry into midlife has precipitated a "menoboom," a pro-liferation of menopause discourse.[4] While Gullette's discussion focuses on menopause, a great deal of her thinking applies to midlife, construed by discourse as the deteriorative menopausal period. Gullette suggests that if "feminism had a broad, effective, menoboom-resistant strain of writers," journalists "could write articles as long as they like about 'Bet-ter Sex after Menopause.' " She offers the following advice in a similarly lightly facetious tone: "when her lover tells her that he *thinks* he's a trifle slower than he used to be," the menopausal woman can say: " 'Women experience no clitoral changes however old they get.' "[5] (She could also say this when a younger man shows her how much he enjoys her sexual responsiveness and tells her how hot she is.)

The sexually vital and insistent midlife woman is a trope almost entirely absent from contemporary culture, soap operas notwithstanding. Gullette's tidbits about midlife sexuality, together with personal narra-

tives that delineate women's sexual agency and urgency, belong in an expansive and enlightened discourse about midlife women's erotic realities and possibilities. The hypermuscular midlife performer can be a generative element that helps bring this trope into being. Although the bodybuilders whose work I consider in this chapter may not be consciously resisting menopausal or midlife discourse, their disciplined physical development and exacting performances forcefully counteract it. These monster/beauties in movement radically take action and alter the conventional pinup's comparative passivity by maximizing sensual grace and strength.

Conscious sensuality—and the erotic dignity with which it invests the entire body—is often a profound outcome of serious bodybuilding, such as that demonstrated by Altomare's 200-pound pulldowns and Wood-Hoyte's 275-pound unassisted squats. As Pamela Moore, editor of the first scholarly anthology on bodybuilding, writes, "thirty reps with a light weight" will "achieve only limited results" in transforming one's strength and shape.[6] Intensive training produces intensive sensual transformation. Al Thomas believes that a woman takes on—acquires—voluptuous muscular shape only by building muscle, by realizing, for example, that in midlife she can execute far more than the 60-pound pulldowns she has become used to doing. From experience working with such a woman in the gym, Thomas knows that a woman of fifty can work up to 120 pounds and that, when she is older still, she can increase the weight even more.[7]

Fierstein reveals that the "sensual element is an important part of the bodybuilding transformation. I don't think a woman would try to make her body more muscular unless she derived some sensual pleasure from it. The sensual aspect is very profound with me. I love my body as muscular as it can be." Fierstein's love of her muscular sensuality appears to be shared by her midlife sisters. Often, younger women who have gained fame or fortune from their muscles neither maintain nor continue to develop their physiques after having reaped whatever profits they can from bodybuilding. Few enjoy the mostly meager financial rewards, and when the commercial or media-driven returns on their training investment diminish, many bodybuilders follow through on a statement Thomas heard from one of the most famous: "I don't want to keep these muscles." As if the "profit" of aesthetic/erotic self-creation, for oneself, for beauty and pleasure in one's everyday life, was not—perhaps ever—the point.

For many women bodybuilders, however, those who will never compete let alone become professionals, the results of training bring precisely this kind of pleasure, for and in oneself. For example, Steve Wennerstrom, historian of the International Federation of Bodybuilding, told me a story, dating from the mid-1980s, about a woman in her early thirties whose bodybuilding had an autoerotic outcome. When she began to see the veins in her biceps and the musculature of her abs, she told him, she "locked herself in a room with a vibrator for a couple days."[8] In repeating the woman's joking recounting of her erotic self-love and -discovery, Wennerstrom interpreted her humorous tone as a deflection of selfishness, as almost a disbelief in the depth of her self-devotion. While many women bodybuilders, especially those who have experienced physical, sexual, or emotional abuse, experience their muscles as a shield, protective strength and hardness are not the only meanings of serious muscle for the "armored" woman. Sensual and erotic power and independence develop along with the muscular development.

Yukio Mishima claims that bodybuilding for him was "similar to the process of acquiring erotic knowledge."[9] He is one of the few people who as both a bodybuilder and an intellectual has considered the bodybuilding experience. *Sun and Steel,* written in midlife—in 1968, two years before Mishima's death at forty-five—describes his own physical and psychic transformation wrought by the "discipline of the steel," which he began in 1955 and continued religiously for the rest of his life.[10] A Japanese man who was intellectual, homosexual, and militaristic comes to bodybuilding with motivations and desires that differ greatly from those of the hypermuscular women in this chapter. Race, profession, sex, nationality, and sexual orientation generate these differences, and Mishima's psycho-muscular trajectory led him to celebrate the heroism of combat and death. An amazingly designed body, which is a primary and continuing achievement of the women, was insufficient for Mishima. Yet despite his body fascism—his belief that the muscular, tan, tough body distinguishes a superior person—the sensual and erotic elements of bodybuilding charge *Sun and Steel* throughout with seductive warmth.

The woman who has created and who loves her body of content does not stop her devotion to pleasure, her discipline in profound sensual development. Altomare began training at age thirty-four in Milan, where she was born and raised; she speaks of "re-creating myself, after many years of not being me," through the "body aesthetic of strength, muscularity, and sensuality." Altomare's performances convey a re-creation

filled with concentrated sensuality. Dark curls and bangs frame her sweet
and highly expressive face, which shifts from shy pout to almost tearful
determination when she flexes her tattooed forearms. Slight smiles and
self-attentive gestures characterize Altomare in *Always Aphrodite,* which
she performs to the poem earlier in this chapter. She bends in an exagger-
ated Venus pudica gesture. She covers her crotch in self-celebratory
"modesty," then caresses it as well as her thighs and lower abs. She
straightens into a front double biceps pose that displays her highly devel-
oped shoulders. A metallic gold posing suit complements her warm skin
tones, as do the red highlights in her hair.

Angelic bruiser, Altomare as Always Aphrodite performs an auto-
erotic dance, as do the women in the 1994 *Fabulous Forties* videotape.[11]
Many of the eleven women on the tape, who are all in their forties, fon-
dle themselves and masturbate, often during or after a striptease.
Altomare teases as well with her flirtatious pseudo-innocence. (She has
made her living in part as an exotic dancer.) She is knowingly alluring,
like the *Fabulous Forties* women, yet she is markedly different: she could
be sexually partnered with someone, but she is not.

*Always Aphrodite reclines in the bathtub, rests her elbow on its edge, and
admires her forearm. The sheen left from water emphasizes muscle, tendons,
veins. In love, in relaxation, she holds her private orgy.*

 Orgy, from Greek for "secret rites."

*I let loose orgies, for I love the shapeliness of scandal, of navels and erect
nipples displayed for any eye, of possibilities embodied in action and
ambrosia.*

Fabulous Forties features women coupling with men in simulated inter-
course or in the women's verbal fantasies. The masturbatory implications
of Altomare's self-attentiveness suggest a primary interest in pleasing
herself, whereas the *Fabulous Forties* tantalizers are less autonomous. The
viewer looks at Claudia Galion's or Jerilyn Walters's close-up genitals so
that he can fit himself into them, into his fantasy of their meaning and
relation to him. (As I'm looking, I'm seeing and feeling, in my mind, my
own cunt—the particularities of folds and plumpness, the pleasures
embedded there.) This kind of looking, which is voyeuristic, scopophilic,
and fetishizing, also occurs when one witnesses *Always Aphrodite,* and
Altomare deliberately stimulates desire. However, as she steps in small

circles, arms close to her body, or executes now forceful, now delicate movements, she often seems to be turning in on herself in sensual self-protection and -sustenance; and her body energy fills a cylindrical volume, which creates a feeling of self-sufficiency rather than isolation.

In *Fabulous Forties*, Jacqui Landrum, identified as a dancer and choreographer, performs an elegant modern dance with her husband. Its paramount motif, coupling, is distinctly gendered. The man lifts the woman. He exhibits physical strength, and she must (appear to) be light. Indeed, Landrum's body is sylphlike. Neither coupling nor heterosexual sex or marriage are inherently evil, and a slender female dancer who moves her body melodically is a visual and kinetic pleasure. However, seeing and otherwise sensing Altomare's and other bodybuilders' spatiokinetic energy move an observer differently because the built body's loquacity, embedded in big muscle and its display in movement, is radically different from the porn beauty's attractive form. The latter is comparatively taciturn except for its request, "Fuck me," behind which is the assurance "I'm yours."[12] I do not minimize any midlife woman's self-confident and sometimes playful "Fuck me," but the modified bump-and-grind performed by several *Fabulous Forties* stars offers only one mode of sexual, let alone erotic, loquacity. Bodily loquacity speaks of erotic capacities both fixed and fluctuating in the visual field that is every human being. Such fields are the aesthetic patterns shaped and colored by certain people's contours, volume, and skin tones.

Galion, who is slight and cute as hell, wears street clothes when she speaks on the videotape about her sexual "philosophy" as an older woman and about why she wanted to pose for *Playboy*. Galion reveals that until she was thirty-nine, she did not understand the "potential for a woman's sexuality." Watching her strip and masturbate, I can't help but feel that her coy, seductive act is more heavily directed than are others on the tape. Posturing more than posing, she is painfully self-conscious—when she flirtily struts; as she licks a finger, then touches it to her nipple; when she pulls down her panties or feels her genitals. I don't believe that she is actually stimulating her clit or that she is wet, and she embarrasses me because her visual/erotic field feels so scattered and manipulated. Galion discloses that her husband sent *Playboy* pictures of her, so that the magazine would consider her for the February 1995 feature on older women. Perhaps posing for the magazine and the videotape helped her to understand more of her midlife sexual potential. In the tape, her sexual

persona feels fragile, as if she has not been creating erotic weight. Her uneasy self-consciousness contrasts with the self-consciousness conveyed by Altomare's body as erotic geometry, a thinking corporeality that loves itself as animate form.[13]

DISTURBANCES IN THE AESTHETIC/EROTIC FIELD

Neither Altomare, Bauch, Dennis, nor Wood-Hoyte work within a feminist performance art theory or practice. Yet their pieces, between two and a half and ten minutes long, often display many characteristics of feminist performance from the last three decades. Using their own bodies to investigate, expose, or even enjoy cultural representations of women, performance artists have challenged female stereotypes and models of feminine propriety. They have celebrated women's sexual bodies, dared to be narcissistic and "vulgar" and to sexualize themselves in the pursuit of self-actualization, resisted and played with clichéd embodiments of woman's desire, subverted gender expectations, collapsed binary distinctions, and delved deeply into the experience and communication of pleasure.[14]

Hypermuscular performance has operated in similar terrain. I do not want to reduce three decades of feminist performance art to a few generalizations or to give the impression that bodybuilders' performances have equaled that art in conceptual complexity or sophistication. Hypermuscular performance is rich in corporeal reality, in the process and product of gym time, in the actual and potential content of the body. In this way, it demonstrates the "agency of the body displayed," which is a key element of feminist performance art.[15] But the seething complications, changes, hostilities, and revelations within feminist theory and criticism, which are informed by popular culture, porn debates, the male gaze and its critique, and queer theory, have not affected women's bodybuilding. Bodybuilders have not created consciously parodic or ironic pieces; they have not deliberately played with sexual objectification, relations with viewers, or their own gender generosity—or terrorism—in performances.

Art historian Josephine Withers maintains that feminist performance art in the 1970s created an alternative version of women and the world, one that was often "utopian and transformative."[16] These two aspects

may be present when the artist employs history—invented, mythic, or actual—in order to create a performance that laments women's erasure or celebrates reunion with their lost or ignored past. Fierstein's piece in the 1993 *Celebration of the Most Awesome Female Muscle in the World* displays such characteristics. Such display is deliberate, for Fierstein is a feminist and a social activist. Indeed, she produced *Celebration,* a performance that featured female bodybuilders and strength athletes. *Celebration* (as well as *Evolution F*) was a watershed event in bodybuilding because it was a noncompetitive exhibition of female muscle. The performers free-posed.[17] Although Fierstein has been one of the strongest women in the world for her height and weight—having executed 225-pound weighted chins, 435-pound squats, and a 265-pound incline barbell press—and has won amateur bodybuilding competitions, she does not believe in the competitive evaluation of women's bodies. Nor does she especially enjoy performing. Her two productions were, in fact, what she hopes are visionary responses to competition, responses that will lead to future diversity in the ways in which women bodybuilders "perform" their muscle.

The serious and feminist content of Fierstein's *Celebration* performance made it a significant contribution to the event. The theme was Magna Mater, with the female bodybuilder heroically and tragically representing Her. In bronze body paint, a one-piece gold posing suit, and upswept hair she deliberately simulated a statue. The color gold is associated with both Aphrodite and Amazons.[18] Grandeur and independence, as well as amazonian power and aphroditean beauty, were essential aspects of the piece, which a female "Greek chorus" accompanied with lines from Al Thomas's writing. In part I, "Magna Mater," lines are recited from Aeschylus's *Oresteia.* Part II, "Defeat," includes some of an ancient Welsh poem "The Battle of the Trees." Parts III and IV are titled "The Struggle" and "The Power." (I quote below from Fierstein's script.)

The first words spoken, by one voice, are "On this November night / With the last of the matriarchies thousands of years behind us, / Muscle and strength are admired in all the creatures of Nature except one, the human female." Within three minutes, the chorus breaks and remakes the muscular woman, once "mighty fortress, chieftain, champion," then "driven, under the ground, outcast, like dirt!" (part II). Next, a battle ensues, when "from the darkness of her glance / Glares an angry

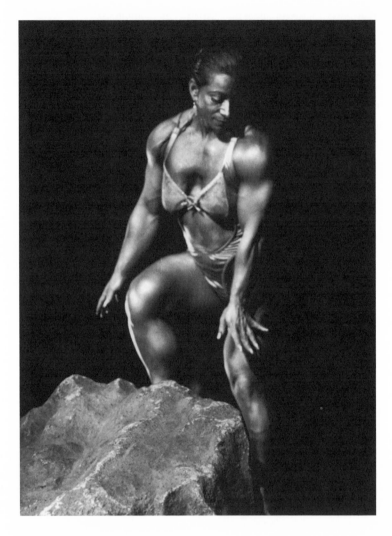

Laurie Fierstein performing in
*Celebration of the Most Awesome
Female Muscle in the World*
(New York City, November
1993). Photograph: Andi Faryl
Schreiber.

dragon's eye," and the muscular great goddess rides in her chariot, lead-
ing a "vast flood" of warriors: "None can stem that ocean-tide." Finally,
she is resurrected and speaks in the power of first-person deity, listing all
she is, telling of renewal: "There is nothing which I have not been."
Fierstein specifies that her attitude is "proud, but not defiant" and her
movement "upright, powerful." Fierstein's movements in fact seemed
tired—she was exhausted from her efforts as producer—yet her compact
and Herculean body, thick through the middle like the Resting Hercules
rather than tapered like the current bodybuilding ideal, appears as deter-
mined as it does overwhelmed.

The program cover for *Celebration*, shot by Jerry Eaderesto, shows a
supremely big and quite vascular Fierstein from shoulders to knees in a
side biceps pose. Her erect nipples show through the posing suit's thin
fabric. Fierstein makes a strange pinup, for we see a complexly designed
body negotiated by a woman who is not one or more of the following:
young, slender, white. Constructed according to an erotic plan that rele-
gates to utopia real possibilities such as the erotogenic midlife woman,
the mainstream pinup suggests that only one type of body is good
design: it is desirable and enviable because it is just about impossible for
most women to match. The perfect pinup is often a cult image of the
Blonde Bunny Goddess, the subject of chapter 10; as such, she is a prob-
lematic model. "Laurie Fierstein is a symbol," Thomas told me, while a
"beauty queen is a sign" who "points to something other than herself."[19]
The conventional pinup, like the beauty queen, points to perfection; Fier-
stein and other midlife Amazons instead symbolize strength and sensual-
ity in the explicitness of their own flesh and its unique design, structured
from muscles that define not only shape and volume but also surface—
the tautness and the movement of skin.

The hypermuscular midlife pinup dresses in the guise of "good
design." She displays herself in a bikini and high heels, or nude; her hair
or wig is sensuously styled and colored; she enhances her facial features
with makeup; she poses as dominatrix, reclining nude, and Venus Anady-
omene, supplying predictable fantasies to tease the camera's lustful eye.
However, because this pinup is implicitly menopausal, she embodies
menstruation's finish, which Gullette calls the "end of a gender
marker."[20] The absence of menstruation cuts off women from sexually
inflected aspects of femininity that are either loosely or blatantly associ-

ated with reproductivity; menopause discourse can produce an erotically exiled body. Hypermuscularity also signals the end of another gender marker, "feminine" softness. As a doubly marked defeminized oddity who has designed her body into monstrous (for her age and sex) development, the hypermuscular midlife bodybuilder in her pinup guise becomes a hyperbolic statement that simultaneously challenges the pinup's standard design and asserts the essence of an individual's sensual grace and dignity.

This fresh and jarring erotic image incorporates the paradoxical feminist gesture—simultaneously constructivist and essentialist—thereby making possible a relatively sophisticated approach to the pinup in question. The "feminist 'both/and' " is apparent in performance and body art works by women who use what performance theorist Rebecca Schneider calls the "explicit body"—their own in its literal physicality. She argues that "critical inquiry, political agency, and discursive mobility" are the spacious feminist field opened by artists such as Carolee Schneemann, Annie Sprinkle, Cindy Sherman, Ann Magnuson, and Spiderwoman, who all employ "both/and."[21]

The explicit body is, of course, a symbolic body as well, so its meanings resonate beyond a theoretical structure of binary polarity that, despite "both/and," orders critical inquiry, political agency, and discursive mobility into manifestations of hegemonic or subversive significance.[22] In the case of the explicit, hypermuscular body, two is not enough. *And* could help to move us away from a binary framework, freeing the hypermuscular woman from confinement to simultaneous enslavement and empowerment, to mirroring and resisting male definitions of bodybuilding. Female hypermuscularity, in practice and in performance, is multivocal, not simply "equivocal." So Alan Klein argues in his chapter on women's bodybuilding in *Little Big Men,* his study of gender construction in bodybuilding, and so feminist critics and theorists have asserted since the early 1980s when women's bodybuilding became news: 1982 cover stories in *Time* and *Life* and the 1983 publication of *Lady, Lisa Lyon,* Robert Mapplethorpe's collaboration with Lisa Lyon, winner of the 1979 first World Women's Bodybuilding Championship.[23]

Two acute feminist critiques of *Lady* in 1983 agree that while Lyon's body and poses experiment with gender, she submits to a conventionally glamorous and sexy femininity that undercuts her challenge to the equation of "muscle" with "male."[24] This line of thinking has continued to be

the standard among feminist theorists: female bodybuilders' sexiness, as determined by the male establishment of bodybuilding, undermines power.[25] Thus Lynda Nead, writing about *Lady* in *The Female Nude*, calls bodybuilding a "mixed blessing for feminism." While it offers a "certain kind of liberation, a way for women to develop their muscularity and physical strength," bodybuilding also succumbs to a body beautiful idealism in which images of women "can easily be absorbed within the patriarchal repertoire of feminine stereotypes."[26] Even more recently, in Moore's valuable anthology *Building Bodies* Leslie Heywood states that female bodybuilders' "self-determination" is undercut by their desire to be (hetero)sexually appealing.[27] In the same volume, writer Laurie Schulze offers a similar argument, while recognizing that the (hyper)muscular woman's "body is dangerous": female bodybuilders "can be pulled into the hegemonic system, . . . weighted down with markers of the patriarchal feminine."[28]

From the 1983 reviews of *Lady* to the 1997 chapters in Moore, feminist critics and theorists seem to display their longing for other categories than essentialist/constructivist, subversive/hegemonic as they try to understand the figure of the female bodybuilder; because they appear to grasp the depth of her actual and potential disturbance in the aesthetic/erotic field. The female bodybuilder strains gender ideology.[29] As feminists and other thinkers further investigate the hypermuscular woman, building on their and others' legitimate fears and doubts as well as celebrations of muscle and just plain curiosity about a phenomenon so "unnatural" and so necessary—a power aesthetic—the refrains of "hegemonic" and "subversive" may no longer ring so loudly. Thinking and theorizing like artists, explicators and poets of a power aesthetic might strike new chords, compose new melodies and harmonics based in the aesthetic ideas of artists such as Carolee Schneemann, Agnes Martin, and Brice Marden, whose lovingly worded sense I respectively quote:

Go back into the body, which is where all splits in Western Culture occur.

there's no difference / between the whole thing / and one thing

Remember immersion—water—land—sky—the all. / Most unforgettable is the joy. The joy.[30]

The bodybuilder's joy of soul-and-mind-inseparable-from-body immersion, of experiencing herself as an integrated body of content, needs to

inform the theoretical discussion of women's bodybuilding, so that theory does not split consciousness from body.

A DIFFICULT BEAUTY

Diana Dennis calls herself a performance artist and is known as one of the greatest posers ever to perform in the sport of bodybuilding. People in the bodybuilding community and press regularly refer to her as a legend; as Steve Wennerstrom asserts, "There is no one like her."[31] Born in 1951 and no longer competing—she began bodybuilding in 1979— Dennis was a finalist in the Ms. Olympia competition eight times, including when she was in her early forties. Dennis is the only one of the bodybuilders I discuss who has compiled a number of her performances on videotape.[32]

Arachnaphobia begins with Dennis as a spiderwoman preening in her web. A large, vertical network of thick white cord provides enough elasticity for her to assume luxuriously sexy, reclining poses. The cord is also taut enough to maintain the tension necessary for her pull-ups, which she performs with back to us and legs less angled than in the spread-eagled position she more than occasionally takes—never facing the audience— in several other taped pieces. Her pull-ups are slow and steady. Characteristic of her movement generally, they impress the observer with Dennis's tremendous strength, grace, preciseness, and flexibility. Barefoot and dressed in a black posing suit, the spiderwoman executes splits, sinuously crawls toward the audience on her stomach, seduces a man wearing everyday clothes into embracing and dancing, leads him to her web, ties him to it, kisses his neck and thereby kills him, and comes even more alive. She is an ultimate femme fatale, a vampire who feeds on men; and when she turns from her victim to the audience to perform her celebratory invigoration, fake blood smears her chin and streaks her chest and upper abdomen. Spiderwoman/vampire is vibrant with sexual power. Head-swinging, a handstand, sensuous caressing of the blood into her skin, and a marine Venus pose from which she brings her arms down to lightly fondle her torso all communicate erotic ecstasy. She climbs back into the upper reaches of her web and takes a position that permits her to wipe blood from her victim so that she can savor it on her tongue before lying in wait for the next target of her lust.

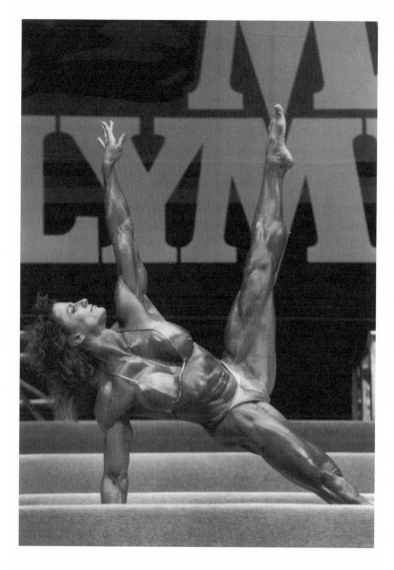

Diana Dennis in Ms. Olympia
Competition (Shrine Auditorium,
Los Angeles, 1991). Courtesy
Women's Physique World.

Arachnaphobia displays woman as a lurid threat, the formulaic fatal woman who uses her dark sexuality to deliberately lure and destroy men. Dennis is the "She Beast," one of the mythic and majestic monsters whose names are titles for photographs of bodybuilders.[33] One might see nothing more in the performance than tired clichés of female sexiness, though here, to be sure, performed by an impressively muscled woman. It is, however, the muscle—and the woman's age—that turns *Arachnaphobia* into a sexually expressive and aggressive spectacle layered with feminist implications.

Muscle, age, and eros create an exceptionally difficult beauty that can become alluring when dressed in conventionally sexy paraphernalia. Dennis and the other midlife bodybuilders discussed in this chapter use what art historian Maria-Elena Buszek terms the "bait-and-switch" technique that can suspend viewers' "disgust over the subversive and turn it into desire."[34] Buszek sees this strategy in the work of feminist artists, such as Annie Sprinkle and Ann Magnuson, who have used themselves as pinups. To my knowledge, midlife bodybuilders have not deliberately used bait and switch as a strategy, but the technique operates nonetheless in their live and photographed performances of muscle. In a September 1, 1997, e-mail to me, Buszek gets excited about the implications of this extension:

> I suppose the "conventional" aspects of their otherwise extraordinary persons are there to be "reassuring": "we're really just 'adorable' women under this crushing physique!" I, myself, read it as holding a very sneaky potential for the feminist "bait-and-switch" that I love in pin-ups. I mean, if these women wore no makeup, cut their hair very short, dressed extremely butch, and were all fairly young, they'd be living up to a stereotype of what a "female bodybuilder" (much like the lesbian) is supposed to be—a male wanna-be. In this respect, the bodybuilding pin-up is much like the femme, "lipstick lesbian" (or the flamboyantly "chic" butch, for that matter), manipulating conventional signifiers of "feminine allure" to inscribe the normally "perverse" body/desire with an unusual popular attraction.

The older bodybuilder/pinup/fatal woman is a killer; she destroys erotically outworn strictures of female beauty.

Dennis is a versatile pinup: by simultaneously enhancing and alleviating her difficult beauty, she can shift identity in order to accommodate desires. Consider her appearances in *The Women* (1994), by photogra-

pher Bill Dobbins, which luridly presents many top bodybuilders in pinup mode. Dennis appears four times, and she is the oldest subject in the book. In a full-page color shot she stands, legs wide apart, in a posing suit whose scarlet is matched by gloves to the top of her biceps, high heels, and a helmet with black strap pulled tight under her chin and smoky-black visor down. The costume is exceedingly revealing; the fabric forms an ovular shape that displays half of each breast—mostly its lower inside—all of her abs, and most of her groin. She holds her right arm in a "Stop" gesture.[35]

Each page of *The Women*'s written introduction features one picture that is a cropped selection from the photographic heart of the book: Dennis the cop-dominatrix appears chest to navel. The focus is on breasts and abs, so the fetish figure—hard, smooth (because hairless), and moist-looking (from oil), dressed in the two favorite fetish-fashion colors, red and black—becomes more specifically fetishized.[36] Breasts that are globelike in their roundness (presumably from implants) and a gloved hand at the waist mark this body as a severely seductive pleasure/threat. Dennis's breasts look as round and hard as her delts. This is no mommy, and her hand—verging on a fist, skin hidden by the color of passion and blood—can hit. She represents pleasure as opposed to reproduction.[37]

Focus on the torso emphasizes toughness. Polykleitos's sculptures became the source for "that standard schematization of the male torso known in French as the *cuirasse esthétique*," writes Kenneth Clark, "a disposition of muscles so formalized that it was in fact used in the design of armor and became for the heroic body like the masks of the antique stage."[38] Alphonso Lingis asserts that civilization "exteriorized the ostensive functioning of muscles into masks, talismans, and costumes."[39] The dominatrix performs a heroic body; she is Amazon warrior and Amazon aesthetic. Unsurprisingly, the Amazon as fetish figure may serve, says fetish-fashion expert Valerie Steele, as a "subcategory of the dominatrix."[40] Because her decoration and expression is muscle, Dennis is not form without function. As dominatrix-cop, she is a no-nonsense enforcer of the law—whichever law you need her to impose or whichever one you, as a woman who identifies with Dennis, wish to impose yourself.

Another color photo of Dennis fulfills a different fantasy. The picture is one of two on a page, it is not full-length, and unlike the cop image it is not confrontational. Here Dennis is the harem "girl," a dream of pos-

sessability. Gleaming in a caressing, hot yellow light and in a gold-decorated thong and bra, she holds a highly decorative golden veil to her face, just below her eyes. This seraglio jewel is probably stronger than many of the men who would like to possess her sexually. Indeed, some might like to wrestle her as part of the sexual play. This aspect of the harem fantasy suggested by Dennis corresponds to real-life female body-builders wrestling, for substantial sums, with men who are attracted to hypermuscular women. Genital sexual activity is not part of the wrestling, but sensual body contact with a physically powerful woman is obviously of the essence.[41]

The final photo of Dennis is a full-page black-and-white "actively" reclining nude. She pushes herself up from the floor with one arm and extends her leg nearest the camera, while a huge artificial snake rests between her legs. Its tail almost touches the floor, and its upper body curls around Dennis's elbow. She is simultaneously Eve, the archetypal female troublemaker, and a spectacularly phallic woman. The latter aspect troubles the meaning of the reclining female nude, part of whose charm is usually her luxurious passivity—a sexualized lounging. Dennis raises herself out of the reclining nude's relaxation into a dynamic posture. From shoulder to toes she is a diagonal, and the snake's similar position emphasizes this line. Snake and human body are a unit. Dennis's arms—the one pushing her up, the other raised gracefully above her torso—counterbalance the massive thrust of her torso and legs with a less extreme and more delicate diagonal. Dennis is the nude as energy; as such, she becomes Clark's conception of the male nude: energetic, athletic, heroic.[42]

Bulk is an essential element of the male nude's athleticism, and bulk distinguishes serious women bodybuilders from weight trainees and fitness princesses. (Competitive bodybuilders develop monster muscle—bulk—and display it in compulsory poses, while fitness competitors showcase less muscle in contests that replicate the definitions of femininity demanded in beauty pageants.)[43] Commonly, people both within and outside the bodybuilding and fitness subcultures associate bulk with men's bodies, not women's: it is bulk that makes women "look like men." *Bulk* simply means large size, mass, volume. People confuse women's muscular bulk with ugliness. For a woman to be big with muscle—rather than with child or with fat—puts into question deeply held beliefs about gender. Bulk is the basic marker of the female bodybuilder's difficult

beauty, and bulk is the root of people's misunderstanding, discomfort, fear, and even anger about women's hypermuscularity.

Bodybuilding's male powers that be today promote fitness over hypermuscularity, because women bodybuilders have become "too big." They have become monsters whose beauty exceeds and therefore cannot be controlled by male desire. Men must keep bigness and hardness— phallic beauty, joy, and power—for themselves, as the current fitness contest phenomenon exemplifies. For example, male (masculine) strength and female (feminine) beauty are contrasted in the text and images advertising the 1996 "Hercules Aphrodites USA Muscle Classic" in Corona, California. On the poster, a drawing of a heroically muscular Hercules, posed with the lion skin won in his first labor, is the center-piece; a bevy of photographed women below him are attractive, compar-atively small-scale, and unthreateningly muscled Aphrodites of fitness. In a conversation with me, Wennerstrom made the point that, ironically, today's fitness competitors are more muscular than Rachel McLish was when she won the competition staged for George Butler's 1985 documen-tary film *Pumping Iron II: The Women* (1985).[44]

Female bodybuilders' power is visually evident, yet the male authori-ties of bodybuilding have put ultramuscular women under siege in an attempt to preserve the "femininity" of the female body. In most sports, regardless of the participants' sex, men are generally in control as coaches, trainers, team owners, judges, and referees, and bodybuilding is no exception. Bev Francis, marked masculine in the 1983 competition documented in *Pumping Iron II* and forever after, appears in Dobbins's *The Women* as a variant of Rodin's *Thinker*. The film narrative pits Francis against McLish, representing median femininity. In only one other Dobbins photograph does the pose exclusively reference a mas-culine source (and it is the same one): the picture of Laura Creavalle, a black woman (discussed further in chapter 10) labeled as a troublemaker by some powers in competitive bodybuilding. Like Francis, she sits in profile on a pedestal. These two "oddities" are the only women in Dob-bins's book presented largely as meditative.[45]

Countering the image of the big, hard female body as manly, as brute force, some female bodybuilders feminize themselves by dying their hair blonde (employing a sign of vulnerability and innocence); painting their nails and curling, ornamenting, or upsweeping their hair (using the artifice of grooming); having breast implants (emphasizing a fetishized part of

female bodies); and wearing corsets or other lingerie for photo shoots (becoming pinups in order to court stereotypical sexual fantasy). As discussed above, the use of feminine gender markers enables a bait and switch, but the necessity to prove their womanliness may take a toll on female bodybuilders' assertion of self-love. I do not deny that a bodybuilder may operate from deficiency: she is never big, hard, or praised enough. Nor do I deny that bodily shame and damaged self-regard may be forces that motivate her and remain despite the power that her body exerts on eyes and minds. But women bodybuilders deserve gender indemnity and mercy, for they are not engaged simply in gender-bending, a term whose fashionableness reduces the bodybuilder to a superficial stylist.

Some bodybuilders themselves are concerned about not appearing too big. One midlife bodybuilder I interviewed told me she wears a size 7. Another said, when I complimented her on her bigness, that she wasn't all that big and that bigness had never been her goal. This concern also appears in *The Women*. Dobbins maintains that Patsy Chapman, who won the 1979 Best in the World contest, "simply could not accept the idea of developing the serious amount of muscle necessary to become competitive, and decided to quit bodybuilding." He also reveals that champion Sharon Bruneau "has run up against the fear of getting too big." Like many women bodybuilders, she has been reluctant to "wear anything remotely revealing" in public, and she has felt that more mass might endanger her modeling work, photo shoots, and guest appearances.[46] Women's hypermuscular bulk is so often perceived as an aesthetic and gender deficit that one cannot be surprised by *The Women*'s hot pink endpapers.

Women's showy, well-shaped bulk is neither "mere wonder" nor simply a style, as Lisa Grunwald suggests about bodybuilders' bulk in general in a *Life* magazine cover story on the muscular women athletes of the 1996 Olympics.[47] To experience wonder is not "merely" to be astounded by a spectacle. Wonder entails admiration as well as curiosity and astonishment. And a woman's seriously built body is much more than a matter of style. The *toned* body is a style—of fit, acceptable femininity—but the massively *built* body is a stylization of bulk, which is a more strenuous accomplishment, both in gym time and in the bodybuilder's likely contention with cultural fears about a gender generosity embodied by "masculine" women (or "feminine" men).

The toned woman is shapely. She shows her commitment to her conventionally attractive appearance by staying in shape, which means that

she develops her body aesthetically; the hypermuscular woman instead develops her body into a hyperaesthetic object of extreme, and to most tastes ostentatious, shapeliness. Just as fetish fashion forces the body to bulge in various places, so the bodybuilder develops her body into a fetish object that swells in a monstrous plenitude so often (mis)construed as ugliness. As if shapely only means pleasingly full and rounded—pretty, like McLish or Lyon. As if women can and must appear small so that men will appear big. I think of Thomas writing me, in a letter from summer 1996, "If we've chosen for our symbols women who are embarked upon becoming shrunken, then it's shrunken women—in all the senses of shrunkenness—that we'll have." Thomas's statement is blunt, but in a series of letters from 1995 into 1997 he reiterated the point that the female mesomorph who is fat receives enormous attention in fashion magazines and feminist literature, whereas the female mesomorph who is hypermuscular is ignored, disowned, or condemned. For Thomas, the high-fashion body is a shrunken woman, and the mesomorph who is fat is treated as though she must shrink herself. Indeed, even women of average size and shape fall under the cultural mandate of shrinkage. Thomas's letters and essays have opened a vision to me of monumentally muscular ancient Greek goddesses. I have come to imagine new Aphrodites, different from Praxiteles' Knidia. I see nudes and seminudes, like the bodybuilders in this chapter, who break beauty canons commonly represented by the female nude in Western art and fashion; I see Aphrodites as heroic nudes come to life in midlife female bodybuilders whose voluptuous shapes redesign my thinking about shapely contours and who possesses them.

COMPORTMENT

Comportment shapes bulk, performs muscle. African American Linda Wood-Hoyte is motivated by the fact that muscles neither develop nor read the same on all women. She believes that the way in which a woman carries her muscle determines how its appearance differs from one individual to another, and she is exceedingly aware of her own comportment in this regard.

An admirer of strength and athleticism who maintains in a *Women's Physique World* profile, "It never fazed me that muscles could be unfeminine,"[48] Wood-Hoyte has likely never had the experience of being called masculine. I saw her once when she was dressed in a conservative, light-

colored business suit and low heels—after her workday as a manager in a telecommunications corporation—and only her elegantly shaped calves, not any signs of massiveness, indicated investment in training. Like another bodybuilder who, when speaking with me, emphasized that she was "developing" and not "sculpting" muscle into an "appropriate shaping," Wood-Hoyte clearly knows what she needs in order to develop her desired physique. As I heard from a bodybuilding compatriot, it was Wood-Hoyte's intention to achieve an hourglass shape, and in order to do so she was reducing the appearance of her waist by not working her obliques and by bringing out her lats.

Wood-Hoyte began bodybuilding in 1982 and had competed in over thirty contests by 1995, winning overall in the NPC (National Physique Committee)-USA Masters Championships in 1988. She is 5′3″ tall, and in 1995 gave her off-season weight as 146 pounds and her competition weight as 132 pounds. Obviously, this is not a weight that many 5′3″ women would desire. However, it is the erotic weight of aesthetically crafted and carried bulk.

Since the early 1980s, women's bodybuilding has been criticized in the popular press when practitioners are perceived as endangering tone with bulk. In 1982, several years after the first women's bodybuilding competitions were established and when women's bodybuilding—for toning—was being touted as a key element in the so-called fitness craze, *Time* ran an August 30 cover story titled "The New Ideal of Beauty," and *Life*'s October 1982 cover proclaimed "Women Muscle In."[49] Both articles impress readers with the information that taut, toned, and sexy-to-men is a winning combination. Although *Time*'s Richard Corliss appears to enthuse about women being "hard and strong" and either "massive or petite," no massive women are pictured, and female muscle must be attractive to men. The most muscular woman depicted is Martina Navratilova, whose forearm and biceps veins are prominent as she wields her tennis racket. Navratilova's muscularity is a pointed choice, because she is a lesbian; the implication is that if a woman develops impressive muscle, she is "like a man," therefore lesbian—and lesbians don't care if men are attracted to them. Heterosexual women, however, having been "liberated from the courtesan's need to entice, have become more enticing," and "for many men this feminine physical assurance can be galvanizing." Indeed, the "new ideal" is "slimmer" and "sinuous," and "men may decide it is sexy for one basic reason: it can enhance sex."[50]

The interrelated themes of no bulk, okay-for-heterosexual-women, and sexy-for-men repeat in *Life*. The subtitle on the magazine's cover is "They Join Men in Body-Building, the Sport of the '80s," and the photo shows world-famous bodybuilder turned movie star Arnold Schwarzenegger standing directly in back of Sandahl Bergman, his *Conan the Barbarian* co-star. Both are holding very light dumbbells, which reinforces the story's information-as-caution: "most women are anxious to avoid brawn."[51] *Brawn* means muscular strength, not huge development, so its use here is inaccurate. Yet in popular idiom, it is men who are brawny, and the women pictured working out—executing 30-pound shoulder presses and 40-pound leg presses—are in no danger of creating bulk. "Lithe" and "sleek" are the name of the game that will produce the following results: "you're more honed to your body and to your sexuality."[52] Some serious—brawny—women bodybuilders would agree, but *Life* contextualizes this statement, made by a twenty-seven-year-old fashion illustrator, within heterosexual norms and lesbophobia.

One of Schwarzenegger's books at the time was *Arnold's Bodyshaping for Women*, and in the *Life* article, the then five-time Mr. Universe and six-time Mr. Olympia lists tips for women who wish to work out with weights. This brawny male authority is shown working out with Bergman in "key exercises that men and women can do together."[53] In *The Women*, twelve years after the *Life* feature, Schwarzenegger is enlisted again as the male authority approving women's bodybuilding. He wrote the foreword, in which he asserts that "everyone should be free to develop his or her abilities and talents to whatever degree possible," while also granting that female muscularity is a "very specialized kind of beauty."[54] *Life* does affirm women's admiration of their own toned beauty, as evidenced in a two-page spread featuring "five successful Manhattan career women,"[55] between the ages of nineteen and thirty-one, who flex—more or less—in bikinis, on top of pedestals. The scene is an art gallery, and each woman, dressed in business attire, gazes at herself, making her two images a unit isolated from the other women. At first, I didn't realize that each woman observed herself; I thought that they were looking at one another. So I wanted to examine the photograph more closely, because women looking admiringly at bikinied women is an exciting image of women's aesthetic/erotic potential and reality. But in fact, each woman, being her own Pygmalion and Galatea, demonstrates that female narcissism of a self-isolating variety supersedes community.

Also, lesbian eroticism is avoided: better that women remain negatively narcissistic than display lesbian desire.

An imperative gender norm underlies the *Time* and *Life* affirmations of women's physical fitness, and more recent articles in women's fashion magazines maintain the same body/bearing rationale: the slender female body exemplifies correct feminine comportment. Citing four male authorities and no women, *Elle*'s Michelle Stacey points out that toning and slimming should be a woman's goals and that they can be achieved though weight training without fear of bulk. "More than definition simply doesn't happen unless you become a fanatic," she assures the reader, simultaneously indicating that any woman who wants brawn is less than rational.[56] In *Vogue*, Wendy Schmid entrusts her body to a male expert, "fitness entrepreneur Edward Jankowski." Light weight training and the treadmill were not producing the desired results: "my body wasn't improving. In fact, certain areas were getting bigger, overly muscular. . . . I'm hoping Jankowski can help me lose some of the dense muscle mass I come by genetically."[57]

Big, dense muscle mass can be majestic. Wood-Hoyte is exemplary, for it was her regal and self-loving comportment as much as the spectacular aspects of her piece that made Wood-Hoyte one of the highlights, if not *the* highlight, of *Celebration*, held when Wood-Hoyte was fifty. She played Cleopatra VII and appears in two out of the six photographs accompanying the August 1994 *Ironman* report on *Celebration*.[58] Steve Neece states in *Musclemag*, "I think the woman who made the biggest impression was 50-year-old Linda Wood-Hoyte. She made a grand entrance as Cleopatra on a litter borne by four strong men. They mounted the stage, and, as she stepped from the litter, an audible undertone was heard in the audience: 'No way she's 50! Not with that skin! Not a line on her face! Not with that body! etc., etc.' "[59] (Serious bodybuilders may ingest enormous amounts of vitamins and other supplements, and perhaps one of their effects is many midlife bodybuilders' taut, smooth-looking skin.) The *New Yorker*'s story on *Celebration* featured a cartoon.[60] In the drawing's center Wood-Hoyte (identifiable as Cleopatra but not as a black woman, for her skin is white) flexes on her litter. Along with producer Fierstein and *Celebration* honoree Bev Francis, Wood-Hoyte is one of the three largest figures depicted.

Wood-Hoyte's piece collapses the Cleopatra–Mark Antony love story into six onstage minutes. While Cleopatra watches men dance and execute

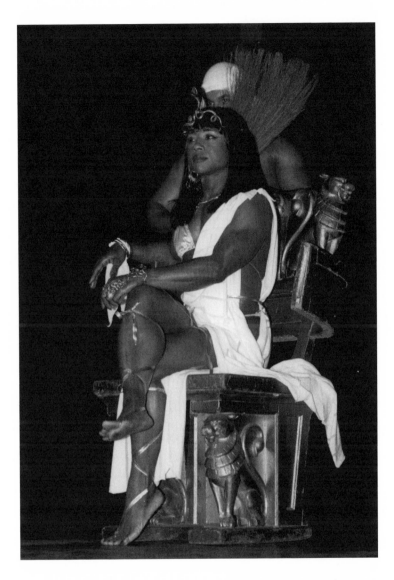

Linda Wood-Hoyte as Cleopatra
in *Celebration of the Most Awesome
Female Muscle in the World* (New
York City, November 1993).
Photograph: Björg.

acrobatic stunts for her, she sits in queenly boredom, utterly confident in her gorgeous muscle, her soul-and-mind-inseparable-from-body poise. African American professional bodybuilder Ron Coleman, as Antony, enters. He attracts Cleopatra through graceful strength rather than flamboyant gymnastics, and the two perform together in tenderness and joy. At the end, Cleopatra mourns Antony's death as she sinks to the floor beside him with elegant attentiveness to both him and her own movements.

Cleopatra wears a gold posing suit, knee-high laces, an Egyptian-style wig, a uraeus crown, and much makeup. On the *Celebration* videotape, Wood-Hoyte says she "wanted to be queen for a day."[61] That desire was accomplished—certainly by her stunning appearance and its reception but even more by her queenly comportment, a critical element of the bodybuilding that Wood-Hoyte calls "my self-realization as a woman."[62]

Wood-Hoyte has also encouraged women forty and older to realize themselves. In "Role Models," her Master Class column in the May 1994 *Female Bodybuilding and Sports Fitness,* Wood-Hoyte advocates bodybuilding for women over forty. After describing the achievements of the five midlife women, besides herself, who performed in *Celebration* she concludes, "I'm sure these stories of women who have succeeded because they never let age become a barrier will encourage more of you to expand your horizons and do what you want to do. Remember, life is for living."[63] Wood-Hoyte exemplifies strikingly atypical beauty, beyond the control of the male desire that has designed female beauty as a symptom of masculine psychology. Strength, dark skin, age, and shapes that engage both space and observers' aesthetic and emotional beings through her muscles' sensual decorum challenge the reign of the Blonde Bunny Goddess.

Yet Wood-Hoyte's beauty remains difficult, even stigmatized, as we see in a 1997 *Vogue* feature, "Venus Envy," shot by Annie Leibovitz.[64] Wood-Hoyte is one of five women who model clothes created by contemporary women whom *Vogue* calls "fashion innovators." She displays an ankle-length tank dress, skintight except for a bulging pad on the right hip, created by Japanese designer Rei Kawakubo. All the other "models"—from movie stars Demi Moore and Liv Tyler, to rock icon Patti Smith, to high-fashion model Stella Tennant—are white and thin. Their faces are all visible, though Smith's appears in profile. All are pho-

tographed in color. All are made to appear as if they are posing in an actual space—outdoors, in a bedroom, in an airplane.

Wood-Hoyte is different. She strikes a front double-biceps pose with head thrown back, so that we cannot see her face. Her posture agrees with Nicolas Monti's description in *Africa Then* of the black woman "imagined without a head: the body is all that counts."[65] (*Vogue* erases Wood-Hoyte's face, and the *New Yorker* erases her color.) With her feet wide apart and chest and ribcage thrust out, her nipples and small breasts strain at the fabric, as do her quadriceps and knees. Bare delts, biceps, and upper lats look vibrantly huge, and the very pose—flexing with elbows, knees, and feet wide apart—makes Wood-Hoyte appear larger than she would if she were simply sitting or standing as the other women are. The over-fifty black bodybuilder becomes a demonstration of monstrousness, which is further singled out in a black-and-white rather than color photograph. (Smith turned fifty in 1996, but she resembles the younger women.)

Vogue presents Wood-Hoyte as an anonymous human female with a severely and voluptuously structured body. She almost reads as a specimen on display, for we see to her left a hand holding on to the dark screen behind her and a foot sticking out from behind it; it is as if this anonymous spectacle requires an anonymous place, one that is purely artificial, ostensibly neutral. She reminds me of a latter-day Hottentot Venus, exhibited in order to be gawked at as a simultaneously grotesque and inviting oddity—a mere wonder. The so-called Hottentot Venus, Saartjie Baartman, was a southern African Bush or San woman exhibited in London and Paris from 1810 to 1815. All attention was focused on the shape of Baartman's buttocks, though their adipose overdevelopment— her steatopygia—was common to women of various southern African tribes. The dress's bulging pad—its bulk—exaggerates Wood-Hoyte's bulk and appears to extend behind her hip, suggesting "Hottentot" buttocks' hugeness and allure. Granted, Kawakubo is known for distorting the body's shape, and *Vogue* labels her "avant-garde" because she "redefines the body . . . in designs fitted with padded bags and bulges."[66] Perhaps an atypical beauty, an "avant-garde" body, deserves and complements avant-garde clothing; yet the black bodybuilder is also a primitivized body, despite her elegant comportment. She is a paradox of atavism and prophecy.

This primitivized body fits into the tropes Marianna Torgovnick describes in *Gone Primitive:* she is animal, sexual, dangerous, innocent, and mysterious.[67] The primitive oversteps Western culture's bodily comfort zone. One of bodybuilding's clichés is that its practitioners are animal. In this context, "animal" is positive, standing for the natural, sensual, and instinctual. Altomare told me, "With a body like this, I feel closer to nature, the instinctual." Adding to the primitivist stew is Lingis's assertion that "these are atavistic bodies, halted before the age of the self-domestication of the hunter-gatherers."[68] A remote, even exotic poetry does haunt the bodybuilder's physique. But the black female bodybuilder may suffer from a representational history that has erased the black woman's individuality to create a primitivist utopia/nightmare.[69] In actuality, the female bodybuilder's development, specifically when shaped by comportment, is highly sophisticated; how she carries her bulk, how she performs it can become a feminist use of space.

Iris Young has written about the "bodily self-reference of feminine comportment, which derives from the woman's experience of her body as a *thing* at the same time that she experiences it as a capacity." She explores feminine lived space as confining: "feminine existence appears to posit an existential enclosure between herself and the space surrounding her, in such a way that the space that belongs to her and is available to her grasp and manipulation is constricted and the space beyond is not available to her movement."[70] Hypermuscular performances such as Dennis's spiderwoman and Wood-Hoyte's Cleopatra, in which impressive female muscles move dynamically and expressively, break confinement and balance thingness and capacity. These are two of the many benefits of female athleticism. The hypermuscular performer obtrudes and advances; she is a confident, flexible, mobile surface whose intense actualization of materiality and motility increases her "obtrusively" aesthetic comportment.[71]

Earlier I distinguished women who are big with muscle from women who are big with child. The latter marks a body female, while the former marks it male. However, I see in Young's description of pregnant embodiment, including her own experience of pregnancy, a model of female corporeal bulk that is useful in understanding a woman's hypermuscularity. Young contends that in our society, which "often devalues and trivializes women, regards women as weak and dainty, the pregnant woman can gain a certain sense of self-respect" because her "weight and

materiality often produce a sense of power, solidity, and validity."[72] This sense of self-respect—which recalls Wood-Hoyte's "self-realization as a woman" and Altomare's "re-creating myself, after many years of not being me"—resides, too, in the bodybuilder's weight and materiality, her bulk. Bulk figures prominently in Young's own pregnancy: "this bulk slows my walking and makes my gestures and my mind more stately. I suppose if I schooled myself to walk massively the rest of my life, I might always have massive thoughts."[73] What a potent and beautiful idea! It leads me to think about how schooling one's body by building muscles and comporting them in stately ways might school the soul-and-mind-inseparable-from-body to become large, and immensely sensual.

INFAMOUS BEAUTY

The fortyish, seductive, and dangerous beauty is hardly unique to *Arachnaphobia*. She appears in literature and in popular culture, as the title character in Mario Vargas Llosa's *In Praise of the Stepmother* (1990), as Jocasta in Ursule Molinaro's *Power Dreamers* (1994), and as Mrs. Robinson in Mike Nichols's film *The Graduate* (1967). In each of these stories, the midlife woman is a potent if not haunting character, yet her erotic "muscle" fails her as the plot plays out. In *The Graduate*, Mrs. Robinson's daughter wins the hero, who is half the mother's age. To be sure, Mrs. Robinson gives no indication that she desires him on a permanent basis. Yet loss—*of* youth and *to* youth—is a recurring theme in midlife/menopausal discourse.[74]

Molinaro's Jocasta is profoundly and restlessly intelligent, and she is anxious because of the perpetual "darkness in my heart." She is afraid of losing her beauty. The first sentence of the novel reads, "Today I finally asked my women if I had *lost* my looks" (my emphasis). Ruminating as usual, Jocasta believes that other than man, the "predominant preoccupation of women" is "Age . . . aging" (Molinaro's ellipsis).[75] Oedipus finds Jocasta's aging allure very sexy. He writes to his parents, "She's beautiful, in a strangely stylized, remote sort of way," and then to a friend:

> Her eyes are out of this world. Heavily painted. She looks like something I might have picked up myself, if I had the guts. She's a little older than what I might have risked. A bit forbidding. Hardly the sweet young thing a son brings home to his parents. Rather the kind of

mistress you might introduce to your father, some night when he's
taking you out on the town to show you the ropes. & you show him
that you know those ropes already. I'd feel more comfortable as her
lover, than as her husband.[76]

Jocasta, who is "close to 40" at the novel's beginning, is a scary prize,
whose attraction to a young man, almost twenty, boosts his male pride.[77]
In both letters, Oedipus mentions, with excitement and some surprise,
that Jocasta is attracted to him. Jocasta identifies with the Sphinx, whom
she calls a monster. Like Dennis's spiderwoman, Molinaro's Jocasta
arouses lust through her highly designed, tartish appearance, which is the
menace of their particular kinds of monster/beauty. However, with
absolute deliberateness, Jocasta throws herself off the Sphinx's cliff. She
emulates the suicide of that other infamous monster/beauty, whereas
spiderwoman emulates the vampire's eternal life. In no way does *Arach-
naphobia* equal the complexity of *Power Dreamers*, yet it is exceptional to
see the midlife monster/beauty, the sexually experienced and dangerous
older woman, triumph as a symbol of erotic gain.

Vargas Llosa's Lucrecia is a tragic figure of loss in *In Praise of the
Stepmother*. She sleeps with her prepubescent stepson, who charmingly
insinuates himself into her heart and genitals, and this action precipitates
the end of her happily wedded life to the child's father. Her dangerously
voluptuous beauty puts her at risk.[78] The legendary Lucretia from the
history of early Rome is raped by a young man and kills herself because
of her shame. Lucrecia, too, suffers a psychic and emotional rape, though
of a more subtle kind. By throwing her out of their home, Lucrecia's
husband casts shame on her sexual involvement, which, unlike Lucretia,
she had thoroughly enjoyed. Stepmother Lucrecia appears to end up
dead to the world of bourgeois comfort and marital bliss. Compared to
Jocasta and Mrs. Robinson, Lucrecia is an innocent; but like them, she is
invested in her aesthetic/erotic well-being. All three suffer some degree
of loss that may be the punishment for midlife strength of eros, which, in
each story, is portrayed as rapacious or, at least, too much.

Dennis's muscle is, of course, too much—for any sweet young thing,
for any daylight romance. She is the risk, the forbidden body and its
meanings, that Oedipus senses about Jocasta and that captivates him.
And *she* is the one to show "the ropes"—to any man she chooses. But her
muscle alone is not necessarily the reason for her triumph. Muscle and
courage can be defeated, as we see in Christa Bauch's piece for *Celebra-*

tion. Dressed in a posing suit that resembles chain mail, she rises from a cloud of smoke: she is the Amazon as phoenix, and she brandishes her sword as if in battle, as if appearing, like a savior, from the smoke of siege. However, she sustains a wound and expires on the floor, in a position resembling that of the Dying Gaul. Nonetheless, Bauch, like Altomare, Dennis, Fierstein, and Wood-Hoyte, is an infamous beauty, and one of the midlife hypermuscular infamous beauty's triumphs is bulking up the pinup with an erotic weight whose aesthetic operation is communal, self-sustaining, and transformative.

Hypermuscular performance is an aesthetic condition and process. The aesthetic, located between somatic knowledge and cultural discourse, can, as art critic Grant Kester asserts, "transgress existing boundaries of knowledge and transcend the here and now to envision a more just and equitable society."[79] From Yukio Mishima to Bill Dobbins to Alan Klein to Jim Pawlowski (author of *Strength Fitness for Women*) to *Vanity Fair*, the bodybuilder's physique is described as aesthetic or art, specifically sculpture.[80] Hypermuscular shape and surface, tooled by weights and diet, and possibly breast implants and drugs, certainly can share the beauty of exquisitely crafted, polished metal or stone. Yet the bodybuilder's artwork tends to stand alone, as an object unto itself and others of its kind; it has not received attention as a profound aesthetic phenomenon—perhaps because this body is infamous, seen as "like a man," drug-taking, fanatically dieted into "unfeminine" vascular leanness. These "infamies" are misunderstandings based primarily in cultural terror of gender breakdown; their persistence is a sign that people do not register weights, diet, cosmetic surgery, or drugs as artist's tools.

I have dealt at length with "manly" bulk and wish to say a bit about drugs, for drugs and bulk become polemical (rather than aesthetic) tools. As such, they turn hypermuscular performance into a moral rather than an aesthetic issue. Women's use of anabolic, androgenic, and metabolic agents does raise legitimate moral, ethical, legal, and medical as well as aesthetic questions that remain virtually undiscussed in the bodybuilding and wider press. Although testosterone levels vary in women as they do in men, women who build massive muscle—easily by nature or with the help of drugs—encounter hostility from male-owned bodybuilding magazines that ignore extremely muscular women, for they are an embarrassment of gender riches, to the person on the street (including students and close friends of mine) who exclaims that serious women bodybuilders

"look like men." As philosopher Christine Battersby argues in *Gender and Genius,* the celebrated male artist has been like a woman but not a woman,[81] for he has seriously appropriated femininity. But the female bodybuilder who is brilliant in muscle must not encroach seriously on masculine territory. If she does, she is infamous, fanatical, lesbian.

The hypermuscular performance aesthetic offers a way back into the heart of Aphrodite. In an alabaster statue found in a Pompeii garden, Aphrodite wears a gold-painted bikini. On the goddess of love, sex, and creativity, for whom the epithet *golden* was the ancient Greeks' most recurrent description, a gold-painted bikini means radiance and power. The hypermuscular performer dresses like this version of Aphrodite, often in gold, generally in some kind of bikini.

How does it feel to be a midlife Aphrodite/Amazon today, strong and nearly naked, in front of a crowd? I hear shyness, then a smile when Fierstein answers this question in a September 1997 telephone conversation. She feels "bold and very sexual in terms of I'm revealing" and the audience is dressed. Then she laughs, "You know how it's always more exciting to have a sexual experience in a place you're not supposed to," like in public.

Somatic experience, the bodybuilder's private art, becomes public—cultural discourse, aesthetic event and communication—when she performs. Her excitement, apparent when we see her, generates a public vision of her radiance.

Infamous beauty is the best. When a woman strengthens flesh into spectacle, she is the flexion and extension of pleasure as a necessary provocation.

Always Aphrodite, I am more than you can hold in your mind or arms. (You cannot quantify the immeasurable.)

I assault beauty as a pale and thin young thing. I destroy allegiance to the fraudulent perfection of limbs and torsos rated according to color, age, and size, adjusted for the marketplace.

I am the pinup released from platitude, borne in massive pleasure.

NOTES

1. Maria-Elena Buszek, "Reconsidering the Pin-Up: The History, Sexual Politics, and Feminist Reclamation of the Pin-Up Genre" (preliminary paper for Ph.D. dissertation, University of Kansas, Lawrence, 1997), n.p., makes this point.

2. I interviewed Emilia Altomare and Laurie Fierstein in May 1995. Statements throughout the chapter by each of them were made then unless otherwise specified.

3. These quoted phrases appear in an August 25, 1997, e-mail message to me from the woman whose experiences open this section; she wishes to remain anonymous. Lynne Segal, in *Straight Sex: Rethinking the Politics of Pleasure* (Berkeley: University of California Press, 1994), defends heterosexual sex in her examination of feminist thinking on sexuality over the past two and a half decades. Segal writes that "casual disparagement" of heterosexual feminists "alongside heterosexual defensiveness has dwelt within feminism too long. This book will show why it is as unproductive as it is foolish, and how reclaiming sexual agency for heterosexual women can help revive a richer and more inspiring feminist culture and politics" (x). *Straight Sex* is a much-needed renewal for feminists describing and theorizing heterosexual practices and agency.

4. Margaret Morganroth Gullette, "Menopause as Magic Marker: Discursive Consolidation in the United States and Strategies for Cultural Combat," in *Reinterpreting Menopause: Cultural and Philosophical Issues*, ed. Paul A. Komesaroff, Philipa Rothfield, and Jeanne Daly (New York: Routledge, 1997), 179, 181.

5. Ibid., 182, 186.

6. Pamela L. Moore, "Feminist Bodybuilding, Sex, and the Interruption of Investigative Knowledge," in *Building Bodies*, ed. Pamela L. Moore (New Brunswick, N.J.: Rutgers University Press, 1997), 85.

7. Al Thomas, letter to the author, January 1997.

8. Steve Wennerstrom, telephone conversation with the author, September 5, 1997.

9. Yukio Mishima, *Sun and Steel*, trans. John Bester (Tokyo: Kodansha International, 1970), 13.

10. Ibid., 24.

11. *Fabulous Forties: The Girl Next Door—All Grown Up*, dir. Vicangelo Bulluck, 50 min., Playboy Entertainment Group, Beverly Hills, Calif., 1994, videocassette.

12. Mishima considers that the body "might have its own logic, possibly its own thought," and he begins "to feel that the body's special qualities did not lie solely in taciturnity and beauty of form, but that the body too might have its own loquacity" (*Sun and Steel*, 16).

13. Maxine Sheets-Johnstone, *The Roots of Power: Animate Form and Gendered Bodies* (Chicago: Open Court, 1994), grounds her advocacy of an evolutionary and biological understanding of male-female power relations in an investigation of animate form. Sheets-Johnstone maintains that animate form has visual and archetypal power. Her argument leads me to consider the female bodybuilder as an extreme embodiment of animate form.

14. Lucy R. Lippard, "The Pains and Pleasures of Rebirth: European and American Women's Body Art," in *From the Center: Feminist Essays on Women's Art* (New York: Dutton, 1976), 121–38 (originally published in *Art in America* 64, no. 3 [May–June 1976]: 73–81), discusses the radical and often problematic nature of women's body art, including performance art by Carolee Schneemann. The essays in *The Amazing Decade: Women and Performance Art in America*,

1970–1980, ed. Moira Roth (Los Angeles: Astro Artz, 1983), set forth prime characteristics that informed the first decade of feminist performance art and briefly document the life and work of significant figures. Josephine Withers, "Feminist Performance Art: Performing, Discovering, Transforming Ourselves," in *The Power of Feminist Art: The American Movement of the 1970s, History and Impact,* ed. Norma Broude and Mary D. Garrard (New York: Abrams, 1994), presents 1970s feminist performance art as a "paradigm of feminism itself" (158), enthusiastic and urgent, challenging art's traditional boundaries and definitions as it blends art and life. Rebecca Schneider, *The Explicit Body in Performance* (London: Routledge, 1997), analyzes aspects of feminist performance art within a theoretical and avant-garde framework. Amelia Jones, *Body Art: Performing the Subject* (Minneapolis: University of Minnesota Press, 1998), theorizes the subjectivity of female performance artists who have created a feminist body art by employing what she terms "nonnormative" bodies. Kathy O'Dell's *Contract with the Skin: Masochism, Performance Art, and the 1970s* (Minneapolis: University of Minnesota Press, 1998), which concentrates on some masochistic performance artists' ability to endanger viewers' certainty in their own skin as protecting and containing, features Gina Pane.

15. Schneider, *Explicit Body in Performance,* 35.
16. Withers, "Feminist Performance Art," 160.
17. *Evolution F,* choreographed by Hope Clark, was a fascinating spectacle but suffered from disorganization and sloppy production. Also, some of the characters and metaphors could have been more subtly conceived and richly developed.
18. I address Aphrodite's association with gold in chapters 9 and 10. Abby Wettan Kleinbaum, *The War against the Amazons* (New York: New Press, 1983), 127, notes the "close association of Amazons and gold"; for other references to gold and Amazons, see 79, 116, 126, 132.
19. Al Thomas, conversation with the author, May 1995.
20. Gullette, "Menopause as Magic Marker," 179.
21. Schneider, *Explicit Body in Performance,* 36.
22. Eve Kosofsky Sedgwick and Adam Frank, in "Shame and the Cybernetic Fold: Reading Silvan Tomkins," the introduction to *Shame and Its Sisters: A Silvan Tomkins Reader,* ed. Eve Kosofsky Sedgwick and Adam Frank (Durham, N.C.: Duke University Press, 1995), 1–2, 5, critique contemporary theory and criticism for their "impoverishing reliance on a bipolar analytic framework that can all too adequately be summarized as 'kinda subversive, kinda hegemonic.'"
23. Alan M. Klein, *Little Big Men: Bodybuilding Subculture and Gender Construction* (Albany: State University of New York Press, 1993), 159, asserts that "women's bodybuilding has created an equivocal presence, at once mirroring male definitions of bodybuilding and resisting male definitions of the sport-subculture." See also Richard Corliss, "The New Ideal of Beauty," *Time,* August 30, 1982, 72–77; Elizabeth Owen, "The Body Shapers," *Life,* October 1982, 46–47; Robert Mapplethorpe, *Lady, Lisa Lyon,* text by Bruce Chatwin (New York: Viking Press, 1983).

24. Susan Butler, "Revising Femininity?" *Creative Camera*, September 1983, 1090–93, and Silvia Kolbowski, "Covering Mapplethorpe's 'Lady,' " *Art in America* 71, no. 6 (summer 1983): 10–11.

25. Leslie Heywood, "Masculinity Vanishing: Bodybuilding and Contemporary Culture," in Moore, *Building Bodies*, 180–82, critiques the efforts of bodybuilding magnate Joe Weider to popularize the streamlined look of "fitness competitors" over female bodybuilders' hypermuscularity.

26. Lynda Nead, *The Female Nude: Art, Obscenity, and Sexuality* (London: Routledge, 1992), 8.

27. Heywood, "Masculinity Vanishing," 177–78. Although Heywood remains critical of female bodybuilders' marketing of their heterosexual sexiness in her *Bodymakers: A Cultural Anatomy of Women's Body Building* (New Brunswick, N.J.: Rutgers University Press, 1998), she also passionately presents female bodybuilding as an activist feminist practice.

28. Laurie Schulze, "On the Muscle," in Moore, *Building Bodies*, 9, 15.

29. Heywood, "Masculinity Vanishing," 182, suggests that "female bodybuilding has the potential to create a new version of female embodiment . . . based in a power rather than a fragility aesthetic."

30. Carolee Schneemann, quoted from her 1991 performance *Ask the Goddess*, in David Levi Strauss, "Love Rides Aristotle through the Audience: Body, Image, and Idea in the Work of Carolee Schneemann," in *Carolee Schneemann: Up to and Including Her Limits*, exhib. cat. (New York: New Museum of Contemporary Art, 1996), 33; Agnes Martin, "The Untroubled Mind," in *Agnes Martin*, exhib. cat. (Philadelphia: Institute of Contemporary Art, 1973), 20; and Brice Marden, "Statements, Notes, and Interviews (1963–81)," in *Theories and Documents of Contemporary Art: A Sourcebook of Artists' Writings*, ed. Kristine Stiles and Peter Selz (Berkeley: University of California Press, 1996), 139.

31. Steve Wennerstrom, conversation with the author, September 5, 1997.

32. The videotape was produced in the 1990s as a vehicle for guest posing at bodybuilding and fitness events (I have been unable to pin down the exact date, even after speaking with Diana Dennis herself). Like tapes produced by many performance artists, Dennis's tape may be understood as both documentation and promotion.

33. Klein, *Little Big Men*, 245–46, lists the "She Beast" among other mythic ideals of the bodybuilder's "glorified self."

34. Maria-Elena Buszek, e-mail to the author, August 28, 1997.

35. Bill Dobbins, *The Women: Photographs of the Top Female Bodybuilders* (New York: Artisan, 1994), 37.

36. Valerie Steele, *Fetish: Fashion, Sex, and Power* (New York: Oxford University Press, 1996), 192, states that in fetish fashion, "for symbolic and visual power, black is rivaled only by red," and she lists associations with both colors that secure their dominant position. For the photograph of Dennis, see Dobbins, *The Women*, 15.

37. Steele, *Fetish*, 196, asserts that the "perversions stand for pleasure, as opposed to procreation."

38. Kenneth Clark, *The Nude: A Study in Ideal Form* (Princeton: Princeton University Press, 1956), 40.

39. Alphonso Lingis, *Foreign Bodies* (New York: Routledge, 1994), 41.

40. Steele, *Fetish*, 40.

41. Wrestling is an arena of hypermuscular performance as yet untouched by critical analysis. Belgian bodybuilder Nathalie Gassel celebrates her own muscularity, and the erotic pleasure she derives from wrestling with men, in a series of four essays—"Muscles as a Form of Megalomania," "Why These Female Muscles?" "Muscle and Eroticism," and "How I Turned into an Enthralled Muscle Woman," written in 1996 and 1997. They appear as "My Muscles, Myself: Selected Autobiographical Writings," in *Picturing the Modern Amazon*, ed. Joanna Frueh, Laurie Fierstein, and Judith Stein (New York: Rizzoli, 2000), 117–19. For the photograph of Dennis, see Dobbins, *The Women*, 117.

42. Clark, *The Nude*, 173. For the photograph of Dennis, see Dobbins, *The Women*, 118.

43. Heywood, *Bodymakers*, 9–10, discusses the distinction between bodybuilding and fitness competitions, as well as the import of monster female muscle, in "Introduction: Monsters, Feminists, Babes" (1–17).

44. Wennerstrom, conversation with the author, September 5, 1997.

45. See Dobbins, *The Women*, 48, 119.

46. Ibid., 12.

47. Lisa Grunwald, "The Soul of These Beautiful Machines," *Life*, July 1996, 66.

48. Linda Wood-Hoyte, quoted in Laurie Fierstein, "Fit and Muscular at Fifty!" *Women's Physique World*, no. 38 (November/December 1993): 59.

49. "Fitness craze" is a term used by Corliss, "New Ideal of Beauty," 74; see also Owen, "Body Shapers," 46–47 (the magazine's cover does not match the title of the story inside).

50. Corliss, "New Ideal of Beauty," 72–73, 76.

51. Owen, "Body Shapers," 47.

52. Ibid.

53. Caption for Schwarzenegger and Bergman weight-training photograph in Arnold Schwarzenegger, "A Beauty and the Best Show How It's Done," *Life*, October 1982, 49.

54. Arnold Schwarzenegger, foreword to *The Women*, by Dobbins, 7.

55. Caption for photograph in "Admiring Their Handiwork," *Life*, October 1982, 50.

56. Michelle Stacey, "The Meaning of Muscles," *Elle*, July 1996, 58.

57. Wendy Schmid, "Rope In," *Vogue*, August 1997, 142.

58. Reg Bradford, "Celebration of the Most Awesome Female Muscle in the World," *Ironman*, August 1994, 52; photographs by Chris Trotman.

59. Steve Neece, "Awesome Women," *Musclemag*, June 1994, 138.

60. Arnold Roth, cartoon, *New Yorker*, November 29, 1993, 76–77.

61. Linda Wood-Hoyte, interview, in *Celebration of the Most Awesome Female Muscle in the World*, 113 min., Fierless Productions, New York, 1995, videocassette.

62. Linda Wood-Hoyte is quoted in Fierstein, "Fit and Muscular at Fifty!" 59.

63. Linda Wood-Hoyte, "Role Models," *Female Bodybuilding and Sports Fitness*, May 1994, 67.

64. "Venus Envy," photographs by Annie Leibovitz, *Vogue*, March 1997, 432–41.
65. Nicolas Monti, *Africa Then: Photographs, 1840–1918* (New York: Alfred A. Knopf, 1987), 73.
66. "Venus Envy," 434.
67. Marianna Torgovnick, "Defining the Primitive/Reimagining Modernity," in *Gone Primitive: Savage Intellects, Modern Lives* (Chicago: University of Chicago Press, 1990), 3–41.
68. Lingis, *Foreign Bodies*, 42.
69. Schneider, *Explicit Body in Performance*, 5, explains that the feminist explicit body artist is, by virtue of being and using her female corporeality, "already primitive, already transgressive." Thus she knowingly calls attention to the primitive and "can expose the cultural foundations of shock" at the female body's "savage" physicality. Wood-Hoyte's hypermuscular performance does not engage this use of the primitive.
70. Iris Marion Young, *Throwing Like a Girl and Other Essays in Feminist Philosophy and Social Theory* (Bloomington: Indiana University Press, 1990), 147, 151.
71. Alphonso Lingis's description of sexual behavior in *Libido: The French Existential Theories* (Bloomington: Indiana University Press, 1985) suggests, to my mind, associations with the bodybuilder's confident movement and spatial thingness. Lingis writes, "The more intense one's sense of one's hovering or advancing motility is, the more intense is one's obtrusiveness in exterior space, one's sense of the surface one turns to the advances of others" (51).
72. Young, *Throwing Like a Girl*, 166.
73. Ibid.
74. *The Graduate* (1967; dir. Mike Nichols, Embassy Pictures) portrays Mrs. Robinson as a loser. She lost her youth to a marriage she did not want, and early on she announces to Ben, the graduate, whom she is trying to seduce, "I'm neurotic," and asks, "Did you know I'm alcoholic?" These are major aspects of her loss of self, and Ben later calls her, to her face, a "broken-down alcoholic."
75. Ursule Molinaro, *Power Dreamers: The Jocasta Complex* (Kingston, N.Y.: McPherson, 1994), 24, 7, 40.
76. Ibid., 43, 49.
77. Ibid., 30.
78. Mario Vargas Llosa, *In Praise of the Stepmother*, trans. Helen Lane (New York: Farrar, Straus, Giroux, 1990).
79. Grant Kester makes this claim for transgressive power while discussing Hegel's *Philosophy of Right* and the "utopian moment of the aesthetic"; see "Learning from Aesthetics: Old Masters and New Lessons," *Art Journal* 56, no. 1 (spring 1997): 23.
80. See Dobbins, *The Female*, 10–11; Klein, *Little Big Men*, 244; Mishima, *Sun and Steel*, 27; Jim Pawlowski, *Strength Fitness for Women*, 3d ed. (n.p.: Wingmaker Press, 1984), 117. The cover of the November 1993 *Vanity Fair* shows a nude and hypermuscular Sylvester Stallone accompanied by the words "Sly's Body of Art."
81. Christine Battersby, *Gender and Genius: Towards a Feminist Aesthetics* (Bloomington: Indiana University Press, 1989), makes this point numerous times.

Three

THE PASSIONATE WIFE,
THE PASSIONATE DAUGHTER

Aphrodite's Ordinance: Look out for anyone who says that pleasure is irrational, for those who, when they think of law, can only say "jurisprudence" and "enforcement." I lie down with the law of love. My body, well-exercised in pleasure, provides the reason for existence. Let my practice persuade you to build the body of love.

I think about permutations of eros, which saturate and penetrate me. I am full of love, and it is dense within me, but not solid.

Apprehensive about responses to my own proclivities, I imagine someone beginning a sermonette to save me: "You like penises too much. You identify with them, you want one because the phallus is the ultimate source and signifier of power, and the penis is its representation. You have hystericized your hatred of cunts and your own body into obsessional attraction to intercourse with men." My critic presses on: "Eros, Aphrodite's son, is just a pudgy boy, ironically innocent of erotic arts but trained by his father Ares in the economy of war: Eros shoots arrows into hearts, creating demand, but he often mischievously and arrogantly withholds supply." He is violent, says my personal preacher, and makes love into war.

Roman Venus and Cupid, Greek Aphrodite and Eros: young man, he is his mother's lover. (Russell, my husband, is younger than I. He is curly-haired and creamy-skinned.) Winged beauty, dove and angel, the son eyes his mother warmly all over her naked body. In Bronzino's *Venus, Cupid, Folly, and Time* (ca. 1545) and other mannerist representations of Venus and her son, the painters play with the pictured couple's mutually lustful attachment. Implied incest is meant to stimulate the viewer. *Incest* derives from a Latin word meaning "unchaste." Dirty thoughts, erotic thoughts, implicate older woman and younger man in passionate acts outside the packaged wholesomeness of maritally sanctified reproduction and its appropriate, supremely clean couplings.

Aphrodite is a married woman, a mother, and a passionate wife. Body to body, she and I assert that Eros is our consort. Body to body, we enjoy consorting with Eros.

The maternal and the sexual intertwine. Paul Friedrich, a cultural anthropologist and expert in Homeric Greek, hypothesizes Aphrodite as a simultaneous erotic and motherly archetype in the final chapter of *The Meaning of Aphrodite,* his classic study of the figure of Aphrodite in antiquity. Sociologist Robbie Kahn elaborates on the same connection in *Bearing Meaning.* These scholars discuss the similarity between undrugged childbirth and sexual arousal, including the possible experience of orgasm in both.[1]

Eros, you were my orgasm in birth. I know you better than did the Renaissance, whose artists depict you as merely a winged youth; and better than the baroque and rococo painters who made you into a plump baby. These portrayals are reductions. To the early Greeks you were one of the strongest and deepest forces in human beings.

Eros, you frankly realize my pleasure. I know your many adult plumpnesses so well—weight-trained calves and deltoids, ass sumptuous and small, cock in all its states of rest and arousal.

My mother sees me masturbating in my bedroom. I'm eight, and I've chosen to wear my long, aqua, nylon nightgown because I feel slinky when it slides around me and I can pull its short puffy sleeves down my arms to bare my shoulders and much of my chest. I'm squeezing my thighs together, which creates a more acute orgasm for me than does fingering my clitoris. I am in love with my voluptuousness, and my mother knows it. I'd closed the door before masturbating but knew, in

the way that lovers intuit each other's imminent behavior, that she would knock and enter before I could completely recover.

Mother, my erotic consort. Because she did not scold me or look at me askance, I was left to my own erotic devices, which grew into the assertions and fulfillments of the passionate wife.

Eros, you bastard I adore, you oversee the most everyday and unruly occurrences in mind and body. You disallow the derogation of wife into curiosity or bore. Though you were born outside of law, I do not see you as taboo. The erotic, which you represent—as does your mother even more forcefully, for her eroticism overcame Ares—exists when flesh in love does not make excuses or create rationales for itself. Aphrodite does not believe in sin, for obedience to father gods and God the Father demands confessions. Less fear, more fun, she instructs her followers. She goes further than the nineteenth-century poet Charles Baudelaire, who wrote that "true civilization lies . . . in the reduction of the traces of original sin."[2] Aphrodite opts for extinction, not reduction.

I like to write with an abundant bouquet of cut flowers on my desk. I thank my father for this luxury.

In his old age, gardening became exhausting for him, but throughout my life he gardened. From our first house I remember a row of roses that began at the terrace outside the living room picture windows; across from the roses, a rock garden full of pansies; in the backyard darkness, bleeding hearts; on the east side, lilacs and honeysuckles; bluebells in the front. From our second house, where my parents lived till recently, pink peonies, a circle of tiger lilies, lilacs (again to the east), and a forest left much to itself most fill my mind. Every bed, of many more flowers than I name here, was lush.

Uncooperative, I helped Dad as little as possible in his gardens, where he would sit late on summer afternoons drinking a Scotch on the rocks and smoking cigarettes. I recognized as a child that he was in his erotic element. He was building paradise. Today his lifelong pleasure is mine.

I bring lilacs, roses, and daylilies from Russell's and my garden indoors, to vases beside our bed. I gather cosmos, Mexican primrose, Russian sage, and irises, my mother's favorite flower. My colors, curves, and muscles are rich and striking, like my and my parents' beloved flowers.

Victorian artist and poet Dante Gabriel Rossetti depicted women with flowers, painted women to be flowers. A feminist could despise this rep-

resentation of conventionally sexualized femininity: red, succulent lips, like the cunts Rossetti loved to fuck; billowing hair; moist, dreamy eyes—thickness of sex and flesh, of flowers in perfect aesthetic proximity of each other in my father's gardens. But I see myself in his paintings, just as I see Rossetti, for they are his self-portraits: the man gets away with being a flower, and I want to pluck him.[3] Rossetti ordered and chose with care the flowers that he painted. Like my father, Rossetti claimed eros through aesthetic attentiveness.

Father, my erotic consort. I have not felt compelled to escape the material world—my body or sensuality.

I read the writings and the bodies of prisoners of earth. They are lovesick for themselves. Yukio Mishima rejoices in an F104 flight, because "on earth, man is weighed down by gravity, his body encased in heavy muscles; he sweats; he runs; he strikes; even, with difficulty, he leaps." In flight "the blue sky was flecked with the semen-white of clouds," for the fighter was "a sharp silver phallus" that ejaculated. The F104 also "ripped the vast blue curtain, swift as a dagger-stroke! Who would not be that sharp knife of the heavens?"[4] The sharp knife is *in*, not *of*, the heavens: a glittering transcendent penis of deified proportions and violent intent. I don't object to the semen/clouds metaphor, which is no more nor less silly or beautiful than vulvas/flowers; but I detest the grandiose abandonment of earth/body and the turning of flesh into weapon/metal. The absolutism of Mishima's imagery reminds me of painter Kasimir Malevich's suprematist theorizing: "We want to conquer the world, take it from the hands of Nature and build a new world that still will belong to us," and "The blue color of the sky has been defeated by the Suprematist system, has been broken through and entered white."[5] Mishima and Malevich leave me longing for Rossetti's outrageous Victorian voluptuousness.

I see a colleague lumbering at a distance down the hallway. Hunched, slouched, and lurching figures are everywhere, embodiments of Eros's revenge on those who do not throw their weight around readily for love. He likes the flagrant speech and bodies that risk endorsing him and his mother.

Russell imagines a younger man than he is, who is attracted to me, being forceful in bed. This younger man, less than half my age, tells me that my erotic scholarship and proclivities intrigue him.

I like hard fucking as well as other kinds of pressures in my cunt. Pleasure comes, too, through the sometimes voluntary effort, sometimes involuntary effect, of vaginally gripping the cock I'm loving.

Grip, squeeze, grasp, embrace, hold on to: I imagine that this younger man would know as well as Russell that a cunt cannot simply receive and be pleased and that he wouldn't need to be a fighter-phallus-knife.

(When we were fucking, a lover would say, with a frequency that made me unable to let the phrase pass, "Split you open." He could not stop saying it. I gave people reasons for my leaving him, but I didn't mention this erotic neutralizer; perhaps I have just let it surface as a contributing cause. I like to spread my legs, so wide that I feel as though I could embrace the cosmos, but I will not be split.)

Aphrodite and Ares were caught *in flagrante delicto* by her husband Hephaestus, who had forged a net that trapped the lovers, making a spectacle of them to the other deities.

My husband is in love with another woman at the same time that he is in love with me. (Rossetti and Jane Morris were in love with each other. She was married to William Morris, a good friend of Rossetti's. At the same time, he was in love with Elizabeth Siddall, whom he married.)

Unlike Hephaestus, I have not punished my spouse's love for an erotic consort other than myself. Pain wounds my equilibrium and casts me into prolonged anxiety of which I am most often not conscious, but I haven't needed to punish or mock them. Deliberate cruelty deteriorates the body of love and weakens one's ability to throw one's weight around.

In July the sun scorches the lawn, and we paint the exterior of our house light peach. In autumn I bring in dried yarrow from our garden and arrange it in a transparent glass vase. I put the vase on the bathroom windowsill. The yarrow stalks are long, and the amber flowers complement, in an exceptionally satisfying way, the low, round, orange vases on either side of the glass holding them. When sunlight shines through the orange vases, their fluted edges turn tangerine, and their plump bottoms, decorated with burnt sienna foliage, glow apricot. Russell rarely comments on flowers I've brought into the house, but he exclaims about the yarrow, "It's beautiful."

We kiss in the kitchen at the sink, he fucks me in the hallway, I sit him on the bedroom chair and kneel to suck him off until he comes.

Eight years into each other's bodies, we are caught up in the acts of eros, which give me this dream:

> Russell and I are in our four-wheel-drive pickup truck in the mountains. The terrain grows steeper, the weather wintry, and the road narrow and icy. Soon we're on a cliff above a canyon at whose bottom I see an iced-over river. The road disappears and we lean left, toward the canyon, intending to touch ground and find a road on the other side. Moving together in this act of love, I am not afraid.

Aphrodite's system of intercorporeality (density of human copresence, time as ripeness) increases erotic community.

Misunderstood as solely man's companion, Aphrodite is all touches, and she is all fingerings that test the textures of skins and psyches.

She is satisfaction, not simply the yearnings of incomplete connections. From autoerotic flamboyance to communal eros, she knows but does not evaluate the difference between brutal and poignant honesty.

A sob sister teaching in a creamy voice, her lessons in supreme sentimentalism demand students' return to eros, no matter what damage they have inflicted on others or have had inflicted on themselves. Aphrodite sleeps and cries with the best and worst of us, for she is the infrangibility of pleasure.

My mother sits on the family room couch and I am lying beside her, my head in her lap. She strokes my hair or rests a hand on my shoulder.

Where surfaces meet, the erotic may exist and love may begin.

We speak a little now and then but make no conversation, whose words would interfere with sound, which is one essence of our touch. I feel Mom's diaphragm swelling and compressing: she vibrates through the back of my head into my brain and permeates the mind that is all of my body. Knowing that she lives in me, I think about my having lived before birth in her.

I am any age up to forty-two, when Mom could no longer love me comfortably in that position on the couch because her arthritic back pained her too much. Her lap and little thighs, her many aphroditean embraces have led me to love sex and my body's sensuousness, to find erotic ease with girls and women, and to seek community with both.

The mother's body is a problematic foundation for erotic feminist community. While feminists have written about the mother from a range of perspectives that present her as sexually vital to maternally caring to

archetypally omnipotent, the extremes of high theory and lived, unwritten experience prevail in my own assessment of where contemporary women and feminists locate the mother.[6] Very few of my friends or students have spoken of having ease with their mothers' bodies. Perhaps this is such an intimate topic that it remains unspoken, certainly in a classroom or a professor's office, and even between closest friends.

Julia Kristeva's *Powers of Horror*, translated into English in 1982, has greatly influenced 1990s feminist theorizing of the body.[7] Here the mother(-to-be) epitomizes abjectness: she enlarges, looks swollen, produces afterbirth, lactates, and shrinks; she is beyond the bounds of even normal female flesh and bleeding; she is breakdown, dissolution, ooze, and magnificent grossness. The mother is perfectly grotesque, a psychic monument to the queasy slipperiness that is the liminal reality of human embodiment, and she represents the chaos that culture has made natural to the female body and the feminine.

The abject mother is an imaginary figure, but as such she assumes an iconic presence that women may use against themselves. Similarly, they carry around the unfriendly facts or atmosphere between their own and their mothers' bodies. Both the abject mother and women's histories with the maternal body provide an undismissible psychological reality; but such misery, rejection, isolation, and repulsion, which excite intergenerational corporeal warfare, do not inspire a woman to love the mother, or the old(er) woman, as a means to making the world whole.

Rebelling against the mother's body, a woman may become a feminist. To atone for the spiritual impropriety of having lived within a female body and then, after the escape of birth, having to live *as* a female body in a male-dominated and often misogynist culture, a woman excommunicates herself from mother eros. At-one-ment, a purposive feminist yearning to make the world whole, cannot occur through antipathetic separation from the mother, who is a primary root of eros.

Mother as a primary root of eros: this is one of Kahn's main points in *Bearing Meaning*. Published in 1995, the book contains no discussion of or even reference to *Powers of Horror*, perhaps because Kahn argues that the maternal body is sensuous and relational—I would say "aphroditean," in its richly connective meaning and reality—and thus neither abject nor horrific. *Bearing Meaning* is a historical study, a theoretical discussion, and a personal narrative centering on pregnancy, childbirth, and lactation. Informed foundationally by Kahn's relationship with her son

Levin—from her pregnancy into his adulthood—the work offers a welcome, important, and beautiful antidote to the model of the abject maternal body. Kahn grounds her model in "a language of sexuality as well as maternity, since the two are fused. Learning such a language may teach an erotic system outside patriarchal constructs."[8]

Among the Olympians, the mother-child alliance is feared by the male gods as a threat.[9]

> *Son, come sleep with me (Language of love)*
> *My touch will not engulf you*
> *Daughter, come sleep with me (Language of love)*
> *Our embrace will rock one another into an easy sleep*

Kahn celebrates "touch and other unworded forms of communication" based in the reality and the model of the erotic mother.[10] Countering negative perceptions of children and parents sharing a bed, including the "overly sexualized" Freudian treatment of child development, she suggests that sensual bodily touch between mothers and infants/children is essential to adults' erotic well-being.[11] When the language of birth is a language of touch, mother and child form a partnership—a notion that draws on the partnership model of relationship developed by Riane Eisler in *The Chalice and the Blade*.[12] Both Kahn's and Eisler's formulations create an aphroditean intercorporeality. Bodily consciousness, from cellular to intellectual levels, grows from what Kahn calls an "economy of plenty" grounded in "access to the maternal body."[13]

Mother, you gave me plenty
You warmed my body, all of me from cell to soul,
We did not have to learn our way into each other's hearts.

You are a monster of the deep, having helped my organs to work in erotic accord with one another. You are a beauty who has given me access to red lips, scarlet women, and a mind on fire.

So, I groom you now. You place one hand then the other on my thigh, and I file your nails. I pluck the hairs from your chin, circle you, turn this way and that in order to see them—some are almost invisible—in different lights. We begin to make faces at one another. We know we're silly, and eros shapes our shared knowledge of absurdity into laughter.

I grant that the mother's body may be perceived as the ultimate monster: in abjection, she is the cultural deformity of Freud's reality princi-

ple overwhelming the pleasure principle. Natural aspects of birth, such as blood, sweat, and excrement, have been abjectified, and Kahn presents other ways in which the mother's body may appear to be a monster's: it shapeshifts—the belly grows larger in pregnancy; breasts fill with milk; the body returns to its usual shape—and, in labor, the mother's body exerts, in Frederick Leboyer's words, "monstrous unremitting pressure that is crushing the baby . . . the mother! The monster drives the baby lower still."[14] For the sake of civilization, man designates woman as monster so that he can be human. The abject mother holds disruptive authority: monster-woman turns the tables on female power as the standard purified beauty of body-as-stasis. Mother-monster functions like carnival, when low becomes high. Queen for a day. But this monster's disruptions do not become permanent social or psychic change, for civilization resists her transgressive beauties by burying the mother's erotic body in the ugliness that operates as the necessary correlate to normative beauty.

Repulsion can entail erotic attraction. Kristeva writes about "this erotic cult of the abject," in which "devotees" yearn for "a coming face to face with an unnamable otherness—the solid rock of jouissance." Mother, the feminine, is this unnamable and unforgivable paradise, a dystopia/utopia that is "desirable and terrifying, nourishing and murderous, fascinating and abject."[15] In her book *Voluptuous Yearnings*, theorist Mary Caputi names the abject mother obscene and argues that obscenity has a rightful and necessary cultural function: to provide a way into "continuous" states, known in sexual, aesthetic, and spiritual activity.[16]

I am the "obscenity" of eros

Despite the "worship" of mother-monster, civilization's denigration of mother/feminine/obscenity/other puts women in a poignantly ironic relationship to the mother that is differently troubled from that of men. Kahn maintains that books on child development rarely affirm the mother-child bond; we live under the assumption, criticized by Kahn and feminist psychoanalyst Jessica Benjamin, that separation from the mother establishes human identity. This is the gist of prevailing psychoanalytical narratives that add to the patriarchal tradition of stories in which the mother-child bond is broken, labeling that break "traumatic." However, Kahn suggests that "many things taken for granted in child development could be the result of Western feeding and nurturing patterns, including the most cherished notion: the ineluctable trauma of separation from the

mother of infancy."[17] This trauma seriously represses eros. The son must separate in order to become, ultimately, a man. In that process he kills the monster—well enough, at any rate, to not identify with her, to be able to turn woman into a monstrously enticing sexual spectacle. The daughter also separates, yet she shares the monster's body.

Eros repressed creates a repellent mother, and the repressed returns in the damaged daughter who identifies with the grotesque mother and must reject that body in order to succeed as a woman. The satisfactory female does not openly and pleasurably eroticize the mother's body, for that is socially unacceptable. In aphroditean practice, erotic relation is wanting to be with and wanting to be like in a connection whose over-arching motivation is a pleasure on which aversion does not impinge.

Aphrodite, sublimated to death by the realpolitik of gendered principles and sexed disorders

Just as Laura Mulvey's ideas about a male gaze came, through her groundbreaking "Visual Pleasure and Narrative Cinema" and writings based on it,[18] to permeate feminist academic and art world thinking during most of the 1980s, so Kristeva's discussion of abjection spread in the 1990s. Abjection, reproduced in feminist theory and internalized as truth, especially when mixed with personal mother-daughter history in a woman's mind that is all of her body, devastates female erotic agency no less than the male gaze. Mulvey's male gaze universalized the spectator into a masculine subject that fixed the female body as passive sex object. Culture, which is not under the sole purview of men but is also consti-tuted by Kristeva, other feminist theorists, and our women friends, lovers, and kin, has socialized women to believe in their own abjection. The reality principle, which civilizes human chaos-as-eros into orderly productivity, debases erotic productivity; it denies Aphrodite's discipline of pleasure.

Aphrodite, mother of Eros

Aphrodite: mother is erotic icon

Between forty and forty-five, when I was looking through the family photographs as I do every several years, a black-and-white picture of my mother that I had not seen before stopped me for minutes. Florence in the forest naked, beautiful as a nude. She might have been in her early thirties but was probably younger, and she leaped several feet off the ground, as lithe and soaring as a male ballet dancer. I wondered why this erotic image was now part of the collection and where it had come from, and imagined that for decades it had been forgotten in the pages of a

book bought by Mom or Dad when they were young. Found and loved, the picture demanded its place in the family's visual history. What most astounded me about my discovery was my mother's grace, which I then realized was a basis of her actual aphroditean presence. Her grace socialized me in eros, and her body is one reason why I enjoy the sheer sensuousness of walking through air, the flexibility of my shoulder joints and mobility of my hips, the loci and contingencies of motion's breadth and balance.

Aphrodite has heard, too many times, these words of so-called reason: to aestheticize and eroticize the mother is sublimation.

Aphrodite says, Happy mothers baking apple pies and holding angel babies is a sublimation.

Erotic friendship with one's body makes possible erotic movement with other people's bodies, which means other people's lives.

Women are often unfriendly with their own and other women's bodies.

Friend, from Old English freond, *friend, love. For Indo-European base, see* FREE.[19]

An artist in her forties, known as a beauty for over two decades, blurted out, "Women hate me because I'm pretty." I loved her art, her intellect, her wit and beauty, but she was also egotistical and bitter, and I was sure that those qualities drew the dislike that she attributed to her bodily charms.

Most often, young women make the mistake of overvaluing their bodies as fuckable items that men want and women covet. "Men only want to fuck me" is an unsophisticated statement, coming from erotic loneliness and bodily insecurity. The statement may feel like a question—"What's wrong with men?"—that could provide an opening for girl talk or feminist analysis with another woman, but the statement keeps women at an erotic distance from one another. "Men only want to fuck me" posits the speaker as ultrafuckable and suggests that the female listener is less attractive, less visible to men, and that competitiveness underlies the seeming desire for sympathy, commiseration, or problem solving. Eroticism encompasses the desire to fuck and to be fucked; but fuckability, so predicated on a youth and reproductivity model that elevates heterosexual relations, corrupts Aphrodite's system of intercorporeality, which makes women visible and touchable to one another.

A younger woman drives with me to the desert in my car. At dinner that sweet-smelling night we'd already begun to talk about a man whose body we

had both known sexually. In the desert we continued, and our stories about him turned to words of love for each other. We came together over his body, dead in comparison to our lust for each other's mouths—our talking till morning, when the coyotes would stop their cries.

Another artist, currently in her sixties, told me hurtful comments about her appearance made to her by feminist artists and critics she had known for years (discussed in a different context in chapter 1). She weight trains regularly and looks as though she's in her forties, and her erstwhile friends shocked her by suggesting that she was body-obsessed and wrong, as an older woman, to not be softer and less muscled, as they were. Assessed as attractive, according to the artist, by her supposed cohorts, she became an erotic threat and oddity. Bodily differences in firmness and size make some women uncomfortable, indeed envious, intimidated, and hostile, especially as they age. American society's construction of the postmenopausal body as generally antilibidinal can easily reduce an older woman's friendliness to her own and other women's bodies. Also, though freed of reproductivity, the older woman may nonetheless carry with her the archetypal mother's burden of erotic nonentity. The grandmother, identified and limited by age and sex and by their concomitant iconography, must not be an erotic icon, a position superficially indicated by appearance, because she would represent pleasure's residence, seductiveness, and communality in bodies that have not been modeled as receptive or attractive to men.

Astro Girl and Cleo ordered beers at the Vagabond Love Cafe's bar and walked through swinging doors to a spacious brick terrace. They sat on high-backed chairs at a round table under the dense blue desert sky. Trellises filled with bougainvillea and oleander climbed the walls. Astro Girl lit cigarette after cigarette. The smoke became a perfume floating quickly away in the clean air. As Cleo and Astro Girl talked, about work, women, men, love, and their own pasts and futures, the waitress came and went a number of times, collecting empty bottles and opening new ones. Cleo used the women's room at least twice, and they shifted their chairs to avoid the sun's severity as it, too, changed position.

Cleo said, "This is corny, but your perfume is intoxicating."

"It's like sweat and grapefruit," said Astro Girl. "I had Sylvie sample it out of the bottle in the store, and she said if I wore it I'd smell like I just got out of bed—from fucking. It's lewd and I love it."

*Cleo looked into Astro Girl's eyes, lavender in the brutal sun, until Astro
Girl was laughing. "My body is a fact, like perfume," said Astro Girl, "and I
enjoy feeling sexy." Cleo laughed too, but stopped sooner. She breathed
deeply and released each breath so that Astro Girl could hear its slow escape
rising, for her alone, over music, tinkling glass, a fountain's hypnotic voice,
and other patrons' crudeness and intimacies. Cleo stretched. She raised her
arms above her head and clasped her hands. Astro Girl watched Cleo's breasts
rise and noticed her triceps' tautness. Cleo lowered her arms, rested them on
the table, and her nipples hardened. Astro Girl stared, then gazing into Cleo's
eyes, she said, "You look great. Tight and supple."*

*Cleo said, "Thanks," and they drank slowly, talking as they each finished
another beer. "You're more of a romantic than you think you are."*

"Why's that?"

"Creating an image, provoking pleasure."

*Now and then Cleo noticed the rock music from inside the swinging doors,
and the water, rolling and dripping in a fountain at the center of the terrace.
During these moments the sounds themselves seemed lucid, as if aware of
their own presence, each tone of its own existence.*

*They turned away from the sun again and Astro Girl said, "I used to be
like a lizard, basking in the heat."*

*"You know one thing I love about the sun? I see red highlights in my hair
when I brush it. In the middle of the afternoon the light pours in the window
by the bathroom sink and mirror. I stroke my hair more slowly than usual and
hold it out to see the different colors sparkle."*

*The lipstick faded from Astro Girl's and Cleo's mouths. Customers arrived
and left. The walls were turning blush, then rosy orange to mauve.*

*Using her hand like a brush, Astro Girl held out Cleo's hair, and Cleo
asked, "Did you know that Astro, Star, comes from a word meaning desire?"*

*"Misnomer. A nickname from long ago, before I ever thought about the
difference between pleasure and desire, about how desire—I want you, can I
have you?—is the means to no end. Keep satisfaction at bay, so you always
have to hunt and pine. But we are pleasure, not desire."*

*"Two friends getting high and having a good talk and prolonging the fact
of pleasure."*[20]

Women friends' flesh is connective tissue, a dynamic substance that while
independent is not absolutely singular. When Robbie Kahn asks, "How
can adults in the United States, deprived of maternal touch, satisfy unmet

longings?" one of her answers is through women's love of women.[21] Through flesh, voice, and mutual looking, women friends can eroticize the world in which they live, which is the microcosm of their own energy field as well as the whole world beyond the proximity of the face to face. Alphonso Lingis writes, in reference to Gilles Deleuze and Félix Guattari's *Anti-Oedipus,* that "sexual desire is invested in whole environments, in vibrations and fluxes of all kinds; it is essentially nomadic."[22] Eros, as I elaborate it, is not limited to sexual desire—directed from one person to another and focused on genitalia—but it *is* nomadic. Eros wanders from body to body to body to body, but it stops at primitive nexuses of uneasy pleasure—chemical reactions in which the synthesis of bodies falters. All reaction is relation, but not all relation is erotic.

> *Overflow, undercurrent, roundabout—*
> *Abundance becomes inhibition.*
> *Blockage causes breakage.*
> *Fixed positions forget the drift of eros*

In a performance art class that I taught, a twenty-year-old woman invited many women from young to old to her piece. Her intention was to honor each woman by creating a community that resonated with archetypal weight and individuals' particular beauties. Maiden, Mother, Crone: the performer designated each of us by one of these names and then, in a short sentence or two, addressed each person's value to the performer. As she was leaving, one of the honorees, who was in her early fifties, asked me, then in my mid-forties, "Why were you a Maiden and I was a Crone?" Since that time, she has never helped me professionally, though there have been times when her assistance could have altered circumstances whose tenor and outcome meant much to me. A while after the performance, she began a sentence about her inability to help me with "No matter how fond I am of you . . ." Archetypal difference sunk in as erotic difference, with Maiden figuring as have and Crone as have-not. Fond farewell to the real Aphrodite, remembered falsely as only young and only sex.

> *Aphrodite sings a sad, but fast-paced song:*
> *Movie Queen inspired lust*
> *Fell so deep bit the dust*
> *Tired of the game of sex*
> *Wandered in the wilderness*
>
> *Sex my goddess here today*
> *Who do you trust?*

Who do you trust?
Suicide Squad she's gone tomorrow
Sex my goddess crazy sorrow

Let healing happen before you're dead, says Aphrodite.

Kahn maintains that "any act of healing is a return to the mother's body" and that "all significant touch . . . is a return to the maternal body."[23] One can touch oneself. This may be masturbation. Other kinds of self-touch are equally erotic. For example, aphroditean building of the body of love includes strengthening the physical body and increasing its flexibility. Aphrodite persuades those who love her into amazonian training. *She says, Physical discipline is the erotic practice of endurance, flexibility, resistance, and extension. The Amazon is neither muscle-bound nor warmongering nor mythic corpse; she is the woman who lifts, bends, breathes hard, and sweats for the pleasure of friendship with her own and other bodies.* In earnest amazonian training, the body's interior parts touch one another differently than in their regular usage and workings. Yoga squeezes, stretches, massages viscera. Bodybuilding, movements performed with resistance that works the body beyond its normal capacity, causes tiny muscular tears. Adaptation is regenerative. Healing creates growth.

Mary and I looked forward to each trip to the gym. We'd gossip as we stretched before working out with weights—separately, but within the touch of occasional talk and mutual, concentrated effort. Mary and I went to the gym regularly during the year we lived in the same town, and our activity solidified our friendship, which remains strong now, close to twenty years later. Mary and I still talk gym and body, for they belong to her and my erotic community, which reaches into other gyms and bodies in amazonian solidarity.

I, Aphrodite, move in solidarity with you, my daughters and my sons. We are not a misalliance, like the words in "mama's boy."
 Son, I am not your dominatrix, swallowing your cock so that no one else can ever see it, so that no one else can ever know that you're a man.
 Daughter, do not pitch your fuckability against me. It is not that you will lose this erotic competition, but rather that your erotic charms will desert you in your anger at my age, which you consider erotic impotence.
 Sons and daughters, we are most potent whenever we see farther than our own skin. The surface is important: I love knowing your birthmarks and scars.

Yet only when we know something of each other's flesh, bone, and blood do we lie down with the law of love.

In May 1995 I met Laurie Fierstein, whose aphroditean discipline changed me. That May she worked with me in the gym, as a trainer and as the bodybuilder that she is, and I have grown stronger in unaccountable ways because of her. Laurie has loved and strengthened many women by organizing *Celebration* and *Evolution F:* she could see farther than her own skin to reshape perception, which enables the monstrously large feminist aim of reshaping the world.

But a bodybuilder who felt out of shape said to me, "I've lost my friend, my body." I read her despair as an erotic falling out or away from herself. Autoerotic breakage is a continuing violence and nuance of feminist embodiment and community.

One woman
Decides to love like a bitch

Two women
Wear a perfume labeled Bandit

Five women
Gather forces once severed from their longing

Eight women
Eat preserves of reddest cherries in the morning after

Thirteen women
Sanctify their love with kisses

Twenty-one women
Call each other honeybunch across a crowded room

Thirty-four women
Scale a canyon in the sun

Fifty-five women
Linger as they squeeze each other's muscles

Eighty-nine women
Grow older than the mountains

One hundred forty-four women
Scarlet to the core sing a torch song

Two hundred thirty-three women
Stop sleepwalking

Three hundred seventy-seven women
Dream that Paradise is love of their own sex

Six hundred ten women
Kiss with open lips on city sidewalks

Nine hundred eighty-seven women
Fly across The Flatlands upside down

Fifteen hundred ninety-seven women
Say my sisters train with sisters

Twenty-five hundred eighty-four women
Excite each others' mounds and hollows

Forty-one hundred eighty-one women
Cruising from the islands to the heartland are
Adding ammunition to the Amazon Brigade

NOTES

This chapter is an expansion of "Building the Body of Love," in *Expanding Circles: Women, Art, and Community,* ed. Betty Ann Brown (New York: Midmarch Arts Press, 1996), 134–42.

1. Paul Friedrich, "Sex/Sensuousness and Maternity/Motherliness," in *The Meaning of Aphrodite* (Chicago: University of Chicago Press, 1978), 181–91; Robbie Pfeufer Kahn, *Bearing Meaning: The Language of Birth* (Urbana: University of Illinois Press, 1995). Kahn deals with sexuality and maternity throughout her book; on orgasm and labor, see 210, 229–30, 240, 281, 339. See Friedrich, 184–85, for a listing of behaviors shared in childbirth and sexual arousal. In chapter 8 I turn to Friedrich's discussion of the fear of the maternal/sexual archetype, including incest, in order to develop the stepmother as a pedagogical model.

2. Charles Baudelaire is quoted in Herbert Marcuse, *Eros and Civilization: A Philosophical Inquiry into Freud* (Boston: Beacon Press, 1966), 153.

3. One of the primary points that I develop in my dissertation, "The Rossetti Woman" (Ph.D. diss., University of Chicago, 1981), is that Rossetti's paintings of women are a kind of self-portrait.

4. Yukio Mishima, *Sun and Steel*, trans. John Bester (Tokyo: Kodansha International, 1970), 88, 97.

5. K. S. Malevich, *The World as Non-objectivity: Unpublished Writings, 1922–25*, ed. Troels Andersen and Edmund T. Little, trans. Xenia Glowacki Prus (Copenhagen: Borgen, 1976), 3:350.

6. Joan Nestle's "My Mother Liked to Fuck," in *A Restricted Country* (Ithaca, N.Y.: Firebrand Books, 1987), 120–22, is, to my knowledge, the only account given by a feminist about her mother's love of sex. Sara Ruddick, *Maternal Thinking: Toward a Politics of Peace* (Boston: Beacon Press, 1989), discusses the characteristics and value of maternal attentiveness. Many feminists have written about the Great Goddess, or Triple Goddess, one of whose phases is the Mother. Interestingly, in "My Mother Liked to Fuck," Nestle removes her mother from "sacred" status, writing, "My mother . . . was not a matriarchal goddess" and "My mother was not a goddess, not a matriarchal figure who looms over my life bigbellied with womyn rituals" (120, 122).

7. Julia Kristeva, *Powers of Horror: An Essay on Abjection*, trans. Leon S. Roudiez (New York: Columbia University Press, 1982). Feminist art historians, critics, and theorists who discuss this work include Joan Kelly, "Models of Painting Practice: Too Much Body?" in *New Feminist Art Criticism: Critical Strategies*, ed. Katy Deepwell (Manchester: Manchester University Press, 1995), 155; Lynda Nead, *The Female Nude: Art, Obscenity, and Sexuality* (London: Routledge, 1992), 31–33; Francette Pacteau, *The Symptom of Beauty* (Cambridge, Mass.: Harvard University Press, 1994), 129–31. Painter and critic Mira Schor cites *Powers of Horror* in the bibliography of her *Wet: On Painting, Feminism, and Art Culture* (Durham, N.C.: Duke University Press, 1997). In a book of essays on art-historical terminology and method that may be used for some years as a text in both undergraduate and graduate courses, *Powers of Horror* is cited as one of three "significant feminist rereadings of [Oedipal] fetishism"; see William Pietz, "Fetishism," in *Critical Terms for Art History*, ed. Robert S. Nelson and Richard Shiff (Chicago: University of Chicago Press, 1996), 206. In the catalog for an exhibition organized by Helena Rubinstein Fellows Jésus Fuenmayor, Kate Haug, and Frazer Ward in the 1991–92 Whitney Museum Independent Study Program, the abject is treated at length in Ward's essay, where the "Abjection and Art" section constitutes one-third of the text: see Frazer Ward, "Foreign and Familiar Bodies," in *Dirt and Domesticity: Constructions of the Feminine*, exhib. cat. (New York: Whitney Museum of American Art, 1992), 8–37. Abjection figures prominently in "The Monstrous Feminine," a theme issue of *Massage* (http://www.nomadnet.org/massage), ed. Mary Jo Aagerstoun. Published on October 30, 1999, "The Monstrous Feminine" features discussions about the work of contemporary artists.

Two influential feminist discussions of *Powers of Horror* in contexts outside art are Judith Butler, *Gender Trouble: Feminism and the Subversion of Identity*

(New York: Routledge, 1990), 133–34, and Elizabeth Grosz, *Volatile Bodies: Toward a Corporeal Feminism* (Bloomington: Indiana University Press, 1994), 81, 192–95. A fascinating and generally enlightened recent anthology of essays on menopause includes a chapter indebted to *Powers of Horror;* see Wendy Rogers, "Sources of Abjection in Western Responses to Menopause," in *Reinterpreting Menopause: Cultural and Philosophical Issues,* ed. Paul A. Komesaroff, Philipa Rothfield, and Jeanne Daly (New York: Routledge, 1997), 225–38, esp. 226–29, 234–36. References to *Powers of Horror* also appear in the book's introduction (3–14) and in another selection, Mia Campioni, "Revolting Women: Women in Revolt" (77–99).

8. Kahn, *Bearing Meaning*, 370.

9. Kahn's discussion of Hesiod's *Theogony* (ibid., 154–61) confirms this claim.

10. Ibid., 95.

11. Ibid., 362, 365.

12. Riane Eisler, *The Chalice and the Blade: Our History, Our Future* (San Francisco: Harper and Row, 1987).

13. Kahn, *Bearing Meaning*, 99–100. On several occasions in the book, Kahn notes the cellular connection between her and her son.

14. Frederick Leboyer, a doctor well known for being a proponent of childbirth without violence, is quoted in ibid., 251. Kahn also quotes from the 1984 edition of the Boston Women's Health Book Collective's *New Our Bodies, Ourselves:* "As one nurse-midwife said, regretfully, 'The most natural aspects of birth— sexuality, blood, sweat, shit, movement and sounds—have no place here,' " in the hospital (336).

15. Kristeva, *Powers of Horror,* 54–55, 59.

16. Mary Caputi, *Voluptuous Yearnings: A Feminist Theory of the Obscene* (London: Rowman and Littlefield, 1994).

17. Kahn, *Bearing Meaning*, 384. See also Jessica Benjamin, *The Bonds of Love: Psychoanalysis, Feminism, and the Problem of Domination* (New York: Pantheon, 1988).

18. Laura Mulvey, "Visual Pleasure and Narrative Cinema," *Screen* 16, no. 3 (autumn 1975): 6–18.

19. *Webster's New World Dictionary of American English,* 3d college ed., s.v. "friend."

20. Excerpt from Joanna Frueh, "Desert City" (unpublished novel, 1988).

21. Kahn, *Bearing Meaning*, 362.

22. Alphonso Lingis, *Libido: The French Existential Theories* (Bloomington: Indiana University Press, 1985), 90.

23. Kahn, *Bearing Meaning*, 376, 385.

Pleasure AND PEDAGOGY

Four
———

THE PROFESSOR'S BODY

The place of the professor's body in pedagogical relationships in which
sexual harassment of a student by a professor is not the issue remains an
unconsidered, ignored, or seemingly forbidden subject for critical analy-
sis. In today's heated, sometimes paranoid, and even rancorous public
and private dialogues about sexual harassment in academia, speaking as a
professor about professors or students as erotic bodies is risky; it is
nearly impossible for heterosexual men, who—because they are the
prime agents in the sexual harassment epidemic and the prime heroes in
the romantic myth of professor-lothario—are likely to be perceived as
silly, sexist, dangerous, or patronizing advocates of student-teacher sex.[1]
Even Jane Gallop, who speaks from the security and privilege of a distin-
guished professorship in English and comparative literature at the Uni-
versity of Wisconsin at Milwaukee, can be seen as self-indulgent or full
of herself and faulted for sensationalism when she discloses, in *Feminist
Accused of Sexual Harassment* (1997), that sex with professors as a gradu-
ate student, sex with students as a young professor, and more recent sex-
ually charged attractions between her and graduate students have
enabled or increased her feeling desirable as a woman, have flattered and
excited her.[2] Sex talk, let alone sex acts, are easily misunderstood and

differently interpreted by participants as well as by outsiders, as a shocked Gallop discovered when two female graduate students filed sexual harassment charges against her in 1992.[3]

I enter the taboo terrain of pedagogical erotics, specifically the territory of the professor's body, for several reasons. I want to better understand the taboo, which separates student from teacher and mind from body, which perpetuates the notion that professors must perform and represent a supremely clean life of the mind, and which suggests academics' distrust of pedagogical authority operating through bodily authority, through an erotic style that manifests in the seeming superficiality of physical appearance. Deeply erotic professorial styles, which are diverse and which do not affect all students similarly, disturb the peace of institutional impersonality. The professor's erotic body, a kind of disorderly conduct, is a welcome personalization of education.

I enter taboo terrain also to clarify my own experiences as a student and a teacher and to theorize from them by constructing a new teacher-student model, that of stepmother-stepchild. I fell for professors whose bodies and minds erotically impressed themselves on my body and mind, found their way into both with or without my speaking of my attraction. While students have rarely told me directly that they are attracted to me, throughout my career students have commented about my body and bodily style to myself and to others. I'm particularly interested in the comments, the responses, of younger students to an older woman in regard to modeling that intergenerational relationship. My experiences are common, for attractions between teachers and students are common, and I'd like the commonality of my experiences and their theoretical outcome to bring about discussions concerning older women professors who embody the authority of eros and knowledge.

Sitting here, not quite knowing what to think of the excessive and unfamiliar feelings/thoughts invading my mind, my being. This train has been running down this track for so long that it has ceased to be a train. . . . So much has happened outside of this specific track that the track itself has become nothing more than an instinctual function, much like breathing. The scenery, so to speak, has done more than completely change itself. The surroundings are more foreign now than ever before. The only thing I know is this track, and, in reality, even the track is foreign. The one constant is art, and art shall remain exactly that, a constant. Operations as an "artist" have changed (like all else) with the scenery, becoming this, becoming that. At one time I was an art

student. I'm not sure when the student left, but the contextual operation within the realms of this track that I know so well is nothing like what it started out to be. It confuses me, the role of art. It confuses me, the role of the artist. . . . Someone I know is finally getting the representation she deserves on the scale that is directly proportional to the magnitude of her person. . . . It is precisely this friend who encourages me to push forwards, to stay on the track and make the track my own. To transform and manipulate the track to travel whichever direction necessary. To never lose touch with the beauty of the aesthetic, the beauty of creation. She has shown me that one does not have to lose what it is that completes the picture in order to realize the self. She is art. She is aesthetic beauty. Art shall never disappear, it is the engine that pulls the train, it is the track on which it travels. . . . To realize and to know the supremacy of the self in relation to all that surrounds the self. . . . I don't rightly know how to express how fortunate I feel to have met someone and made what I feel to be (without a doubt) an extremely meaningful and unbelievably unique friend-ship. I get a little teary thinking about such things, truly meaningful relation-ships are somewhat few and far between. I apologize if this response is not quite as structured or formal as a response to a question should be, however I feel it to be quite fitting.

A twenty-four-year-old male student, the stepson, a graduating senior who had taken two art history courses with me, wrote the above in response to the final exam question for an independent study that he took with me when I was forty-eight. (I do not name him because we are out of touch and it would embarrass him.) The question was *Discuss any issue that is of personal and intellectual concern to you. Frame your discussion on the assumption that this issue is aesthetic, whether it obviously seems to be that or not.* I quoted most of the student's response, which moved, scared, pleased, and excited me. In his response, I am the friend about whom he writes.

In the Platonic erotics of the *Phaedrus* and the *Symposium,* the noble lover, the master, guides the younger male in a pursuit of beauty, a shared seeking for truth. Platonic pedagogical erotics, a partnership of man and boy, calls for transcendence of bodily desire in order to embrace wisdom. In that relation a reversal of normalized seduction occurs: the younger desires and pursues the older. As Foucault observes, the beauti-ful young men courted by many "are in the position of *erastes* [usually the older suitor], and he [Socrates], the old man with the ugly body, is in

the position of *eromenos* [usually the younger object of love]."[4] Throughout this section of my book I will address the pedagogical relationships between older—desirable—professorial bodies and younger student bodies, focusing on the older woman professor and both female and male students in their twenties.

The older male teacher has been the standard model of erotic and intellectual authority. He is Socrates. He was my professor of nineteenth-century poetry when I was a graduate student, a man who said he wrote in recommendations for me that I did not stand for cant; a man who, as I sat down in his office wearing a tan sheepskin jacket, red lipstick, knee-length leather boots, and a camel-colored turban, said I reminded him of Sacher-Masoch's *Venus in Furs;* a man whom I seduced, despite his reluctance—he liked my friend, the long-haired blonde with the less aggressive, more Rossetti-woman beauty, better; a man I slept with once unpleasurably; a man whose book on Swinburne I loved because it departed from standard academic prose and format.

The older male teaches man to man and man to woman. He is the figure who conveys knowledge through sex, the transmitter in Foucault's characterization of ancient Greek pedagogy and the University of Massachusetts at Amherst professor William Kerrigan, who helps young women students mature by being their first lover. Foucault: "In Greece, truth and sex were linked, in the form of pedagogy, by the transmission of a precious knowledge from one body to another; sex served as a medium of initiations into learning." Kerrigan: "I have been the subject of advances from male and female students for twenty-five years. . . . And there is a particular kind of student I have responded to . . . who was working through something that only a professor could help her with. I'm talking about a female student who, for one reason or another, has unnaturally prolonged her virginity. . . . There have been times when this virginity has been presented to me as something that I . . . can handle—a thing whose preciousness I realize."[5]

Precious knowledge, precious virginity: the male teacher's intellect and body are metaphoric and mythic treasures that gain entry into the desirable innocence of student minds and bodies. I could be sarcastic about those treasures, for society can understand that smart men are sexy but promulgates the notion of smart women as prim, frigid, or castrating.[6] I can read Kerrigan's precious male knowledge penetrating his stu-

dents' precious virginity as the current offspring of a professorial geneal-
ogy whose egocentricity and pretentiousness are as ludicrous as *Feminist
Accused of Sexual Harassment* appears to Roger Kimball, the *New Crite-
rion*'s managing editor.[7] But Gallop is not a joke: regardless of what read-
ers think and feel about Gallop's sex acts and sex talk in academia or how
they interpret her tone in terms of her own desirability, only the mean-
spirited would fail to grant that Gallop is fighting for an understanding of
women's simultaneous embodiment of eros, authority, and knowledge.
In *Feminist Accused of Sexual Harassment*, the second half of her dedica-
tion, to her daughter, is moving: "And for Ruby, / hoping she will grow
up to a world / where smart, powerful women are widely / held to be
sexy." Underlying mean-spirited critiques such as Kimball's is perhaps
umbrage at Gallop's audacity to state with utter certainty that she, a
woman academic, is brilliant and sexy.

The student who in his exam calls me friend and responds to me as
influential and beautiful, whom I moved through a variety of pedagogi-
cal vehicles, including my body, understood that an older woman can be
powerful, smart, and attractive.

Stepson, do not betray, once again, your amorous stepmother.

The stepmother teaches woman-to-woman and woman-to-man. She is
an amorous, attractive, maligned, and monstrous figure. I redesign her in
chapter 8 as a model of pleasure.

Quadrille by Balenciaga. When I wear perfume, that is the one.
 *I step out of the shower, dry my body, then wrap the towel around the top
of my head to dry my hair. I smooth eye cream all around my eyes and mois-
turizer into my face, throat, and neck, front and back, massage a buttery yel-
low body cream into my skin from chest and shoulders to toes. I put on a white
terry-cloth robe, lean forward from my waist, comb my hair with my fingers,
stand up and throw my head back, look in the mirror and brush my hair off
my face. I make a middle part with my right index finger then comb down my
bangs.*
 *Coffee rich with half-and-half and talk with Russell are the next pleasures.
Then I eat oatmeal with butter and maple syrup, sometimes scrambled eggs
and toast, or if I wake up especially early, apple-cheese muffins that I make
from scratch. After eating and before I dress, I scent myself with Quadrille,*

from a one-quarter ounce bottle of deco design. The stopper grazes the skin between my breasts, at my wrists and inner elbows, behind my knees, at the inside of my ankles, and touches my pubic hair.

I leave home by 8:15 A.M. for my 9:00 class. Whenever I am walking around the classroom handing back exams or papers and I am wearing perfume, I wonder if the students smell it, if they are aware that they are smelling me. I am very aware of fragrances enveloping students' bodies. In my late teens or early twenties I read that job seekers should never wear perfume to interviews because the interviewer might detest the scent chosen by the interviewee. Perfume could make a bad impression, could contribute to not being hired. Often I feel self-conscious walking around the 9:00 A.M. class freshly perfumed. Perhaps I'm experiencing interview anxiety: will I perform competently, let alone brilliantly? will I deserve to return?[8] *Quadrille increases my anxiety and excitement, my pleasure.*

Within pedagogical theory, the specificity of professors' bodies is all but unexplored, and neither in that theoretical arena nor in critical studies devoted to the midlife female body does anyone discuss the older woman professor's body, let alone specific ways in which one enjoys being that body or being with it.[9] Academics write only minimally—and rarely— about their own professorial bodies or the bodies of their professors.[10] Literature dealing with sexual harassment on campus is replete with mostly implicit references to male professors' bodies. A touch or a body part may be mentioned.[11] That feminist women are professors and that implications, possibilities, and difficulties follow embodiment as a female professor are at the heart of feminist pedagogical theory. Yet the detailed realities of teaching in a woman's body and of its effects on students remain unwritten. Ironically, the professor's body is a foundational negative condition, whether sexed primarily male—in sexual harassment discussions—or as a universalized female whose unique flesh, voice, laughter, movements, scent, and style have disappeared. Sex colors the first picture, sexlessness the second; and erotic lack joins the two in an absence of pleasure.

Though Gallop and the dialogue between bell hooks and Ron Scapp discussed below are exceptions to the no-body-no-pleasure norm, bodily details do not appear in their accounts. *Feminist Accused of Sexual Harassment* presents the genesis of Gallop's pleasure in learning as an undergraduate, which feeds into her pleasure in educating. Both plea-

sures are bodily. She describes her exhilarated and accelerated learning at the beginning of the 1970s, a "double transformation" she credits to feminism, when she "came into a sense of my sexual power, of my sexuality as drive and energy. In that very same year I became an active, engaged student committed to knowing as much and as well as possible."[12] As I read Gallop's book I imagine a passionate woman dancing, talking, fucking, teaching, but she omits any sensuous specificity about her body and the bodies of her professors (as well as those of her students). I miss the sight of her—suits, hair, jewelry, the volume of her voice and body, the creation she makes of herself, the feel of her. For it is the desirable feel of her that simultaneously attracts and intimidates her students, that is a taproot of her teaching. That Gallop's statements about relating personally to her students, which belong to feminist teaching tradition, turn on the erotic indicates the bodily basis and dynamics of her pedagogy: "I had engaged in personal relations with students—that is to say I had relation to them . . . *as people*. As a pro-sex feminist, I had assumed that involved recognizing—and when pedagogically useful, commenting upon—the sexual as part of the relation between people. By 'sexual' here, I do not of course mean sex acts but rather the erotic dynamics which intertwine with other aspects of human interaction."[13] I miss observing Gallop in her own words or her students' or colleagues'.[14]

In bell hooks's *Teaching to Transgress*, which is full of pleasures about educating, the professor's body as a sensuously specific physical reality appears only briefly in one chapter, a dialogue between her and her friend and fellow teacher Ron Scapp. hooks speaks about being acutely aware of her embodiment as a black woman, a particular historical and cultural subject. She remembers an alcoholic professor of hers who, "stumbling around drunk," gave "the same lecture he gave last week." The image is striking, the professor's body a lasting impression. His students did not intervene, and for hooks he exemplifies "ways we see the body, the 'self' of the professor" as an authority who cannot be disrupted by students.[15] Scapp understands that a professor's sensuous bodiliness is integral to teaching. He says, "When you leave the podium and walk around, suddenly the way you smell, the way you move become very apparent to your students. Also, you bring with you a certain kind of potential, though not guaranteed, for a certain kind of face-to-face relationship and respect."[16] hooks makes clear that a professor's acknowledgment and use of her embodiment, especially its difference from the

white male norm, "deconstruct the way power has been traditionally orchestrated in the classroom, denying subjectivity to some groups and according it to others."[17] And her story presents a powerfully negative instance of professorial bodily authority. Scapp's face-to-face image, like that of hooks's alcoholic instructor, resonates with a sensuous charge. Yet neither hooks nor Scapp grounds the sensuousness in detail—a hairstyle, an article of clothing, a color; a professor's facial expression, posture, or quality of voice—and explains how one or all shaped words into ideas. Sensuous specificities contribute to the compelling pleasure of a professor's erotic body. My belief that pleasure is a basis of education motivates me to explore the taboo terrain of pedagogical erotics.

SEPARATIONS: STUDENT FROM TEACHER

In the overwritten story riddled with contradictions that establishes professorial power, the professor's body is untouchable. It represents an intellectual authority that students must respect by keeping physical and verbal distance from the professor's flesh. To trespass corporeally is to mistake a mind for a human being and to initiate, even if slight and tentative, a leveling of the power discrepancy.

At an art exhibition opening in the art department in which I work, three undergraduate women students in their twenties and I are talking. I've worked with all of them in at least two classes. One of the students begins to boast about the hardness of her muscles and she flexes a biceps for all of us to feel. The other two flex and we all feel. I flex and no one feels.

At the same opening another undergraduate in her twenties, who is so unrestrained verbally and emotionally that she often causes listeners discomfort, says to me, "You look pretty sexy." The use of the modifier is unlike the speaker, so later that evening I ask her why she said *pretty*. She answers that she thought she would offend me otherwise, and she fears she has offended me anyway. I allay her fear.

I am thirty-five and Erik is twenty-two. I do not recall whether, at the time of the bit of conversation I will relate, he and I have yet become lovers in a romantic relationship. I say to him that male students rarely come into my office to talk with me, which gives me pain, that he is an exception. Erik says, "There are eighteen guys in the class and they all want to fuck you." Clearly

*that is an exaggeration, a statement of Erik's desire, but it shocks me. It is
entirely unexpected. He adds, "They know they don't stand a chance," to
which I respond, "True." According to Erik, they are protecting their pride
and masculinity. I ask why he took the risk, and he says something like,
"Because you're interesting."*

Erotic—and sexual—attractions between students and professors are so
much a forbidden habit, with or without consensual relations policies,
that often neither teachers nor students question their behavior of keep-
ing verbal, emotional, or physical distance. When I and the independent
study student mentioned at the beginning of this chapter talked about
sleeping together he said that he could not imagine the reality: "It would
be like sleeping with a movie star."[18] I read that more as a metaphor of
distance, tremendous inaccessibility, than as a statement about my bodily
beauty. I did not delve into the student's words with him, but the fact that
consensual erotics had not further closed a power discrepancy between
us hurt me.

Naive, idealistic, radical: the motivation for pursuing consensual
erotics rests in my being all three.

Teachers distance themselves from students as readily and unknow-
ingly as students do from teachers. hooks was naive about her hostility to
a student to whom she was attracted during her first semester of college
teaching.

> I received a call from a school therapist who wanted to speak with me
> about the way I treated this student in the class. The therapist told me
> that the students [*sic*] had said I was unusually gruff, rude, and down-
> right mean when I related to him. I did not know exactly who the stu-
> dent was, could not put a face or body with his name, but later when
> he identified himself in class, I realized that I was erotically drawn to
> this student. And that my naive way of coping with feelings in the
> classroom that I had been taught never to have was to deflect (hence
> my harsh treatment of him), repress, and deny.

hooks then became "conscious . . . about ways such repression and denial
could lead to the 'wounding' of students."[19]

*Before the stepson called me "aesthetic beauty," I had heard from trustworthy
people that he was attracted to me. I subsequently became attracted to him and
wished our erotic interest to be spoken openly to one another. Hidden attrac-*

tions fester; such repressions become toxic wounds. The parties overly romanticize or mystify one another. To state one's erotic attraction to the person who is its object gives a relation greater consequence. Erotic relations are relations of consequence, and that is one reason they are of educational value. The stepson denied his attraction to me, then admitted it. When I asked why he had denied his feeling, he responded, "Deflection." When I told him I was attracted to him he said he felt relieved.

Poison released, for a while. Breathing easier, at first. Stagnancy gone until relational movement, our particular trajectory of pleasure, stopped altogether. Sometimes I push when I should observe.

Perhaps it was the day I said I was attracted that I asked, as the stepson was leaving my office, if I could hug him. We hugged and would always do so from then on when parting.

Your solidity and warmth eased deep within me, your soft cheek, scratchy with a few days' beard growth, firmed with a smile as I kissed it, and I felt you give yourself to eros.

Rarely have students initiated touch with me, and I have only done so with them after delicate emotional negotiations in which mutual comfort or desire has been established either verbally or gradually and implicitly over months. Sometimes I initiate touch when a student is crying in my office over a scholastic or emotional trauma. Wanted touch nurtures the erotic, and teaching the whole student includes teaching the student's body—which may mean touching it in erotic affirmation of a student's academic or personal success, in erotic sympathy with her failure or achievement, in erotic celebration of learning, in a combination of sexual and intellectual affinity. Gallop says that in her experience of teacher-student sex, as both a student and a teacher, the student always "made the first move . . . initiated sexual activity."[20] First moves are very hard to pin down, because first moves are not obvious, such as asking someone to sleep with you. Seduction in consensual erotics is often slow, realized over months. Looking back, one sees numerous moves of initiation—sprint, shuffle, pirouette, flex. Moves of seduction request or demand cooperative moves: a professor's idea in class invites a student's look that invites a few words from her or the professor at the end of class that ask to be a conversation and a touch on each other's shoulder over coffee in a few weeks.

SEPARATIONS: BODY FROM MIND

Consensual erotics is a seduction that lessens teachers' alienation from their own bodies just as it lessens bodily separation between teacher and student. Madeleine Grumet, an important voice in feminist pedagogy theory, says, "We have burdened the teaching profession with contradictions and betrayals that have alienated teachers from our own experience, from our bodies, our memories, our dreams, from each other."[21] Grumet's "we" are women educators who practice in public schools, yet her words apply to university and college teachers. The impersonation of mind betrays body, and professors contradict—speak against—their bodies when they insist on having a good body, by which I mean a well-behaved body.[22] Current academic insistence on a well-behaved body, at all levels, reinforces a history of teachers' bodily self-erasure, which hooks sees as a legacy not only of "our professorial elders, who have been usually white and male," but also of the "predominantly black college." hooks equates body with passion and feeling, which undergo "repression and denial" in the classroom. Body is also physiology, such as menopausal and everyday sweating, menstruation, excretion. hooks writes, "When I first became a teacher and needed to use the restroom in the middle of class, I had no clue as to what my elders did in such situations. . . . What did one do with the body in the classroom?"[23] Forget and pretend. But that, of course, is impossible. The teacher's body is not a corpse, and live bodies make their needs known.

Having a good body demands that professors be pure of heart, purely mind, purified and ultimately purged of body. The heart is a muscle that lives in the body, so location alone might indicate the heart's impurity. Also, the heart is a libidinous organ, strengthened by erotic pleasure. Purge the heart of its physical location and its corporeality and you have the ethereal yet cruel ecstasy of pure-hearted professors who represent a supremely clean life of the mind. Impersonating mind is particularly problematic and acute for the female professor. Age, which one hopes will bring ease if not certainty, does not alleviate her bodily, academic dilemma. Instead, exacerbation of difficulties may occur.

Helen was talking in general about professional situations. She said, "Sometimes you have to wear a bra."

. . .

I tried to discuss women professors' bodily expressiveness and attractiveness with a female colleague. We touched on fashion, diversity of female faculty's dress, and toned, even muscular bodies. She said, "You can wear what you want, but you can't be sexy." I saw this statement as a significant inconsistency in the diverse style hypothesis and, if true, as an aesthetic absence in academia. My colleague added, in reference to a former professor at our university who was a midlife bodybuilder when she left, "Bodybuilders are fanatics."

A student told me of a midlife male professor, about whose teaching she was enthusiastic, who touched his crotch more than occasionally during class. She thought this was odd, an idiosyncrasy, but neither provocative nor menacing. Such a gesture, which could be interpreted as sexual, from a normatively professional man—plain-looking, older, heterosexual—can be neutralized by students. Because the male body in higher education remains the stable sign of teacher and thinker, a male professor's oddities of gesture and attire are taken as part of a lack of body consciousness that students as well as colleagues let pass: the teacher is so utterly engaged in intellectual activity that he is pure mind—which is expected, for a professor is naturally absentminded about his body. Paradoxically, the white, heterosexual male professor's sex and gender neuter his body, so he is free (or at least freer than a woman professor) to make what for her would be seen not only as an outrageous but also very likely an inflammatory, highly discomfiting gesture. Because body partakes of speech and speech partakes of body, he may also draw less untoward attention than would a female professor were he to set forth a provocative theory or show sexually explicit contemporary art. Because the normative male professor is clothed in the safety of his sex and some version of its typical masculine costume, he remains understood by students as mind.

Muscle signifies masculinity, so to a male colleague insecure and possessive about his virility, the muscled female professor may be encroaching on his territory. To a feminist female colleague, the muscled woman professor may represent male surrogacy. To students or faculty, the midlife muscled woman might seem overly devoted to body discipline. Such devotion conflicts with the idea that professors must discipline themselves as mind only and with the idea, still too prevalent despite baby boomers' interest in self-care and fitness, that older women are not—which means should not be—unmatronly. The muscle "fanatic" is the phallic woman as loose cannon, untrustworthy to women and to men, who may use her power of representing the supposedly transcendental

signifier—the phallus—to benefit or inhibit both her own sex and feminism.

The professorial body overly developed through body discipline, as manifestation of extreme self-devotion, may indicate the presence and operation of monster/beauty. Some may perceive too much body in an academic as an overwhelming or cancellation of mind, as betraying a narcissism that is inappropriate to professorial bodily denial and that is negative. Narcissism, which is Narcissus's discipline, can be self-contemplation as training in monster/beauty. Intellectual material pursued erotically leads one to self-contemplation, not as some kind of reductive navel-gazing but rather as a point of connection between oneself and the world of both ideas and action. Erotic engagement in ideas means acting with, for, and against them by putting them into practice or revising or discarding them. Training in monster/beauty means regarding yourself erotically, aesthetically, not as an end point but with a look of love arising from aphrodisiac capacity. I use *aphrodisiac* here to mean a complex of broadly erotic pleasures, and I use *narcissism* to mean a technology of the self that can become arrogant self-indulgence but is at best audacious belief in the erotic embrace of self-disclosure that is unavoidable as soul-and-mind-inseparable-from-body.

My colleague was partially correct when she said that women professors may dress as they wish but not be sexy. The sexy calls attention to body, which should be invisible. hooks says, "Trying to remember the bodies of my professors, I find myself unable to recall them. I hear voices, remember fragmented details, but very few whole bodies," none of which she chooses to describe.[24] My undergraduate art history professor Carol Duncan has remained lucidly in my soul-and-mind-inseparable-from-body, for I consented to hers joining with mine, becoming mine. If, like Carol, one is brilliant and attractive, which might be called sexy, then in our culture one is probably very visible, a position that carries risks for a female professor. She is supposed to be invisible, just as men are, in order to be professional. Miss Mentor (Emily Toth), the Miss Manners for academic women, advises readers who wish to succeed to blend in or look unremarkable; to wear nothing that reveals the body's shape, nothing noticeably stylish; to be blandly elegant.[25] Because woman has been culturally identified and defined as body and thus in this regard been made more visible than man, in the classroom a woman professor will be obviously visibly different from a man professor; the designated sexy

woman is even more obviously visibly different, not only from him but also from her female colleagues who have learned to reduce their bodily difference in order to be taken seriously.

In the 1990s a new dynamic came into play, as sexiness was fore-grounded as requisite to academic publicity if not success. In "The Star System in Literary Studies" in the January 1997 *PMLA*, David R. Shumway situates famous scholars Jacques Derrida, Judith Butler, and Stanley Fish by examining the history of nineteenth-century theater, film studio publicity, and the changing terms of academic success in the twentieth century. He cites several recent trends: the power of glamorous portraits, the demand for stars to appear at conferences, the stars' mobility and authority, the "expanded role of gossip" and the highlighting of the personal in published work, and the fashioning of a persona in oral presentations.[26] These characteristics overlap with those familiar from a more general or Hollywood type of stardom, as specified by Budd Schulberg: "self-love, vivacity, style, and sexual promise."[27] Yet, in both cases, the model of sexiness constituted is likely to be only superficially erotic. *Sexy* is an overused term, often applying to glitter rather than to the substance of erotic richness.

Sexy elevates and denigrates the female academic and teacher. While sexiness determines to some extent the degree, kind, and extent of her success, measured today in academia too often as it is in more public professions by celebrity, sexiness also contaminates her. Gallop is a perfect example. Her legendary flaunting of her own body at academic conferences, her sexual teaching style, and her flamboyant—for academia— treatment of sexual material in her scholarship have readily designated her sexy and scandalous.[28] The celebrity professor becomes body, has not only a name but also an identifiable face and body through photographs. The celebrity sexy professor, who must also be brilliant and a productive publishing scholar, functions as one model of extreme academic success for younger professors. It is a precarious model for women in a world that still has trouble understanding that a woman can simultaneously be smart and be bodily self-aware and self-possessed. Remember Gallop's dedication to her daughter, "hoping she will grow up to a world / where smart, powerful woman are widely / held to be sexy." Though Gallop and I use *sexy* differently, I read in her words a lament I share.

Woman's body is seen and felt to undermine female intellectual authority. Kathryn Pauly Morgan wrote in 1987 that "in many circles, the exercise of female rational authority is still often felt, if not thought, to

be a contradiction, a kind of metaphysical impropriety."[29] More funda-
mentally, the exercise of such authority is a physical impropriety, for
body contaminates thought. Body literally stands—sits, moves, farts—in
the way of knowledge. Jo Anne Pagano, a feminist theorist in education,
writes that

> the body persists [in the classroom]. It seems in the way. It seems in
> the way of communion. The body stands as a barrier to the meeting
> of the minds. The body imperfectly reflects our beautiful thoughts.
> The body betrays. . . . Because of the body's indurateness we can
> speak only metaphorically and know inferentially. Knowledge is a
> substitute for its own incompleteness. It is a substitute for its own
> original loss and its own unnameable desire [in both cases, of the
> mother]. The figurative position, though, is an impossible one for the
> . . . teacher . . . who would take up her position as female also. To
> stand just there, she must exclude herself, for her body will insist on
> resembling that of the first disappeared object—the maternal body.[30]

The tabooed body, the tabooed desire, the first human object of desire,
the first erotic object: body par excellence, ad infinitum, without mind—
the female body.

Woman's physical and metaphysical improprieties, felt by some
women as readily as by some men, have cost women both others' under-
standing and their own self-exploration of soul-and-mind-inseparable-
from-body pleasures. As Morgan says, "In extremely regressive circles,"
some women's "comfortable exercise of various forms of authority and
power often costs them their public womanhood as they become labelled
'masculine.' "[31] That is, fear of women as soul-and-mind-inseparable-
from-body leads to female professors' disembodiment, which can make
them into surrogates of white heterosexual males. When a woman pro-
fessor disembodies herself—neuters her body through dress, gesture,
depersonalized teaching—she may reproduce the academic institution's,
the academic fathers', desire that she conform to a normative masculine
pedagogical style. Otherwise she jeopardizes her seriousness, for the
female body professing may be a joke. It hyperbolizes the separation of
mind and body, and of course not only does father know but father
knows best.[32]

Female professors impersonating the male as mind undergo assimila-
tion. Pagano suggests resisting its pull, not succumbing to "the tempta-
tion to be *like* those in control[,] . . . by asserting our connection to our

students, our colleagues, to the everyday."[33] She does not specify using the body, but because the body grounds the most daily connections, she would probably agree that in asserting connection with their bodies women work against assimilation. Covering up the body for assimilation, literally not showing its life, proceeds from self-surveillance—from watching oneself in the knowledge that others are watching and judging. In order to not be a danger to herself, her students, and the institution of higher learning, the female professor may deny or severely reduce the ways in which being a woman's body is public spectacle.

The female body is many private parts—glands, organs, muscles—spectacularized for public consumption and evaluation. A woman's body becomes a kind of public property. Feminist theorists have understood women's self-surveillance primarily as society's demand that women be beautiful, a demand that sends them on a search for beauty—being a body and maintaining its beautiful appearance. To be a mind, however, the female professor may self-surveil to determine ways to obscure her body, to maintain her privacy. Professorial erotics often partakes of spectacle—the flamboyant gesture, such as swinging a leg onto a desktop, lying on the raised floor in front of a lecture hall, or good-naturedly "strangling" a student to awaken more productive conversation as one circles a seminar; the decorative jolt, such as a dandyish suit, a huge rhinestone brooch, or fuschia lipstick. Asserting bodily privacy, pride, and pleasure for a female professor can be a struggle against bodily shame.

"Sometimes you have to wear a bra." Even when I do, my erect nipples show. When, braed or braless, I become aware of this during class, I often become aware at the same time that I'm slouching. "How long," I wonder, "have I been slouching?" curious if the time coincides with my nipple erections. Slouching is erotic and aesthetic lassitude: my body has embarrassed me. I tell myself to stand straight. I assert my living body, my erotic authority.

Clothed but braless breasts are signs of a sexed female body; and clothed yet visible nipples in public, in professional situations, are scandalous. Loose breasts, loose woman, loose scholarship instead of the academically sanctified rigorous thinking; femaleness as the intimate and intimidating sloppiness evident in menstruation, lactation, vaginal lubrication during sexual arousal. Erect nipples indicate erotic excitement, which must not be a professional spectacle. The professor's body must not make the erotic visible.

Nipples, over whose stiffness a female professor has as little or less control than a male professor does over his self-touch—indeed, she cannot control nipple erections—are academic eccentricities. Female breasts deviate from the standard, and they not only signify, they *are* female sexual presence in the classroom. The sexed and designated sexy female body endangers the stability of the male model—especially when that female body is charged by anatomical and expressive markers of femininity, such as loose breasts, erect nipples, a short skirt, stylish hair, makeup, or abundant or unusually designed jewelry.

Carol Duncan wrote, in an essay first published in 1973, about the nonrenewal of her contract at Sarah Lawrence College, where she began teaching in 1969: "I was charged with 'overemphasizing the social aspects of art history' at the expense of 'art appreciation.' "[34] This was part of her brilliance—to make history real by not prettifying it. Recently when I was talking with Carol she mentioned her firing and added that she had not been only intellectually incorrect. "I didn't wear a bra," she said, sure that her appearance had contributed to the personnel committee's negative evaluation of her. Carol also made the female body real and not nice by eroticizing it. She was a radical departure from what have become acceptable female faculty models of dress: matron, blue-jeaned student double, ethnic-inspired hippie, and serious-suited professional.

Carol was a spectacle in control of her mind. Formidable but not uninviting, female professors who are actively soul-and-mind-inseparable-from-body present the double whammy that resonates beyond a woman's suspect blend of brilliance of mind and brilliance of style. The latter may be called beauty. In an interview about beauty and danger, art critic Dave Hickey says that artists "always find themselves operating in opposition to the deep, puritanical, iconoclastic tradition of American Protestantism—which is grounded in The Word."[35] Beauty antagonizes The Word, gives the lie to it, endangers it. We are back with Pagano's classroom in which "knowledge is a substitute for its own incompleteness." The coupling of word—trained intellect—and female bodily assertion with style—beauty—unhinges a narrative and an iconography of professors' stylistic, sartorial puritanism, the good body as a decent one.

Before addressing ways in which decency informs the body taboo in pedagogical erotics, I want to think about the institutionalized though most often silent enforcement of a female professor's separating mind from body as a kind of sexual harassment. The Institution of Academia,

an abstraction, oversees all within the system of higher education. This disciplinary power guides the academy's ideals as well as administrators' and faculty members' spoken and unspoken judgments of one another's excellences and defects.

"You were too uterine," says a former colleague about why my teaching style had offended a male faculty member at her school, from which I had resigned a few years before our conversation. The man had told me I was a "rebel" and "misguided" as I sat in his office listening to his rationale for voting against my reappointment as assistant professor. Ultimately my department voted to reappoint me, and I took a leave of absence to teach at another school and then resigned when that one-year position was offered to me as tenure track. Perhaps my male colleague did believe that the body misguides the mind.

Linda Brodkey and Michelle Fine interpret women students' solutions to sexual harassment by male professors as attempts to repudiate their own bodies. In written narratives the students "struggle to represent themselves as genderless."[36] In order to continue working despite being "unable to imagine institutional change," the women "default to reworking relationships with faculty, or, even more consequentially, to reworking or denying their bodies." Such denial requires them to separate body from mind: "the narrative positions women assign themselves suggest that they understand their own survival to depend on the ability to cleave their minds from their bodies."[37] Cleaving is violence: to slice, sever, split, ax. Feeling that she must cleave herself from herself, cleave body from mind and divest body of so much apparently dangerous, sexy, or erotic female substance that she puts body aside, into a private and unspectacularized safety: this is the result of sexual harassment.

Carol's sense of the personnel committee's response to her incorrect because braless appearance and my being told of my problematic because uterine teaching may be, despite their apparent tenuousness, more visible than are the usual enforcements of the Institution of Academia's power to discriminate against women faculty by creating a "hostile" environment toward their bodies. Note that the Institution of Academia suggests that the female body—asserted in appearance or pedagogy—creates an "offensive" learning situation, offensive because of its "intimidating" assumption by a woman of her power as soul-and-mind-inseparable-from-body. (In campus sexual harassment policies, creating a hostile environment or an offensive learning situation can lead to harassment

charges.) The Institution of Academia undermines female professors by insinuating that their erotic souls-and-minds-inseparable-from-bodies are harassing spectacles.

DECENCY AND THE BAD BODY

Whether woman or man, a teacher must be decent. *Decent* is related to the Latin *docere,* "to teach." The common belief that teaching is moral supervision descends from nineteenth-century educational ideology, still influencing not only elementary but also higher education.

Harass: to trouble, worry, or torment, as with cares, . . . repeated questions.

Sanction: to cleave body from mind.

The academy implicitly, continuously questions the female professor's body. Her body is a question to the academy posed of many cares and questions as well as pleasures. The model teacher must be polite, and it is polite to downplay the body, to refine its intimate, sexual, vulnerable signs into an authority of civility, into a transcendent mind never in danger of being too much: too attractive, too funny, too big, too smelly, too bosomy, too prosaic, too human. Model decency for the teacher is a perfect operation of mind over matter. Regulation, management, and cruel discipline are the names of the game that professorial bodies must try to play, for professorial body management translates into classroom management. The behaved and silent body creates a behaved and silent classroom where the radiating asceticism of vocalized intellect, information, and ideas can lodge in the brains—of student bodies that have absorbed the lesson of being supremely clean. Teacher as surrogate parent cannot be sexual in the student's-child's eyes but must teach, through bodily muffling, a kind of sexual hygiene in the classroom.

Mother-teacher: a feminist model for women's studies professors
Doktor-Vater: *a German name for the thesis advisor*
Graduate students complain of infantilization by their professors or school. One of my colleagues persists in calling our department's students, all undergraduates, many in their thirties through fifties, "the kids." Gallop writes about students' transference with their professors.

In her article on Gallop's sexual harassment case in *Lingua Franca,* author Margaret Talbot suggests, "Better for an academic to err in the

direction of a selfless, sexless schoolmarm" than to expose her erotic pas-
sions.[38] These passions are always indecorous because they are in part
bodily and because they do not exist within what Billie Wright Dziech
and Linda Weiner call, in *The Lecherous Professor,* "the sexually uptight
environment of academe": the misbehaving erotic body does not con-
form to "some grand commitment [by academe] to the image of the
scholar as dignified ascetic."[39] The misbehaving or bad body troubles the
Institution of Academia's sense of the teacher's moral authority, for the
bad body, in its erotic viability, often incites visual and sometimes sexual
pleasure, and pleasure is not a priority in higher education.[40]

In the classroom, the bad body may be an uncomfortable eyeful. It
can be any race, size, age, or sexual orientation. The bad body may be
the good body of popular parlance, but not necessarily. It is not the
"beauty," a misnomer used to fool people into believing that some
women are born gorgeous, most are not, and the luck of birth runs out
with age: she was once a beauty. The "beauty" is trompe l'oeil, an effect
and experience produced through style, whereas the bad body is styled in
the heresy of eros. It does not simply display good taste or skill at the
feminized task of self-decoration, of dress and undress. Erotic aptitude
and deliberateness enable some female professors to take aesthetic license
with themselves. License turns licentious when the body loosens itself
from the regulated and regulatory status of moral supervision. The point
of style is to break rules.

The bad body is thought to break rules, but being a bad body does not
make one a bad girl. When I say that Carol was not nice, I do not mean
that she was the bad body gone bad girl. To many art world and aca-
demic ears, "bad girl" rings as transgressive.[41] Gallop has herself taken
on this title and identity. But the name is too limited to express the jolting
potential of the erotic female body. In the art world, as in popular cul-
ture, the bad girl is good, what one might want to be in order to get
noticed. Goodness neutralizes or at least ameliorates badness, as does
society's trivializing the bad girl into a naughty *succès de scandale.* Mon-
ster/beauty's rhetorical punch dissolves in the infantilizing of the femi-
nine. Hickey has said that "those terms 'bad boy' and 'bad girl' are pure,
parental institution-speak."[42] Agreed; but *bad girl* connotes merely
naughtiness, the erotic woman reduced to a disobedient or mischievous
child or to a saucy icon displaying sexy underwear. Also, *bad boy* has a
grownup form, *bad man,* which oozes mythic Western glamour: the des-

perado is bold, not impertinent. The bad girl is simply, even pathetically, desperate—to be taken seriously.

Perhaps being taken seriously is a hindrance to transgressiveness and radicalness, because women would then be authorities and not disrupters. But the good girl/bad girl opposition is frustrating because of the all-too-familiar mother and whore division: pit women against women and construe them more as woman than as anything else.

Some may argue that the sexed, erotic female body in the classroom spotlights the woman more than the professor, as does the mother-teacher, significant in feminist pedagogical theory and practice, whose informality, nurturance of students, and reciprocity counter the patriar-chal father-instructor's insertions of information into student recepta-cles. The female professor who chooses to be a "woman" by being maternal or (and) by styling herself sexy and feminine may treat—please—her students, for she is living proof that woman and professor are not oil and water. The bad body may be the good mother—safe, comforting—if the maternal breast and scandalous nipples unite in a sophisticated reality that does not cling to "mother's" breast and "whore's" nipples as blisses of differing orders.[43] Elide the fantasy oppo-sitions of erotic female bodies so that the mother is not solely decorous and the whore not solely sexual shrewdness, change maternal and sexual availability to erotic self-possession: then the female professor does not have to suffer from either the politeness or damage that moral authority demands.

NOTES

1. Billie Wright Dziech and Linda Weiner's *Lecherous Professor: Sexual Harassment on Campus*, 2d ed. (Urbana: University of Illinois Press, 1990; first published in 1984), is the classic study of the problem of sexual harassment in academia. In the "Author's Note" Dziech discusses her and Weiner's original decision to emphasize "victimization of female students by male professors," which she calls the "epidemic form of sexual harassment" (xix). In chapter 1 the authors present the history of sexual harassment statistics and legislation from 1974 through the early 1980s, when sexual harassment became a visible public issue.

 In September 1993, *Harper's* published a roundtable, "New Rules about Sex on Campus," on student-teacher sex. It features five professors, including Wil-liam Kerrigan, identified by *Harper's* as a "professor of English and the director of the Program on Psychoanalytic Studies at the University of Massachusetts

(Amherst)." Kerrigan's defense of student-teacher sex, including his relations with women who entrust what he calls their "unnaturally prolonged . . . virginity" to his deflowering (36), could be considered an epitome of dangerous practice and advocacy. Larissa MacFarquhar, "Dankness Made Visible," *Lingua Franca*, November/December 1994, 6–7, declares that Kerrigan "got himself pilloried" for his position, and she offers up Barry M. Dank of the California State–Long Beach sociology department as another fool—one whose "weapons" are of the "variety, *sounds feminist but bears an uncanny resemblance to nasty old-boy conservatism*" (her emphasis).

2. Jane Gallop, *Feminist Accused of Sexual Harassment* (Durham, N.C.: Duke University Press, 1997). Roger Kimball, "The Distinguished Professor," *New Criterion* 15, no. 8 (April 1997): 21–25, is exceptionally derisive. He calls Gallop a "publicity-seeking feminist" and describes the book as "essentially a work of sexual exhibitionism," "subacademic sensationalistic trash," "deeply pathetic," "pure blithering nonsense," and "rubbish."

3. In *Feminist Accused of Sexual Harassment*, Gallop presents her version of the charges against her, defends consensual amorous relations, and discusses her amorous academic past and its relation to feminism. For an earlier treatment of her position, see Jane Gallop, "Feminism and Harassment Policy," *Academe*, September/October 1994, 16–23. Margaret Talbot, "A Most Dangerous Method," *Lingua Franca*, January/February 1994, 1, 24–40, considers the charges in the light of her interviews with Gallop and with Dana Beckelman, one of Gallop's accusers. In "Resisting Reasonableness," *Critical Inquiry* 25, no. 3 (spring 1999): 599–609, Gallop again defends consensual relations, arguing that "What consensual relations policy presumes to be a conflict *between* love and pedagogy is actually a conflict *within* pedagogy" (608, her emphasis). She wrote the essay in order to redress her own dissatisfaction with the response she gave when asked in the many interviews following publication of *Feminist Accused*, "But what about treating consensual relations as a conflict of interest?" (600).

4. Michel Foucault, *The History of Sexuality*, vol. 2, *The Use of Pleasure*, trans. Robert Hurley (New York: Vintage Books, 1990), 241.

5. Michel Foucault, *The History of Sexuality*, vol. 1, *An Introduction*, trans. Robert Hurley (New York: Vintage Books, 1990), 61; Kerrigan is quoted in "New Rules about Sex on Campus," 35–36.

6. A recent icon of the smart, sexy man was Henry Kissinger, a Harvard University professor who became secretary of state under Richard Nixon. Popular accounts of his amorous life thrilled to his dating sex bomb Jill St. John.

7. For Kimball's dismissal of *Feminist Accused of Sexual Harassment*, see note 2.

8. Even Wayne Booth, who won teaching awards at the University of Chicago and who is internationally known for his work in literary criticism and rhetoric, notes that he was a "very anxious kind of teacher" who, in autumn, would "start having dreams about not knowing anything, not knowing where the classroom is. All the teachers I consider to be first-class talk about having dreams and anxieties. . . . I've sometimes been so tired and so anxious about what's going to happen that I could hardly get out of bed. It's very hard work, very demanding and

you want to be at your best, to be the hero." Or, to smell good in your perfume. See "Style and Substance," interviews by Debra Shore, *University of Chicago Magazine*, June 1997, 28.

9. Two recent books that would seem to be likely sources for such discussions are Paul A. Komesaroff, Philipa Rothfield, and Jeanne Daly, eds., *Reinterpreting Menopause: Cultural and Philosophical Issues* (New York: Routledge, 1997), and Jane Gallop, ed., *Pedagogy: The Question of Impersonation* (Bloomington: Indiana University Press, 1995). Many of the essays in *Reinterpreting Menopause* consider the midlife female body in complex ways, and Gallop's own essay in *Pedagogy*, "The Teacher's Breasts" (79–89), implicitly deals with the older female professor's body in relation to that of a younger male student. Mary Ann Caws writes one brief and beautiful paragraph about the erotic vitality of the older woman professor; see "Instructive Energies," in *The Erotics of Instruction*, ed. Regina Barreca and Deborah Denenholz Morse (Hanover, N.H.: University Press of New England, 1997), 73. The visual skills and acuity of artists might give them special insight into the significance of the professor's body, yet in *New Observations*, no. 118 (spring 1998), guest-edited by artists and educators Lucio Pozzi and Bradley Rubenstein and devoted to teaching art, no one addresses the subject.

10. I consider several exceptions to the rule of silence about professors' bodies in chapter 6. Also, I have discussed the body of my undergraduate art history teacher, Carol Duncan, in "Fuck Theory," in *Erotic Faculties* (Berkeley: University of California Press, 1996), 44, and I write about her in chapters 5, 6, and 7 of this volume. Jane Gallop briefly describes and analyzes her "costume" for delivering a conference paper: "I wore spike heels, seamed hose, a fitted black forties dress and a large black hat. I was dressed as a woman, but as another woman. . . . I was in drag. My clothing drew attention to my body but at the same time stylized it, creating a stylized body"; see *Thinking through the Body* (New York: Columbia University Press, 1988), 92.

11. See Dziech and Weiner, *Lecherous Professor*, for numerous women students' accounts of being sexually harassed by male professors.

12. Gallop, *Feminist Accused*, 5.

13. Gallop, "Feminism and Harassment Policy," 23.

14. In chapter 6, I present Margaret Talbot's description of Gallop as well as the intimidated response of one of Gallop's students to his teacher's appearance.

15. bell hooks, *Teaching to Transgress: Education as the Practice of Freedom* (New York: Routledge, 1994), 160.

16. Ron Scapp in ibid., 138.

17. hooks, *Teaching to Transgress*, 139.

18. Earlier in my academic career, when I was teaching at Oberlin College in my early thirties, a young male student made a similar comment. To paraphrase him, I was as out of reach as Farrah Fawcett, who is about my age and was at that time a sex icon. The metaphor's recurrence to describe erotic distance between teacher and student suggests that other female professors have also heard it.

19. hooks, *Teaching to Transgress*, 192–93.

20. Gallop, *Feminist Accused*, 49.

21. Madeleine Grumet, *Bitter Milk: Women and Teaching* (Amherst: University of Massachusetts Press, 1988), 57.

22. The essays in Gallop, *Pedagogy*, argue that teaching is a performance of impersonation. Gallop's contribution, "The Teacher's Breasts," foregrounds the "bad-girl feminist teacher" (88), who stands in contrast to the woman teacher's "traditional 'good' femininity" (83): a "selfless, sexless nurturance" (83) that has become part of women's studies pedagogy.

23. hooks, *Teaching to Transgress*, 191–92.

24. Ibid., 192.

25. See Emily Toth, *Ms. Mentor's Impeccable Advice for Women in Academia* (Philadelphia: University of Pennsylvania Press, 1997), 46–48, 86–89, 107, 115, 120–24, 147, 172–73, for tips and cautions most pertinent to pleasure and pedagogy. A discussion considering variations on the same themes took place on the Women's Studies Listserv list (wmst-l@umdd.umd.edu) from August 4 to 26, 1998.

26. David R. Shumway, "The Star System in Litera ry Studies," *PMLA* 112, no. 1 (January 1997): 85–100.

27. Budd Schulberg, "What Price Glory?" *New Republic*, January 6 and 13, 1973, 27–31.

28. Courtney Leatherman, "A Prominent Feminist Theorist Recounts How She Faced Charges of Sex Harassment," *Chronicle of Higher Education*, March 7, 1997, A12, begins her article, "Jane Gallop is used to creating a spectacle. She's been causing a scene ever since she started wearing a skirt made of men's silk ties on the academic lecture circuit nearly 20 years ago. Legend had it that the skirt was made of the ties of her ex-lovers. The story wasn't true, but Ms. Gallop delighted in the myth."

29. Kathryn Pauly Morgan, "The Perils and Paradoxes of Feminist Pedagogy," *Resources for Feminist Research* 16 (1987): 50.

30. Jo Anne Pagano, *Exiles and Communities: Teaching in the Patriarchal Wilderness* (Albany: State University of New York Press, 1990), 79.

31. Morgan, "Perils and Paradoxes," 50.

32. I refer to the 1950s sitcom (of radio and then television) *Father Knows Best*.

33. Pagano, *Exiles and Communities*, 147.

34. Carol Duncan, "Teaching the Rich," in *The Aesthetics of Power: Essays in Critical Art History* (Cambridge: Cambridge University Press, 1993), 136 (first published in *New Ideas in Art Education*, ed. Gregory Battcock [New York: Dutton, 1973], 128–39).

35. Dave Hickey, "Gorgeous Politics, Dangerous Pleasure: An Interview with Dave Hickey," interview by Ann Wiens, *New Art Examiner* 21, no. 8 (April 1994): 17.

36. Linda Brodkey and Michelle Fine, "Presence of Mind in the Absence of Body," in *Postmodernism, Feminism, and Cultural Politics: Redrawing Educational Boundaries*, ed. Henry A. Giroux (Albany: State University of New York Press, 1991), 105.

37. Ibid., 113, 105.

38. Talbot, "Most Dangerous Method," 1. The complete sentence reads, "Better for an academic to err in the direction of a selfless, sexless schoolmarm than in that of a Miss Jean Brodie, triangulating her passions through the bodies of her girls."

39. Dziech and Weiner, *Lecherous Professor*, 57–58.

40. Jennifer M. Gore, *The Struggle for Pedagogies: Critical and Feminist Discourses as Regimes of Truth* (New York: Routledge, 1993), 123, critiques the tradition of teacher as moral authority.

41. Transgressiveness is both implicit and explicit in the U.S. catalog for the *Bad Girls* exhibitions that took place in 1993 and 1994 in New York, Los Angeles, and London. For example, Linda Goode Bryant's essay in *Bad Girls*, exhib. cat. (New York: New Museum of Contemporary Art; Cambridge, Mass.: MIT Press, 1994), is titled " 'All That She Wants': Transgressions, Appropriations, and Art" (96–108). Transgressiveness is also of the essence in Maud Lavin, "What's So Bad about 'Bad Girl' Art?" *Ms.*, March/April 1994, 80–83, which mentions these exhibitions and features artists Rachel Lachowicz, Coco Fusco, Janine Antoni, Nicole Eisenman, and Marlene McCarty. Antoni was in the New York exhibition; Eisenman, Lachowicz, and McCarty were in the Los Angeles exhibition. Corinne Robins, "Why We Need 'Bad Girls' Rather Than 'Good' Ones!" *M/E/A/N/I/N/G: Contemporary Art Issues*, no. 8 (1990): 43–48, critiqued a good girl feminism that she saw in Mary Kelly's 1990 *Interim* exhibition at the New Museum and posited it against the recent *Bad Girls* exhibition that she had curated. Robins defines art's bad girls as women "who wanted to be more, who wanted to be artists and makers rather than symbols and muses" (43)—who, in effect, transgressed assigned art world roles.

42. Hickey, "Gorgeous Politics," 14. The parental institution is the art museum.

43. In "The Teacher's Breasts" (87–88), Gallop distinguishes the symbolic, maternal *breast* of the good teacher from the sexual(ized) *breasts* of the bad teacher (my emphasis). Nipples are not part of her discussion.

Five

CONSENSUAL EROTICS

If pedagogy is an erotic process, then eros lives in the teacher's body. There the professor engages the student and the student engages knowledge. Mind and body perform as one in the presentation of classroom material and the facilitation of discussion, in the professor's words and gestures felt and read by a student during office hours or over an off-campus drink or coffee. The erotic is not exclusively or even necessarily sexual, nor is the professor's body a simple sex object. The erotic may include sexual desire and physical acts. Most important, it encompasses relations whose potency, unpredictability, and usefulness proceed from and create the capacity for individuals' intellectual, emotional, and spiritual transformation, which may activate social transformation.[1] The erotic reveals possibilities and makes possible. To believe that eroticism and pedagogy are distinct is as delusional as believing that body and mind are of unequal pedagogical impact, mind predominating over body. Teaching is a complex transfer of information in which more than only minds participate.

I learned avidly and erotically from Carol because she was an icon and reality of self-enjoyment. I loved the sensuous pleasures of visual art, and

Carol was a seductive and unthreatening model of aesthetic presence. She was a sex object existing, too, as an art object and, I felt, as the subject and agent of her erotic life, which included mind in body, body in mind. The art history classroom was a site of consensual eros embraced and facilitated by Carol, in her early thirties, with a luxury of black hair and red lips, a length of leg revealed by a miniskirt, pale skin emphasized by black fishnet stockings, a wide-eyed humor and lust for learning and exchange, a laugh so deep and luscious that it undulated into my mouth, down my throat, and around my cervix, uterus, spine, and vulva, an intellectual swagger that motivated the gesture of her entire body as she sat smoking a cigarette and lecturing on nineteenth-century art. Because of Carol's erotic verve and fearlessness, art history was an orgasmic experience.

Whenever people are in a room together, all of them come into play regardless of which parts of them are obviously being addressed: the emotions in a theater whose actors perform a tragedy, the appetite in a restaurant, sexual hunger in a porn show, acquisitiveness in a shopping mall, the mind in a classroom. In the last location, despite a teacher's and students' greater or lesser attentiveness to each other and to the intellectual material from day to day or course to course, and despite tremendous variation in professors' bodies—fascinating combinations of age, race, gender, sex, size, shape, posture, height, smell, gesture, clothing, voice—the desire for knowledge and the professor's desirability, residing partially but authoritatively in her body, coexist beneath a classroom's surface.[2]

The professor performs erotically with her students. Together in the classroom they are, at their best, erotic partners. That partnership is consensual erotics, whose process both in and outside the classroom and in personal relations between student and professor is a basis of pleasure in learning. Similarities and differences exist between consensual erotic and consensual sexual and amorous relations; sexual harassment policies often forbid the latter two between professors and students, who operate with unequal professional power. In this chapter I will be presenting consensual erotics against the realities of those sexual harassment policies, and I will be relating my own experiences with undergraduate students in their twenties.

"You teach erotically. Finally I found someone who teaches erotically and they're leaving." My student Dan said this to me during a break in

performance art class. At the beginning of class I'd announced that I had decided to leave teaching and was resigning from my position. Dan was barely twenty, gay, and of Latin heritage. He wore loose shirts and long shorts and regularly carried with him, to school and around town, a feminine purse (which I coveted) and a teddy bear. Dan was brilliant and beautifully imaginative, and I loved having him in performance art and in art history courses. The semester before my resignation, the performance art students had presented work publicly. Dan's *The Persistence of Ashes* focused on the relationship between the Holocaust and being gay. His piece was so moving that chills kept traveling though my body as I watched, and one of the studio art professors later told me that she was crying during the performance because of its impact on her.

If any other of my students had said to me what Dan did, I would have been equally caught off guard, for no one before had so explicitly commented to me about what I understood to be the sensuousness, bodiliness, and student relatedness of my teaching. It was 1983, and I'd begun teaching in 1977. I had not started doing so with a clear-cut pedagogical method or strategy that I had articulated to myself, nor had I developed such a method or strategy. I knew that my teaching came out of the second wave feminist understanding that the personal is political, which meant to me that the personal is also the intellectual, that the personal informed and even determined the intellectual. From my senior year in college, 1970, when I became a feminist, into the present, I have believed that scholarship and criticism—in general—grow out of the researcher's and writer's profoundly personal concerns, reflecting some combination of his or her psychological foundations and cultural identities. So, presenting lectures with formal, scholarly distance from the material has not been my modus operandi. A professor can be informed, acute, and respected, and simultaneously emotional, physically mobile, and loving. I have told many classes of mine, during the semester but especially at the end, how much I've enjoyed them—if I have—and in some classes I've said to the students as a group that I love them. The latter is never easy for me: I feel vulnerable, both emotionally and intellectually on the line, but I believe that withholding feelings of passionate affection does nothing to further students' self-confidence as intellectuals or as human beings. My statements of love and enjoyment come from the fact that teaching is a pleasure for me, and pleasure is a basis of learning. (Except, of course, those times when class chem-

istry or my own inadequacies in handling particular material or human dynamics create almost continual pain, frustration, and anxiety.)

Dan articulated to me my own pleasure—and his—a condition that I now call *consensual erotics*. Consensual erotics occurs in the classroom, and it becomes much more complex when a teacher and student form a personal relationship, regardless of who initiated it.

Russell asked me to dinner at the end of spring semester 1988. I'd be leaving town permanently, returning to a marriage in a distant city. I said, "Yes, you're interesting, I'll go." Russell had been a graduate student in my feminist art criticism seminar. Peggy, my friend and colleague, had told me about Russell before the semester began by saying, "There's a brilliant, beautiful graduate student who does performance. He did a piece for his M.F.A. review exhibition that was incredible." Russell had built a gallery-long wall of wood shards. He stripped from street clothes to tights and put on climbing shoes. Next he projected three slides of an inscrutable male face—it was a Chicago gangster—and climbed through them. Then he projected slides narrating a simply told story whose rich and heady images spoke at once of mystic and physical birth and of homosexual date rape. I was totally intrigued, even more so when Peggy said, "I wonder if he'll have the guts to take your class." He did. His final paper was stunning—elegantly written, intellectually astute, concise and lyrical. As I write this, almost nine years later and after seven years of marriage to him, I most remember, besides the overall qualities of his paper, its stories of morbidity and adventure, both childhood and familial.

Russell and I talked little outside of class, and always formally, so I was surprised when he asked me to dinner. Peggy said, "It's a date." I said, "No, it isn't." I was wrong.

Delicious bread and sweet butter. Slow glasses of merlot. Spring heat in the desert. So hot in the daytime that if you walk around outside for any length of time without a hat or water you'll feel dizzy.

One of the first things Russell did over dinner was to ask me the question, "Why do you teach?" No student had ever asked this before. I paused longer than usual in answering questions. I could only tell the truth, and it made me feel vulnerable, like telling a class that I love them. I said, "Because it's erotic. Because I love the students." His question and my short response precipitated a fascinating conversation, about teaching, about the erotic, of which I do not recall a word. But it was the first time I began to articulate a

connection between teaching and the erotic. And that beginning articulation
made me know that I wanted to write about the subject.

I was so luxuriously vulnerable, so astounded and excited by this man's
charm and utter lack of bullshit that I knew I was in a dangerous relation, a
quickly and profoundly erotic relation that he had initiated, which was part of
its special power for me.

That beginning articulation of teaching and the erotic took me and Russell
to the saguaros west of town, where I struggled to determine how consensually
erotic I wanted to be. (Technically, he was no longer my student, but the
teacher-student basis of our meeting and relationship lingered, and I won-
dered if a romantic or sexual involvement with him would interfere in the
future if he wanted or needed me to perform some professional task, such as
writing a letter of recommendation.)

Because Dan, whom I so admired and loved, told me I taught erotically, I
was exceptionally struck by the comment and curious about it; but I did
not begin to analyze its reality, in terms of myself and pedagogical the-
ory and practice, until 1988, at dinner with Russell—and I did not write
anything that focused exclusively on pedagogical erotics until I partici-
pated in the 1996 College Art Association conference session "Sexuality
and Pedagogy," which was chaired by Chris Reed.[3]

Teachers and students consent to the surprise, delight, and often diffi-
culty of information and ideas in action, information and ideas activated
by and often residing in the professor's body. Mutual attraction to think-
ing and learning together is mutual respect and responsibility for course
material and for pleasure. Classroom pleasure should not be confused
with having fun or being entertained, which, though they may be com-
ponents of learning pleasure, are not the basis of erotic relation. That
basis is the professor's body, which is the prime initiator and facilitator of
the erotic.

 bell hooks, calling as a professor for structural change in education,
charges, "We are invited to teach information as though it does not
emerge from our bodies."[4] As hooks understands, pedagogical disem-
bodiment ensues from the traditional assumption that bodies that
differ—in age, race, sex, gender—do not need, attempt, or appear to
present the same subject differently from one another.[5] An illogical belief
with no basis in observable reality seems to underlie this assumption:

teachers have the same body or no bodies, because the teaching body is universal. Indeed, many teachers act as though they have no bodies. They impersonate mind—intelligence or seat of consciousness.

He is a great mind.

He has a great body.

Mind is sexed male and overarches body, makes body disappear. Body is an attribute, something smaller than mind. Professors must be large of mind, for supposedly that is the source of their power.

The professor's erotic body is large, monstrously and beautifully radiating the energy of information and ideas—abstractions—and of thinking and learning—processes. Professorial monster/beauty is *thinking*—on her feet, through her eyes, in vocal tones and qualities that hold authority, reprimand, affection, and adventure. Monster/beauty is not motionless and militaristic, waiting for the command of mind (alone) to move her into predictable pedagogical positions—behind the podium or desk, in male lecture mode, which hears only itself and brooks no interruptions; she is at utmost attention, considerately ready to be moved by erotic necessity. Monster/beauty is attentive like a suitor, willing to be slow, to take her time, and she is on alert, quick as she can be.[6] Every monster/beauty is a far cry from the absurd politician-orator trained in image, cutting or jabbing the air in ineffectual assertiveness, as if he had to prove his physicality. But his physical movements rarely have a connection to his entire body, to his soul-and-mind-inseparable-from-body. His fake gestures are tactics, tacked on and consequently not erotic. In listening to most politicians speak, we experience the opposite of consensual erotics: no exchange, no unguardedness, no visceral touch—no movement of power between speaker and audience.

The erotic is circulatory and dynamic because it is a relation. Therefore, though the teacher holds power in the classroom that is greater than her students', for she is the authority on the subject being studied, she does not become authoritarian. Rather, she leads: creates, if skill and luck are with her, a libidinized classroom in which desire for knowledge fostered by pleasure in learning is the prime operation. She luxuriates in educational libido, leads students astray—which is the meaning of seduction—from the standard perverseness of teacher-student acquiescence to bodily shame and denial in the classroom.

As a comfortable class of mine, of about twenty people, is about to begin, students are chatting with one another, some banter with me, and

one woman in that small group addresses me: "You've got lipstick on your teeth." I'm slightly embarrassed, take a finger to my teeth, and ask her if the lipstick is gone. She says, "Yes," and I say, "Thank you for telling me, I don't want to go around looking like an idiot"; the room grows silent as I continue to speak, saying something like "I do appreciate your telling me if something is amiss, like red in the wrong place— lipstick, blood." If I remember correctly, a number of students laughed and the feeling in the room was light. I began my lecture.

hooks says, "The person who is most powerful has the privilege of denying their body." When a professor is a conscious body in a classroom and is consciously a body in the classroom, she restructures power by humanizing and eroticizing a space that has institutionalized bodily denial. hooks goes on to provide an example: "I remember as an undergraduate I had white male professors who wore the same tweed jacket and rumpled shirt or something, but we all had to pretend. You would never comment on his dress, because to do so would be a sign of your own intellectual lack. The point was we should all respect that he's there to be a mind and not a body."[7] Suggesting her and other students' distaste for some professors' lack of attentiveness to their own aesthetic/erotic self-creation,[8] hooks indicates the students did not consent but rather submitted to that lack.

In this way, the professor's body can establish a consensual thanatics in which bodies become dead to one another. In that de-eroticized condition, human beings also close their minds and tighten defenses, for pain results from experiencing aesthetic/erotic lack, and a dead(ened) body provides more protection from pain than does an eroticized one. Eros, life force, enlivens soul-and-mind-inseparable-from-body. The professor's erotic body eroticizes the student; and the professor's initiating erotic attitude and actions, with student consent, becomes a process that is kept alive through mutual pleasure. As hooks observes, information "emerge[s]" from professors' bodies. But these bodies do not simply carry and project information, for the professor's erotic body *is* the information. Erotic bodies encourage thinking and touching beyond the formulas of institutionalized behavior and thought. Erotic bodies counter a common undergraduate fear of thinking critically about academic material and of thinking for oneself—or of expressing one's own thoughts; and erotic bodies invite the ordinary humanness of physical touch. Aspects of the academic environment, from scholarship and the intellect

to the distant and often intimidating professor, may seem cold, dry, and unwelcoming to many students. By warming academia, consensual erotics helps students know that teachers are approachable and that academic work is enjoyable, even when it remains challenging, demanding, and perhaps difficult.

Dana, whose best grade all semester was a C+, came to me, in the classroom, after the last lecture of the semester. She asked me questions about her most recent paper and about the final exam. Verbally acknowledging her mostly below average grades, she touched my upper arm—a gesture of ingratiation or affection, I'm not sure which—and said, "I *like* this class, *I like you*."

Consent: *com-*, "with," + *sentire*, "to feel." The professor and student feel with each other. In consensual erotics they lust together, share an appetite for living in a skillfully and elegantly thinking body. They agree on pleasure in order to obtain more pleasure. Professor and student *want* pleasure together. In class this means attentiveness and engagement. Outside of class—on- or off-campus—it means talking with one another, and it may include eating or drinking together, shopping, working out in the gym, visiting an art gallery, or other activities that friends enjoy. Some instances of private consensual erotics are sexual, for the sexual is an inflection of the erotic. The sexual is not a degree of the erotic, nor is it more intense than the erotic. The erotic does not necessarily lead to the sexual, but rather encompasses it as one element in which consensually erotic partners may engage.

Campus sexual harassment policies censure sexual relations between professors and students because of the professional power that one group has over the other. Professors grade and they write recommendations; they can praise and criticize in formal and informal ways that may have short-term or lasting effects on students' academic performance. My school's policy, which is typical, explains that sexual harassment introduces **"unwelcome"** (the word appears in bold) sexual comments or activities into the educational environment that interfere with the student's ability to perform academically.[9]

Like many other policies, which similarly quote Title VII Guidelines on Discrimination because of Sex, the policy of my school, the University of Nevada, Reno (UNR), defines sexual harassment as the creation

of an "intimidating, hostile or offensive" learning situation, which can entail coercive invitations or demands for sex. The "Consensual Relationships Policy" section "prohibits romantic or sexual relationships" when "one of the individuals is in a position of **direct** professional power over the other."[10] The professor may be charged with harassment by the student or a third party, and the parties engaged in (only apparently) consensual relations will receive a written or verbal warning from the appropriate dean or chair. Indeed, they are to consult with the dean or chair, or the Office of Affirmative Action. Avoidance of future "exploitative" relations is recommended to professors and students when one has no professional power over the other at the moment, because such a power differential could later arise.[11] Another caution: a student may interpret past consensual relations as nonconsensual. Sanctions for faculty may be severe: they range from an oral or written warning to dismissal, and the most severe penalty can result from a first offense. Past, present, future: sexual relations and romantic relations *are* sexual harassment; they have not been, are not, and will not be consensual. The University of Minnesota prohibition is more severe than UNR's, for the "administration and the Sexual Harassment Board involved with a charge of sexual harassment shall be expected, in general, to be unsympathetic to a defense based upon consent when the facts establish that a professional faculty-student . . . power differential existed within the relationship."[12]

Gallop, found guilty of a "consensual amorous relation," challenges the now common policy that holds no amorous, romantic, or sexual relations between students and teachers to be consensual.[13] She argues in *Feminist Accused of Sexual Harassment* that discrimination because of one's sex, not sexual relations, is the foundation of sexual harassment law. Her claim is based in feminists' contribution to the legal definition of sexual harassment as sex discrimination under Title VII, guidelines enacted in 1980 that remain in effect today.[14] As Gallop sees it, the sexual rather than the sexist has been cast into the harassment spotlight. (The Anita Hill–Clarence Thomas hearings contributed to making the sexual highly visible, as did charges brought against Senator Bob Packwood of Oregon by his female staff members.) Gallop maintains that sexual relations are not necessarily discriminatory and that student consent is possible, and she criticizes the idea that "because students cannot fully, freely,

and truly consent, all teacher-student relations are presumed to be instances of sexual harassment."[15]

Perhaps a student's desire, her or his wanting an amorous, romantic, or sexual relation with a teacher, jars the meaning of "consent," makes it possible. Neither *wanted* nor *unwanted* appears in either Minnesota's or UNR's consensual relations policies. *Consensual* appears in UNR's, and *consent, consenting,* and *consensual* are in Minnesota's. To desire and to consent are not necessarily the same. Consent carries a legal meaning, and desire does not know the law. *Unwanted* and *unwelcome* recur in sexual harassment policies and discussions, and their distinction from *wanted* is useful because it marks the difference between erotics and thanatics. Wanted consensual romantic or sexual relations between professor and student indicate that both are desiring subjects who may be erotic agents.

Feminist theorists have considered at length the importance of women being desiring subjects. The usual premise has been this: because women have mirrored men's desire, women have not discovered, let alone acted out of, their own desire. Gallop defends consensual sexual relations between professors and women students on the grounds that women need validation and authority as desiring subjects—which such consensual sex or romance may give them. Protectionism, says Gallop, underlies policies that forbid sex between professor and (woman) student.[16] I am reminded of the paternalistic warning and consulting in the UNR policy. Gallop and other women students she knew when she herself was a student—"lots of other smart, ambitious young women, many of them likewise feminist academics today"—benefited from sexual relations with professors, and that reality is also part of her defense of consensual relations: "I felt that . . . I was both a desirable woman and a serious scholar. And thus I believed I could be both."[17]

As a young professor, Gallop had sexual relations with students—she makes a point of not calling the relations "romantic"—which also contributed to her feeling desirable and important, the latter because some of the students were very interested in her scholarly work or impressed by it. Gallop says she always slept with people because "they engaged me as human beings"; in other words, together Gallop and a consenting student humanized one another's lives. Soul-and-mind-inseparable-from-body, at the heart of consensual erotics, is a humanization of education that intersects with Gallop's argument against bans on consensual sex. She points out, "We fight against sexual harassment precisely because it's

dehumanizing. . . . Telling teachers and students that we must not engage each other sexually ultimately tells us that we must limit ourselves to the confines of some restricted professional transaction, that we *should not treat each other as human beings*."[18] Consensual erotics between one professor and one student, like some sexual relations in the same configuration, makes evident the power and beauty of the individuals involved, their unique, precise creation of monster/beauty, which is a root of any erotic attraction.

I read assent to pleasure in Gallop's defense of sexual relations. Assent to pleasure—an essence of consensual erotics—is critically important to human relations, so I, like Gallop, disagree with prohibitions against consensual sex. But, unlike Gallop, I do not advocate teacher-student sex.

The one professor I slept with, when I was a Ph.D. student, did not reciprocate my sexual passion. I had too fervently seduced him, worked too hard for the bit of pleasure I got with him. He kept his socks on during sex, which was unsatisfactory—quick but inefficient, which a fast fuck need not necessarily be. The entire event, which included lunch in my apartment, was rushed, and I had fed him what I had planned to be a delicious, leisurely meal but ended up being seriously flawed: crabmeat salad with a dressing that was runny and Brie whose ripeness made his breath reek. I am sure that our psychological discomforts maximized the unpleasant smell. If I served dessert, it was probably luscious; but I do not remember it, so its taste or the results of eating it did not alter my painful but also humorous memory.

My professor wrote, to my knowledge, an excellent recommendation when I applied for teaching jobs, although I had never removed an incomplete in a course I took from him. Had I not slept with him, I would have performed academically in my usual fashion—work done well and on time.

I slept with one M.A. student and one undergraduate, both men, during my first two years as an assistant professor. Both were younger than I, the first by eight years, the second by thirteen. These romantic relationships occurred before sexual harassment on campus became very visible in the mid-1980s.[19] Tom, the graduate student, became my first husband, and the undergraduate and I lived together for several months. Our relationship seriously upset his studies, for he left school, which has made me wince a number of times over the years. I do not know if he ever finished his B.A. What Tom perceived as my aggressive desire for him, aggressiveness-cum-coercion, disturbed him throughout our relationship.

When Russell and I became lovers he was almost twenty-seven and I was forty. I was no longer his professor and no longer a faculty member in the department in which he was working on his M.F.A. Nonetheless, during the first six months that we lived together, extreme professional difficulties arose for both of us. These were generated by department faculty as he was completing his degree, and the repressed cause was our relationship.

Without pleasure, one dies aesthetically and erotically—poisoned by thinking that the prosaic is boring, by existing in amusement rather than living in erotics. Assenting to pleasure and thereby activating it is a key to women's taking themselves seriously, to their becoming erotically large—elegant and skillful thinking bodies. Moreover, protectionist policy for young women threatened by older men plays differently when (older) women are professors, for they, too, like women students, need validation and authority as desiring subjects who assent to pleasure and activate it. When an older woman professor and a younger male student engage in a consensual erotic or sexual relation, they break down Oedipal fear of the older woman and decontaminate Oedipal lust and love for her.

"You're a beautiful woman," says the stepson to me when I am forty-seven. "She's hot," he tells an instructor, a man who advises, "Admit you're attracted to her and move on." Months later, when the stepson and I have become erotic partners through classroom responsiveness and many coffees, I dreamed I was walking with Johanna, who shares the stepson's age. She said to me in the dream, "Tell him you want to fuck him." Then she repeated over and over, "You want to fuck him."

The stepson and I grew closer until he graduated, and our relationship could have been called amorous. The phrase *amorous relations* does not appear in UNR's sexual harassment policy, but it does in the policy of Gallop's institution, the University of Wisconsin at Milwaukee, as well as those of others, such as Tufts University, the College of William and Mary, Harvard University, and Indiana University. Gallop's "crime" of consensual amorous relations resulted from Gallop and one of her students talking personally and intensely about sex, kissing in a bar. I, like many professors who become friends with students; who talk intimately and passionately with them, sometimes about sex; who hug, kiss, and touch our students in various ways, am acting amorously in assent to

pleasure. Simultaneously intellectual and bodily relationships are likely
to belong to an ongoing consensual erotics, whose specifics, like those in
any relationship, are always undergoing subtle negotiation.

NOTES

1. Audre Lorde, "Uses of the Erotic: The Erotic as Power," in *Sister Outsider:
Essays and Speeches* (Trumansburg, N.Y.: Crossing Press, 1984), 53–59, elabo-
rates on the transformational power of the erotic, as do I in the introduction to
Erotic Faculties (Berkeley: University of California Press, 1996), 1–25.
2. Magda Lewis, "Interrupting Patriarchy: Politics, Resistance, and Transforma-
tion in the Feminist Classroom," in *Feminisms and Critical Pedagogy*, ed. Car-
men Luke and Jennifer Gore (New York: Routledge, 1992), 182, relates the diffi-
cult, sexually inflected conditions of women's intellectual work, the
"antagonistic relationship drawn between women's desire for knowledge and
our embodiment as sexually desirable human beings [that] is an issue that lies
always just below the surface in the classroom." Lewis cites examples of female
students being assaulted in simultaneously sexual and intellectual ways, yet
female professors are also at the center of sexual tensions in the classroom. For
them, these tensions may be positive or negative.
3. Pedagogical erotics does come up in my "Fuck Theory" (43–50) in *Erotic Facul-
ties,* as well as in my introduction to that book.
4. bell hooks, *Teaching to Transgress: Education as the Practice of Freedom* (New
York: Routledge, 1994), 139.
5. Leigh Gilmore, "Becoming Obscene: Pedagogy as Sexuality, Pedagogy as Pri-
vacy" (paper presented at the "Sexuality and Pedagogy" session, College Art
Association conference, Boston, February 1996), addresses the problematic par-
ticulars of being a professor in a female body, of impersonating both woman
and the material she teaches.
6. Milan Kundera's novel *Slowness*, trans. Linda Asher (New York: HarperCollins,
1996), teaches and celebrates the necessity of slowness for erotic beauty to
occur.
7. hooks, *Teaching to Transgress*, 137.
8. hooks makes clear her interest in her own aesthetic/erotic self-creation in
"Women Artists: The Creative Process," in *Art on My Mind: Visual Politics*
(New York: New Press, 1995), 125–32. In this essay, she writes about preparing
herself for writing.
9. "Policy Prohibiting Sexual Harassment," University of Nevada, Reno (August
1995), 1.
10. Ibid., 2, 3.
11. Ibid., 3.
12. Appendix IV, "Presidential Statement and Policy on Sexual Harassment, Uni-
versity of Minnesota," in *The Lecherous Professor: Sexual Harassment on Campus,*

by Billie Wright Dziech and Linda Weiner, 2d ed. (Urbana: University of Illinois Press, 1990), 206. The president's statement was dated January 20, 1989.

13. Jane Gallop, "Consensual Amorous Relations," in *Feminist Accused of Sexual Harassment* (Durham, N.C.: Duke University Press, 1997), 31–57.

14. See Appendix I, "Title VII Guidelines on Sexual Harassment," in Dzeich and Weiner, *Lecherous Professor*, 189–91.

15. Gallop explains that the "final determination" of the head of the affirmative action office found her "guilty of violating university policy because I engaged with one of my students in a 'consensual amorous relation' " (*Feminist Accused*, 34). The document declaring Gallop's guilt defines an amorous relation as one that was " *'sexual' but did not involve sex acts*" (her emphasis).

16. Ibid., 35–39, focuses on consensual relations, desire, and protectionism.

17. Ibid., 43.

18. Ibid., 51 (her emphasis).

19. Dziech and Weiner's "Sexual Harassment on Campus: The State of the Art," in *Lecherous Professor*, 9–37, presents both the history of sexual harassment policy and its campus visibility since the early 1980s.

Six

EXERTIONS OF FLESH ON FLESH

Students read and reread the professor's body, day after day throughout a semester and in some cases, such as undergraduate majors in a teacher's field or graduate students with a dissertation adviser, year after year. The professor's body receives a critique, is analyzed and interpreted. It is self-disclosing, whether inadvertently, as were bell hooks's rumpled instructors discussed above, or deliberately, as was Wendy Chapkis, whose description of her appearance and her intentions in creating and presenting her body to a class are discussed in this chapter.

Jo Anne Pagano concurs that students critique female professors' bodies: "Everything she does is open to judgment—her speech and gestures, her hair, her dress, her makeup, . . . her poise."[1] Although Pagano is writing about relationships between supervisors and student teachers, her statement applies to classroom relations and indicates that appearance may be an essential part not only of students' learning environment but also of their learning experience. Here I attach passivity to environment and activeness to experience. The student is not a passive consumer of the professor's body. If we see the student and the professor respectively as reader and text, then the teacher's body produces meanings that circulate within and beyond the classroom. Nor does the professor pas-

sively consume students' bodies. She reads them—slumping, clock-looking, pen-tapping; smiles, smirks, and laughs—in order to redirect both her own and students' remarks. Classrooms are interactions of bodies speaking with each other, exerting a range of pleasure and pain on each other.

Critical pedagogy theorist Peter McLaren writes about the exertion of flesh on flesh:

> Brian Fay argues that learning is not simply a cognitive process but also a somatic one in which "oppression leaves its traces not just in people's minds, but in their muscles and skeletons as well." That is, ideology is not realized solely through the discursive mediations of the sociocultural order but through the enfleshment of unequal relationships of power; it is manifested intercorporeally through the actualization of the flesh and embedded in incarnate experience. Fay describes it as "transmitting elements of a culture to its newest members by penetrating their bodies directly, without, as it were, passing through the medium of their minds."[2]

McLaren and Fay describe unpleasant, nonerotic, even antierotic learning brought to bear on and within bodies. Fay speaks of children, but his and McLaren's words apply as well to the readiness of older students' bodies to absorb lessons. Bodies absorb from bodies, and the professor's body is an entity, an event, an act, a performance of persuasion. The body is rhetoric whether or not the professor puts that knowledge to use.

As hooks's examples of drunk and rumpled professors and Chapkis's self-description below make clear, the professor's appearance—looking at the professor—can bring pain or pleasure depending on the aesthetic/erotic content of the teacher's body. Professors rarely write about their own bodies or style; nor do former students or other observers describe or analyze professor's physical self-presentation, their bodily rhetoric. I found three examples—all describing women—that evidence persuasion through the power of pleasure; only Chapkis's is written by a professor about herself. Susan Bordo writes about her own pleasure at losing weight but finds problematic the effects of her bodily change on female students.

> I know, for example, that although my weight loss has benefited me in a variety of ways, it has also diminished my efficacy as an alternative role model for my female students. I used to demonstrate the possibility of confidence, expressiveness, and success in a less than adequately

normalized body. Today, my female students may be more likely to see me as confirmation that success comes only from playing by the cultural rules. This may affirm some of them, but what about those who cannot play by the rules? A small but possibly important source of self-validation and encouragement has been taken from them. Even though my choice to diet was a conscious and "rational" response to the system of cultural meanings that surround me (not the blind submission of a "cultural dope"), I should not deceive myself into thinking that my own feeling of enhanced personal comfort and power means that I am not servicing an oppressive system.[3]

The "overweight" female body may well be a powerfully erotic bad body, whereas the normalized female body that is simply sexy may encourage submission to cultural rules. But pedagogical erotics comes from personal comfort and power; alternative role models are many, as are most bodies even when they are slender, for flaws are numerous in a system that pushes an oxymoronic ideal—the attainability of perfection.

Chapkis feels not only comfortable but excited in her teaching body/costume/rhetoric, which presents an alternative role model.

> In teaching Sexual Politics, I was always aware of the ways in which I presented myself as an object of desire to the class. I dressed in my very best dyke drag for each lecture, complete with leather and rhinestones. The costuming was partially protection: giving a lecture to over a hundred people was clearly performance, and the outfits were effective props. But it was more than that. My costuming was also an attempt to perform gay culture as well as to teach it. My appearance was intended to serve as a model of the pleasures of gender transgression (bright red lipstick under a full blonde moustache) and of a shameless lesbian sexual presence.[4]

Knowing student responses to Bordo's and Chapkis's bodily rhetoric would help us to understand more about the authority of appearance. Different bodily rhetorics work for different students.

"Your lipstick and makeup," said the student with bee-stung lips lined and colored, "they give me permission." I listened, smiled, and thanked the young woman, then imagined a kiss that would mix my own clear red with her rosy mocha.

"You always looked sexy," said Andrea, now a curator of contemporary art, to me. "I remember rhinestone pins glittering when you'd walk into slides,

clothes that showed the beauty of your body and gestures that made me notice
its strength and grace. You didn't flaunt your body, but you were very con-
scious of it. You were a relief to me, and your body is part of why I became a
feminist."

Jane Gallop has described herself in conference gear, but not in the
classroom.[5] In her *Lingua Franca* article on the sexual harassment case,
Margaret Talbot quickly details Gallop's legendary appearance, a look
that "challenges. . . . Her outfits and accessories—the skirt made of
men's ties, the glove-tight Joan Crawford suit she sometimes dons for
conferences—seem to announce themselves with quotation marks as
'parody' or 'eccentricity' or 'fetish.' " Gallop's bodily rhetoric also
includes "a single rattail braid [that] hangs from tousled shoulder-length
hair and . . . long crimson nails, except for one gold pinky nail." Talbot
quotes a graduate student who remembers his terror on the first day of
class with Gallop: "first, she was wearing this bright red power suit with all
these wild accessories. And second of all, she started out by telling us we'd
have to work harder to satisfy her expectations than we ever had before."[6]

Talbot remembers from her own undergraduate days a professor who
"wore little black leather skirts and played up her resemblance to Jeanne
Moreau." She was intellectually passionate, she enjoyed "long drunken
dinners with students, and . . . had a lover and a baby whom she some-
times told us about." Her style and her daringly shapely way of living
"made it seem possible to lead the life of the mind with no apologies for
leading it in a woman's body." Talbot calls her professor "intemperate"
and wonders "whether someone has since clipped her wings to fit the
time."[7]

I remember Carol in her shameless, miniskirted heterosexual pres-
ence. I remember students' comments to me.

Sometimes at the beginning of fall semester in Reno the art history room
gets very hot. The air conditioner is extremely noisy from where I stand, and
it doesn't work well, so I often don't use it. I turn it on and off. Frequently I'll
begin a lecture in my jacket then take it off. In the heat, my next layer is gen-
erally a black tank top. Donna, an art history major in her twenties, said to
me a couple of years after she'd first seen me take off my jacket in these cir-
cumstances, "I knew I was in for a wild ride."

I used to work out at an off-campus gym, one reason being that I was
unlikely to run into many students. One day there a young man in one of my

100-level courses came up to me and said hello followed by an observation from the classroom, "I've noticed that you're in good shape." I was flattered and, naively, surprised. Like Chapkis, I dress attentively for class, but most often I forget my appearance during it even though I know I'm using my body rhetorically.

I imagine Chapkis, Gallop, and Talbot's teacher, all "loose" women, aesthetic spectacles, endangered species, in the erotic rant of a fluid lecture whose verbal and visual rhetoric displays and demands intellectual ardor and arousal: in other words, erotic connection. In a basic and spacious way bodies such as theirs suggest that education can be erotogenesis and erotology. Live professorial performances of couplings such as mind and body, sexuality and intellect, passion and accuracy, scholarship and pleasure, history and personal experience can engage and hone lust for learning. Such performances are powerfully, authoritatively pleasurable, and likely demanding. Lust is the pleasure enjoyed in erotic exploration, without which classroom learning is a drab experience if not an impossibility.

Lust is also the voyeuristic and communal student gaze, which has far greater classroom leisure than the professor's gaze to scrutinize its object. The voyeuristic student gaze takes in the loose woman professor's formidable appearance: first, as Gallop's student reveals, comes the impact of bodily style and then the observer must perform.

The student gaze that evaluates the female professor is simultaneously powerful and vulnerable. Like the male gaze, it may well be scopophilic. It may eroticize or try to eroticize her body, and it can do so sneakily, surreptitiously, especially in a dimly lit art history lecture. The student gaze enjoys and interrogates, in the dark, the professor's image, just as the professor enjoys and interrogates the slide images she displays. Looking is a primary student activity in classrooms. While one could say that some students do not see, that their souls-and-minds-inseparable-from-bodies are so disengaged as to not consciously know what they are looking at, one could also say that classroom looking is especially intense. Facing the teacher focuses students' attention in one place, and a class generally lasts fifty or seventy-five minutes, a substantial amount of time in which to be looking at one moving object. Even in seminars in which everyone sits around a table and students give presentations, students look at the professor with greater curiosity and expectancy than

they do at their peers, for students are looking not only *at* but *to* the professor.

Back in the lecture room the teacher visually dominates, for she can look at everyone. But everyone can look at her. Perhaps some students leer or ogle her body, exemplifying a kind of excessive, unnecessary looking. "Unnecessary . . . leering or ogling at a woman's body" might be sexually harassing, according to a list of acts and behaviors provided in 1978 by the Association of American Colleges' Project on the Status and Education of Women.[8] (Necessary leering or ogling, I suppose, would occur at a sex show or during a lap dance. Other kinds of looking would be offensive to the performer or signs of shame.) Students necessarily look at the professor, must look at her, so perhaps their classroom looking can never constitute harassment because they are distinctly not in sufficient control of it.

Young male students stare at my breasts when they talk with me at the end of class or outside of class. I wonder if they are conscious of their gaze, which I generally respond to with a combination of amusement and annoyance. Maybe I am insufficiently mind. Sometimes I have to restrain myself from laughing and asking the men about their interest in my breasts. I doubt that the men see me as the maternal breast. My breasts are not large, so I am not a picture of pillowy, motherly sexual comfort. The scandalous nipples must be points of interest.

In the art history lecture room, which differs from all others in being dark while the professor lectures, the darkness offers an intimacy and mystery into which students can escape the professorial gaze more readily than usual. While teachers may be unable to see students in the back rows, and dim light is more conducive than bright to students' falling asleep, darkness here can promote intensified looking at the object of the gaze, as it does in a movie theater.

However, the scopophilic aspect of the student gaze cannot easily or entirely control the female professor who is the bad body, for she has invited the gaze, asked for what is ironically forbidden despite must-look-at-the-teacher classroom design.

Shame and looking/being looked at go hand in hand. Students and professors are not supposed to look too closely at one another—too long, too penetratingly—especially in a consensually erotic gaze that makes their mutual desire known either publicly or privately. One's own desire and desirability are embarrassing if not terrifying. Vulnerability to passion exposes us.

A graduate student in psychology who took a performance art class with me talks during a critique of another student's work about wanting to look closely at the students performing and at people in general. She focuses on her being a lesbian looking at other women in the class, both lesbians and heterosexuals, and feeling inhibited. I recall, not as precisely as I'd like with the distance of several years, the student's concern about others' (mis)interpretation of her looking, that she would be perceived as desiring.

I said something to the effect that her remarks were a provocative and important avenue of thinking. The discussion did not go much of anywhere. I was disappointed, but I did not urge further or deeper conversation because I was embarrassed to show how profoundly the subject interested me. I was afraid to talk about how I like to linger visually over students' bodies and how I resist that pleasure, and I did not want my professorial authority to force the class into discovering or analyzing the student gaze. I ventured in as far as I could bear, as far as I dared, for I felt that I was endangering consensual erotics. Sometimes I observe when I should push.

But shame is such a sad and hardy companion that attempting to dismantle it in a class—even in performance, which draws out and highlights some students' shame in self-destructive works—is a daunting and perhaps inappropriate endeavor.

Consensual erotics counters the usual classroom dynamic of looking without seeing, the bodily "repression and denial" that hooks criticizes, the dynamic of politeness, because the bad body is a radical impropriety that demands being reasoned with.[9] By assertively inviting the student gaze, unlike the supremely clean body that paradoxically demands and deflects such looking, that acquiesces to the gaze out of institutionalized pedagogical and spatial formats, the bad body challenges and disrupts what Madeleine Grumet has called the "look as a strategy of domination." That look is the teacher's alone, which can isolate, terrify, and humiliate; which is a managerial gaze. Grumet has also said that the "look of the teacher is endorsed with an authority that disclaims history, motives and politics."[10] The female professor bad body is a woman with erotic motives and radical pedagogical politics. Her inviting appearance asserts deliberated bodiliness and generates the shared looking of consensual erotics that is grounded in students' and professors' mutual bodily desirability, which both moves and is desire for knowledge.

Like Manet's Olympia, whose body directs the viewer to reconsider meanings and operations of looking through the construction of the

female nude—Olympia is self-possessed, intelligent, aggressive, complexly corporeal—so the female professor bad body reformulates classroom powers of looking and being looked at. Both she and Olympia are meant to be looked at and are authoritative souls-and-minds-inseparable-from-bodies.

The female professor's very aliveness of soul-and-mind-inseparable-from-body—the fact that her body thinks—may endanger her professional legitimacy. Yet feminist pedagogical theory has not elaborated on either the dilemmas or pleasures of women teachers in the flesh, of women teachers as flesh. Leigh Gilmore, a professor of English and women's studies at Ohio State University, states the problem like this: "Feminist pedagogy is filled with ghosts—the revived and recovered ancestresses brought back from the grave, the recovered voices and silences that haunt phallocentric discourse. The tropes consistently used to build feminism's revision of disciplinary history are of the reanimated or living dead. But we don't do so well with live bodies."[11]

The loose woman professor, the aesthetic spectacle, sharpens attention and attentiveness through her appearance. She grounds herself in the visual, as artists do; and Chapkis, Talbot on Gallop, and Gallop herself have made it clear that these professors' politics are in their vision of themselves. A politics of visual erotics rooted in aesthetic self-creation appears to be coupled with feminism. The examples I have found and have experienced of radical rhetorical bodies are feminist academics: Carol, Chapkis, and Gallop; Christine, Peggy, and Barbara, whom I describe below. They are live erotic acts, who provoke by displaying the cultural fact that the repressed and the scandalous are never far apart in the female body. These provocateurs, three of whom are artists, are not typical feminist academics. ——

The female art history professor steps into the picture and changes it. She walks into the projector's light, becomes the screen, becomes the image about which she speaks. Any woman professor is a provocation because she is the wrong body, but the art historian who walks from the podium into a slide risks becoming an attractive abomination—Olympia, Ingres's odalisques and bathers, a demoiselle d'Avignon and reclining Venus, the naked Maja, a Bellmer doll or de Kooning ball-buster, a Sherman witch with her legs spread. The female art history professor risks becoming obscene. "Becoming Obscene: Pedagogy as Sexuality, Pedagogy as Privacy" is the title of the paper written by Gilmore from which

I quoted above. Her main contention is that the "spectacle of the graphic image or text attaches to certain teachers and elides their identities with that spectacle so that when we teach so-called explicit materials, we are in the process of becoming obscene."[12]

Carol, Chapkis, Gallop, Christine, Peggy, and Barbara have all dealt with sexual material in their teaching and their own work. Gallop is known for her sexually explicit treatment of graphically sexual material, and Chapkis, a professor of sociology and women's studies, titled her recent study of prostitution *Live Sex Acts: Women Performing Erotic Labor*.[13] Carol has analyzed the female nude in her classes and scholarship. Her lecture on Olympia in the nineteenth-century art class I took with her included information on prostitution and fashions in female body types. Three of her classic essays dissect the female nude in modern art.[14] Performance and digital artist Christine, painter Peggy, and photographer Barbara discuss sex and gender frankly in their classes and have treated the female nude and sex and gender issues in their art. The unclothed female body as a cultural production and as organs, glands, and muscles has likely resonated in these women's classes in many students' souls-and-minds-inseparable-from-bodies as explicit, even obscene material.

Many contemporary art works are more or less graphic, depending on a student viewer's points of reference and the instructor's language. One can call Judy Chicago's *Dinner Party* (1973–79) plates organic imagery, vaginal iconography, or cunt art. One can discuss these terms' meaning historically within the goals and achievements of feminist art or the nuances of phrases naming female genitalia. One may not want to say *cunt art* in a contemporary art class that treats feminism. However, because feminists have wished to reclaim words used to denigrate women and the female body, if one chooses to delete the explicit and—to many—obscene word *cunt*, one deletes a significant aspect of history.

When a woman says *cunt*, perhaps she is one.

When a man says *cunt*, perhaps he hates women.

The female nude itself is both art and obscenity. As Lynda Nead says in *The Female Nude*, "More than any other subject, the female nude connotes 'Art.' The framed image of a female body, hung on the wall of an art gallery . . . is an icon of western culture, a symbol of civilization and accomplishment." At the same time "obscenity is representation that moves and arouses the viewer rather than bringing about stillness and

wholeness." Surely the nude has this effect and therefore becomes an image that "seems to defy classification and where the values themselves are exposed and questioned."[15] The female professor who is an erotic/aesthetic spectacle defies classification by "harassing" the stagnant and false completeness of mind over body.

I am the immoderation of eros, slick with my own cum.

The female nude is coming apart at her modernist seams, tattooed and splattered with someone else's pleasure. She has lap-danced her way through history in skin too smooth for her own good.

I execute an exotic dance through a genealogy that has betrayed the female body into perfection and prescription. In that lineage I have looked at and loved so many unclothed women that I identify with all of them. Although they are eros degenerated through most artists' erotic ineptitude, which creates the sorry sight of homogeneity through period fashionableness and individual artists' styles, the unclothed women are not simply whorehouse or harem or moronic showgirls who can tell me nothing.[16] They remind me that I am never innocent of lust, either my own or my beholders'. Impressed on their unconscious, held in their libidinous hearts, I am the problem once determined and resolved by the feminist formula that bound the sexed and designated sexy woman to male desire as its reflection and reproduction.

The female nude is the degradation of female erotic potential and the revelation of scopophilia as a pedagogical tool. She is monster/beauty, whose operation on an audience must not be theoretically predetermined.

Exploring her body year after year, I rethink the uses, benefits, and discomforts of pleasure.

The female nude is a guide who leads me to believe that scopophilia reconstructs the intellect and that the visual pleasure invested in the female body can be a useful rhetorical device rather than always and only a trap.

The repressed and the scandalous are never far apart in the female body, as Zoe Leonard demonstrated in her *Documenta 9* installation (1992), in which she placed black-and-white photographs of women's vulvas next to eighteenth-century German paintings of decorous women. The female art history or studio art professor who talks about portraits of women, the female nude, or cunt art becomes the most fundamental symbol of woman: she is the uncanny evidence, lagging in the students'

unconscious, on the brink of Leonardesque revelation, that the portrait reduces to the nude, which reduces to the cunt. Perhaps *reduces* should be *expands,* for cunt in Western civilization has been paradise, pollution, oracular site, feminist ecstasy, floral beauty, stinking pit—enchanted and enchanting. An ultimate monster/beauty, cunt as paradox of pleasure can only be complex. Indeed, the glamorous cunt, the loose woman in her getup meant to get-it-up, is the phallic woman muscled in the pleasure of aesthetic/erotic performance.

My mind's eye lingers on my memory of Christine, at forty-four larger than I've seen her before, as she lectures about feminism, performance art, and the art world. She moves sensuously under her loose-fitting clothes as if she were coming with laughter.

I think of Peggy at fifty-four, who has appeared at opening receptions for her work in a baseball cap, high-fashion hunting jacket, and jodhpurs.

I see Barbara, when she is near fifty, in black jeans and top, nails painted black, hair dyed black. I sit here imagining her muscles, looking at them, then feeling them. Her creamy complexion invites my touch. Next time I see Barbara her hair is undyed and silver. The friend I'm with says to me when she sees Barbara, whom she's never met before, "She's gorgeous."

I see Christine, Peggy, Barbara, Carol, Chapkis, Gallop, and Talbot's teacher as a portrait gallery of bad bodies. Being a bad body becomes more difficult as one grows older, and sorrow and hardships easily turn erotic radiance to moribund emotional and physical flab. Mary Ann Caws addresses all-too-briefly older women professors' erotic attractiveness and their tiredness: "Energy, just pure unadulterated *energy,* can be attractive. Even grown-up, aging energy. Even when it isn't male. Do I mean seductive, erotic, *winning?* Is it fun to manifest? To watch? It seems to be, sometimes, all of the above. Its very manifestation appears to strengthen everyone. . . . Energy is delightful, doing no harm. It can nourish everything else, including feeling. BUT, coming from a woman of whom, alas, much is expected, maybe too much, it can wear you out."[17] Without discounting Caws's understanding of the older female professor's likely exhaustion, I wish to assert that the female professor in her aesthetic/erotic authority, especially when she is midlife or older, is an emancipatory pleasure for some students.[18] Credentialed and heretical, she gives permission to students to articulate the extremity (in our

culture) of erotic integrity, which includes appearance as a manifestation of soul-and-mind-inseparable-from-body potency.

NOTES

1. Jo Anne Pagano, *Exiles and Communities: Teaching in the Patriarchal Wilderness* (Albany: State University of New York Press, 1990), 43.
2. Peter L. McLaren, "Schooling the Postmodern Body: Critical Pedagogy and the Politics of Enfleshment," in *Postmodernism, Feminism, and Cultural Politics: Redrawing Educational Boundaries*, ed. Henry A. Giroux (Albany: State University of New York Press, 1991), 153. He is quoting Brian Fay, *Critical Social Science: Liberation and Its Limits* (Ithaca, N.Y.: Cornell University Press, 1987), 146, 148.
3. Susan Bordo, *Unbearable Weight: Feminism, Western Culture, and the Body* (Berkeley: University of California Press, 1993), 31.
4. Wendy Chapkis, "Explicit Instruction: Talking Sex in the Classroom," in *Tilting the Tower: Lesbians, Teaching, Queer Subjects*, ed. Linda Garber (New York: Routledge, 1994), 14.
5. In *Thinking through the Body* (New York: Columbia University Press, 1988), 92, Jane Gallop lists "spike heels, seamed hose, a fitted black forties dress and a large black hat" and gives a concise interpretation of these items.
6. Margaret Talbot, "A Most Dangerous Method," *Lingua Franca*, January/February 1994, 24. Jeff Walker is the student quoted.
7. Ibid., 40.
8. Billie Wright Dziech and Linda Weiner, *The Lecherous Professor: Sexual Harassment on Campus*, 2d ed. (Urbana: University of Illinois Press, 1990), 22.
9. bell hooks, *Teaching to Transgress: Education as the Practice of Freedom* (New York: Routledge, 1994), 192–93, tells a story of her own erotic repression and denial regarding one of her students (discussed in chapter 4 above).
10. Madeleine Grumet, *Bitter Milk: Women and Teaching* (Amherst: University of Massachusetts Press, 1988), 111, 112. In a chapter titled "My Face in Thine Eye, Thine in Mine Appeares: The Look in Parenting and Pedagogy" (95–116), Grumet critiques the absence of intersubjectivity in the look between teachers and students.
11. Leigh Gilmore, "Becoming Obscene: Pedagogy as Sexuality, Pedagogy as Privacy" (paper presented at the "Sexuality and Pedagogy" session, College Art Association conference, Boston, February 1996), 10.
12. Ibid., 1.
13. Wendy Chapkis, *Live Sex Acts: Women Performing Erotic Labor* (New York: Routledge, 1997).
14. See Carol Duncan, "The Modern Art Museum: It's a Man's World," in *Civilizing Rituals: Inside Public Art Museums* (London: Routledge, 1995), 102–32; "Virility and Domination in Early Twentieth-Century Vanguard Painting," in

Feminism and Art History: Questioning the Litany, ed. Norma Broude and Mary D. Garrard (New York: Harper and Row, 1982), 293–313 (originally published in *Artforum,* December 1973, 30–39); and "The Aesthetics of Power in Modern Erotic Art," *Heresies: A Feminist Publication on Art and Politics,* no. 1 (January 1977): 46–50.

15. Lynda Nead, *The Female Nude: Art, Obscenity, and Sexuality* (London: Routledge, 1992), 1, 2, 11.

16. "Nothing seems more like a whorehouse to me than a museum," writes ethnographer and man of letters Michel Leiris, in *Manhood: A Journey from Childhood into the Fierce Order of Virility,* trans. Richard Howard (San Francisco: North Point Press, 1984), 30.

17. Mary Ann Caws, "Instructive Energies," in *The Erotics of Instruction,* ed. Regina Barreca and Deborah Denenholz Morse (Hanover, N.H.: University Press of New England, 1997), 73.

18. Questions regarding authority, power, and empowerment—both the teacher's and the student's—have consistently circulated within feminist pedagogical theory. Recent considerations of these issues include Jennifer M. Gore, *The Struggle for Pedagogies: Critical and Feminist Discourses as Regimes of Truth* (New York: Routledge, 1993), and Carmen Luke and Jennifer Gore, eds., *Feminisms and Critical Pedagogy* (New York: Routledge, 1992).

THE PRIMACY OF PLEASURE

Leisure, Crush, the Dominatrix

April on campus. Lust loosens tongues.

Mid-May. The professor is in erotic rant.

Often she and her students get looser near the end of the school year. Lilacs and apple blossoms are full and fragrant then if a late frost hasn't interfered.

Married and unmarried, she has never been confessor, mother. Those are not the roles in which her students have cast or needed her.

This is autobiography and it is the fiction of myth; many details are missing from this telling, and the ones I elaborate as well as leave out enlarge both to fit into and to belie narratives of the professor's supremely clean or mentally lascivious life, of the mythos of white male mind, and of the midlife woman's erotic vagrancy, her wayward soul-and-mind-inseparable-from-body. Many details are missing, not because I do not remember them but rather because it is never the time for every memory to be recalled at once and told.

Learning has always been one of my primary pleasures. My mother gave me a sensuous infancy, a love of my body and of women's bodies, of words and of literature. She has been an erotic educator of soul-and-

mind-inseparable-from-body, as has my father, talking Braque and abstract expressionism: hands in the dirt, growing abundant pansies, bluebells, lilacs, honeysuckles, peonies, tiger lilies, and many more kinds of flowers throughout most of my life. My parents bought Eames, Aalto, and McCobb; Tiffany, Gallé, and Mucha before I was in college. I absorbed Mom's and Dad's intuitively given aesthetic/erotic instruction, read many of the art books in the house, and checked out literary classics from the library.

Pedagogues of pleasure.

When I lay on the library sofa to read, often on weekends for whole afternoons, life was full. I'd nap a little, smell the vegetation given earthy intensity by summer humidity, wake up to kitchen sounds, to Mom or Dad cooking dinner. The scholar's leisure took hold of me early on. Writing today at my black enameled McCobb desk; gazing to the left at one of my Dad's collages, in which the word L'ARTE predominates; looking out the window at the front garden planted by Russell and me, a part bright with pink roses and yellow coreopsis, I am in a state similar to the one I enjoyed for years in the family library.

First grade was especially tedious. I felt like pushing over the desk I sat at in class. I drew pictures of pinups from a deck of playing cards owned by the older brother of my friend Joyce. The drawings must have been funny because of their naive execution, but her brother wanted them. I'd sit in class sometimes thinking about the pinups, which interested me far more than did Dick, Jane, and Spot.

I didn't like Joyce's brother. His sexuality nauseated me, as if it emitted an evil odor. I sensed that he liked the pinup bodies differently than I did, that his soul-and-mind-inseparable-from-body worked on them from violation; for though I gave him some of the drawings, I felt dubious when I did so. His masturbation would shame the female body, whereas mine enveloped it in love. I imagined being the pinup women, but not for him.[1]

Already instructed in wanting to be what my feminist generation would fiercely critique, woman as sex object. Already aware that a female soul-and-mind-inseparable-from-body could perform for its own pleasure.

Mother-teacher's lessons outweighed the brother's, whose filial devotion to misogynist norms makes me queasy even today.

Seven years old and working to stay in love with myself.

. . .

Pedagogy is labor. The erotic body works for educational purposes through dress, voice, and movements.[2] The art of instruction produces literal professorial sweat. The student labors in consensual erotics with the teacher over difficult material, learning that hard work and pleasure are partners.

The pleasure of red: Miss Parson's, my third-grade teacher's, red, poufy hair; Carol's, my undergraduate art history professor's, red lipstick; my graduate nineteenth-century poetry instructor's red velvet suit delineating his slender limbs. They were, in respective and powerful stereotype, the prom queen, the vamp, and the dandy, and they marked me, in my visual sensitivity, with the beauty of their colors and shapes. They marked me as striking sculpture does, provoking my identification with them by means of color, shape, surface, volume, texture.

In childhood as well as later, pedagogy worked on me through erotic connection. Some would call that simply a crush.

In fourth and fifth grades I was teacher's pet. My teachers were young men, Mr. Rohrs and Mr. McCabe, whose styles were very different from one another. Mr. Rohrs was stocky and warmly bearish, Mr. McCabe was refined and slim.

> *My pet—my darling, my favorite, my pleasure*
> *Crush: infatuation or intense but passing attachment; puppy love, the foolish affection of immaturity.*

My memory and affection for my teachers—Miss Parsons, Mr. McCabe, Mr. Rohrs, Mr. Grunska, and Carol, for Sheila, Jerry, Everett, and Dr. Fajardo—have not passed; they are lifelong. Consensual erotics does not precipitate passing fancies.

The stepson told me he had a crush on me. Later, as if it were an admission or confession, he said, "I've been attracted to you for years"—his undergraduate career.

Crush: inane, hopeless desire; to destroy by placing between two opposing forces; to alter the shape through pressure; to overwhelm.

Crush precludes discussion, for discussion gives weight. Crush makes mind and body oppositional, so that the erotic is pulverized between them and changed into a misshapen impossibility.

A so-called crush is transference of student on teacher, a reaction to authority, and it is also the response to pedagogical erotics and to the pleasure of learning.

Medical officer Dr. Crusher in *Star Trek: The Next Generation* is a beautiful midlife woman. She is smart and designated sexy, the likely object of a viewer's crush, and she is an interesting analog to the bad body female professor on whom a student might get a crush. The name *Dr. Crusher* emphasizes the ludicrous impossibility of such a woman's responding to an underling's statement of attraction with anything but nasty power. Yet Dr. Beverly Crusher is warm, kind, and gentle, and she adores her son. Their relationship reminds me at times of those I've seen between midlife mothers and their sons who are in their late teens to mid-twenties. I've heard the mothers speak of their love for their son's physical beauty and intelligence. Dr. Beverly and her son Wesley read as a filial-amorous couple, like the stepmother-stepchild model I develop in chapter 8.

Beverly sounds soft and undulant. *Beverly* derives from Middle English *bever,* "beaver," and *ley,* "lea." A lea is a meadow.

Beverly—my pet, my pleasure, my meadowsweet pussy

I am pouring my love all over you

In high school Mr. Grunska tells me, after he has heard my presentation and read my paper on Lillian Hellman's *Children's Hour,* "You're brilliant. Why don't you talk in class?" I was an A student in his class and had chosen to study the play on my own. I had not expected his enthusiasm about the material and my sympathy toward it. Hellman's tragic work is about two schoolmistresses slandered by a twelve-year-old girl who thinks that they are lesbians. In *The Children's Hour* even the suspicion of partnered education and eros engenders rabid paranoia.

Mr. Grunska is heterosexual, a family man. I am sixteen, in love with my best friend Suze, though we focus our sexual talk and attentions on boys. He contributes to my ability to explore soul-and-mind-inseparable-from-body in scholarly and corporeal ways.

Sheila, who in college taught me early-twentieth-century English literature and with whom I read Proust in an independent study, tells me, as we're eating together on campus, that I look respectable. This disappoints me because I imagine she's saying I look boring, but her take on

looking respectable is that people trust you. "So you can lie to them?" I ask. "No," she says. "They'll believe what you say."

Many years later, Jennifer, once a student of mine, talks with me right after hearing a paper I've given at an academic conference. She says something like "You can say anything, you can say the most outrageous things because of how you look." I ask her why, and she replies that my attractive and respectable appearance gives me intellectual leeway.

Sheila also says to me, perhaps in the conversation mentioned above, "Don't apologize." Her words return to me even in my forties when I have heard myself being the sorry female, the professional woman who reveals her lack of self-confidence by apologizing for her ideas, her knowledge, or her authority by saying, "I'm sorry."

Australian writer Helen Garner tells a sorry-woman story. I quote it in full because of its currency—it happened in the early 1990s—and because of its resonant implications regarding women's deep unease about bearing a power whose roots are pleasure.

> In New York last year I heard a well-known woman journalist give a talk about a recent trip to Eastern Europe. The applause had hardly died away before her host at the event, a male academic whose special field was European politics, aggressively challenged her on a factual point. She produced from memory a more recent statistic than the one he had used to contest her argument, and courteously laid it down— but as she did this, she blushed. *She said, "Sorry."* "Male power," "patriarchal insensitivity"—yes, all this, with impatience and bad manners thrown in—but also *our* hesitancy, *our* feebleness of will, *our* lack of simple nerve. What *is* this fear women have of our own power—of just calmly taking hold of it, calmly putting it to use?[3]

The body betrays inability to enjoy the primacy of pleasure in knowing one's stuff: she blushes because she knows more than a man whose challenge displays grounding in power and pleasure. In this instance, his power and pleasure are perversely joined and used; but, nonetheless, men have learned that power and pleasure exist together and can be wielded in partnership. Women's wielding power need not be a feminist sin, an interference with liberatory pedagogy, an interfering authority that is particularly problematic for women students' coming into their own authority rather than having it imposed on them from a professorial height. (Authority, power, and empowerment are contentious issues

within feminist pedagogical theory.)[4] Sheila's "Don't apologize" meant to me almost thirty years ago, as it does today, that shame obstructs power/pleasure exercised erotically.

It is a shame to tone down, to efface the pleasure of being a particular soul-and-mind-inseparable-from-body, of simply enjoying oneself in the presence of others.

I realize one day in my late twenties, lying on the couch from which I sometimes escape visually into the upper stories of Chicago's Loop, that pleasure is the point of living. I say this to Dr. Fajardo, my psychoanalyst, who sits behind me. I have no memory of what immediately precipitated that revelation, nor do I recall what followed my statement. I remember being elated, and I have never doubted the truth of my statement.

Grandma, my mother's mother, says to me in my teens or early twenties, "We're here to suffer." She, Mom, my sister Ren, and I go on laughing jags together—over Jewish folktales that Gram tells with a perfect sense of absurd pictorial and narrative detail, over a rabbi's ridiculous (because repeated and circular) emphasis in an orthodox bar mitzvah on the words *core, nut, kernel,* and *essence.* The four of us laugh till I get hiccups. We laugh the way I did in my teens with my girlfriends, when I'd also get hiccups. Gram is often the essence of pure delight, so her grim picture of the human condition surprises me. I reject her lesson in suffering, gravitate instead to uproarious and contagious fun among girls. I respond to her, "Well, *I'm* not here to suffer."

Power comes to me through an old woman and a male psychoanalyst, pedagogues from whom I learn that pleasure operates against indoctrination.

Power comes through the rich release of laughter grounded in girlish guts and the resonant revelation that living can be erotic discipline.

Everett, my voice teacher, is a pyramidal volume, a Renaissance grandeur seated on his piano bench. In my mid- to late twenties he changes my breathing, my posture, my hair, and, of course, my voice. He brings my voice, which he calls golden, out into the open from my viscera. *He brings it out from my entire flesh and all my organs:* I think this when I am most fully in charge of that erotic tool and vehicle—my voice. He teaches me to stand straight; tells me to get on the floor of his studio, where he has me practice asanas; feels my abdomen so that he and

I together understand the pressure and strength of my breath. He says my perm makes me look like a poodle, sends me to one of the best hair-stylists in Chicago, gives me articles to read out loud to him so that I learn the information he wants me to along with clear enunciation and rich tonality. Everett attends a performance at which I'm one of the two singers. He tells me, "You stepped up onto the stage like you were a dog lifting its leg," then is very complimentary about my singing.

He advises good treatment of people because "whoever you meet on the way up the ladder you'll meet on the way down." The subtleties of good treatment are remarkably elusive. He says, "It's not who you know but who knows you." This makes perfect sense, a tenet I already practice. Everett gives me a typed, photocopied article six pages long titled "The Voice." It is about vocal erotics, though the author, whose name does not appear on any page and I was never told, doesn't use the word *erotics*. I sing as Everett plays piano, light classical pieces and popular songs from the forties into the seventies. He gives me books by Ouspensky and others to take home and read. He buys me vintage gowns at estate sales, sexy satin luxuries: emerald with fake crystal beads at the breast, milk chocolate with an overlay of netting, scarlet so that I will work myself into its vibrancy, not fear the voice that now came from my diaphragm.

Everett's voice is one of the two most beautiful voices I've ever heard. Its depth and mellowness are lessons in goldenness. He has developed an aphrodisiac voice. His soul-and-mind-inseparable-from-body is his voice.

It took me years to grow into red, to wear bright red lipstick comfortably.

"The Voice" is in the file cabinet to the right of my desk, bottom drawer, first folder. Whenever I read it, sometimes every several months, sometimes not for a few years, I relearn Everett's beautiful and severe lessons, the pleasures of aesthetic/erotic self-creation.

The pedagogue of pleasure teaches from the grave, commands me to perform with unique excellence, to apologize neither for it nor for bearing a power whose roots are pleasure.

Women who do not apologize for their display of power and pleasure may be called, unaffectionately, *bitch* and appear to mercilessly dominate. Some students call such women academics (rarely to their faces) *femi-nazi*, conservative talk-show host Rush Limbaugh's neologism. The "dominatrix" may provoke terror. Remember the effect of Jane Gallop's

red suit and attention-grabbing accessories, along with her demanding expectations. Perhaps people confuse *dominate* and *domineer,* believing that the female professor who exhibits power and pleasure does not deserve the respect of an expert who does dominate her classroom. She can only be a tyrant, and maybe a sexualized one.[5]

Dominatrix. I've heard through the grapevine that students think I look like a dominatrix. That's the word they use. As far as I'm aware, this articulated perception has occurred in my forties, when I am very clearly no longer a kid in appearance or professional standing.

Dominatrix: it must be my long dark hair (with distinct silver for a number of years), severe bangs, and True Red lipstick. (I didn't wear shocking red lipstick regularly before my forties.)

"You're so sexy." "I really want to kiss you." "She looks like Cleopatra; I'd like to bend her over." "Feminazi." "I'm lusting after you." "You look like the angel of death." Students and colleagues, sober and drunk, women and men, have made these comments to and about me in my forties. They suggest that visual and sexual pleasure and cruel power may attend a female academic who asserts both her body and feminist theory and politics, all of which, to her, derive from the primacy of pleasure.

Dominatrix. Shades of my nineteenth-century poetry professor telling me I remind him of Sacher-Masoch's *Venus in Furs.*

Dominatrix. The stepson wants to talk about latex fetish gear. I say I'm not into latex and don't know much about it as a sexual pleasure. He says that he's not into it either, but he brings up the subject on more than one occasion.

Dominatrix. The female professor in love with soul-and-mind-inseparable-from-body pleasure is a matrix of fantasy and speculation. Origin and legend: of evil—feminazi; of punishment—expert sadist; of sexual aesthetics—whipmistress in stilettos, corset, and latex.

My looks: respectable and quick as a fist.

The teacher is a disciplinarian who applies correctional methods and instruction. This sounds old-style elementary school but exists in the current professor's servitude to the supremely clean. Correction: from wrong to right, from abnormal to normal, from body to mind, from female to male, from pleasure to pain or simply indifference. This kind of correction discourages learning. Higher education seems rooted in Freud's reality principle. In order to establish and maintain civilization,

people sacrifice themselves to a work ethic that corrects one's longing for eros and the practice of erotics. Erotic practice is a different kind of work.

Eros enters situations unpredictably. Suddenly, or so it seems, you're in love or you laugh at something that seconds ago was not funny, or you understand a concept that has eluded you for days. When eros becomes erotics, it is purposeful activity. Erotics is a discipline of pleasure, so through pedagogical erotics a professor encourages educational and everyday pleasures.

Students do not generally associate pleasure with educational process or material. Few of them in my experience and research think deeply about pleasure, even in women's studies courses. There one would imagine that feminists' extensive theoretical discussions about female desire and the lack thereof would filter into if not be a prime subject of undergraduate as well as graduate courses—especially those in women's literature and art, where both the producer's and the audience's aesthetic and other pleasures are paramount.

I ask a feminist art criticism seminar in 1996 how they would define female pleasure or simply pleasure. No definition or description is forthcoming. One woman says she doesn't understand what pleasure is. Thus female pleasure is made an even greater blank.

In the mid-1990s a politically active feminist student who has taken a number of my courses in art history as well as performance art asks me how I can bear to study women and feminist theory; what one finds out (she has in mind the feminist theory and method class I'd recently taught) is so depressing. As a student and teacher we knew one another well, so her statement disheartened me. I'd presumed that learning and thinking about women had given her pleasure, and I was surprised that my own pleasure in those processes had not fostered hers. I suggested to her that rather than getting emotionally bogged down by the information, one could use it transformatively, to alter one's own and others' understanding and behavior. This needn't be a grand scheme, I said. One's daily intimate, school, and work relations can be loci for change.

I was a senior about to graduate from Sarah Lawrence College when four students were killed by the National Guard at Kent State University. In response, several women and I opened an alternative bookstore in the second-floor living room of the mansion-turned-dormitory where I

lived. I read the books and pamphlets we were selling, one of which was Valerie Solanas's *SCUM Manifesto*.[6] Acute, raw, funny, visceral, wicked, brilliant; power and pleasure: I loved the book, the passionate intelligence, the high monster/beauty that was relentless, efficient, seductive. The *SCUM Manifesto* is a key element in my becoming a feminist, and we Sarah Lawrence women were wildly smart and beautiful and often knew this because we were teaching one another pleasure.

The reasons why feminism has become for younger women who are feminists so frequently a depressing, grim business are complicated; it is not by any means solely the doing of feminists themselves. Feminism was fun of the richest variety; it was pleasure not amusement, a joyous play among women and ideas. For some of us, feminism meant sexual and intellectual freedom, soul-and-mind-inseparable-from-body play that urged us to purposefully act and think in behalf of others' freedom too, in behalf of eros. I concur with Gallop: "When I call myself a feminist, as I have for twenty-five years, I necessarily refer to that milieu where knowledge and sex bubble together, to that possible community, to that possibility for women."[7] For all. In behalf of eros.

Leigh Gilmore tells a teaching story that parallels my own accounts of how higher education's dearth of pleasure has merged with feminist failure to instill the rowdy and heady joy that many of us, now in our forties and fifties, felt when we became feminists as students in the late 1960s and early 1970s. Gilmore's story suggests that eros does not commonly visit the classroom, feminist or otherwise.

> I am teaching my first graduate course. My students, it seems to me, respond to every text as if they had been asked to complete the following sentence: "What I don't like about this text is X." I bring this up and ask them to consider how their analyses would be different if they were embedded in, or were an elaboration of, a discourse of pleasure. Not of formalist appreciation, but something else. Could they imagine it, were they familiar with it already, and what would it sound like? There is a long silence, as silences go in classrooms. They stare at me. One student says, "I never thought about pleasure in connection to graduate school." Another follows, "I've never thought about pleasure in a women's studies course."[8]

A recent comment by Israeli novelist A. B. Yehoshua reinforces the dearth—and necessity—of eros in the classroom. He remembers observing the controversial University of Chicago professor Allan

Bloom's interaction with students at a conference in Vermont: "I saw him encircled, surrounded by students, . . . chain-smoking, in dialogue with them. There was high erotic tension you could see in his students. That was the most important thing in this meeting, the eros. What we lack in teaching literature is this eros. It is the key to identification and participation. How can we reintroduce eros to departments of literature?"[9] Eros needs to enter other departments as well, and it needs to exist without embarrassment so that it can flourish.

Gilmore laments the low priority given to a pedagogy that works with classroom pleasure-and-power structures and that treats knowledge about sexuality. The subject of sexuality would, of course, seem to demand a discussion of pleasure, yet the significance of pleasure in education, as process and as subject, may be seen, according to Gilmore, as "supplementary or inappropriate for public discourse; something like dessert: what you can have after you've learned what is truly important, or, like dessert, what you may decline."[10]

People decline dessert because they think it will make them fat. One dessert, let alone dessert after dessert, is too much. Dessert is the monster/beauty food par excellence. People fear that abundance is treacle, icky emotion. They ingest it and feel guilt and shame. *I gorged on a pint of chocolate ice cream. I broke down and ate cherry pie à la mode. I cheated on my diet and ate a couple bites of lemon tart.* How begrudging we are. We can't get enough pleasure, so we give ourselves bits and speak in terms of losing control. We must keep our innards supremely clean, free of sweetness. We act as though sweetness is toxic rather than reasonably seductive.

People believe they don't deserve sweetness. Pleasure is apparently gratuitous. One must persuade them to pleasure. *Sweet,* related to Latin *suadere,* "to persuade," and *suavis,* "sweet."

Pleasure and eros are the sweetness of life, with which one does not have to have a harassed relation and without which one easily grows grim and unforgiving. Pleasure is a necessary luxury, for it is the fat of education, the finest, richest part.

NOTES

1. Maria-Elena Buszek, at the University of Kansas, is writing a doctoral dissertation on the pinup; in one section, she delineates and assesses what she sees as a

feistist reclamation of the pinup from the 1970s through the present. I include my own self-representations as an aesthetic/erotic subject and object in this reclamation, as does Buszek.

2. bell hooks, *Teaching to Transgress: Education as the Practice of Freedom* (New York: Routledge, 1994), 138, contends that "part of the class separation between what we [professors] do and what the majority of people in this culture can do (service, work, labor) is that they move their bodies. Liberatory pedagogy really demands that one work in the classroom, and that one work with the limits of the body, work both with and through and against those limits: teachers may insist that it doesn't matter whether you stand behind the podium or the desk, but it does."

3. Helen Garner, *The First Stone: Some Questions about Sex and Power* (New York: Free Press, 1997), 209. *The First Stone* is Garner's account of sexual harassment charges against a Master of Ormond College at the University of Melbourne. The book engendered enormous controversy in Australia, where many feminists have responded to it with great ire because of what they see as Garner's insensitivity to feminist issues and to the students who filed the charges. I use the passage quoted because it acutely describes a phenomenon that I witness in observing both female students and academic and art world professionals.

4. See Jennifer M. Gore, *The Struggle for Pedagogies: Critical and Feminist Discourses as Regimes of Truth* (New York: Routledge, 1993), and Carmen Luke and Jennifer Gore, eds., *Feminisms and Critical Pedagogy* (New York: Routledge, 1992), for recent debates about authority, power, and empowerment.

5. Joan Hawkins, a professor in the Department of Communication and Culture at Indiana University, presented a paper at the Style Conference held at Bowling Green State University (Bowling Green, Ky., July 25–28, 1997) that addresses the risky position assumed by the female professor whose dress, manner, and intellectual style are flamboyant. Titling her paper "When Bad Girls Do High Theory: Academic Style and the Performance of Transgressivity," Hawkins cites the writings and self-presentation of Avital Ronnell, Jane Gallop, and myself as she elucidates the possible attacks that female professors may endure when they use a "libidinally charged teaching/writing mode" (11).

6. Valerie Solanas, *SCUM Manifesto* (New York: Olympia Press, 1968). The work has been reprinted several times and is now available on a number of websites. SCUM is the acronym of Society for Cutting Up Men.

7. Jane Gallop, *Feminist Accused of Sexual Harassment* (Durham, N.C.: Duke University Press, 1997), 6.

8. Leigh Gilmore, "Becoming Obscene: Pedagogy as Sexuality, Pedagogy as Privacy" (paper presented at the "Sexuality and Pedagogy" session, College Art Association conference, Boston, February 1996), 3.

9. A. B. Yehoshua is quoted in John Easton, "Bloom in Review," *University of Chicago Magazine*, August 1997, 24. The article reports on a three-day conference, *The Closing of the American Mind* Revisited, held at the University of Chicago, May 16–18, 1997. Yehoshua was a participant in this event, which commemorated the tenth anniversary of Bloom's best-selling and controversial *Closing of the American Mind*.

10. Gilmore, "Becoming Obscene," 3.

Eight

THE AMOROUS STEPMOTHER
A Pedagogical Experiment

I wish to save the stepmother from her cultural fate, from her status as a cliché victim of her own monster/beauty, and to recuperate her as a pedagogical model of the female instructor's—especially the older instructor's—authority and intelligence as they are vested in her aesthetic/erotic substantiveness. My recuperation does not vindicate the stepmother by remaking her from martyr into saint, for the stepmother must remain a provocative figure, as are all archetypes and individuals steeped in erotic allure. However, my reconfiguration releases her from the archetype's scandalous and perverse essence.

The stepmother-stepchild model *is* outrageous compared to the common parent-child models that I discuss in relation to it. Throughout "Pleasure and Pedagogy" the stepmother has been an implicit and, I imagine for some readers, a disturbing model. She reads this way because our models for female professors are so few, so restrained and even stunted by the mythic good-mother teacher, which is a model of the supremely clean. I do not want to celebrate outrageousness for its own sake, but I do agree with Linda Brodkey and Michelle Fine, who advocate intellectual and practical activism as a method of treating women students seriously, that "the outrageous is . . . of untold pedagogical

value."[1] As an addition and challenge to familiar familial models, the stepmother operates, in feminist poststructuralist terms, within "the gaps and ruptures in practice—the breaks, confusion and contradiction that are always a part of the interplay in teaching"; it is these gaps and ruptures "that offer the greatest insight and possibilities for change."[2] The stepmother's bad body is just such a rupture in pedagogical practice, and that body's reality in the classroom urges description and analysis of its difference from father- and mother-child models. The stepmother, the female professorial bad body, points out a gap in pedagogical theory, a gap that we must expand by understanding ways in which she contradicts and confuses parent-child and other teacher-student models.

While finding then using gaps and ruptures has been a poststructuralist strategy, it recalls a passage in Monique Wittig's novel *Les Guérrillères* well known to feminists, from which I quote the most famous lines: "There was a time when you were not a slave, remember that. . . . You say there are no words to describe this time, you say it does not exist. But remember. Make an effort to remember. Or, failing that, invent."[3] The stepmother in the West has been a slave to the malevolent archetype that has developed from the social reality of stepfamily conflict through Western history. From Greek and Roman literature to Anglo-Saxon and Merovingian dynastic chronicles to nineteenth-century fairy tales and twentieth-century movies, the stepmother's persecution if not murder of children from her husband's earlier marriage(s) is a running theme. Marina Warner explains that such stories and records worldwide "exhibit the different strains and knots in different types of kinship systems and households, arising from patrilineage, dotal obligations, female exogamy, polygamy."[4] The archetype thrives today not only because it has so long gripped the imagination but also because it continues to be distilled from the struggles of divorce and remarriage. For example, Patricia A. Watson opens her book *Ancient Stepmothers* (1995) with two contemporary anecdotes whose stepmother figures fit firmly into the archetype. In one anecdote, first published in 1983, the recounter exclaims, "Oh, boy, I could tell you some stories about stepmothers. I have clients who relate tales that would make your hair stand on end. Really, some of them have been absolutely brutalized by their stepmothers. . . . They can't be human."[5] Following Wittig's directive, this chapter invents the amorous stepmother, a type of evil stepmother appearing in ancient myth and classical literature, as monster/beauty—so different from the inhuman

monster of contemporary accounts and misogynist Athenian culture, so useful to an elucidation of the teacher's and the student's mutual affections in consensual erotics.

Like Wittig, the authors of *Mother Daughter Revolution* (1993) advise "inventing yourself," a practice that includes girls and girlhood, daughters and mothers, and "the next generation of women." They introduce Lisa Sjostrom's *Reader's Companion to "Mother Daughter Revolution"* by asking, "How can we raise great women instead of 'good girls'?"[6] One of the answers given by Sjostrom is to renounce the evil stepmother, who populates stories that girls learn to live by, and to "make up stories and fairy tales with your daughter."[7] Evil stepmother stories teach girls to revile older women.

Johanna has told me that I'm like a mother to her, but very different as well. We've talked about our erotic attachment to one another, as teacher and student, as older and younger woman, as mind to mind and body to body, and she names me her fairy stepmother. "Fairy" in order to dispel the archetype's enmity toward others' children.

I'm having coffee with a friend. A man in his early twenties brings it to us and says to me, "You and [the stepson] are good friends." My friend's raised eyebrows and her smile teasingly say, "Oh, so you're sleeping with him." In politeness I respond to the young man who is apparently the stepson's friend, "I guess so," then tell my friend that there's nothing going on between the student and me.

At the time of this coffee I would not have said that the stepson and I were good friends. I didn't think that we knew one another very well. Perhaps we were professional and romantic acquaintances. Our relational designations always seemed uncomfortably though excitingly obscure to me. Being his mother's age, I was like a mother? But he didn't feel like a son. More like an erotic playmate, like a smart, attractive younger brother. More like a lover-to-be or -not-to-be. Months after the coffee, soon after the stepson's graduation, I said to him, "It feels like we're lovers but we're not sleeping together." His almost shocked look surprised me. Our relationship ended, an unresolved love story, after that night.

Johanna and my stepson, I loved you as I do all my students who are talented and thinking, and I have loved you more and differently because, in aesthetic/erotic partnership, we crossed generational boundaries. We responded to each other's exertions of flesh on flesh.

Such relationships are difficult to fashion and tenuous. Society does not sanction them; perhaps more essentially, society provides no workable names

for them. Names can enslave us, stick us in positions from which it is a strug-gle to escape, but names can also offer freedom from claustrophobic categories, especially if we invent the names and remodel the categories.

Fairy stepmother, fairy stepdaughter, fairy stepson. These names activate and augment consensual erotics. The fairy godmother magically enhances a godchild's life. Magic equals erotics, for both are the practice of profound con-nection. The fairy stepmother "magically" sponsors—takes responsibility for—her fairy stepchild's inseparably intellectual and fleshly improvement, and the fairy stepchild is similarly responsible for the elder fairy kin.

Phaedra and the evil queen in the Snow White fairy tale are major Western paradigms of the stepmother. In Greek myth Phaedra, the sec-ond wife of Theseus, king of Athens, falls in love with his son Hippoly-tus. Her ravenous lust sets in motion events that cause both Hippolytus's death and her own. The evil queen discovers, from her mirror's words, that her stepdaughter Snow White is more beautiful than she, which infuriates the queen so much that she commands her huntsman to kill the girl. Because he takes pity on Snow White and saves her, she lives to marry a prince; on her wedding day she forces her stepmother to dance in shoes that are red-hot irons till she drops dead. Euripides' tragedy *Hippolytus* (428 B.C.E.) is a basis for Racine's play *Phèdre* (1677), and the tragic mode of drama continues into the twentieth century with H.D.'s *Hippolytus Temporizes* (1927) and Kenneth Rexroth's *Phaedra* (1951). (Euripides wrote two versions of the play. In the first, which did not sur-vive, Phaedra is shamelessly sexual; in the second she is Aphrodite's innocent victim with a character apparently found more sympathetic by the audience. In this chapter I refer to the second version.) Tragedy is also the fairy tale's dynamic, for it is a story of generational hatred, of competitiveness between an older woman who fears that she is becoming ugly and a young woman who has no understanding of her elder's aes-thetic or erotic complexity. The Snow White story's black-and-white les-son contains no conflicted emotions or perceptions. Simply, neither step-mother nor stepdaughter can admire or respect the other's allure. In Euripides and Racine, Hippolytus cannot even tolerate his stepmother's passion; he finds it loathsome. Hippolytus is the devotee of Artemis, goddess of chastity, and Aphrodite, goddess of bodily love, rules Phaedra.

Both Phaedra and the evil queen are dazzling and alarming figures. They radiate acute intelligence that is burdened by aesthetic/erotic fire

and amplitude; thus the stepmother, an archetype of passion that is scandalous, manipulative, uncontrolled, and dangerous to the social order, must be punished—tortured emotionally or physically—then killed off. Young men must not bond amorously with women whose erotic energy belies the chaste morality deemed suitable under patriarchy for good mothers, wives, and women in general. Phaedra is too hot for her own good, is certainly too hot for a youth to handle. Even though she is not much older than Hippolytus, she is far older in living, in erotic sophistication. Her heat is the fever of lovesickness aggravated into madness. In H.D., Hyperides, a courtier of Athens, tells Hippolytus that "They say, / [Phaedra was] stricken with fever, / hot and hot and hot" before she hanged herself.[8] This fever is a sexual heat as well as a mental and physical ailment; "The Argument" that precedes act 1 affirms that Hippolytus "inflames" Phaedra.[9] In both H.D. and Rexroth, Phaedra and Hippolytus sleep with one another—something that does not happen in Euripides or Racine. In order to satisfy her lust in *Hippolytus Temporizes*, Phaedra uses subterfuge, but in Rexroth's play she bluntly expresses how hot she is for Hippolytus. When it is clear that he desires her yet cannot say that he wants to sleep with her, she takes over, continuing their erotic verbal dance but with an aggressive charge that permits him to deliciously submit to her.

> Phaedra: Do you want me?
> Hippolytus: I want
> What you want.
> Phaedra: No you don't. But I
> Will take you. Maybe it is what
> I want.
> Hippolytus: I want you to take me.[10]

The "No you don't" of Phaedra, who was probably a high priestess in her homeland Crete, suggests that she, the wise woman, knows death will be her fate and that of her erotically uneducated lover-to-be.[11] In Rexroth and H.D., despite the stepmother's and stepson's sexual engagement, the story remains a classic of unrequited love in which *her* out-of-bounds eros engenders the trajectory of doom.[12]

Snow White's stepmother is also hot—a proud beauty; in Disney's animated film (1937) she is a spectacularly glamorous, seductive figure. Her desperate jealousy is a kind of madness or mental fever that drives

her to vow death to Snow White "even if it costs me my life!"[13] Like
Phaedra, this stepmother is a woman of magic who, in the Grimms' ver-
sion of the story, employs the "help of witchcraft,"[14] so her exclamation
is more than simply foreshadowing: it is foresight if not prophecy that
she will burn in those Sadeian shoes because she is too hot to live into a
healthy midlife in which she and Snow White—a young beauty who
could become a hot, mature woman—can be erotic companions. The
Snow White story is an exemplum: older women and young women do
not bond with one another in aesthetic/erotic empathy, and it must be
the former who are aesthetically/erotically unstable, whose wayward
eros—no longer at home in their bodies—instigates their own demise. As
Marguerite Yourcenar writes in her acerbic "Phaedra, or Despair," her
collection of poetic prose pieces about love, Phaedra "haunts her body as
if it were her personal hell."[15] Until her death she lives like a refugee.
This is as true of Snow White's stepmother as it is of Hippolytus's.

The amorous stepmother's stock characteristics, assessed on first
glance, appear not to make her a worthy pedagogical model. She is, Wat-
son states, "a special offshoot of stepmotherly malignity" whose basic
evils are the same as those of the more common murderous and cruel
type portrayed in Greek stepmother myths and many Greek tragedies
based on them.[16] Watson asserts that bias against the stepmother in
Greek texts reflects a general misogyny, such as that seen in the writings
of Aristotle and others.[17] In accord with feminine nature, the amorous
stepmother lacks self-control, displays brazen and avaricious sexuality, is
corrupted by jealousy, and uses cunning and treachery. Usually the
amorous stepmother and not the stepson initiates, or tries to initiate, a
sexual liaison, and usually she fails not only in this endeavor but also in
her attempt to ruin her stepson.[18] The archetypal story of the amorous
stepmother, apparently originating in an Egyptian folktale from the four-
teenth century B.C.E., displays certain foundational elements: a step-
mother sexually propositions her exceptionally chaste younger stepson;
he recoils from the proposer and her desire; with righteous anger he
affirms his loyalty to his father and his devotion to god; infuriated by her
stepson's rejection, the stepmother falsely accuses him to her husband of
attempted rape; the father is inclined to believe that his son is guiltless,
but sees to the innocent's trial and punishment; later, the son is exoner-
ated, his fortune increases, and the stepmother is punished.[19]

The stepmother's feminine nature ensures that she is a monster, and
scholars often apply the words *monster* or *monstrous* to stepmothers. Thus

Warner states that Cinderella's and Snow White's good mothers are "supplanted by a monster"; and Watson remarks that in folktales stepsons separate from and vanquish a mother figure "represented by a stepmother, monster, or other form of persecutor,"[20] a list that tends to equate monsters and stepmothers. Phaedra's passion for Hippolytus is, of course, monstrous, and in Racine she calls herself "another beast of Crete," referring to the Minotaur of her homeland, and a "terrible monster."[21] Phaedra herself is the daughter of a monstrous mother, Pasiphaë, who coupled with the Minotaur, so her monstrous passion should be no surprise.

Bruno Bettelheim claims in *The Uses of Enchantment,* his classic Freudian analysis of fairy tales, that the wicked stepmother in the Snow White story is a figure with whom no one can identify.[22] Everyone, it seems, identifies with the sympathetic heroine Snow White and her development. Not me. When I was a little girl and saw the Disney film, the queen intrigued and even seduced me. I don't recall how old I was when I first read or had read to me the Grimms' fairy tale, but the film and the writing must have combined to create my image of an older woman who was strikingly beautiful, commanding, and *magically* intelligent, a woman of powerful voice, bodily movement, and clothing—a monster/beauty whose highly articulated style impressed upon me its more substantive underpinnings. Unlike too-sweet and ignorant Snow White, who seemed dumbly domestic (keeping house for the dwarfs), the stepmother knew how to make and use magic potions. This is a skill common among evil stepmothers—concocting aphrodisiacs and poisons—and in retrospect I think that the power of the stepmother's erotic knowledge outweighed for me the malevolence of its employment to kill Snow White.

The amorous stepmother teaches Snow White how to plant herbs, how to cut dead flowers for further blossoms, how to garden, how to grow

Aphrodisiacs together

Fairy stepmother and stepdaughter test, then quaff and devour different love nutriments and potions. These homegrown foods aid the elder's self-love as she ages, and they bring the two into one another's arms, hearts, and heads so that they can tell each other, "The mirror is a spy and liar."

The stepmother confesses, "I bought it when I was young and not as good at magic as I've become. As you'll learn, our art is full of rhyme and reason, but it is imperfect."

Then the mirror confesses too, for spells are being broken. It speaks in a voice so transformed from the game-show announcer or snake oil salesman intonations to which the stepmother has been accustomed that she exclaims, "What platitudinous and painful horseshit you were cursed into proclaiming. Now maybe we can have some conversations."

In the middle of a class one day during a section of the course focusing on women and aging, I ask the students to respond in writing to the question, "What is an older woman?" Johanna writes the following:

> *She is a risk-taker. Sometimes a risk-maker. Outliving her potential, she creates new potential. Awe inspiring, fear inspiring, aggressive merely by persistence. Parody, paradox, space-maker, space-taker. Proof positive of the invisible, proof negative of time stood still. Monster hero, Cinderella's descent, ascent. A reminder of the future of tenacity, of fragility, of morality, or immortality. Chaotic grace, unrelenting life. Fingernails, toe-nails, eyelashes, eyebrows, hair. Elixirs and omnipotence. Undetectable change and growth. Unmistakable presence. Thicker, denser existence of rings like trees. Can only be reproduced through like tenacity. The sensuous choice to look intensely or not look at all.*

The mirror sighs in relief and stepmother and stepdaughter collect flowers from their garden, fill vases with them, and set a vase in the castle's every room, including one vase on each side of the mirror. Realizing that magic is not a habit or a rote ritual but rather a daily invention formulated from prosaic materials—flesh, food, flowers, talk—the mirror, stepdaughter, and stepmother, all brought to their amorous senses, compose a song and sing it.

No dance to death no iron shoes
We've already paid some hellish dues
No more mirror's claim to truth
When its eyes are used to loving youth
No more good girls who gaily sweep
Instead of knowing eros deep
Inside clichés of female narcissism
Time for wisdom time for wisdom
Listen to crimson listen to crimson
Snow White's lips and her stepmother's
Speaking love to one another

Johanna and I are strained and exhausted from overwork. I meet her late on a hot summer day at the gallery where she is working and she tells me almost

immediately that we must go to a nearby diner and share a chocolate pudding, which she has raved about before. The whipped cream–topped dessert is as delicious as she had promised, and my lemonade is perfect—not too sweet, served in a tall glass. We gossip about the art world. I feel refreshed.

In eighth grade I played Snow White's stepmother in a school play. My lips were crimson, and a floor-length gown gracefully skimmed my woman's body. Sequins sparkled here and there on the simply designed dress borrowed from the clothing collection of a woman in my hometown who rented costumes for Halloween and parties. I wore a crown, and a cape clasped by a gleaming brooch covered my shoulders and revealed my chest and torso. I was very pleasurably aware of my breasts and height. (At that time I was one of the tallest girls in my class.) Like the archetypal stepmother in Grimms' tale and Disney I used my corporeal intelligence—my voice, stride, posture, expressive face, and sense of what many years later I would call the erotic—to *be* the stepmother, not simply to imitate her. Not only did I identify with the stepmother; I loved her. I was successfully potent, for the teacher who directed the play told me that the boy playing the huntsman said I had terrified him.

Snow White's stepmother has no name. What she has more than anything else is envy, rage, pain, and grief; Bettelheim adds to these qualities immaturity, because she "cannot age gracefully and gain satisfaction from enjoying her daughter blooming into a lovely girl."[23] As I have written elsewhere, aging gracefully is "a euphemism for fading away, lulling lust."[24] A substitute pleasure for one's own aesthetic/erotic self-creation is frustrating, even self-negating. To be sure, another's beauty is a pleasure to witness, to sit across from in conversation. But in Bettelheim's interpretation of the fairy tale, the older woman is in the wrong. Any injury to the stepmother—by the stepdaughter or the mirror, by social opinion or an ageist ideology on which it is based—is unseen. Indeed, the Snow White story "carries the wronged *child's* name, as does the story of Oedipus" (my emphasis).[25]

Amorous stepmother without a name
Let me give you several:
Florence, my mother with her crimson lips and black hair, my good
 mother, my erotic guide
Johanna, who asks me how our garden grows
Jamila, whose passion transgresses the four walls

Maria, who calls me mentor; I call her mine
Ida, my grandma, who believed that granddaughters could be great
 women

Johanna is a beauty of the blonde bunny goddess type. Given Bettel-
heim's and Jungian analyst Jacqueline Schectman's interpretations of the
Snow White fairy tale, I should probably envy if not despise Johanna: as
Schectman believes, "Age will always envy youth her unbound spirit,
will always need to leaden her lightness with suspicion."[26] This pro-
nouncement comes from a chapter in Schectman's book *The Stepmother
in Fairy Tales*. Not promising. The author leadens the older woman
reader with more than the suspicion that she is meant to suffer. The
midlife woman feels "the weight of age," because any Snow White in the
older woman's purview is a "beautiful usurper" who surpasses her.[27]
Schectman's chapter " 'Snow White' and the Loss of Youth: A Midwin-
ter's Tale" perfectly illustrates my critique—in chapter 2—of midlife
women's prominence in narratives of loss. Bettelheim and Schectman use
the Snow White story to teach the older woman a lesson, to concoct a
self-fulfilling prophecy of self-destruction, to embroider upon what
Maria Tatar aptly calls, in her study of fairy tales and childhood culture,
"the pedagogy of fear in fairy tales."[28]

*Johanna and I begin to have lunches together. It takes more than a year for
her to believe that her ideas are interesting. Then our conversations become
quick, fun, and penetrating, and I feel light with her.*

*The generations become one another. Amorous complements and counterparts,
they do not seek a fountain of youth in cursed mirrors. Instead they find eros,
the flower and sustenance of monster/beauty, in each other and it makes
them luminous.*

> Myrrhina *O lady, lady, lady,*
> *luminous more*
> *than any spray of myrtle*
> *or white flower*
> *of the enchanted flowering citron-tree. . . .*
>
> *O lady, lady, lady*
> *luminous more*
> *than golden spray of orange*
> *or white flower*
> *of pearl and fire*[29]

*"You were luminous last night," the stepson gleams. "I've never seen you like
that before." His compliment refers to a performance of mine in which I wore
a white velvet dress whose translucent, stretchy fabric revealed contours, erect
nipples, and the darkness of pubic hair.*

*(Can anyone believe that the stepmother does not want to look like Snow
White?)*

*"Phaedra," one of my women friends calls me, humorously remarking on my
relationships with younger men.*

The parent-teacher is disembodied. Representing the university in loco
parentis, she or he must be the good body, aesthetically/erotically unob-
trusive, for the parent-teacher not only intellectually but also morally
guides the student, the latter in conventionally appropriate ways. The
parent-child model denies that everyone is more or less erotically
embodied—and potentially extremely so—and that such embodiment
provokes amorous feelings. This denial implicitly defines the student as
very young. But university students in their twenties are adults, and most
are not uncommonly chaste like Hippolytus. Most young male heterosex-
ual students would not agree with him—in word or deed—that sex with
women is verboten. They may explicitly or subtly hate women, as does
Euripides' Hippolytus—"I'll hate you women, hate and hate and hate
you, / and never have enough of hating"[30]—but an amorous attraction
would seem just fine, could happen despite such misogyny. (Misogyny
and love, and of course misogyny and sex, do not cancel out one
another.) Also, young male heterosexual students, sufficiently experi-
enced in both misogyny and sexual and emotional relations with women,
may detest or fear smart women—"Lust breeds mischief / in the clever
ones"—and believe that they are "beauty heaped on vileness";[31] but
most young men have not evaded Aphrodite, have not infantilized them-
selves erotically as does Hippolytus.

"My bed is never empty," the stepson tells me.

*A drunken student the stepson's age, who has until now been sexually
involved only with men, declares, a little pleadingly, "I want to kiss you," as
she describes to me her recent and first sexual relations with a woman.*

If parent-child infantilizes young women and young men by ignoring
their erotic lives—and, as I have been arguing, it is erotic vitality that
promotes the deepest intellectual learning—then father-teacher infan-

tilizes by being so much the authority and even the enforcer, so much the representative of institutionalized knowledge, that the student receives information and ideas rather than acting on them or creating new avenues of thinking. Some professors may say that such action or creation is not an undergraduate's job; but besides providing both traditional and current disciplinary knowledge, higher education must enable and encourage creative scholarship from undergraduates as well as graduates so that—returning to Wittig—slavery, to rote or to fashion, gives way to an erotic invention of the future that is grounded in remembering the past.

Father-teacher *can* be a body. He is the male instructor who through sex transmits knowledge to either women or men. The clichéd metaphor for this particular kind of erotic pedagogy is penetrative intercourse as penetrating intellect: the process, based on a conventional heterosexual model, being the student's passive receptiveness; the result being the reproduction of knowledge. The progeny of this model is conservative in contrast to a possibly radical, erotic invention of the future that I suggest above.

The mother-teacher complements the father-teacher. They are partners under patriarchy, so she plays purity to his sexual skills. (Theseus's sexual exploits are part of the versions of the Phaedra myth that I have cited, but Phaedra has had no such history.) Mother-teacher *is* a body, the outsize mythic breast of the nurturer. She is the good mother, a feminist model of the women's studies instructor, who is nurturing, lovingly understanding, and intellectually supportive rather than judging. Certainly, as I point out in chapter 3, the maternal intertwines with the sexual, with original erotic learning. In *Exiles and Communities* Jo Anne Pagano pinpoints and develops the maternal body as a site of desire and knowledge.[32] Mother's body provides a child's earliest information and intelligence about life itself, and children desire mother's love—not her body in any genitally sexual way. The mythic mother's love is oceanic, which *is* erotic, and her love teaches through the wholesome givingness of the breast.

Both father- and mother-teacher can be construed as amorous models. The amorous person can be fond of someone or full of love for her without necessarily being in love or sexually motivated. Fond or loving: the amorous stepmother, like the mother-teacher, can be either one. In love or filled with lust: she, like the father-teacher, can be these as well. But

her ability—her curse?—to be able to cross genders, to love like a bitch and like a fucker, is not what is most striking and useful about the amorous stepmother as a pedagogical model. Rather, it is her aesthetic/erotic "abnormality," even blatancy, her capacity to "open" and "enable" students by means of kindly breast *and* aphrodisiac nipples, to unashamedly opt for pedagogical pleasure in classroom and personal relations, to challenge patriarchal academic and cultural conventions, and to connect with students both in and outside the classroom in ways that stimulate and even sustain students' challenges to the same conventions— at least during their university education.[33] Granted, operating in the territory of both parents/sexes is a challenge to customary rigid sex and gender roles. The stepmother's deviant motherhood—being the bad body instead of the good, not being the biological mother—allows her to operate as a distinctly female monster/beauty who is neither a substitute nor surrogate for the natural and "naturally" good mother.

Phaedra never belongs in Theseus's family. She is a foreign princess and she detests Greece. Phaedra is always a step, if not many more, removed from both Theseus and Hippolytus. Pointing out the etymology and etymological associations of the prefix *step*, Watson acknowledges its negative connotations: "the stepmother is one step removed, i.e., second best, or alternatively . . . she is stepping into someone else's shoes."[34] Compared to the stepson's mother Hippolyta, Phaedra, in Hippolytus's estimation, is a failure and a depressing disturbance. H.D.'s Hippolytus loves and praises his mother. He calls her "my loveliest mother" and tells Artemis that Hippolyta's "white soul lives in me, / . . . Hippolyta is my arrow-point / my spear," that "my great mother / shaped me to her will" and gave "no space to woman vagaries" like Phaedra.[35] In Racine he confides to his teacher Théramène that "since this Phèdre . . . / came here, she has upset my life." Théramène responds, "Phèdre . . . depresses you. / The first time she met you, she hardly let you smile / before she ordered your immediate exile. / . . . [H]er raging hate . . . had you in its hold."[36] Yourcenar suggests that Phaedra's bad mothering is the reason why her stepson finds women repulsive: "She hates him, she raises him; he grows up against her, rebuffed by her hatred, accustomed, since his early years, to mistrust women."[37] In Euripides the hatred Hippolytus bears toward women is crystallized in his hatred for his stepmother. Simply put, Phaedra has never tried to replace her stepson's biological mother.

As for Phaedra's wifely passion, in no version of the Phaedra myth that I have cited does she appear to love or sexually enjoy her husband. Yourcenar relates, "In Theseus' bed she has the bitter pleasure of cheating, in actuality, on the man she loves."[38] Phaedra is always unfaithful to Theseus in fantasy or in deed, and she finds him sexually unsatisfying in H.D. and Rexroth. In a fatefully ironic speech to Hippolytus, in which she inadvertently reveals her attraction to him, Racine's Phèdre speaks of loving Theseus because Hippolytus reminds her of her husband when he was young: "He had your poise, your gaze, your manner and your grace, / a gentle tender smile that lighted his whole face."[39] H.D.'s Phaedra confides in her serving lady, "What is the dotard love / of a dull king, / Myrrhina? I know / what love might have been."[40] While H.D.'s stepmother impersonates Artemis and sleeps with her stepson in this guise, Rexroth's Phaedra finds love and sexual ecstasy with Hippolytus as her obviously lustful self, revealing to her new lover that "Aphrodite who turns / Men's hearts inside out never / Haunted the bedside during / My scrimmages with Theseus."[41] For her and Theseus, sex has been at best a game, at worst a battleground. Even Euripides' virtuous Phaedra couches her horror of her scandalous feelings not in the pain of betraying a man she loves but rather in concern over "the wife who herself plays the tempter / and strains her loyalty to her husband's bed."[42] She has shamed that bed, and shame is one of this honorable stepmother's dominant feelings.[43]

Phaedra has filled no one's shoes as wife or mother. Nor does she properly respect marital duty to fidelity. Whether Phaedra actually commits adultery or only imagines it, she threatens society's well-being. Her disloyalty to father-mother complementarity is infidelity to the institution of marriage/motherhood, and it is she, as the victim or messenger of Aphrodite, who makes possible the student-stepson's invention as challenger of the status quo. Amorous stepmother and stepson do not have to fuck one another in order for this to happen. But they do have to *look at one another closely,* so that taunts of robbing the cradle and incest do not make her run from eros and so that he can overcome his fear of the older woman who embodies an aphorism by Thomas McGuane, recited to me—not verbatim—by a friend: There is nothing more frightening than a beautiful and intelligent woman who is interested in you. The amorous stepmother must surmount Phaedra's shame, and the amorous stepson must risk saying, like Rexroth's Hippolytus, "Let me

forget my father. / Tonight we are going to start / To make ourselves new memories." Part of his stepmother's brilliance is her simultaneously oracular and matter-of-fact bleakness. She responds,

> People have tried that before.
> Memory, unhappily,
> Is not some wandering ghost
> That the mind can dispossess,
> But living bone that our acts
> Made powerful over us.[44]

Phaedra needs to listen to her stepson—to the young—so that they can make new memories, which build new bone, which supports new muscle.

The amorous stepmother as a pedagogical model that serves as erotic guide needs to pay attention to Wittig more than to ancient myth so that she can be a loving friend to her stepson and so that she and he can stay alive. Despite Rexroth's significant departures from ancient myth and its best-known retellings, he foregrounds as much as ever Phaedra's and Hippolytus's deaths. Though her advances are welcome, though the two have exceedingly pleasurable sex with one another, and though Theseus even says—to Hippolytus himself—that he's proud his son "gave her comfort in my absence," that he even "planned it this way," that he wishes them well together and will give them "Crete / For your province,"[45] the deaths validate the truth of old erotic myth. Even Theseus the great hero, a "bawdy / Old campaigner" who has just returned home from Hell, where he fucked Persephone,[46] cannot conquer the profound moral and cultural memories held by stepmothers and stepsons—memories of the father, of the patriarchal laws and habits that cannot easily be forgotten. One of the reasons why the stepmother has been so despised is that she "is by definition an intruder who imposes a new domestic regime on the household."[47] Like Snow White and her stepmother, Hippolytus and Phaedra can create new erotic myths to generate and reflect a new social order. All of us, children of an old regime, may not welcome the new.

The stepson is admiring my bright blue, high-heeled, suede gillies and comments, "You have so many great shoes." I hadn't known that he looked.

Phaedra brings her own shoes to Athens. She has many pairs.

"Can I try them on?" suggests Hippolytus.

"Why?" Phaedra asks.

"Why not? Hippolyta wouldn't let me ever put on even one."

Phaedra nods assent to her stepson's request and offers, "Theseus has been remiss with me, sort of stingy, like Hippolyta. He never tells me I'm beautiful."

"Father doesn't care about beauty—in women or anything else. He likes to fuck them young, but I would rather be Eros to Aphrodite."

"Motherfucker?"

Hippolytus's laugh shades into a "gentle tender smile" that "light[s] his whole face," the expression that Racine's Phaedra finds so alluring in her stepson.[48] "Not exactly. Hippolyta appealed to Theseus, though I loved how she loved me with all her monstrous Amazon muscle and her one breast, better than most mothers' two. She was big, lean, and beautiful." He looks at Phaedra's bare arms and shoulders, her round muscle, smaller and covered by more fat than Hippolyta's was. "You don't have to be big to be beautiful." As their eyes meet, she notices the length and thickness of his eyelashes.

In the Phaedra myth and its retellings Theseus readily believes that Hippolytus has raped Phaedra. Watson asserts that while no evidence exists of Athenian amorous stepsons, "the father's ready credence of the stepmother's false accusation in myths of the Phaedra type might demonstrate, if not Oedipal feelings, at least a common acceptance of the idea that a stepson might be sexually attracted to his stepmother rather than the reverse."[49] In classical Athens sexual attractions or unions between a stepmother and stepson were not considered incestuous, as they were in Rome.[50] So Hippolytus, if he desires Phaedra or sexually consummates that desire, is not a motherfucker.

Mother-child incest sexually violates the good mother and the concept of motherhood itself, which she represents. But incest is not an issue between amorous stepmother and amorous stepson, whose relationship operates according to a different psychological, emotional, and instructional dynamic than the parent-child models I have discussed. The taboo in this new model is the erotic itself.

The amorous stepson is a different kind of hero from Oedipus. Neither his desire nor its physical satisfaction compels him to feel castrated by an older woman. He does not have to blind himself because he cannot bear to look at something he may still love and want, the lover-mother—embodied by Jocasta in the Oedipus tragedy, which is the most enduringly

230

famous development of the archetype. Although a young man does put himself into a more vulnerable position than an older man as the seducer or lover of an older woman, who by virtue of sheer experience becomes a figure of authority—even though Western culture demeans her *erotic* authority—he, like the older woman, also harnesses the aesthetic/erotic potency of what Paul Friedrich calls the suppressed lover-mother.[51]

During our first meeting away from school, the stepson says about sex, "I don't have much experience." I'm surprised but say nothing. I wonder if he's telling the truth, then I wonder why he wouldn't. I imagine that his perception of my authority or experience causes him to be intimidated, to downplay his own sexual authority. Much later, after I hear that statement that I earlier quoted, "My bed is never empty," I imagine that from the beginning of our relationship he has never been inexperienced.

Friedrich's rich insights into Aphrodite's liminality, her joining of "sex/sensuousness and maternity/motherliness," apply to the amorous stepmother as a pedagogical model.[52] These "two complexes"—segregated from one another, as Friedrich elaborates, in Greek myth, Western literary classics, folktales, and many individuals' behavior—express a "culturally patterned and indeed enjoined antithesis" that is an essential feature of the father- and mother-teacher couple. The amorous stepmother instructor, who, unlike Phaedra, is not a slave to Aphrodite but rather represents the goddess's liminality, similarly operates within "a single deep emotional and symbolic stratum" whose cultural sanctioning, claims Friedrich, would "threaten the male's image of his authority" and infringe on his role as mythmaker. Bridging the complexes would "entail or imply too great a concentration of power"—sexual and emotional—in women, making it difficult to maintain "normative representations that dupe women into keeping their place." Friedrich asserts that men are the primary contrivers of theories and myths that "tend to mold the growing woman, including future female myth-makers." All women can be growing, not only the young, and future male as well as female mythmakers are molded by the same representations. Father- and mother-teachers, themselves pedagogical myths, are restraining models that minimize the female professor's power by producing it as the antithesis of the male professor's power. Friedrich terms the conventional molding of mythmakers "indoctrination."

Hippolytus rolls his eyes. "Ever since I can remember, I've been indoctrinated in Oedipus. As if every friendship or flirtation between a young

man and an older woman must collapse into a juicy mess of error, crime, pollution, death—miscalculations and misunderstandings built on misidentification."

"The almighty Oedipal encounter as heroic myth," adds Phaedra, "in which suffering is the truth of relationship. Unless a woman fits the mold of old maid schoolmarm, she's ripe for tragedy."

"No one is a schoolmarm, that prim and condescending, all-knowing and tyrannically authoritative, removed and bitter, bodiless impediment to education."

"Jeez! Some invective!"

The amorous stepson teases Phaedra, "Not exactly a foreign princess."

Her intonations are sarcastic. "Witch, high priestess, all soul and body wisdom, the exotic knowledge of erotics?"

"Yeah, we're all so full of shit."

Phaedra walks over to Hippolytus who sits a few feet away and kisses him on the cheek, close to his ear. She nods toward the red mark her lips have left. "What would Hippolyta say about this?"

"She would have asked, 'What's that?' and I would have answered, 'Lipstick.' " Several seconds pass before he easily says, "I don't know how anyone couldn't be attracted to you."

Phaedra takes this as a compliment and thanks her stepson but also wants to analyze, at another time, her fear that his flirtation is flattery, a worthless amorous inventiveness paradoxically derived so much from formula. "Perhaps," she wonders to herself, "my insecurity is poisoning my insight. We're all so full of shit."

Billie Wright Dziech and Linda Weiner take aim at the father-teacher: "An average woman of fifty would never be expected to whet the sexual appetite of a twenty-year-old male, and he would not be accused of seducing her. But people believe a twenty-year-old female can easily be transported to rapture by the attentions of a fifty-year-old male."[53] Their caustic phrasing reduces myth to ridiculousness. This helpful monitoring of reality puts into acute perspective a difference between father- and mother-teacher, yet it accedes to the cultural belief that older women are aesthetically/erotically lacking. One reason why the mutually amorous stepmother and stepson story is of value today is that it instates the older woman's aesthetic/erotic power in the cultural imagination. The older

man's erotic power is well established. That is why people believe the twenty-year-old-female-student/fifty-year-old-male-professor relation.

Harrison Ford, 56: Anne Heche, 29. Gwyneth Paltrow, 25: Michael Douglas, 53. Along with "Older Actors, MUCH MUCH Younger Actresses," this copy appears on the cover of the August 10, 1998, *People* magazine. More than ten other such cinema matches, from 1944 through the present, are noted or discussed in the article "What's Age Got to Do with It?"[54] Their archetypal flavor gives such matches credence, and they reflect a current social reality more accurately than do older woman–young man partnerings. When films feature the latter "couplings," the actual age difference between the actors may be less than in older man–young woman counterparts: Anne Bancroft was thirty-six and Dustin Hoffman thirty in *The Graduate* (1967). Also, glamorous female characters, such as Bancroft's Mrs. Robinson in *The Graduate* and Gloria Swanson's Norma Desmond in *Sunset Boulevard* (1950), are nonetheless perverse, obsessive, and tragic, like Phaedra.[55]

Today's cinematic older man–young woman model has historical precedents, one being the classical Athenian custom of girls in their early teens marrying men of thirty or so. A second wife might likely be closer in age to her stepson than to her husband; in Attic tragedy Phaedra is probably in her twenties, Hippolytus in his mid-teens, and Theseus around forty. Men often wed young virgins as second wives, but when Phaedra meets Hippolytus, she and Theseus have been married for a number of years and she has had two children by him. Watson points out that Phaedra, despite being closer to her stepson's than her husband's age, "is still to be regarded as an older woman, especially in terms of experience," and as Hippolytus's "older (but still youthful) step-mother."[56] The youthful person radiates eros, as does Aphrodite, is radiant with eros. Thus age is irrelevant to erotic charm, and fifty-year-old women can be as erotically exciting as twenty-year-olds (not all of whom themselves are erotically vital). The irrelevance of age, which is at the heart of *Monster/Beauty,* does not coincide with either insulting and contemptuous Athenian attitudes toward older women's sexuality or with contemporary American attitudes, which resemble the Greek. Watson asserts that Phaedra can be seen in the same light as old women, whose "abuse . . . is a well-established erotic and iambic/satiric topos. In this context . . . old age is relative: an 'old' woman is simply one who is older than the man to whom she is attracted."[57] Cultural diminishment of

older women's aesthetic/erotic aptitude and value promotes women's self-diminishment, their likely doubtfulness when any man, but especially a young man, tells them, "I don't know how anyone couldn't be attracted to you." To accept such a compliment with greater confidence and less insecurity, a woman must not be ashamed at adulterating the ideology of purity that undergirds aesthetic/erotic competence and success, in which only the young are worth flirting with and looking at.

Flirtation is a dangerous instructional tool, as Jane Gallop discovered. In his essay "Pedagogy and Sexuality," an energetic and humorous discussion of the subject, Joseph Litvak takes to task "a critic named Gerald M. MacLean, who . . . writes: '. . . In class I flirt, consciously and consistently. But I play for laughs and flirt with the men too.'" Litvak criticizes MacLean, "who comes out unmistakably as a married heterosexual man," because he appears to be oblivious to the fact that his sexual and marital status protects him in ways unavailable to professors who do not share them. A gay man would probably not play for laughs while flirting with men, and the same would be true of a lesbian with women. For them shame, hypocrisy, or self-deprecation could overshadow humor, and the teachers would risk the likelihood of opening themselves to "the charge of using [the] classroom as a recruitment center." As for straight female teachers? Litvak thinks they would be "asking for trouble" if they flirted.[58] He does not explain why, but it seems to me that a woman who flirts with students in or outside the classroom indicates that she is something very other than mother-teacher or schoolmarm. Also, she has exceeded metaphors that, in Kathryn Morgan's delineation of paradoxes within feminist pedagogy, "give some promise of equality—sister, peer, friend, or translator."[59] Feminist instructors have often desired and tried to strategize for equality; but equality between teacher and student is a perilous pursuit, fraught with power exchanges, which are part of any relationship, and with consequent hierarchical dynamics that may cause misunderstandings and hostility as easily as luxuriously erotic tensions.[60] Morgan recognizes that her listed metaphors-cum-models are problematic: "it seems that the teacher's role, qua teacher, vanishes altogether."[61] In that light, the amorous stepmother is a troublesome figure, especially if she flirts. Does this mean that the erotic role is insufficient for teaching qua teaching? Or is it just unnecessarily in excess of teaching's parameters?

In response, I take us back to the amorous stepdaughter and the amorous stepmother who delight in their garden and put forward the

pedagogical relational model of gardening. Certain aspects of that model are concisely described in a post to the Women's Studies mailing list by instructor Linda Deutschmann, who finds a gardening analogy more useful than a mothering one:

> I attempt to help (when help is needed) each type to be whatever it can be . . . providing fertilizer (books, ideas, hope) and clearing away weeds (dead-ends; dead-heads), etc.
>
> I know that I do not control what kind of flowers end up in my classes. My success is when they are enabled to make the most of what they came in with, whatever that might be.[62]

Gardening is a satisfying pedagogical model whose serious theoretical development would further complicate the notion of the amorous stepmother; although Deutschmann does not say so, gardening is an erotic activity. Without connection, without erotic involvement, to various elements—soil, sun, water, and weeds, as well as the plants themselves—a garden will not flourish. In light of this, gardening with another person or persons can be an erotic partnership that fosters a kind of flirting distinct from the toying, trifling attentions that permit a professor to play for laughs.

Gardens and gardeners educate one another. In the latter's attempts to create Eden, whose Hebrew root (it has a Ugaritic one as well) derives from "the root word for enjoyment and enlightenment," gardeners enjoy themselves in a process of becoming "more refined, more delicate, more attuned"[63]—more erotically learned; and flirting may be an elegant, compelling way to cultivate such education. The amorous stepmother's and amorous stepson's or stepdaughter's mutual erotic attention is a commitment to flowering. *Flirt*, from Old French *fleureter*, "to touch lightly," literally, "to move from flower to flower": gardening requires a light—flirtatious—touch. The gardener contends with the heavy hand of nature—downpours and drought—and may well prevail; and although she must cut and pull, the gardener effects an overall lightness, so that coarse growth and overspread are civilized into gracefulness. Intuition as well as gardening principles enter into this process, in which the heavy-handedness of overplanning impedes unpredictable pleasures and unforeseen necessities. Heavy-handedness restricts people's ability to build gardens, love, or minds.

Flowers and gardens, of course, have an ancient tradition as erotic symbols. The Greeks associated Aphrodite with apples and with flowers,

especially roses, which today are singularly appreciated gifts from lovers. Gardens have often been settings for love, as in nineteenth-century novels. In Renaissance paintings Cupid presides over the Garden of Love. Titian's *Festival of Venus* (1518–19) is thick with cupids who grab each other and Venus's golden apples, which fill baskets and trees. A statue of the goddess oversees the activity as she does in Rubens's *Worship of Venus* (1630–33): foliage, fruit, flowers, and the fleshiness of cupids, satyrs, and women are present in abundance. The medieval walled garden, cared for by women, becomes in the twelfth century a literary and social setting for courtly love. The female is also erotically connected with the garden in the Song of Songs: "A garden inclosed is my sister, my spouse; . . . Thy plants are an orchard of pomegranates" (4.12–13); "Let my beloved come into his garden, and eat his pleasant fruits" (4.16). Unsurprisingly, the pomegranate is Aphrodite's fruit (not only Persephone's), and in the opening speech of H.D.'s Phaedra, when she is attesting her hatred of Greece, she invokes Aphrodite: "*O glorious, / sweet, / red, wild pomegranate-mouth*" (her emphasis). Later the rose is a symbol for succor: "O, is it not enough to greet / the red-rose / for the red, red sweet of it?"[64] All of these connections lead us in the West to think of gardens/flowers as having feminine attributes; we hold this belief even more strongly because flowers are pretty and delicate, just as women have been believed to be, and because flower (and plant and spice) names are reserved for women—Lily, Rose, Rosemary, Ginger, Columbine.

The garden model of instruction might appear to feminize the young male student. However, the garden is dually gendered in the West. In his essay "Thoughts Occasioned by the Old Testament," Achiva Benzinberg Stein, an expert on landscape architecture, notes that Hebrew has both feminine and masculine forms of the word for *garden*. Also, men and women, he affirms, "have had a long association with the work of raising and nurturing plants and trees. In fact, it is one of the few occupations that seems to have been equally open to both."[65] My father created gorgeous gardens at both homes that I grew up in; my appreciation of his devotion to those gardens (see chapter 7) makes clear that it taught me much about aesthetic/erotic creativity and commitment. Like the amorous stepmother, the garden crosses genders. So the amorous stepson is not a (step)mama's boy or her sweet and dumb boy-toy, but rather

a man who does not fear the reality of his own or other people's always equivocal gender.

The garden is an erotic respite from so much in our everyday lives that is distinctly unlike Eden. The respite is not escape but rather security and pleasure. Robert B. Riley, a professor of landscape architecture, states that the garden "is a place where sex is available for human delight in a controllable context."[66] The garden has served as erotic metaphor and as a place for people to have sex: but the instructional garden need not be rife with sexual innuendo or activity. The erotic exists in the wild and in wild states in human beings, yet it is so undercultivated and its growth so stunted in our culture that its refinement, secured at least to some extent by the amorous stepmother and her stepchildren, requires an attentive protectedness.

One of people's greatest erotic delights in gardens is looking, whether lightly or—depending on one's interest or attraction to a particular flower—more scrutinizingly. Similarly, one of people's greatest erotic delights in each other is mutual looking, especially if they are forming or involved in an amorous partnership. Yet just as Snow White's step- mother is approaching a point at which she can no longer bear to look at herself because she does not know how to enter new erotic territory, so (and for the same reason) the young man cannot bear to look at the older woman. Perhaps he is reluctant because he becomes his father's rival and potentially his betrayer. Oedipus, who has looked lustfully at Jocasta and followed his eyes to action, clearly liked what he saw. Ursule Molinaro examines a similar dynamic in describing Oedipus's visual love of his mother in her novel *Power Dreamers:* he sees an exotic aphrodisiac of a woman, who is near forty to his almost twenty. Having seen too much— his mother/the older woman in erotic undress and ecstasy—he has to blind himself so that he will never see that pleasurable sight again and so that he will return to being his father's son. No matter that the father is dead. Rexroth's Phaedra physically resembles Molinaro's Jocasta. When Phaedra says, "I'm hot," she is speaking about her visual effect as much as she is about her bodily temperature and sexual fire.[67]

In *The Name of Oedipus* (1978), a play by feminist theorist Hélène Cixous, Jocasta's and Oedipus's looking and not looking at each other have psycho-emotional implications, indicating their ability to see or not see an eros independent of names that categorize amorous partners into socially limited erotic relations such as mother-son, husband-wife, and

lover-beloved, which also tend to bind the partners into gender and generational structures. Jocasta exclaims to Oedipus,

> *If only you knew who you are! . . .*
> *O my lover, son, my lover*
> *My husband son, my lover*
> *My mother my life, you.*[68]

Just as the mother births her children, so the son can birth the mother, giving her a life outside of the Oedipal triangle. "Let the dead die," Jocasta implores her son, wanting him to forget his father. A question to Oedipus, "why believe / The oracle's poisoned tongue?" is an earlier (unsuccessful) attempt to release both her and her son from the tragedy of being blind to the many forms of love(r) two people can play with one another.[69]

Jocasta asks of Oedipus, "Give me the gaze / That unveils everything."[70] If granted, no look could be more erotic. Later, following sex, discovery, and recrimination and shortly after Oedipus wonders, "How could I be free of fear?" the chorus observes, "*For the first time / This time / His glance deserts her*"; and although he soon recalls, "What bliss to set my eyes on you, what ecstasy to be saved," Jocasta has to beg, "Look at me!"[71] Matters worsen still. Oedipus cries out, "Stop looking at me!"; stage directions follow immediately and explain, "Oedipus never looks at Jocasta—as if he cannot turn his head in her direction. A 'natural' impossibility."[72] The body stiffens into a living rigor mortis when fear overwhelms it. The "forbidden body" of the mother, which represents the older woman's tabooed eros, is an aphrodisiac antidote to the oracle's poisoned tongue.

Fear, shame, and desire, separately or in combination, deeply color Phaedra's and Hippolytus's ability to look at each other, just as they consistently affect Oedipus and Jocasta in Cixous's play. For example, Racine's Hippolytus believes that he sees Phaedra's love for Theseus "irradiating you." Once it becomes evident that she is eyeing her stepson, discomfort overcomes him: "My shame cannot stand here and let you look at me."[73] As is often the case, Rexroth's characters break with indoctrination. Explaining to Phaedra that "I never hated you," Hippolytus reveals "how much I love you" and tells her he does not understand her: "I am only a young man / . . . tortured by conflict."[74] Having "found the bliss we think we have," Phaedra "can't believe" that she and Hippolytus are lovers. Taken aback, Hippolytus confesses,

... For ten years—
Since he brought you back from Crete—
I hardly dared to look at you
For fear I would reveal myself.
You have stood by me in his court,
And your perfume swept over me,
And I have been struck blind with it,
And not known what I was doing.[75]

Hippolytus does not choose to stay blind, and the lines quoted above begin a speech about his passion for Phaedra—"mortal female flesh"— greater than his devotion to Artemis, "a goddess as love's surrogate," a speech that impels Phaedra to ask, "Have you found vision?"[76]

I catch the stepson looking at me from the other end of a long corridor. Suddenly I feel self-conscious in my light wool pants, cut beautifully, accentuating the line from my waist to hips and over my buttocks.

I'm sitting in a classroom listening with many people to a visiting speaker. The stepson walks in late, wearing shorts. I try not to stare at his well-shaped calves.

We look a lot and know that we do. We never talk about what we see. Finding vision does not require discourse, but understanding vision often does.

"Do you know what vision costs?" Phaedra asks Hippolytus.[77] In the Phaedra myth and its retellings, the answer to her question appears to be death of the stepmother and stepson. Lack of vision also costs lives and humanity. When Snow White kills her stepmother, she kills her own heart and her ability to be an amorous older woman erotically inclined toward either herself or young women. I would like to see the cost of vision paid by the social order, not by potential or actual amorous partners. In a moment of remembered vision, Cixous's Oedipus describes what is at stake: "The moment I saw you all laws and limits were abolished. / . . . [T]he future had arrived."[78] It is difficult to live the future in the present, but the garden eases this pursuit.

The amorous stepmother arranges a garden party. She invites her stepdaughter and stepson. Aphrodite arrives dressed to kill. Her luminosity makes the darkness die in people's eyes. The past is her target. She intends to kill it in such a way that it does not disease living bodies.

She picks an apple from one of the stepmother's trees. "It has been forgotten that the apple is one of my fruits and that I tend the Garden. I've lost sleep over Eden, which, after being home to Adam and Eve,

seems to have become empty of the human race. But they and the serpent still live there in our bones and flesh, overwhelming apples, roses, and so many other flavors and fragrances with sin, a word I cannot understand, a supposed human condition that eternally exacts a price for vision, as if it's crime. Here, have a bite." She offers the apple to the group, who pass it around.

The apple acts like a love potion, uniting thoughts and every place they reside in the body, and stepmother, stepdaughter, and stepson, an amorous chorus, address Aphrodite: "We are trying not to live in oblivion."

NOTES

1. Linda Brodkey and Michelle Fine, "Presence of Mind in the Absence of Body," in *Postmodernism, Feminism, and Cultural Politics: Redrawing Educational Boundaries,* ed. Henry A. Giroux (Albany: State University of New York Press, 1991), 117.

2. Mimi Orner, "Interrupting the Calls for Student Voice in 'Liberatory' Education: A Feminist Poststructuralist Perspective," in *Feminism and Critical Pedagogy,* ed. Carmen Luke and Jennifer Gore (New York: Routledge, 1992), 84.

3. Monique Wittig, *Les Guérillères,* trans. David Le Vay (New York: Avon, 1973), 89 (published in French under the same title [Paris: Les Editions de Minuit, 1969]).

4. Marina Warner, *From the Beast to the Blonde: On Fairy Tales and Their Tellers* (New York: Farrar, Straus, and Giroux, 1995), 214.

5. Patricia A. Watson, *Ancient Stepmothers: Myth, Misogyny, and Reality* (Leiden: E. J. Brill, 1995), 1.

6. Elizabeth Debold, Marie Wilson, and Idelisse Malavé, in *A Reader's Companion to "Mother Daughter Revolution: From Good Girls to Great Women,"* by Lisa Sjostrom (New York: Bantam, 1994), 3.

7. Sjostrom, *Reader's Companion,* 13.

8. H.D., *Hippolytus Temporizes* (1927; reprint, Redding Ridge, Conn.: Black Swan Books, 1985), 95.

9. Ibid., 7.

10. Kenneth Rexroth, *Phaedra* (1951), in *Joseph and Potiphar's Wife in World Literature: An Anthology of the Story of the Chaste Youth and the Lustful Stepmother,* ed. John D. Yohannan (New York: New Directions, 1968), 143.

11. If the skills and education of wise woman and high priestess coincide, then Phaedra is both. Rexroth appears to acknowledge this, for his Phaedra's spiritual knowledge is devastatingly smart and elegant. Her intoxicating speech and what the chorus identifies as the "Minotaur dance"—"a terrible dance / To watch; ordinary folks / should not look at things like this"—indicate her power (ibid.,

139). Norma Lorre Goodrich, *Priestesses* (New York: HarperPerennial, 1990), 95, describes Phaedra as both queen and high priestess.

12. The most recent version of Phaedra that I read, Sarah Kane's *Phaedra's Love*, which was first performed in 1996 at London's Gate Theatre, is also a gloomy story of unrequited love. Here, Hippolytus is a loser who has had many sexual encounters, including with his stepmother. As in classical tragedy, she subsequently commits suicide.

13. "Little Snow-White," in *The Complete Grimm's Fairy Tales*, intro. Padraic Colum (New York: Pantheon Books, 1944), 255.

14. Ibid., 254.

15. Marguerite Yourcenar, "Phaedra, or Despair," in *Fires*, trans. Dori Katz in collaboration with the author (New York: Farrar, Straus, Giroux, 1981), 7.

16. Watson, *Ancient Stepmothers*, 18.

17. Watson's discussion of Greek misogyny reflected in a bias against stepmothers begins in ibid., 84.

18. Stories do exist of stepsons initiating successful liaisons. See the historical example of Antiochus I of Syria's love for his stepmother Stratonice (ibid., 214–16) and modern studies of actual attractions of stepsons for stepmothers (82).

19. In some versions, such as the biblical story of Joseph and Potiphar's wife, the lustful woman is not a stepmother.

20. Warner, *From the Beast to the Blonde*, 201, and Watson, *Ancient Stepmothers*, 46. Richmond Lattimore, "Introduction to *Hippolytus*," in *Euripides*, ed. David Grene and Richmond Lattimore (Chicago: University of Chicago Press, 1955), 1:159, affirms that the "monstrousness of the relationship" between Hippolytus and Phaedra "is the hinge on which everything turns."

21. Jean Racine, *Phèdre*, trans. William Packard, in Yohannan, *Joseph and Potiphar's Wife*, 99.

22. Bruno Bettelheim, *The Uses of Enchantment: The Meaning and Importance of Fairy Tales* (New York: Alfred A. Knopf, 1976), 207.

23. Ibid., 195.

24. Joanna Frueh, "Polymorphous Perversities: Female Pleasures and the Post-menopausal Artist," in *Erotic Faculties* (Berkeley: University of California Press, 1996), 83.

25. Bettelheim, *Uses of Enchantment*, 195.

26. Jacqueline Schectman, *The Stepmother in Fairy Tales: Bereavement and the Feminine Shadow* (Boston: Sigo Press, 1993), 36.

27. Ibid., 33. Bettelheim states, "Fairy tales do not tell *why* a parent may be unable to enjoy his child's growing up and surpassing him, but becomes jealous of the child" (*Uses of Enchantment*, 195).

28. " 'Teaching Them a Lesson': The Pedagogy of Fear in Fairy Tales" is the title of chapter 2 in Maria Tatar, *Off with Their Heads! Fairy Tales and the Culture of Childhood* (Princeton: Princeton University Press, 1992), 22–50.

29. H.D., *Hippolytus Temporizes*, 49–50. H.D. describes Myrrhina as Phaedra's "serving-lady" (6).

30. Euripides, *Hippolytus*, trans. David Grene, in Grene and Lattimore, *Euripides*, 1:190.

31. Ibid., 189–90. Froma I. Zeitlin, "The Power of Aphrodite: Eros and the Boundaries of the Self in Euripides' *Hippolytos*," in *Playing the Other: Gender and Society in Classical Greek Literature* (Chicago: University of Chicago Press, 1996), analyzes Hippolytus's "refusal of eros" and failure "to complete the initiatory scenario that would have him pass from the yoking of horses to the yoking of maidens" (222–23).

32. Jo Anne Pagano, *Exiles and Communities: Teaching in the Patriarchal Wilderness* (Albany: State University of New York Press, 1990). See especially "Teaching the Text" (63–81), in which Pagano bemoans education's loss of "the corporeality of knowing" (78). We pay the "price of exile from the maternal body [which] is exile of connection from the realm of knowledge" (73).

33. In summing up her views on relational teaching models on the Women's Studies Listserv mailing list (wmst-l@umdd.umd.edu), May 24, 1997, Marge Piercy wrote, "Basically the teacher opens and enables. We are the keepers of doorways."

34. Watson, *Ancient Stepmothers*, 15.

35. H.D., *Hippolytus Temporizes*, 23, 25, 27–28.

36. Racine, *Phèdre*, 79.

37. Yourcenar, "Phaedra," 6.

38. Ibid.

39. Racine, *Phèdre*, 97–98.

40. H.D., *Hippolytus Temporizes*, 50.

41. Rexroth, *Phaedra*, 145.

42. Euripides, *Hippolytus*, 180.

43. Froma I. Zeitlin, "Figuring Fidelity in Homer's *Odyssey*," in *Playing the Other*, 29, explains, "In traditional diction, terms for adultery and fidelity focus on the state of the marital bed, defined between the two poles of 'shaming' . . . or 'respecting' . . . its sacrosanct qualities."

44. Rexroth, *Phaedra*, 145.

45. Ibid., 154.

46. Ibid., 156.

47. Watson, *Ancient Stepmothers*, 77.

48. Racine, *Phèdre*, 98.

49. Watson, *Ancient Stepmothers*, 72.

50. Watson distinguishes sexual liaisons between stepmothers and stepsons in Rome and in Greece: "a sexual union between stepson and stepmother was in Rome (as distinct from classical Athens) not merely adulterous but incestuous" (ibid., 137).

51. Paul Friedrich, *The Meaning of Aphrodite* (Chicago: University of Chicago Press, 1978), titles the introduction to his final chapter "The Lover-Mother as Suppressed Archetype."

52. I quote the title of Friedrich's final chapter (ibid.) and, later in this paragraph, from 183–84, 187–88. See chapter 3 above for a consideration of sex/sensuousness and maternity/motherliness in regard to actual mothers and children.

53. Billie Wright Dziech and Linda Weiner, *The Lecherous Professor: Sexual Harassment on Campus*, 2d ed. (Urbana: University of Illinois Press, 1990), 83.

Although the authors do not specify the father-teacher as their target, their statement elegantly applies to that model and its embodiment.

54. "What's Age Got to Do with It?" *People,* August 10, 1998, 93.

55. In chapter 2, I discuss Mrs. Robinson as a figure of female midlife loss. See Lucy Fischer, "*Sunset Boulevard:* Fading Stars," in *The Other within Us: Feminist Explorations of Women and Aging,* ed. Marilyn Pearsall (Boulder, Colo.: Westview Press, 1997), 163–76, for an acute analysis of female beauty/aging/loss.

56. Watson, *Ancient Stepmothers,* 89.

57. Ibid., 90.

58. Joseph Litvak, "Pedagogy and Sexuality," in *Professions of Desire: Lesbian and Gay Studies,* ed. George E. Haggerty and Bonnie Zimmerman (New York: Modern Language Association of America, 1995), 27.

59. Kathryn Pauly Morgan, "The Perils and Paradoxes of Feminist Pedagogy," *Resources for Feminist Research* 16 (1987): 51.

60. Piercy, Women's Studies mailing list, believes that "the student-teacher relationship is inherently unequal . . . because presumably the teacher does have more knowledge than the student and has a lot to impart about how to as well as what. . . . But the inequality has to be tempered with genuine respect and a quality I can only define as a carefully distanced tenderness."

61. Morgan, "Feminist Pedagogy," 51.

62. Linda Deutschmann, Women's Studies Listserv mailing list (wmst-l@umdd.umd.edu), May 25, 1997.

63. Achiva Benzinberg Stein, "Thoughts Occasioned by the Old Testament," in *The Meaning of Gardens: Idea, Place, and Action,* ed. Mark Francis and Randolph T. Hester Jr. (Cambridge, Mass.: MIT Press, 1990), 43.

64. H.D., *Hippolytus Temporizes,* 48–49.

65. Stein, "Thoughts," 40.

66. Robert B. Riley, "Flowers, Power, and Sex," in Francis and Hester, *Meaning of Gardens,* 67.

67. Rexroth, *Phaedra,* 138. See Ursule Molinaro, *Power Dreamers: The Jocasta Complex* (Kingston, N.Y.: McPherson, 1994), discussed in chapter 2.

68. Hélène Cixous, *The Name of Oedipus: Song of the Forbidden Body,* in *Plays by French and Francophone Women: A Critical Anthology,* ed. and trans. Christiane P. Makward and Judith G. Miller (Ann Arbor: University of Michigan Press, 1994), 256.

69. Ibid., 274, 266.

70. Ibid., 257.

71. Ibid., 278, 279, 282–83.

72. Ibid., 284.

73. Racine, *Phèdre,* 97–98.

74. Rexroth, *Phaedra,* 142.

75. Ibid., 146.

76. Ibid., 147.

77. Ibid.

78. Cixous, *Name of Oedipus,* 301.

Icons OF PLEASURE

Nine

DRESSING APHRODITE

Frueh wears a bias cut, ankle-length, ecru dress of fabric that clings to her upper body and gently reveals the contours of her hips and thighs. The sleeves cover most of her forearms, and the neckline curves around her collarbones. Her shoes are pewter-colored high heels, an exotic Mary Jane style, and her pulled-back hair emphasizes bronze-toned earrings, each decorated with three pink glass drops. To one side of the black music stand at which she performs, a clear glass vase is full of creamy lilies and red roses. To her other side, a white pedestal holds a large crystal champagne glass filled with water.

Gold and roses, laughter, fragrance, flowers, smiling, bathing, oils and unguents, cosmetics, jewelry, and other ornaments: the ancient Greeks styled Aphrodite, their goddess of love and beauty, in these attributes and powers of pleasure.[1] She embodied and enabled techniques and skills of an *ars erotica,* which included bathing and decorating for making love with others and with oneself. Neither Greek sculpture nor literature presents a masturbating Aphrodite, and autoerotic activity should not be understood literally as genital masturbation or as simplistic self-gratification. The word *aphrodisia,* meaning for the Greeks sensual pleasure, carnal acts, sexual relations, and pleasures of love, does not refer to specific sexual practices.[2] Desire, pleasure, and act are an ensem-

ble. *Aphrodisia* is related to *aphrodisios*, of Aphrodite, who was also the goddess of creativity.

In classical Greece, the *aphrodisia* were an ethical practice created for men by men. Let us differently configure *aphrodisia* so that Aphrodite may suggest to us ways in which to use and to be pleasure, appearing dressed, undressed, and in-between as a model of a technology of the self, practiced in aesthetic/erotic self-creation.[3]

Men took pleasure in Praxiteles' Aphrodite of Knidos and her successors: Aphrodite was an aphrodisiac.[4] Perhaps she inspired or encouraged women and men to become aphrodisiacs, to create themselves as sensuously stimulating and welcoming both by entering into and by creating in others *aphroditē*, a psychological state combining passion, empathy, and attraction.[5] To these qualities I add attractiveness. Independent and giving, calm and fun-loving, full of the grace that became loving-kindness and that we admire today in the charismatic decorum of a star athlete's body at ease, Aphrodite offered beauty of appearance and being as means through which one could gain material and spiritual knowledge.[6]

The ancient Aphrodite invites us to care about styling ourselves, to tend to details of human expression and behavior that design the extreme self-articulation I call monster/beauty, details that are corporeal and connective—pertaining to the single body that is our own and to its opulent and expansive erotic possibilities with other bodies. Eros is errant and it flows from body to body ad infinitum: bodies of people, knowledge, vegetation, paw prints, water, and unorthodoxies. I speak here of sex and beauty because they are Aphrodite's domains, and to love human bodies, through looks and touches that belong to her *ars erotica*, is one way to develop concord, a social transformation through pleasure. I choose Aphrodite over narcosis because she teaches me to treat the body as an oeuvre. I work against inaction, paralysis caused by bodily shame or even by an embarrassment of riches that I could feel in the process of fulfilling what I understand to be her ordinance, which is to build the body of love.

I step into Aphrodite's shoes. I am building the body of love. This does not mean that I am incomplete, always in a state of desire, in contrast to a state of pleasure, of satisfaction. Pleasure engenders its reproduction.

I step into Aphrodite's shoes. Like her body, I am body to body ad infinitum. My body articulates with others the pleasures that my husband and I share. Aphrodite was a married woman and a passionate wife. That

Eros is the illegitimate child of Aphrodite and Ares may lead to the false conclusions that passionate wives are insatiable (nymphomaniac) or unsatisfied with their husbands (frigid at home): myth upon misunderstanding. So the passionate wife becomes a pervert, for law sanctions few erotic activities and marriage supposedly kills eros: the passionate wife becomes a paradox, for she can lust, fuck, and fantasize only away from her husband. In truth, the passionate wife styles herself in *aphrodisia*.

I step into Aphrodite's shoes. She and I are not bad girl bodies, not images or housings of coy, efficient sexual rhetoric. Body to body, she and I are fearlessly invested in loving women with the force of little girls who feel invincible because they are intimate with each other; in spreading our legs for men who undress us slowly like Anchises (see below) or in a rush of will; in embracing black and golden skin unfalsified by ethnographic exhibition, gleaming differently from white marble, freed of the snide lust that searches for some new Hottentot Venus or Latin lover. (This is not Gauguin's gold. It is Aphrodite's.)

I step into Aphrodite's shoes. They improve my bedside manner.

I return to my hotel room after talking with Guillermo for the first time. He is gifted in the erotic art of conversation, in which smiles and touches are as significant as words, in which all three sustain an intricacy of *aphrodisia*.

I step into Aphrodite's shoes. My cunt is wet. I undress and sit on the side of the bed and the following picture fills me:

I'm wearing my long, silk robe embroidered with one gold leaf over each breast. I'm naked except for black boots that catch the light like satin and white anklets with a tiny lace cuff. The robe bares me down the middle and I'm sitting as I actually am on the side of this bed. Guillermo is in front of me and I part my legs a little, and when I feel his tongue, on, then inside my labia, his hands, one on each thigh, become wedded to them.

This image does not replicate a chic porn photograph. It is not a film noir still, updated with nostalgia for a mystique-filled portrayal of lust. The atmosphere is golden, nowhere near the light that rakes the bodies in porn movies. We are bodies, not figures, and we move with shifting motivations as we negotiate pleasure.

From the Knidia to Titian's Venuses loved by lute players and mirrors to Marilyn Monroe, Aphrodite, in mostly degraded forms, has come to read

as perfection, and therefore as a kind of being who is impossible to become. Women, including feminists, from diverse disciplines and in popular and scholarly publications, decry and critique the imperialism of feminine beauty standards, which not only ignore and demean differences in human beings' attractions but also contribute to people's difficulty in even seeing their species' wide-ranging beauties. The idea, the anxiety of bodily perfection misrepresents aphroditean beauty, for the goddess embodies the comfortableness in oneself that is a basis of erotic and aesthetic confidence.[7]

Perfection is the feminine truth of the body that ancient Aphrodites, later Venuses canonized in art history, and the twentieth-century fashion model declare to be an attribute of females.[8] The perfect body is supremely clean, sterilized of sweat, of variable color beyond shades of white, of women's lustful participation in each other's beauty. The perfect body is deprived of the ability to enjoy anything but a look—of appreciation, envy, or desire—to be anything but a glimpse of sensual plenitude. Today's perfect body is erotically atrophied. Because it can only be thin, it exhibits symbolic if not literal anorexia that shrinks the body. The goddess flattens into merely a figure, an icon with no tactile range, an outline filled in with stupidity. Her skin, which should speak of volume and which is the intelligence of *aphroditē*, is a garment with which to lure. A goddess frees our aphrodisiac capacities, but perfection is the liberation of nothing.

We imagine the perfect body's sweetness when we test *Vogue* samples of Calvin Klein's Eternity, Donna Karan's Chaos, Givenchy's Organza, or Ralph Lauren's Sport. Sport: neither the blonde in her white T-shirt nor we are meant to smell the efforts of her athleticism. Eternity: the Eternal Feminine lives on in images of a wife-and-mother who is young, fair-skinned, and dressed in white. Windblown, sitting at the shore, she squints, and her startled casualness is an effect of photography. Chaos: the ad bids, "Discover the calm within"; and, back to us, a nude, as creamy as the Aphrodite of Rhodes, bows down her head. The page cuts off her lower legs, so she is a deliberate fragment, unlike statues from antiquity that lost their wholeness to the vagaries of time and inattention. Karan's Aphrodite appears to sit on stone that simulates the inside of a surfer's wave. Her spine is sister to that of the *Grande Odalisque*. Calm may be meditative, but it is also immobilization and possible engulfment. Organza: it will allow us to "slip into luxury." The model in a pleated,

bright white gown and the golden bottle, whose vertical ridges resemble pleats, are the same height, and they look like fluted columns.[9] The ads recall Aphrodite's sea-birth and autonomy, her authority over fertility and procreation, and the richness of her golden necklaces and earrings— her glimmering, as we see in Homeric Hymn 6, "with every sort of jewel";[10] but the ads mistranslate the goddess, for perfection eliminates bodiliness.

Seawater cleanses but not absolutely, for salt and algae cling. The body's scent can be ambrosially briny.

The small bronze and stone copies of the Knidia that were popular in antiquity ranged from plump to slim.

Aphrodite was never a caryatid. Nor did the Greeks or Romans sculpt her in a frontal pose that registers as static.

Stark white fabrics on white skin replicate the marble of the Knidia and the drapery that she holds, the way that we see her today in Roman copies. Originally her skin may have been painted a light, unnuanced tint, and perhaps she had been lightly buffed. Her hair was gilded or yellow; her lips, cheeks, eyes, and jewelry were painted; the vase was gilded to resemble bronze; and the drapery was painted flat bright tones. She was white, but not as white as she appears in perfume ads, and today a goddess whose attributes and powers cannot be complicated beyond the sex and color of her origin is useless as a model of aesthetic/erotic self-creation.

Female perfection reeks of a high femininity molded out of racial purity and class privilege: white is the cleanest skin color, unflawed by the "defect" of darkness; and perfection, which the fashion and beauty industries try to persuade us will be ours if we work hard enough at it, is an upper-class possession. Female perfection is an ideology, driving those industries' economies, that exacts ultimate hygiene, so designer perfumes can serve as antiseptics. Black and Asian-featured models rarely appear in designer perfume ads, which are primarily geared to middle-class or upwardly mobile women, because marketers believe that black bodies and Asian-featured faces cannot sell the ideology of the supremely clean.[11]

In the early 1970s, when I was in my mid-twenties, I was a salesgirl at Saks on Michigan Avenue in Chicago—a high-class department store in the city's ritziest commercial district. My manager, a white woman younger than I, told me she'd been riding a bus sitting next to a black

woman who smelled. My manager's vocal inflections indicated that *smelled* meant *smelled bad.* Then she added, "You know what I mean, how they smell."

Spring semester 1997. Midori Ishibashi, a young Japanese American woman in a class of mine, includes in one of her papers a letter she had submitted to the *Sagebrush,* my university's student newspaper. She was countering a letter to the editor written by a man who, from what I gather in her letter, bemoaned what he saw as current biases against white males such as himself. Midori wrote, "I would guess that most white . . . males have never heard anyone walk by them in a grocery store muttering that people of their race . . . all smell like fish." She quoted part of the man's letter: "We're entitled to be treated like dirt."[12]

High femininity sanctifies antisepsis. Darkness, dirt, non-Caucasian features, and putridness conflate, making stink and black skin the opposite of sweet whiteness. As the man's remark brings into relief, white men have not been and must not be made dirty.

I rose from the ocean, pungent like cunt and fish. Don't call me sweetie without thinking about the implications of all my bouquets and spices— fennel, myrrh, cinnamon; roses and lilies, two of my favorite flowers.

Roses
What corny excess they've inspired
In romantics of both Church and Sex
 Your mouth is like a rosebud
 Your skin is soft as a rose petal
 My love is like the red red rose
 Mary is the Mystic Rose
 The Holy Rose a medieval scholar writes of as a
 vulvic sign
 The scarlet flower fucked to ecstasy
 The white rose of Dante's paradise
 You smell like a rose
 Or am I just excited by the Infinite Aroma of your pheromones?
 O leave your dewdrop in my rose

Theologians talk to god in orgies of epistemology
 Lily lie lay lewdly say
Authorities of Nothing Much about the suction and the friction of the
 sexes

 Lily lie lay lowdown
They don't even know
 Lovemaking is charisma
I know
What I know
I speak with lubricity about ideas of ardent origin
I trust no orthodoxies jaded beyond belief
 in the body commonplace
 is a temple sentimental
Born in the dimensions of a gem with undetermined facets
And the Acknowledgment
To fuck your lover high and low

Ambrosia is like honey, sweet but not cloying, golden not white. Ambrosia's aphrodisiac thickness sticks to one's skin, creating the aura of radiance. Ambrosial aura does not simulate beauty; aura isn't necessarily artificial, commodified charisma. Unlike perfumes marketed for the user's creation of atmosphere, so different from *aphroditē*, Aphrodite's ambrosias, one of which *can* be the golden liquid, perfume, signify the sweet heart (one's own or another's) that will satisfy longing for deliciousness in our lives. Aphrodite's ambrosias—her perfumes, oils, cosmetics, cum, saliva, balms—will change your heart, which means that they will change your body.

 I call every body Honey.

In Homer's *Odyssey* Penelope, a faded beauty and Odysseus's wife, becomes marvelous to the Achaeans with the application of Aphrodite's balm. In this instance, Athena beautifies Penelope. The gifts of Aphrodite provide for pleasures greater than beauty, pleasures that cannot be reduced to mere visual effect.[13] They are the sources that shape the smiles and laughter Aphrodite so enjoys.

 Smile and *marvel* share the Latin cognate *mirus,* "wonderful." Aphrodite, Penelope, and numerous once-faded Aphrodites blooming because of ambrosial balms, which neither remove blemishes nor minimize pores—you are wonders groomed to monstrousness, not feminine perfection.

 One cannot be indifferent to ambrosia.

Sometimes I can barely smile. How wary I've become of myself. I dress in off-white. Whose skin do I imitate? If only it were simply golden

Aphrodite's. Wearing white protects me against nothing. It is the troubled power of brides and virgins. Ecru, my color for today, is closer than bright-white to blood, veins, and tissues, not refined into the perfect female's sacred adornment.

Ecru and whiter white cloth are always dirty. White is the sign of visible and potential dirt. Dirty as the ground, as sweat, as excrement, and the making of love. Dirtiness is one of monster/beauty's attractions. Because she perverts, subverts, and diverts the purity of white, wearing white is for monster/beauty a partially perverse strategy.

Gleaming off-white fabric also creates the illusion of gold, which is radiance, and this gossamer-feeling fabric, of undergarment color, fondles me like lingerie and recalls the depiction and significance of Aphrodite's body, which asserts and reveals itself even when dressed. Her clothing, such as the filmy, clinging drapery in the Parthenon's east pediment and the resplendent garments she wears before permitting Anchises to remove them for their lovemaking, is meant to make the observer or reader aware of Aphrodite's body. Dressed or undressed, Aphrodite is always a nude.

For the Greeks, nudity displayed liberty and power.[14] Aphrodite's nudity manifested her divine authority and her authority in the arts of love. Nudity, the beautiful dress of skin and flesh, is aesthetic/erotic technology, and as such it provides human beings with the pleasure needed for vitality of the soul. Nudity suggests possibilities, potentials; we need not read it as a goad to be a particular body type. (Remember: the Knidia's successors varied from full to slim.) Style can be part of *aphrodisia* because style—dressing attractively—is about nudity, which should not be reduced to fashion, for fashion relies on the currency of perfection, whose particulars it shapes.

In a tongue-in-cheek tone that is nonetheless biting, Betsy Berne underpins her November 1996 *Vogue* article, "What Works at What Age?" with the model of nude perfection. Whenever *perfect* as a description of women's bodies appears in a fashion magazine, the word startles me, for I'm fool enough to think that the last thirty years of feminism could have ended women's desire for perfection and their belief that it is manifest in some women's bodies. Berne's piece supposedly treats problems and exemplars of admirable style, but we learn in a humorous though agonized tone that only "seventeen-year-olds have perfect bodies," that "No one should wear [this season's metallics] unless they have a

perfect body," and that women over forty and especially over fifty had better rethink and discontinue the style they favored when younger because they are undergoing "the ravages of age" and they will appear ridiculous if they insist on "cling[ing] to . . . fading youth." Feminist theorists, too, agonize over, to use Berne's words, "that perfect-body thing again."[15] A recent example of such agonizing is Leslie Heywood's *Dedication to Hunger* (1996). There she analyzes the relationship between supremely clean, spare high modernist literary style and women's drive to perfect their bodies.[16]

Nudity, which styles the body, is one of Aphrodite's sophisticated skills necessary for her highly civilized practice of lovemaking. In Roman copies of Praxiteles' sculpture, she appears to have just bathed. With right hand near her genitals, gaze distant but not averted, and left hand holding drapery that falls over a hydria, a water vessel, Aphrodite is neither flaunting nor ashamed of her body.[17] Aphrodite would not have bathed to become supremely clean of soul, as in baptism; to rid herself of everyday dirt, like you or me; or to purify herself of sexual sin. Sex did not turn a goddess into filth, and the Greeks did not understand women to be impure, as does the contemporary ideology of high femininity. Bathing was part of sexual conduct; Greek literature presents it as preparation for lovemaking.[18] It had this function for humans and for Aphrodite, who, before seducing Anchises in Homeric Hymn 5, is bathed by the Graces, who then rub her with perfumed oil. Bathing was hygienic, refreshing, and restorative, a pleasure enjoyed by men and women.

Aphrodite is nude with the Graces and with humans, Anchises, and ourselves, so that we can *see* her. This point may seem obvious; but to see a goddess unclothed was in general taboo, and transgressors suffered blinding or a gruesome death—such as that inflicted on Actaeon, who inadvertently saw Artemis bathing. She turned him into a stag, and his own hounds tore him apart.[19] We *see* Aphrodite nude so that we understand the body's liminality—how, as deliciously clothed, it brings together or crosses over nature and culture, human and divine, corporeality and spiritual grace, female and male. (Only male gods were commonly depicted nude.) In such liminality, the nude Aphrodite is most abundantly and essentially erotic, because of her connective magnitude.

Lying in the bathtub, water's nice and hot
Feeling like an embryo, liking it a lot

Steamy pressures buoy me, sweet oil soothes my skin
Smooth and so embracing, won't you step right in?

Vita nova vie nouvelle
Promise that you'll kiss and tell
When the New Life strikes your head
And says it's stupid to be dead

Begats and begottens, misbegotten songs
Born of forgetfulness and golden rings gone wrong
Honey, I don't owe you unless the fires spark
If you like the burning bright I'll give you a birthmark

Vita nova vie nouvelle
Promise that you'll kiss and tell
When the New Life kicks your butt
And says you're boring in your rut

Heat and bodies vibrate while laughter fills the air
I can't measure beauty, I wouldn't even dare
Muscles are for building, like hearts, all gleaming tools
If your pleasure wills their use then we can break some rules

Vita nova vie nouvelle
Promise that you'll kiss and tell
When the New Life claims control
Of your body and your soul

In the black-and-white, four-photo series *She Wasn't Always a Statue*
(1996–97), Louise Lawler shows sculptures of standing and crouching
female (and male) nudes. The female figures read differently than the
males. In order to be beautiful, woman, Lawler suggests, does not have
to remain on the pedestal of high femininity, eternally white, stuck, and
uncomfortable. Only a statue holds a pose forever. Women do not have
to be finished products, like objects of art. They must assert the will to
pleasure, which guarantees infinite becoming.

Roberta Seid writes about women, "Our bodies, our fitness, and our
food should not be our paramount concerns. They have nothing to do
with ethics, or relationships, or community responsibilities, or with the
soul. They have nothing to say about the purpose of life, except that we

should survive as well and as long and as beautifully as we can. They give us no purpose beyond ourselves. This is a religion appropriate only for a people whose ideals do not extend beyond their physical existence and whose vision of the future and of the past is strangely empty."[20] Lawler's photos convey emptiness. The statues are grouped, but each feels isolated. High femininity as a religion of bodily perfection is close to the religion Seid denounces, and high femininity breeds the void of nonaccomplishment. Solitary self-castigation accompanies such failure.

Seid damns being "beautifully"—ideally—thin, and I understand why she is so severe. Women waste themselves for beauty, spending too much money and time, enfeebling their health by dieting for thinness, ruining their self-confidence. Yet Seid assumes that she and we know what beauty is. Most of us think of it as an end product and ultimately, for older women, endgame and pointless rituals. That finished-product, done-for female beauty consumes the erotic/aesthetic energy that Aphrodite represents and teaches. The arts of love have precisely and expansively to do with ethics, relationships, and community responsibilities. Aphrodite's arts of love civilize relationships—not only one-to-one sexual encounters, I would say, but also community relationships, for the creation of aphroditean beauty manifests and fosters erotic connection, the bringing together that I spoke of earlier. The concords and pleasures of lovemaking and golden self-beautification help people resist envy, greed, and commodity culture's relentless production of lack at a material level. That lack, coupled with people's lack of self-worth, spins out from their souls and psyches and enlarges a societal fabric of spiritual and aesthetic poverty.

Seid might consider beauty a luxury—literally and figuratively costly, serving no purpose beyond a palliative self-aggrandizement. Aphrodisiac beauty is a different kind of luxury: it is a time and space of joy and comfort that may or may not have been created with expensive goods. bell hooks describes the beauty she styles for herself—the "comforting cloth," such as "silks, satins, and cashmeres" next to her skin, high-priced "French lemon verbena soap and fruity perfume," "adorning myself just so"—that induces erotic connection with her writing. hooks understands that creating a loved body and place uplifts people by transforming the fabric of poverty. In this regard, she uses the words "hope" and "healing."[21] Fashioning a home and garden one loves is an aphroditean articulation of spirit, a necessary extension of pleasure that may grow out of

aphrodisiac self-styling. The fragrance of lemon verbena soap can pervade a small house.

Feminist philosopher and psychoanalyst Luce Irigaray theorizes in behalf of female deity, which would provide for women a glorious subjectivity and new goals and values. Different from the feminist project of critiquing and opposing social and cultural wrongs against women, Irigaray's "divine project" includes women's insisting on the creation of their own beauty as self-loving and self-fulfilling. Envisioning this, I see bodies of content whose intelligent style and purpose prove that, in contradiction to Seid, beauty has great meaning beyond simple physical existence. For the early Greeks, Friedrich points out, the arts of love "were a set of practices, skills, sentiments, attitudes, and moral and aesthetic values that were learned and transmitted and that at once guided behavior and made it comprehensible and meaningful."[22] Aphrodite represents an ethics, and its performance demands a will to pleasure. Female beauty built from the will to pleasure has no formula, and it blossoms in the practice of infinite becoming.[23]

Becoming beauty
I envelop myself in scent over favorite scent: rose, rosemary, lavender,
 Quadrille, yellow honeysuckle, brine, champagne, and fish
Perfume joins divinities and human beings[24]

Becoming beauty
I choose pearls from her birthplace, and gold, the brightness of wedding
 bands, so that I can marry her, Aphrodite, passionate wife

Becoming beauty
I choose a fabric that catches light in ways that pearls and honey do
I luxuriate in a dress whose tight arms, length, and bias cut make me look
 statuesque; but I am no pillar of the community of beauty, bracing an
 isolating narcissism, the outcome of a static femininity. I move away
 from the Knidia's rationally perfect pose, because I am only human
 and her poise—a possibility for me—is what I seek, her overwhelming grace that lets me know we can create a new logic and erotics of
 form, from a stunning but to some degree sepulchral monument[25]

Becoming beauty
I don't believe in volunteerist femininity, that I am completely free of the
 museum of moribund perfections. You could say I'm standing still,

volunteering for a romance with decorum. Each shift of weight from
foot to foot, each crossing and uncrossing of my arms may only be
the gestures that age embeds, just as the pudica pose became the
familiar sign of a modesty that you, Aphrodite, as the Knidia, did not
originally connote. With a hand at breast and crotch in the Capitoline
and Medici versions of you, your body has turned into nudity as a
teasing, shameful state. In his *Venus Italica* (1811), Canova shows you
inadvertently exposing your left breast while holding drapery to your
right breast so that the elegant folds hide and reveal you with a feel-
ing like that projecting from a movie starlet in a towel. You no longer
place a hand at your crotch. Your cunt is an obscene memory.

I style myself in your Knidian comportment of elegant attention to your
cunt. You never spread your legs in sculptures or paintings to declare
your love of genital pleasure or your enjoyment of intercourse with
men. *Aphrodisia* style a cunt in grace[26]

Becoming beauty

My moves are subtle and I flame like you in your golden robes and gir-
dles.[27] We are brilliant textures, forms, and surfaces, like modernist
sculpture that celebrates its own materiality. We are flesh sculpted
from food, drink, and movements, everyday and educated in gyms
and pools, on rocks and ice, in surf, on courts

Earth, concrete, wood, and carpeting shape my walk differently. I sink or
glide with a material that is part of the pivot of my hips, the align-
ment of shoulders and torso, the softness or stiffness of my knees.
The resonant and connective beauty of materials is one of the best
legacies of your nudity

I love you, Aphrodite. Be my training partner, we will bend and stretch
together, hold different asanas beyond our desire or ability to count
the minutes, lift and press weights that strengthen every bone and
muscle in our bodies.

Becoming beauty, I dress to the frigging hilt. Without planning to, I buy
my costume on Friday, Frigga's day. A Great Goddess of northern
Europe, Frigga was a deity of sexual love. Friday was the Roman *dies
Veneris*, Venus's day, and French remembers this in *vendredi*.

The Friday of my purchase was also Valentine's Day, originally the
Roman Lupercalia, sacred to sexual delirium when enthusiasm over-

comes self-control. On that fucking Friday afternoon I gave myself to Aphrodite Salacia, whose sacred day was Friday.[28] I buy to become salacious, knowing that state to be salubrious for me.

Between my appearances in a selection of skintight, mesh, and filmy off-white dresses, which I try on unclothed for accurate fit and effect, Peggy, whom I love in her peach lipsticks and pale skin, her high-collared, sometimes many-buttoned tailored jackets, shirts, and dresses that reveal her body in fantasies of unfastening, undresses and dresses me in a mirrored, curtained cubicle. Like Sappho, one more passionate wife, we assume the persona of Aphrodite, and like her we know the unbridled and not always easy pleasure of styling oneself in love.[29]

In the Homeric Hymns, written over centuries by various poets (many still unknown), three songs celebrate Aphrodite. The composers are pious and enthusiastic about her radiance and beauty, and Hymns 5 and 6 describe her clothing. Hymn 5 also treats her humorously and enjoys presenting her as a charming and magnificent seducer.

I sing of Russell, rosy-cheeked, a rose among men. Allow me to undress you, as Anchises did with his eyes then hands when Aphrodite appeared to him. Peggy says you look like an angel and always will. Russell, carrier of divine accord between a passionate wife and husband, you don't need conventions—a white robe, wings, or halo—to prove your radiance. More Caravaggio Cupid than quattrocento innocent, you are the nude who lives in real life. You sweat perfume.

Sweet Russell, our garden in June is heavy with the fragrance of honeysuckles. We are *in flagrante* in our bedroom at dusk, and the scent, floating through a window open as wide as it can be, envelops us. You love wild growth; spring cutting back of plants distresses you, as if I were destroying Aphrodite's playfulness, which manifests in her love of all growth and creativity. Without them, not only vegetation but also *aphrodisia* would die. "Don't cut back the climbing roses," you say. I agree with your acuity.

A man, my mother, a girl, my brother; we all cross-dress for Aphrodite.[30]

I sing of Heather, radiant: with muscles built by many, heavy pounds and pressures in the gym; with balletic grace; with black skin oiled to exquisite gleam; smiling self-love and embrace. The most sophisticated of nudes in your bikini as you performed for an audience near two hundred,

you were no Hottentot Venus, no Saartjie Baartman whose black body Londoners minimized to sexualized parts and spectacle. Like other black female bodies on naked display at Parisian social functions in the 1800s, Baartman's body was an entertainment, especially her buttocks, as if smirking lust had twisted beauty into a mockery of Aphrodite Kallipygos, who gazes over her shoulder to admire her nude and splendid ass.[31]

Heather, subordinate to no one, not even Aphrodite. Strong, broad, and large, akin to the Aphrodite I see when she shows herself as goddess to Anchises. Heather, the definition of your muscles is the dazzling self-definition displayed by a body of content. I witness in you Aphrodite Amazonia, who does not submit to divide—strength from beauty—and conquer.[32]

I sing of Guillermo, your long black hair and brown skin, your elegant investment in spoken words that are sequined, fringed, embroidered—decked out like your body in the midst of most people's prosiness. Guillermo, I see your full lips kiss the syllables as they leave your mouth, I hear your voice sustaining baroque and rococo climaxes in conversation. The ornamented voice, words, and body do not privilege either foreplay or consummation, for both exist in a continuum of pleasure.

I sing of Laura, forty-four and theorizing a feminist performance of femininity. It caught my eye before I could place her any other way. I was walking back from a restaurant to my hotel the night before the beginning of a conference. I saw a woman a little younger than I coming toward me, dressed in dark pants, a black leather jacket, and long, reddish hair. She had a swagger and held a book. I thought, This woman is going to the conference and maybe she and I can be friends.

Laura, you know that beauty is fresh and it is years in the making. You parade lipstick, tight sweaters, a bracelet from France, a designer coat, and you love to show off the little leaf tattooed on your biceps, to push the air around with your big voice and laugh. Take me into the heart of their production, for you, Laura, like me and Aphrodite, are graying at the temples, becoming radiant in reds and silver. We know many ways to gleam.

Styling hair, makeup, and body is no joke in terms of time and money. Becoming beauty also requires effort, the disciplined pleasure of continually reinventing and thus redressing Aphrodite. The myth of the perfect

body, besides damning all our bodies to imperfection, supports belief that beauty does not take work, because perfection for some is a natural state. So, foolish are the people who work at beauty, for failure is the only possible outcome of their aspiration, and failure they deserve.

The perfection myth and fashion magazine beauty falsify the seriousness of aesthetic/erotic self-creation and the necessity for a new Aphrodite who is not a siren song luring us to kill ourselves for beauty, by which I mean exhausting our self-love by overinvesting in beauty purchases and practices that do not build aphrodisiac capacity and power. Aphroditean self-attentiveness and intimacy with others take effort; but because they require discipline not perfection, human beings can participate without a foregone conclusion of failure. As siren song, Aphrodite is a poignant undercurrent in narratives of loss and absence: losing youth, losing weight, losing the color of your hair, losing love.

Celebrity sex icon Cher remarks, "Sexy is a feeling and an art and something you have to really be interested in, like playing the violin— you've got to really like doing it and really be good at it." Cher's statement indicates that commitment to an *ars erotica* comes from enjoyment. Committed pleasure puts the lie to moralizing and frustration. Yet, Cher says, "I'm very insecure about my looks."[33] Also, *sexy* is a light word compared to aphrodisiac. Sexy is the surface of being and using pleasure, and it signals our loss of Aphrodite.

Cher, fifty in 1996, observes that she probably dresses in age-inappropriate clothes, such as filmy lace pants that reveal tattooed buttocks. She seems happy to continue not acting her age.

Act your age
Live the narratives that always require loss
Act your age. Mine is the revolutionary Age of Aphrodite, whose very
 beginning will make it unnecessary for me to ask, How many stories
 must each of us tell in order to remember one story of true love?

NOTES

"Dressing Aphrodite" was performed as a keynote event at the conference Subject to Desire: Refiguring the Body, State University of New York at New Paltz; at the Nevada Museum of Art, Reno; the Style Conference, Bowling Green

State University, Bowling Green, Ky.; and the University of Arizona, Tucson; all 1997.

1. The three sources I have found most helpful in defining and describing Aphrodite's attributes are Paul Friedrich, *The Meaning of Aphrodite* (Chicago: University of Chicago Press, 1978); Christine Mitchell Havelock, *The Aphrodite of Knidos and Her Successors: A Historical Review of the Female Nude in Greek Art* (Ann Arbor: University of Michigan Press, 1995); and Homeric Hymns 5 and 6, in *The Homeric Hymns*, trans. Apostolos N. Athanassakis (Baltimore: Johns Hopkins University Press, 1976).

2. Michel Foucault, *The History of Sexuality*, vol. 2, *The Use of Pleasure*, trans. Robert Hurley (New York: Vintage, 1990), discusses the problematization of the *aphrodisia* and defines them (35–52).

3. Bathing was an example of aesthetic/erotic preparation enjoyed by both Greek men and women for "well-being before and renewal after sex," and "no Greek divinity enjoyed bathing more than Aphrodite." See Havelock, "Aphrodite's Bath," in *Aphrodite of Knidos*, 19–37 (quotations, 25, 24), regarding meanings and purposes of bathing in ancient Greece. Foucault, *Use of Pleasure*, 10–11, makes clear that the *aphrodisia* belonged to a technology of the self, but Aphrodite apparently has little to do with a male ethical practice of the *aphrodisia: Aphrodite* does not appear in the index of his book. Both Friedrich and Havelock remark on the "disappearance" of Aphrodite from scholarly discussion or on bias against her. Havelock sees a "certain patriarchal bias . . . built into the long history of scholarly endeavor on behalf of Aphrodite statues" (6) and concludes that the central role played by Polykleitos and the Doryphorus in relation to the "marginalized" Praxiteles and the Knidia "is a modern prejudice" (140). See Friedrich, "The Avoidance of Aphrodite," in *Meaning of Aphrodite*, 1–3.

4. The famous story of Pliny the Elder (23–79 C.E.) about a man so erotically overcome by the Knidia that he left a stain on it, a sign of his lust, bears out the notion of Aphrodite as an aphrodisiac, as a passage of Lucian (ca. 120–200 C.E.) regarding himself and two male companions who are struck by the Knidia's beauty from her front as well as her back sides. Havelock, in *Aphrodite of Knidos*, 138, suggests that Aphrodite appealed strongly to women; small-scale terra-cotta statues of her have been found not only in tombs and domestic shrines but also in private homes, and "ordinary Greek and Roman women seem to have found the figures of the goddess complimentary and idealizing, and therefore an acceptable projection of their gender. Aphrodite could be their friend and sister in the home, the domestic shrine, the garden, or the tomb" (142). Also, as Havelock writes, Aphrodite was the patroness of queens—she linked them with divine authority and beauty—and courtesans (126–29). Surely Aphrodite was an aphrodisiac for Sappho, a vehicle for erotic self-creation. Friedrich calls Aphrodite Sappho's persona (*Meaning of Aphrodite*, 127) and says that the poet "incarnates the goddess' most fundamental trait: her subjectivity, working through the heart, the synthesis of wild emotion and high sophistication" (123).

5. Friedrich, *Meaning of Aphrodite*, 92, 97, and 124, defines *aphroditē* as a psychological state.

6. *Charisma* is a cognate of the Greek *charis*, usually translated as "love" or "charity." Barbara Walker, *The Woman's Encyclopedia of Myths and Secrets* (San Francisco: Harper San Francisco, 1983), 161, says that *charis* is "the grace of Mother Aphrodite." In her entry on "grace" (s.v.), Walker says that *charis* originally included sensual pleasures, which Christianity deleted from the meaning of *charity*.

7. The notion of *perfection* recurs in feminist writings about beauty. Here I cite three examples. Naomi Wolf, *The Beauty Myth: How Images of Beauty Are Used against Women* (New York: Anchor Books, 1992), all-too-briefly critiques perfection. Susan Bordo, *Unbearable Weight: Feminism, Western Culture, and the Body* (Berkeley: University of California Press, 1993), 149, 151–52, describes "the young anorectic" as a "perfectionist." Anorexia may be part of the moral and spiritual perfection attached to women's pursuit of bodily beauty. *Perfection* appears now and then in Francette Pacteau, *The Symptom of Beauty* (Cambridge, Mass.: Harvard University Press, 1994), where it implicitly underpins Pacteau's critique of female beauty as male fantasy, as the construction of an ideal. If we equate ideal female beauty with a representation of perfection, then examples of feminists dealing with perfection multiply.

8. Robin Tolmach Lakoff and Raquel L. Scherr, "The Representation of Venus: An Ideal in Search of a Definition," in *Face Value: The Politics of Beauty* (Boston: Routledge and Kegan Paul, 1984), 44–68.

9. For the Sport advertisement, see *Vogue*, March 1997, 221; Eternity, March 1997, 121–28; Chaos, November 1996, 251–54; Organza, September 1997, 561.

10. Homeric Hymn 6, *Homeric Hymns*, 56 (line 14).

11. To be sure, there is an Asian-featured model in an ad for Chanel's Allure in *Vogue*, May 1997, 125. But she is an exception even to other Allure ads placed in *Vogue*, which include a Caucasian model (March 1996, 98–99), a Caucasian model dressed in white (November 1999, 169), and the perfume bottle itself—in a Nordstrom advertising section selling French perfumes (September 1996, 124); in another advertising section, "Time in a Bottle: Fifty Years of Fragrance" (September 1999, 295), the bottle is pictured next to a white rose.

12. The man called himself a Christian as well as a white male, so his *we* encompasses both groups. Midori Ishibashi's paper was dated February 27, 1997; her letter to the editor was dated November 7, 1996.

13. *The Odyssey of Homer*, trans. Allen Mandelbaum (Berkeley: University of California Press, 1990), 375–76:

> And to the sleeping queen, the goddess gave
> .
> immortals' beauty, that she might amaze
> the suitors. First she cleansed her lovely face
> with the ambrosial balm that Cytherea
> the fair-haired uses to anoint herself
> when, in entrancing dance, she joins the Graces;
> then, too, she made her taller and more stately,
> and made her skin more white than new-sawn ivory. (18.191–98)

14. Havelock, *Aphrodite of Knidos,* 36.

15. Betsy Berne, "What Works at What Age?" *Vogue,* November 1996, 298–305, 345.

16. Leslie Heywood, *Dedication to Hunger: The Anorexic Aesthetic in Modern Culture* (Berkeley: University of California Press, 1996).

17. Many writers have interpreted the "pudica gesture," exemplified by the Hellenistic Capitoline Aphrodite and Medici Aphrodite, as one of shame. On this gesture, see Havelock, *Aphrodite of Knidos,* 74–80.

18. On bathing, see note 3.

19. See Ovid, *Metamorphosis* 3.138–253.

20. Roberta Seid, "Too 'Close to the Bone': The Historical Context for Women's Obsession with Slenderness," in *Feminist Perspectives on Eating Disorders,* ed. Patricia Fallon, Melanie A. Katzman, and Susan C. Wooley (New York: Guilford Press, 1994), 14. Seid primarily critiques the contemporary ideal of thinness. "I am not suggesting," she says, "as many past and present feminists have, that we do away with beauty and fashion standards altogether. . . . The impulses toward adornment and self-beautification run deep in human culture and are connected to its noblest aspirations" (13).

21. bell hooks, *Art on My Mind: Visual Politics* (New York: New Press, 1995), 120, 125.

22. Friedrich, *Meaning of Aphrodite,* 144.

23. Luce Irigaray, "Divine Women," in *Sexes and Genealogies,* trans. Gillian C. Gill (New York: Columbia University Press, 1993), 61, brings together will, necessity, and becoming in an ardent passage that reads as a plea: "Are we able to go on living if we have no will? This seems impossible. We have to will. It is necessary, not for our morality, but for our life. It is the condition of our becoming. In order to will, we have to have a goal. The goal that is most valuable is to go on *becoming,* infinitely" (her emphasis).

24. Friedrich, *Meaning of Aphrodite,* 70, mentions that Marcel Detienne, *Les Jardins d'Adonis* (Paris: Gallimard, 1972), has analyzed "the role of perfume, incense, and so forth in joining gods and men." On another note, female genitalia are said to have a fishy smell; and the *vesica piscis,* Vessel of the Fish, has been a symbol of the Great Mother worldwide. Many ancient goddesses in various cultures were associated with fishes. Real female bodies smelled of the goddess. See Walker, *Woman's Encyclopedia,* 313–14, for connections between goddesses and fishes.

25. Havelock describes the Knidia's and the Doryphorus's "rational perfection of the pose" (*Aphrodite of Knidos,* 19).

26. Havelock interprets the meaning of the Knidia's right hand, which both covers and reveals her genitals: "The gesture of the right hand of the Aphrodite of Knidos is undeniably riveting. Because it conceals, it forces the spectator to imagine what is behind it and to recognize its importance. The placement of the hand must be understood as a motif designed explicitly to screen the goddess' 'modesty' and, at the same time, to celebrate it. Was the concealment also meant to save the observer from Actaeon's fate and Teiresias's blindness? The answer would seem to be yes. For not only would exposing the ultimate source of her power harm the mortal viewer, but even more importantly, the revelation would diminish the goddess' divine authority" (ibid., 36).

27. See Homeric Hymn 5: "She was clothed in a robe more brilliant than gleaming fire" (*Homeric Hymns*, 49 [line 86]).

28. Walker writes, "The fish-goddess Aphrodite Salacia was said to bring 'salacity' through orgiastic fish-eating on her sacred day, Friday" (*Woman's Encyclopedia*, 314).

29. Sappho's Aphrodite oversees heterosexual and lesbian love. Sappho herself was the wife of a wealthy businessman, and in her poetry she writes of various passionate loves: heterosexual and lesbian, mother for daughter.

30. Merlin Stone, *Ancient Mirrors of Womanhood: Our Goddess and Heroine Heritage* (Village Station, N.Y.: New Sibylline Books, 1979), 2:184, writes, "To those who entered the holy places of Aphrodite, love was love. Thus at Her Oschophorian rites, young boys dressed as girls. And at the Argive feasts for Aphrodite, men put on the robes of women, while women donned the clothes of men."

31. See Havelock, *Aphrodite of Knidos*, 98–101, on the Aphrodite Kallipygos; bell hooks, "Selling Hot Pussy," in *Black Looks: Race and Representation* (Boston: South End Press, 1992), 61–77, for a critique of the sexualization of black women's bodies, including buttocks; Sander L. Gilman, "Black Bodies, White Bodies: Toward an Iconography of Female Sexuality in Late Nineteenth-Century Art, Medicine, and Literature," *Critical Inquiry* 12, no. 1 (autumn 1985): 204–42, for documentation of the sexualization of black bodies, especially the female black body; and Londa Schiebinger, *Nature's Body: Gender in the Making of Modern Science* (Boston: Beacon Press, 1993), 160–72, for a discussion of the Hottentot Venus.

32. I invent the name "Aphrodite Amazonia" to combine beauty and strength; in addition, gold is associated not only with Aphrodite but also in the Renaissance imagination with New World Amazons. Abby Wettan Kleinbaum, *The War against the Amazons* (New York: New Press, 1983), 114, 116, writes that "Renaissance romances gave Amazons sexual as well as financial appeal, and Califia [the Amazon queen] and her golden armor, her extraordinary beauty and wealth, were to play a part of great importance in the New World"; Renaissance "capitalists" who contracted men to search for gold and Amazons held a firm "conviction widely shared in early modern times: the gold is where the Amazons are."

33. Cher is quoted in Brantley Bardin, "Cher," *Details*, September 1996, 238.

Ten

BLONDE BUNNY GODDESS

Praxiteles' Knidia was probably a blonde. Her hair was painted yellow or gilded. Aphrodite's hair represented her radiance, a quality we today so desire and so misread that many women dye their hair blonde or wear a blonde wig in an attempt to be radiant. Dyeing one's hair blonde is not necessarily a problematic personal choice. A woman can weigh the aesthetic/erotic meanings of blondeness and decide how well they suit her, what kinds of aphrodisiac they mark her as, and how her entirety alters the meanings. People would also do well to know that they cannot wholly separate self-creation from contemporary ideologies and cultural practices that mark the inseparable body/mind/soul. Though perhaps the soul achieving radiance remakes the deeply inscribed mind and body in its goldenness.

I met you in sixth grade. We were two of the tallest girls in class. You stayed tall and I did not.

Sharon, you were a belle of the ball. I remember you at a party early one August evening when we were barely twenty. Your ankle-length dress fits snugly; its chiffon elegantly outlines your slimness, suggests roundness here and there. As usual, you have groomed yourself into grace, and your colors

*still strike me: summer gold hair; skin tanned slightly, tawny pink in the set-
ting sun; sheath bright as a pink-orange geranium. This is the color I pick
today to plant in pots on my deck.*

*One afternoon in seventh grade we sat on a couch watching TV in the den
of your parents' house. Our hips were touching and one of our heads rested on
the other's shoulder. I believe that your father, home from work, stepped into
the room to say hello. I do not recall any discomfort from any one of us three.*

Sharon, you and I belonged to Aphrodite.

Golden describes Aphrodite more often than any other epithet given to
her by the Greeks. A golden appearance is precious, excellent, mellow,
joyous, rich. Golden men and women are prosperous because radiance
flourishes in them; that radiance spreads into others, where it activates
bodily and even socially transformative practices motivated by pleasure.[1]

*I met you at the same time that I became friends with Sharon. Later, by our
second year in high school, you had become my first lover. I think this hap-
pened after we saw the movie* Beckett *together. The next day in a school corri-
dor you gave me a note that was the beginning of our many love letters. I kept
them all for more than thirty years, till my parents moved to a condominium
without the storage space of their large house. I regret that our letters are not
in my own home now.*

*You caught your mother looking at my letters to you. You were distraught
and asked me if I would care for them, take them, which of course I agreed to
do. You had already been keeping them in a shoebox that you had decorated
with flocked paper.*

*In your first letter you said that you were like Henry II and I was like
Beckett and you cherished our friendship.*

*We neither kissed nor touched in ways that people would call sexual. We
were erotic intimates, sitting together on my canopy bed commenting on pic-
tures of rock stars in the teen magazines we both collected. Our letters to one
another often detailed our fantasies about the other's sexual activities with her
favorite male rock stars. We elaborated on each other's beauty and erotic
allure, loved each other's hair—your long blonde strands spread out, shim-
mering on a pillow.*

*Your quick intelligence and my intellect supported our shared love of the
absurd. We wrote stories together that made my mother laugh. I laughed a lot
with you, and so hard and long that I repeatedly got the hiccups.*

Boys loved you, Suze, for the same reasons that I love champagne: you gave them a vivacious intoxication; your voice flowed and bubbled. At your wedding I drank many glasses of champagne and spilled most of one glass on my dress. Boys loved you in ways I have never known men to love me because I cannot flirt. I'd watch you with them, laughing in your maroon bellbottoms and dark, tight, ribbed top. You didn't talk with me about handjobs, blowjobs, kisses.

One night as we stood outside a movie theater about to buy tickets, a man walked by and told us we were very attractive boys. Our hair was falling in our faces and we were dressed in pants and pea jackets. We looked at each other and laughed, greatly amused by both his misidentification and the compliment based upon it.

Suze, you and I belonged to Aphrodite.

In the March 1997 *Vogue* a Mondi ad reads, "Personal style is a state of mind."[2] The accompanying photo shows a broadly smiling woman dressed in a snug-fitting skirt and top and a shirt that billows out from her torso. Her head is down, so she seems to be looking at herself or the ground. The image is boxed in, enclosed by a black border. The woman is isolated in her attractiveness, and the longer I look at the image, the thinner and more cramped she feels. Aphroditean style, which fosters golden moments that persuade and educate in the invaluable pleasures of erotic and aesthetic self-creation, has contracted into personal style, whose goal is privatized superficial beauty, possessable as a luxury by few individuals. Beauty for misers is privation, a far cry from *aphroditē*.

I met you when we were graduate students. We had enrolled in a seminar on nineteenth-century English poetry taught by a professor with whom we both were studying. He assigned us to work together on a seminar presentation. The topic was one that held no special interest for either you or me. Our professor wanted us to work on him, so that he could fantasize our conversational study of his sexiness and thereby provide him pleasure.

He had prepared us for one another. I told you that he had described you to me. One element of his description was your blonde hair, and I sensed that he found you to be beautiful. You were. You told me that he had described me to you, but I do not remember the details on which you said he focused. We thought he was perverse, inventing us as rivals. We became friends.

We knew that we were not the only women graduate students whom he desired and slept with.

The two of you lusted and pined after one another romantically. You were both married, and you were his Pre-Raphaelite dream: Cheryl, with your glossy reddish-blonde, breast-length waves; your oval face, delicate features, and creamy pink complexion. You obsessed about him for years. I wonder if I loved you better than he did. He had positioned us, for himself, as blonde and brunette beauty, in an outworn formula that casts the former as sweet and pure, the latter as darker in every way. My erotic gifts tantalized him far less than yours: you wanted to possess him more than fuck him.

You and I were born the same year, one day apart.

Cheryl, you and I belonged to Aphrodite.

Aphrodite iconolatry, alive in the movie and entertainment industries' creation and worship of Jean Harlow, Lana Turner, Candice Bergen, Cybill Shepherd, Melanie Griffith, Marilyn Monroe, Jayne Mansfield, Grace Kelly, Uma Thurman, Pamela Anderson, Mamie Van Doren, Geena Davis, the Gabor sisters, Brigitte Bardot, Heather Locklear, Catherine Deneuve, Gwyneth Paltrow, and an array of lesser goddesses attests to the prototype's power, as does the cult of what I call the Blonde Bunny Goddess, whose members range from actress Jane Fonda to recently deceased ambassador Pamela Harriman to Secretary of State Madeleine Albright to murdered child beauty queen JonBenét Ramsey to black bodybuilder Laura Creavalle. The Greeks' Aphrodite represented youth, beauty, and fertility. Her white skin completes a picture of impossibility for most people that resonates in the elevation of supremely clean femininity for women.

A variety of women, not only those who are graying and gray-haired, try to look reproductive and vulnerable. Blondeness is often the sign of innocent and usable desirability. No wonder Sade made the ever-fucked-over Justine blonde and her terrifyingly brilliant libertine sister Juliette brunette. Justine is the classic dumb bunny. Aphrodite was vulnerable to sexual passion and to love, was devastated, as Venus, by the death of her lover Adonis; but she was never raped and she was sexually independent, choosing lovers while she was married to Hephaestus, god of fire and the forge. She was a married woman and a passionate wife.

I met you in an art gallery. You stood at the threshold, between the exhibition space and the office, where I sat. You felt bigger than most women. Your energy, aggressive and unwieldy, edgy and concentrated in your stance and gaze, imposed itself on me. You were a vision of colors and combat: pink

beret, thick blonde hair to your shoulders, glasses, white aviator's scarf, beat-up black leather jacket, jeans (or perhaps overalls), work boots. You always dressed in high aphrodisiac style. I fell in love with you.

Immediately after our first kiss we denied its import, convinced ourselves that it didn't excite us, that it wasn't good enough. The kisses became very good, and with you my cunt was the rose it loves to be. (I am not a dilettante of the rose, slave to the woes and wonders of a metaphoric, floral femininity.)

Janet, your blood is a burnished red when you streak or scream it onto canvas. Your mother, Louise, gave birth to an Amazon blonde.

Janet, we belonged to Aphrodite.

By simultaneously concealing and emphasizing her pubic area with one hand, the Knidia indicates Aphrodite's sacred fertility as well as her interest in sexual pleasure. That gesture recurs in recent popular and high-art representations of female sexuality. In one of the most famous images of Marilyn Monroe, she holds both hands to her crotch to keep her skirt from blowing up over her waist. A practical gesture, or so it seems. Cindy Sherman's *Untitled #131* (1983) replicates and skews the sexy innocence of Monroe's pose, the fact that it is coded *female fertility*. Looking as if she's cooing as she stands in front of a white and pale gold flower-print backdrop in a honey-colored corset and fitted satiny pants laced on the outside from tight ankle to lower calf, Sherman as silly star-let holds the corset's crotch-length bottom. Her hands assume an ambiguous, painfully self-conscious, and ridiculous position, not quite pressing or cupping her crotch, sort of fiddling around or not sure what to do, suggestive of a little kid needing to pee.

The cult of the Blonde Bunny Goddess defends female reproductivity as part of the fucking rights of man, which privilege younger over older female bodies as signs of potential or actual marking by male seed. The female body that can be sown is El Dorado, the golden place, eternal youth for the implanter.

To link sexual pleasure with procreativity as does the cult of the Blonde Bunny Goddess is to degrade sexual pleasure into merely sexual activity. This is not the point of *aphrodisia*, to endow only youthful bodies with aesthetic/erotic power. The popular phrase *golden years* is a *1984*-ish euphemism for gentling people into what is too often the tarnished reality of age—tarnished, in part, because our society lives out an impoverished idea of the erotic. The erotic *could* permeate human rela-

tionships; the golden years could be part of an aphroditean revolution in which aging is a process, not a midlife-on regret. Everyone is experienced in aging, not only those pressed into aging gracefully.

Aging gracefully is another euphemism, like *golden years,* that serves to keep people in their proper place, which is acting their age. Yet *aging gracefully* also evokes the Greek idea of grace, *charis,* that Aphrodite represents: loveliness, handsomeness, beauty, as a personal attribute and as a source of gratification. *Charis* also means deeply satisfying pleasure, which bears a relation to favors that one has given or received.[3] Aphrodite is charismatic, and I see the practice of *aphrodisia* as education in becoming charismatic like her, which is very different from being charismatic like a movie star or politician.

I met you in a classroom. I was your teacher. You were a golden boy if ever there was one. You gave me your lucid poems, your too-inexperienced love, and your androgynous-looking blonde-haired and blue-eyed beauty. Your intellectual adventurousness seduced me, not your appearance, which was gorgeous but sexually reticent.

You were so deft with language. Once, in bed, you created a sentence about the impetus for passion or the effect or the outcome of passion. I wish I remembered your crisp thinking. I wish I had written down your words. Your logic differed so radically from mine, and it fascinated me.

Erik, we ran away together. (Running away: we deserted our lovers, escaped a small town.) We left the Midwest for the desert, where you wore dark, long-sleeved shirts and pants during the 100° days.

You left me in the desert, which I love more than I've loved most people. I wonder if you're still alive.

Endymion

I

The sensitive system needed a rest: no nourishment to divide the organ's attention, fasting, in solitude like a fat, little monk.

Sometimes the cleansing is a purge: no dissenters against the cause of a soul in revolution.

II

I walk in the door and smell sweat. You also wear the scent of fish. I'd always read that's how we know the female's place. Were they wise men's words? "When her cunt is damp, it is because she has just stepped out of the ocean."

You are not the woman you once were. Your body no longer melts when we move together naked. A change in passion has differently construed flesh and bone.

Ah, press into me. You are firmer than before, a fucking man.

III

Remember Endymion. It is a painting in the Louvre. He is a youth forever in the forest, lips turned to the moon. We call her Selene or Luna the celestial whore, Diana or Artemis who never hunts for men. Her light lays him bare. He undulates, for she burns without fire to the blood.

They will never obey one another and that is their love—lunatic watching touching sleeping, undemanding they carry on, in the close night air, through the distance of dreams never knowing how deep they are

Erik, we belonged to Aphrodite.

The cult of the Blonde Bunny Goddess tries to convert women into girls, experience into innocence and vulnerability. Bunnies are rabbits to which we give a diminutive term of endearment, a pet name, and the Blonde Bunny Goddess is a diminution of Aphrodite. Rabbits are smaller than hares, and people have often confused the two because they belong to the same genus, Leporidae. Also, both propagate abundantly, and the female leporid remains from ancient times a symbol of great fertility, making the Blonde Bunny Goddess a perfect icon of fecundity. She is also "a little beauty queen," as Peter Jennings called JonBenét Ramsey in January 1997.[4] In contrast, Aphrodite takes up space. Her monumental size and radiance frighten Anchises when she appears before him in her deity dimensions the morning after she, in the guise of a maiden, has made love with him.[5]

Ramsey was the all-too-perfect incarnation, in little-girl beauty contest getup, of the Blonde Bunny Goddess. She was angelic beauty— innocent, often white-costumed—assumed to be sexually untouched.[6] Aphrodite was no angel in her sexual knowledge or behavior; and she was not god's messenger, she was herself deity. Grown to adulthood, the hairless, flawless "little beauty queen" turns bosomy and dim-witted. The Blonde Bunny Goddess model matches Angela Carter's Beautiful Blonde Clown in her book *The Sadeian Woman and the Ideology of Pornography.*[7] Carter's discussion of Sade's Justine focuses on a patriarchal dream of Aphrodite, film-star representations of the blonde, female,

sexualized body—Jean Harlow, Jayne Mansfield, Marilyn Monroe—as comical and comedy.

Carter understands that our culture makes a joke of the sexual, reproductive female body—jiggling tits and ass and wet cunt—as if it were abnormal, grotesque as a cartoon character. A case in point is Jeff Koons's *Pink Panther* (1988), a large porcelain sculpture featuring the cartoon star held lightly by the Blonde Bunny Goddess to one breast. He is a Pepto Bismol pink phallus and she looks like Cicciolina, a former porn star and ex-member of the Italian parliament. (Koons and Cicciolina married each other in 1990.) Like the Knidia, the Pink Panther's Blonde Bunny Goddess has hair painted yellow and her skin is light. She wears a Miss America smile, which means she looks like a desperate, grinning idiot. She is Carter's female clown, whose erotic self has been masked in fluff.

Blonde Bunny Goddess cult initiates are especially susceptible to being jokes; their matrilineage includes Justine, who, like them, exudes erotic allure without recognizing her erotic intelligence—in other words, her ability to get plenty of pleasure for herself while also giving pleasure to others. In profound innocence of their own attractiveness, members of Blonde Bunnydom may serve as buffoons in literary and film narratives and objects of abuse in their personal lives. *I'm blonde, I've got big tits, and I'm an idiot:* the dumb blonde pacifies men's and women's fear of powerfully aesthetic/erotic women who know, like Aphrodite, what they are. Such women are simultaneously learning and practicing *charis,* granting and enjoying favors. They can be loving and they can love on their own behalf.

I met you at a university. You wrote and spoke with exceptional eloquence. You were a German national who was far more articulate in English than most of the other students. Your critical sharpness excited me, and you were as smart and wicked about men as you were about art. We quickly became friends.

I was a young professor; I never questioned becoming so close with a student. We talked intimately, ate meals together, uncovered ourselves in many ways to one another. I never saw you naked. I imagined.

The desert sun lightened your dark blonde, stylish bobs, and you chose loose clothing, to midcalf or longer, that only hinted at your voluptuousness. I am sure that I am not making it up. I am sure that my eyes felt it accurately through the attractive textures of the fabrics you enjoyed on your body.

Andrea, you said you didn't like your legs. I liked them in my mind, and I would have liked them then—and now—in actuality.

You complimented me one hot day. I was wearing a black-and-white checked cotton sundress with tiny straps and a purple plastic belt that emphasized my waist. "You have a beautiful body," you said. I want to pay you the same compliment based on having seen at least your undressed shoulders and arms; the shape, through clothes, of your breasts, of your ribcage into waist and hips into thighs; your legs revealed from ankles to at least your knees.

I have wanted to witness the beauty of your flesh as I have witnessed the beauty of your mind.

Andrea, we belong to Aphrodite.

We feminize bunnies and kittens by overplaying their sweetness and fluffiness. Bardot was the Sex Kitten not the Sex Cat, so that she, like the Blonde Bunny Goddess, could be fluff rather than threat. Yet Bardot and many other movie stars and starlets were blonde bombshells, explosively alluring, shockingly or surprisingly sexy, destructive to men's self-possession and to conventions of ladylike composure. The sex bunny/sex kitten image is a delicious provocation for women to sexual activity and even pleasure and to imitation, but the blonde bombshell fails to shatter perhaps *the* major formula for representing female sexuality. The primacy of this one model means insufficiency, for the Blonde Bunny Goddess, besides promoting youth over age and white over black, endorses heterosexual over same-sex couplings and supersweetness over nasty wit. The Bunny Goddess also neutralizes the intelligence of young, beautiful, blonde women.

Bombe feels like a more accurate epithet than *bombshell*. A bombe is a light and frothy molded, frozen dessert full of whipping cream, eggs, and sugar; so it is rich. The Blonde Bunny Goddess contains some choice ingredients—Aphrodite's beauty and her capacity for fun and for kindness in giving—though they have frozen into a recipe for women's deficient aesthetic/erotic agency. The bunny bombe is refined sugar compared to the ambrosia signified by Aphrodite, which is the combined sweetness of grace and great sexual pleasure.

Sweet medicine always letting me down
Sweet medicine from the female clown
That sweet medicine causes me strife
How can I, the Blonde Bunny, be a passionate wife?

Dying dying to be someone sweet
Not saccharine Justine so incomplete
Aphrodite, take away my shame
About tending my body in your sweet name

We all need sweetness in our lives
But the Blonde Bunny Goddess needs to take a dive
To rise like Aphrodite, sign of real sweet bitches
Who do not feel themselves to be embarrassments of riches

Dying dying for something sweet
Won't be your trick, won't be your treat

I met you in the desert—bar, club, restaurant, your home or mine, I don't recall. You were many women's lover and I wanted you to be mine. You were impossible, as narcissistic and manipulative as misogynist myth makes women out to be. Your luxuriant blonde hair and riveting blue eyes were your best features. You were kind, but full of false promises, and you loved alcohol and heroin more than you loved anyone you fucked. My obsession with you was corporeal in the extreme. That kind of extremity is ludicrous from a distance, though confidantes of mine were compassionate as I elaborated the hardness of your cock to my hands and tongue, the sheer sensuousness of your body weight on me, the frustrating reasons why we never fucked. My obsession kept my cunt opulently moist, kept me in sexual riches, kept my mind alive in the ways I need and thrive on: eros wakes up intellection.

Obsession can be a corny perversion when it is not too dangerous. (I did not want to trouble my first marriage.) Thank you, Scott, for catalyzing my erotic potency. You were one of the best, precipitating numerous delicious bouts of masturbation. Accept a lyric, saved by passion from unmitigated corniness, written in your honor.

The desert is a waste
I wonder about you
With your liquor and your coke and girls
And sweet debauchery

I saw a neon sign
A cactus burned real bright
I read dull letters "Road to Ruin"
A bar on an old highway

I imagined you there
So I wanted to cry
You told me you don't think you're done for yet
So I thought of your fire hands

You're a fire-eater, firestorm
Drink firewater till your heart turns warm
You're the old flame and the new
You're the fire man with the fire hands

You're a flamethrower, firestick
Drink firewater till your mind is thick
With fire power, no escape
You're a fire man with the fire hands

Deserts are for demons
And deserts are for saints
When I was a child I heard men stole fire
But you were born with fire hands

Scott, you and I belonged to Aphrodite.

The cult of the Blonde Bunny Goddess turns women into little girls and animals into feminized fluff. The cult also turns little girls into women, blacks into whites, and masculine into feminine. The cult's age, race, and gender transformations indicate the aesthetic unacceptability, in the Western tradition of human beauty, of women's aging, of men's femininity, and of anything but Caucasian skin tones.

Ramsey, hair curled, lips painted red, poses in a white-and-gold costume that resembles a Las Vegas showgirl's. She fits Koons's description of Cicciolina—"very seductive and very innocent."[8] Marnie Weber played wickedly with this combination in her 1997 exhibition at the Jessica Fredericks Gallery in New York. One series of small collages features buck-toothed portraits of Breck Girl–ish women whom Weber alters into bunnies, and another series shows a young, white, beautiful female nude variously bound, tortured, and dead. Each Weber girl is, like Ramsey, the "murdered innocent."[9] Hares in ancient Greece were Aphrodite's favorite offering, and an Irish poet in the mid–twentieth century tells of an acquaintance of his, a farmer who believed that hares enjoyed being hunted.[10] Justine, JonBenét, Jayne, and Norma Jean: small

game sacrificed, respectively, by self-willed ignorance, by murder, by traffic accident, by suicide or, in some minds, government plot, to the extant but unsystematized and uncompiled mythology of the Blonde Bunny Goddess.

Weber sings a song she wrote, "I'm Not a Bunny," whose lyrics lament an adult's loss of bunny sweetness while also suggesting that to be a cute, lively bunny of a female is to be missing something substantial of oneself.

> I'm a grown up girl
> I know that I should be bouncy
> . . . should feel really swell
> . . . should be perky
> I know that feeling good bunny smell
> I lost part of me
> Can anyone tell
> I'm not a bunny[11]

I met you in a diner where you worked. You made a great burrito, fat with beans, cheese, and vegetables. Soon after you became a student of mine, you declared your desire to become friends. You took a chance, which I admired and appreciated, so I gave us a try.

You have become the only person I have ever called daughter.

When I met you, your hair was dyed black. Then you colored it glamour queen yellow, and you would wear cherry red lipstick, a great deal of makeup, and costumey clothes—short or glittery or tight—that focused attention on the whiteness of your skin, your large, round breasts, your investment in appearance for the sake of a simplistic seductiveness that began to bore you. During your high blonde phase, a friend of mine told me you were beautiful, a colleague of mine exclaimed to you in the hallway, "You look like Virginia Mayo," and a fellow student in a performance art class you took with me compared you to a bunny.

Then you let your own hair live. It is darker blonde and silkier than it was in your classic blonde bunny look. You no longer dress up every day, and often your face is naked. You are more beautiful than before.

I have seen you discover the pleasures of intellectual discipline. Mother and daughter are bookish partners. When you call me "geek," you implicitly refer to our erotic kinship rooted in a love of book work.

We eat lunch together, shop in vintage clothing stores, talk about our imperfections. One day we focus on legs. We encourage each other to be barelegged; we encourage each other's beauty.

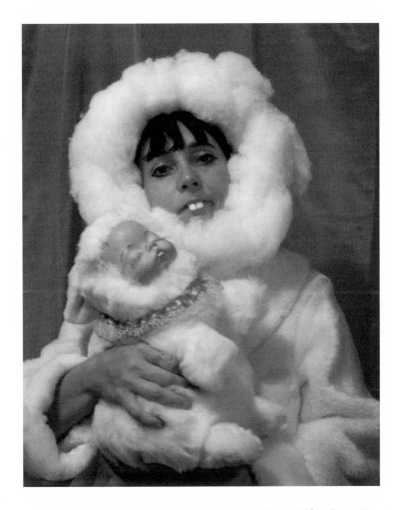

Marnie Weber, "I Am Not a Bunny." Photograph: Chris Warner.

*We walk with arms around each other's waists. We say clearly as we look
into one another's eyes, "I love you."*

Johanna, we belong to Aphrodite.

Like Ramsey-cum-showgirl, Michael Jackson is a vanilla bombe in
Koons's *Michael Jackson and Bubbles* (1988). The chimpanzee's and Jack-
son's skin is lightly tinted and their hair is golden, which recall the Kni-
dia. Koons refers to the sculpture as rococo.[12] Both Jackson and his pet
are entirely clothed in gold and white, except for red lips and darkly
made-up eyes. Jackson has feminized and "whitened" his facial features
through cosmetic surgery, and he has said that he suffers from vitiligo, a
loss of skin pigmentation. Koons pushes Jackson's choices and affliction
into high femininity, a creepy evolution in which Blonde Bunnydom is
the guiding principle of natural selection. The problem is not that Jack-
son appears feminine but rather that he is purified racially into the
supremely clean style of femininity.

Champion bodybuilder Laura Creavalle's cosmetic surgery has trans-
formed black into Caucasian beauty by narrowing her lips and nose, and
in Bill Dobbins's *Women* she appears with a chin-length, dark-honey red
bob; loose, shoulder-length, bright yellow curls; and an amazing mass of
tight, blonde ringlets that fall almost to her waist.[13] Creavalle began com-
petitive bodybuilding in her own short Afro and started ornamenting
herself in blonde wigs for competitions by the early 1990s. (Later, the
International Federation of Bodybuilding powers that be ruled that wigs
and extensions could not be worn in competition.) Creavalle reads like
black sex symbol singer Tina Turner, whose big blonde wig has satisfied
the racist aesthetics epitomized in the Blonde Bunny Goddess.[14] At the
same time, Creavalle's double goldenness—blonde wigs and bronzy
black skin—is gorgeously decorative, as is Koons's radiant Michael Jack-
son and the hair of friends and lovers whom I celebrate in this chapter.
Creavalle in her wigs and Jackson in his gold hair represent the height of
artificially adorned self-creation that is monster/beauty; and Creavalle's
aesthetic manipulation of her appearance does not necessarily indicate
only a racist aesthetics. Blonde hair complements black skin very differ-
ently from how it complements white skin, and blonde hair/black skin's
particularities of nuance and contrast emphasize difference from white-
ness rather than pointing out a desire to resemble a white person. (Older
women's dyeing their hair blonde probably has more to do with wanting
to be young than black women's dyeing their hair blonde has to do with

wanting to be white.) Gold hair dramatically accessorizes a black aes-
thetic, as with African American rap and R & B artists, such as Lil' Kim
and Mary J. Blige; and black women's choosing to be blonde belongs to
an appropriative postmodern aesthetic in which races, genders, genera-
tions, and ethnicities borrow from one another. Blondeness like Turner's
and some of Creavalle's may be wild—the black woman as "sexual sav-
age"[15]—but black women's blonde hair is also contemporary fashion, as
is evident when one of the three models in a L'Oréal hair color ad is a
dark-skinned woman with nappy blonde hair.[16] The blondeness dis-
played by the L'Oréal model and Creavalle destabilizes the privilege
bestowed by culture on blonde hair/white skin. Simultaneously the
privilege of blondeness assimilates the bodybuilder and the model into
the blonde's commodification as a middle-class white ideal.

Blondeness is distinctively beautiful and expressive. Yet, whether or
not their entry into blonde bunnydom is the key to women's desire for
golden hair, the Blonde Bunny Goddess remains an insidious model. In
Dobbins's book Creavalle is the only woman, of any race, who sits in a
partial stock or pillory, her forearms confined. Various subjects sport
S&M gear, but Creavalle is the sole black woman with blonde hair, so her
punishment is the torture suffered both by the Blonde Bunny Goddess
incarnate and by the black woman who dares to be the white ideal but, of
course, can be only a savage impersonation. Ike Turner, Tina's husband,
physically abused his blonde bombshell wife,[17] and Creavalle, the blonde
black Amazon, also must be brought under control. Dobbins succeeds,
and he stands in for the white male bodybuilding powers who have con-
sidered Creavalle to be an uncontrollable personality.[18]

Creavalle's artificial blondeness also helps to soften her hypermuscu-
larity, which our culture equates with masculinity. Many white female
bodybuilders, such as Kim Chizevsky, who dyes her hair, also count on
blonde hair to feminize their muscles. In *The Women* she flexes a biceps
while her poufy mane floats stiffly over most of her face and she pouts in
childlike seductiveness.[19] Chizevsky fills out a fuschia corset, its candy
color corresponding to the bunny babe's hot sweetness. Chizevsky may
be hard candy, but she is candy nonetheless.

The Blonde Bunny Goddess cult initiate works hard to maintain her
position. Otherwise she might be like me: dark-haired, with the dirty
insistence of gray.

Give me the dirt. Because I am a lesson in the prime of life.

I stand in line at Kiehl's pharmacy, 109 Third Avenue, New York, waiting to celebrate Aphrodite with my purchases, the thick yellow creams that encourage slow application, luxuriation in the texture of my skin. Like Aphrodite, I often tire of trying to recognize myself in mirrors. Touch is a lesson I am always looking for. I recognize myself one way through flesh, by stroking my skin and pressing into muscle. I am not feeling my way around myself: I am tender, sometimes probing; I do not have to be cautious, wary of what I find and know. I feel my way into flesh rather than around it.

I attempt to be unmotivated by numbers alone: the tape measure of my teenage years, the proportions of Miss Americas, the weight of fifty. I attempt to be unmotivated, too, by colors as the signature of cruel perfection: yellow hair moves me no more than any other color, golden skin attracts me.

Like Aphrodite, my training partner, I push my lover Russell down on his back, on the bed. I keep him, one erotic instant upon another, in the place of love.

I recognize the radiance around us on a sunny mid-September morning when I suck him off in our backyard and see the blue and cloudless sky as I smell the aphrodisiac odors from his face, his head and pubic hair, his dirty fingers. He is pungent with Aphrodite's ocean birth. Our jeans are loose, warm to the touch from sunlight, and pink petunias bloom near our feet. Two neighbor cats come and go. The heat of sex and sun are as brilliant as Aphrodite's naked body.

She knows that she is beautiful, and she knows why. She is neither ignorant nor silent about this. She is no dumb blonde.

I know the same things about myself.

Russell and I belong to Aphrodite as we continually learn the lesson of her radiance, which is more pragmatic, more prosaic, more possible, and more lustrous than the Knidia's blonde hair.

NOTES

1. Although the basis for social change in Audre Lorde's "Uses of the Erotic: The Erotic as Power," in *Sister Outsider: Essays and Speeches* (Trumansburg, N.Y.: Crossing Press, 1984), 53–59, is not pleasure per se, the essay's focus on passion,

richness, and joy has always suggested to me that social transformation can occur through people's radical restructuring of their lives in pleasure.

2. Advertisement, *Vogue,* March 1997, 129.

3. Paul Friedrich, *The Meaning of Aphrodite* (Chicago: University of Chicago Press, 1978), 106–7, defines the "distinctively Greek (and Mediterranean) cluster of meanings" that is *grace* (*charis*).

4. Peter Jennings, *World News Tonight,* ABC, KOLO, Reno, Nev., January 7, 1997.

5. Homeric Hymn 5, in *The Homeric Hymns,* trans. Apostolos N. Athanassakis (Baltimore: Johns Hopkins University Press, 1976), 52, reads, "When the noble goddess had clothed her body in beautiful clothes, / she stood by the couch; her head touched the well-made roof-beam" (lines 172–73).

6. JonBenét was found tied, strangled, and sexually assaulted in the basement of her parents' Boulder, Colorado, home on December 26, 1996.

7. Angela Carter, *The Sadeian Woman and the Ideology of Pornography* (New York: Pantheon, 1978), 57–71.

8. Jeff Koons, interviewed on *Jeff Koons: The Banality Show,* dir. and prod. Paul Tshinkel, Inner-Tube Video, New York, 1989, videocassette.

9. Tom Brokaw, *NBC Nightly News,* KRNV, Reno, Nev., December 31, 1996.

10. John Layard, *The Lady of the Hare: Being a Study in the Healing Power of Dreams* (London: Faber and Faber, 1944), 185–86, claims that the hare's liking to be hunted is a "symbolic image . . . of the basic truth enshrined in all 'willing sacrifice' that instinct wants to be transformed into spirit," and he calls the hare "this loved but at the same time hunted animal." Quoting mainly from a German source published in 1863, Layard focuses on the hare as a love symbol in ancient Greek literature and art (212–20). In this discussion, the hare is cited as Aphrodite's favorite offering.

11. Marnie Weber, "I'm Not a Bunny," on *Cry for Happy,* Ecstatic Peace! 1996, CD 86.

12. Koons, *Jeff Koons.*

13. Bill Dobbins, *The Women: Photographs of the Top Female Bodybuilders* (New York: Artisan, 1994), 72–73, 85, 45, 119.

14. bell hooks, *Black Looks: Race and Representation* (Boston: South End Press, 1992), 68, writes of Turner that "blondeness links her to jungle imagery even as it serves as an endorsement of a racist aesthetics which sees blonde hair as the epitome of beauty."

15. bell hooks, ibid., says that Turner promotes "the visual representation of woman (and particularly black woman) as sexual savage."

16. Advertisement, *Vogue* (January 1999), 19. Kobena Mercer's "Black Hair/Style Politics," in *Welcome to the Jungle: New Positions in Black Cultural Studies* (New York: Routledge, 1994), 97–128, is a classic consideration of the aesthetics of black hair. Mercer's discussion of the conk, a 1940s style for men, has useful implications for interpreting contemporary blonde hair/black skin: "the element of straightening suggested resemblance to white people's hair, but the nuances, inflections and accentuations introduced by artificial means of stylization emphasized *difference*" (119, her emphasis); "I think the dye was used as a styl-

ized means of defying the 'natural' color codes of conventionality in order to highlight artifice, and hence exaggerate a sense of difference" (119). Dyed hair belongs to an African American aesthetic inventiveness "that should be valued as an aspect of Africa's 'gift' to modernity" (128). Lisbeth Gant-Britton generously permitted me to read her essay "Bronze Blondes, Black Blondes, and Designer Bodies," presented at the 1999 Modern Language Association's session titled "Theorizing Beauty I: The Aesthetics of Hair, Bodies, and Brides," which was chaired by Holly Laird. Her ideas about assimilation, destabilization, and commodification helped shape my thinking about the differences between the blondeness of Anglos and that of Latinas and African Americans.

17. In *I, Tina,* written with Kurt Loder (New York: William Morrow, 1986), Tina Turner recounts Ike Turner's physical abuse of her (76, 86, 90, 97, 116, 120, 129, 133, 136, 159–60, 163, 167–69).

18. Men's control of women's bodybuilding is a contentious issue. Despite Doris Berlow's efforts from 1978 into the beginning of the 1980s to put women's bodybuilding competitions under women's control, aesthetics of the built female body and professional women's bodybuilding competitions remain very much controlled by the brothers Weider, Joe and Ben. See Alan M. Klein, *Little Big Men: Bodybuilding Subculture and Gender Construction* (Albany: State University of New York Press, 1993), 98–100, on the Weiders' monopolistic enterprise.

19. Dobbins, *The Women,* 85.

Eleven

BORDER COWGIRL

For Peggy Doogan

You got out of your car
You walked to the center line
You saw a snake curled up
The sun made its scales shine

You stood in the desert
A spider crawled to your boots
You put it in your hand
Tarantula to your roots

Chorus:
You may be an old spider woman
You may be a snake lady's child
To me you're a border cowgirl
So willing to be wild

You made love on a rock
Till your back began to bleed
Stone and sand are tender
When your love's a tumbleweed

You saw a smiling boy
At a Mexican motel
He strangled a songbird
You told him, Go to hell

Chorus:
You may be a scarlet woman
You may be a snake lady's child
To me you're a border cowgirl
So willing to be wild
Put on your boots of green leather
Let's take walk in the wild
Down Mescal Road and Manlove Street
So willing to be wild
Let's stand out in the monsoon rain
You'll hug me when the winds are wild
And soothe me when I've walked too far
So willing to be wild
You are my border cowgirl
So willing to be wild

Twelve

SCARLET WOMEN

I sat at a bar with some women
They said, Let's go out back
To the tables, chairs, and fountain
The moon came up so flat

Their perfumes were mixing with flowers
We didn't count the beers
We were loud, like a storm at midnight
And soft as leaves and tears

Chorus:
We are the scarlet women
We've been burned by the sun
We walk the streets at high noon
We have no need to run
From heat that makes our heads swim
And makes our bodies shake
We are the scarlet women
The bottomless blue lake

I am a scarlet woman
I came here for the heat
I came here for the palm trees
I came so I could meet
Some other scarlet hearts of steel
Some lips and nails as red
Because we're scarlet women
You'd like to see us dead

But we are burning too hot
And you are just too cold
You've got no hunger or thirst
That cannot be controlled
By some dreamed-up oasis
And even though I ache
I am a scarlet woman
The bottomless blue lake

Thirteen

SADE, MY SWEET, MY TRUFFLE; OR, GIVING A FUCK

Frueh wears a dark brown sheath. Spaghetti straps, bare legs, an aquamarine-and-diamond necklace, and three-and-a-half-inch spectator pumps of umber leather and suede contribute sex and sparkle.

Who gave me this hand to smack you with?
Who gave me this throat for swallowing piss?
Who gave me this whip to bleed your flesh?
Who gave me this palate that so loves shit?
Who dictated that giving a fuck means violence, tumult, chaos, damage, frenzy?

These questions, asked by a recanting Mme. Duclos, one of the marquis de Sade's storyteller whores in his novel *The 120 Days of Sodom,* or by me in a nightmare, are at once rooted and buried in a Western erotic tradition of shame; and they also challenge that tradition. It is a dominant modern erotics and a taproot for contemporary clichés of transgressiveness and abjection.[1]

Sade's relentless and literarily original erotics of grossness and cruelty is embraced by one of Georges Bataille's definitions of *eroticism* in his 1957 *Erotism:* "We use the word eroticism every time a human being behaves in a way strongly contrasted with everyday standards and

behavior. Eroticism shows the other side of a facade of unimpeachable propriety. Behind the facade are revealed the feelings, parts of the body and habits we are normally ashamed of."[2] Bataille devotes two chapters of *Erotism* to Sade. On the back cover of the 1986 City Lights edition of *Erotism* a blurb by Foucault reads, "Bataille is one of the most important writers of the century."

Sade, the Divine Marquis, is, of course, legendary. This reputation is earned by his influence on numerous nineteenth-century literary lights and lesser figures—Byron, Pétrus Borel, Swinburne, Théophile Gautier, Baudelaire, and Octave Mirbeau. Although *120 Days* was not published until 1935, Sade's novels *Justine* and *Juliette*, as articulate as *120 Days* in the erotics of shame, pain, and doom, were first available, respectively, in 1791 and 1796. Sadism—the word derives from practices in Sade's writings—is glamorous when touched by romantic and symbolist artists and writers, and it looms in surrealist works such as Hans Bellmer's *Les poupées* and Max Ernst's collages *La femme 100 têtes* and *Une semaine de bonté*. A host of twentieth-century theorists and philosophers, Bataille and Simone de Beauvoir among them, have written about Sade. That list also includes contemporary feminists, such as Jane Gallop. Moreover, a Sadeian aesthetic reverberates in a recent art phenomenon to which much of the November 1997 *New Art Examiner* is devoted: "low-life scum, grotesque deformity, . . . sexual perversion, and senseless violence" is Kathryn Hixson's description in her editorial.[3] The lowlife in Sade is the shameful body of Bataille's definition.

I do not intend to compare the 1990s and the 1790s; and Sade was an aristocrat, as are many of his created debauchees, who are either born into the aristocracy or whose noxiously accumulated wealth makes possible the extravagances enjoyed by that class. However, independent video/film producer Jennifer Reeder's *New Art Examiner* essay promulgates a Sadeian philosophy of revolution through giving a fuck as lowlife "cultural terrorism." Agreeing with feminist cultural critic Laura Kipnis that the lower body and the lower class are associated, she asserts that by "embracing this farting, shitting, puking, pissing, cumming, bleeding, pussing, fucking, spewing body we threaten bourgeois ideology and the most basic elements of class stratification."[4]

Reeder seems thrilled by what she perceives to be her own shameless trashiness. Her essay feels dangerously close to the fashionable impropriety that Hixson addresses. Despite Reeder's tongue-in-cheek verve, she is too reliant on language that signals today's voguish engagement with

transgressiveness.[5] Reeder's articulation is simplistic, for her "low" aesthetic partakes of the dominant artistic and intellectual discourse—an erotics of damage—that projects from and into individual bodies that are acutely ashamed. To be thrilled about one's shamelessness is very different from the delight one experiences in being a relatively unashamed body. Cultural terrorism, whether Sadeian or postmodern, may foist shamelessness into spotlights, but I give a fuck for a cultural eroticism that can help unshame the body. I give a fuck about people's experiences of the most prosaic events, such as shitting, fucking, and menstruating. I give a fuck, donate myself in passionate pleasure, to these events not as a litany of shames or a list of imperative-to-desirable bodily acts and processes; rather, I give a fuck about indulging in the pleasure of those acts and processes.

Sade was certainly self-indulgent. He molded me after himself and what he loved and desired. Men delighted in my whippings, and I was one of the best friggers in Paris. So good that the four libertines who chose me to entertain them at the Château de Silling, Sade's paradise of gothic eros, appointed me to instruct the little girls who were in my lords' dissolute care in jacking off men. Sade called me, Duclos, a "gifted whore," which I have been professionally since the age of nine, and the libertines wildly appreciated my lubricious stories, which kept them cumming night after night. Curval, one of the four, exclaimed to me, before his cohorts, "Rejoice at the effect of your discourses."[6]

Yet Duclos, "our heroine," worries, "I fear that the anecdote I have . . . to relate . . . is far too simple, too mild for the state you are in."[7]

I have wanted a bedroom chair for several years, and Russell and I have been looking for one that long, which is about half the time we've been married. We are hard to please. Recently we spotted a likely possibility in a San Francisco store where the merchandise is contemporary, often exquisitely designed, and extremely expensive. The floor model is dove gray leather. We would order a light butter yellow. Sitting in the chair, each alone, we feel embraced and supported; we rest a leg over one arm, then the other. Good for reading and conversation. We imagine how the chair will hold and brace us when we fuck in various positions. The chair assumes a primary role in a fantasy of pleasure, in which Russell and I are hot as well as amorous subjects.

It is the second aspect that makes us obscene in light of the erotics of damage, which censures loving sentiment as if it were too sweet, a

chocolate horror the pleasure of which would cause the savorer to throw up. Roland Barthes considers this situation when he asserts, "Discredited by modern opinion, love's sentimentality must be assumed by the amorous subject as a powerful transgression which leaves him alone and exposed; by a reversal of values, then, it is this sentimentality which today constitutes love's obscenity."[8] In this modern—and contemporary— moral framework, sex is not obscene; rather, it is pleasure through loving-in-fucking that becomes not only obscene but also arrogant.[9]

In his essay "The Use Value of D. A. F. de Sade," Bataille extols sadistic revolution—"violent death, gushing blood, sudden catastrophes, . . . horrible cries of pain"—and ranks it superior to a "revolting utopian sentimentality."[10] For him, the "truth of eroticism is treason," but only when exploding, disintegrating, and furiously penetrated bodies, which demonstrate a correlation between pleasure and pain, challenge the "established patterns" of a "regulated social order" that Bataille condemns as limiting and that he believes the erotic shakes to its foundations.[11]

Pleasure is an elixir of love, root and bloom of an erotics different from that of Sade and Bataille. The erotic exists in genital sexual gratification, but it can operate much more expansively in recognitions of plenitude and in the development of wisdom regarding satisfactions relatively unadulterated by conflict, pain, hostility, shame, or frustration. Pleasure in these terms is neither utopian nor Pollyannaish. Freud wrote that reality overwhelms the instinct for pleasure. This appears to be true, and when reality is an erotics of damage it establishes its own patterns. Because everyday exigencies, which may be brutal or simply annoying, erode people's instinct for pleasure and deplete their will to pleasure, people do not seek more than a tolerable level of unpleasure. However, pleasure can be chocolate rapture and contentment rather than nauseating horror, and pleasure remains an urgent instinct beneath the cultural burdens of belief in pleasure and pain as unavoidable and necessary correlates and of sentimentality's association with a despicable propriety.

A soft and elegant substantial chair that gives with the pressures of buttocks responding to a slow tongue on a hard cock and of knees driven into and cushioned by the seat; a chair for marital partners to enjoy the revolutionary positions of a loving erotics.

I am as proud of my beauty as I am of my oratorical and narrative skills. Sade describes me, forty-eight years old in 120 Days, *as "majestic," and he*

especially lauds my ass—"one of the most splendid and plumpest," one of the "finest" anyone could hope to see, a "matchless ensemble."[12] (He praises many asses with superlatives, but still I appreciate his compliment.) Both he and I know my breasts are superb. In his and the libertines' eyes I am a "radiant creature," just like Aphrodite, and my autobiographical tales spellbind my audience and brighten their November.[13]

I am as lugubrious as I am lubricious, for I am the libertines' sister, servant, and minion. We are all intent on pleasures for the body and crimes against it: I plunder bodies, careless of souls, with my deceit and avarice; I create events for people who love corpses, who cum when they can terrorize mothers, children, and virgins. I am one vicious and cynical cunt. Who doesn't much like cunts at all. And though I love Sade because he knew that I am smart and linguistically stirring, that I am gorgeous, in dress as well as undress—"bejeweled, more brilliant with each passing day," he says—he was a rigid son of a bitch.[14] The party at the Château de Silling proceeded according to the libertines' Statutes, their program of pleasure and punishment.

And Sade, lover though you are to me, you made me too perfectly beautiful; you should have described the broken capillaries that decorate my legs, just here and there, and how those signs of poor circulation drove some clients and lovers of mine mad with lust. You missed that perverse passion.

Also, my Lord, my dear Sade, lover of my midlife power, I must remind you that some of the practices you made me preach disgust me. I hate cum shooting in my face, your poignant cliché of ecstatic male power, and I hate eating shit.[15]

I first read all of *120 Days* several years ago, when I was forty-eight. I identified in some respects with Mme. Duclos, who is forty-eight when narrating over a month the "150 simple passions," which include permutations involving urine, mucus, excrement, flagellation and other epidermal and subcutaneous stimulations with needles and hot irons, and terror aroused in unsuspecting pawns through morbid, anxiety-provoking talk and situations.

I enjoyed Maurice Lever's *Sade: A Biography* on finishing *120 Days.*[16] As I read books and critical works on Sade, I fell in love with him. He was smarter, funnier, and sexier than most men I meet, though he was also a jerk. In my late teens I looked at Sade fitfully, so repulsed by the tortures he adores that I never read anything by him cover to cover. From then through my early thirties I scrutinized and luxuriated in writ-

ings by many of the romantic and symbolist Sadeian family. I belong to
it: it is an opulent erotic world, filled with beautiful, often quick and
sometimes deeply intelligent fatal women, and I was captivated and
inspired not by their cruelty but rather by their profound sensuality, the
sovereign power of their erotic bodies as well as their minds. Femme
fatale–ism, feminism, femininity: they and I could operate on all fronts.
So I am steeped in the tradition of erotic damage, and when I met Duc-
los, a supreme femme fatale who, unlike most of her nineteenth- and
twentieth-century sisters, is not young, I also met, in certain ways,
myself.[17]

> *Duclos and I sing a song for Sade:*
> Come sail your ships around me
> And burn your bridges down
> We make a little history, baby
> Every time you call around
>
> Come loose your dogs upon me
> And let your hair hang down
> You are a little mystery to me
> Every time you call around
>
> Chorus:
> You talk about it all night long
> We define our common ground
> And when I crawl into your arms
> Everything comes tumbling down[18]

I will not revise Duclos into a recanting character, for that would
shame both her and Sade. She is a gem as she is, a memorable and useful
star of a pornographic classic. Sade's four storytellers are all midlife
women—forty-eight to fifty-six—and the libertines, four midlife men,
choose Duclos and her peers precisely because they "had attained their
prime—that was necessary, experience was the fundamental thing
here."[19] Though unlike Duclos in that she doesn't relish the pleasures
that her cunt can provide, I am in sympathy with her style—"very scanty
and very elegant attire," adornment in makeup and jewelry; with her
understanding that erotic satisfaction necessitates moral as well as physi-
cal sensation and is enhanced by "mentally heating" conversation and
philosophizing that quicken genital excitement; with her vivacious and

sophisticated ability to speak that kind of prose and to proudly enhance its piquancy with artful rationality.[20] As she declares, "After having perverted you it is my responsibility to restore you to reason."[21] She moves her audience unashamedly from body to mind—again and again, so that neither is starved of erotic sustenance.

Shit is sustenance for the libertines, and they force others to eat it. They and many of Duclos's clients are connoisseurs of shit, as some people are of chocolate. Sade himself loved chocolate. One of Duclos's customers exclaims to her, "What pleasure you give me! I've never eaten more delicious shit!"[22] Shit is a delicacy—a libertine swallows a "turd for dessert"[23]—and Sade would have us believe that we should all like eating shit better than chocolate.

In defense of chocolate

Cocks turn soft in my mouth, like chocolate candy bars and ice cream that become smaller through intimacy with tongue, warmth, and teeth.

Hannah Wilke's *Venus Pareve* (1982), a nude self-portrait chocolate sculpture, is an autoerotic image of repleteness. Pareve: neither meat nor milk. The divine Hannah: essence of neither sexflesh nor motherfluid. The divine Hannah: able to conceive of the human body as chocolate, a symbol of love, the ultimate pleasure food, a Valentine's Day gift of supreme sentimentality. She dispenses with shame about a forbidden delight.

Compare that with Janine Antoni's *Chocolate Gnaw* (1992), a monumental block of chocolate, a huge piece of pleasure whose consumption would sicken a single individual. A minimalist cube becomes minimal pleasure, for here chocolate is a symbol of desire embodied as the absurdity and even horror of satisfaction, especially when we know that Antoni sculpted the originally 600-pound cube with her teeth. The (im)possible extravagance of pleasure gnaws at people.

Sade, chocolate lover that you are, I thought you might like to try my mother's brownie recipe.

Brownies: Single Recipe

1 stick butter
1 cup sugar
 Cream together

2 eggs
Add

6 tablespoons cocoa or
3 squares melted chocolate
Add

1 cup sifted flour
1 teaspoon vanilla
1/2 cup walnuts

Bake at 350 degrees for 18 minutes

Duclos's attributes make her a typical Sadeian heroine (and hero): she is an "abnormal" woman who stands against pregnancy, motherhood, heterosexual vaginal intercourse, and men. (Her casting aspersions on pricks as shriveled, tiny, soft, discolored, "wretched," ugly, stublike, often altogether "miserable relic[s]" and on their ejaculate—measly, dribbling, squirting, pathetic—critiques the image of men as infallibly and beautifully potent.)[24] Duclos's abnormalities, including unashamedness about her body, present Sade as feminist, though one may also read him as frighteningly misogynist. He is full of contradictions, for giving a fuck is not a monolithic position that the giver should protect with self-righteousness.

I would love to receive a love letter from Sade. He wrote delicious ones, full of aristocratic lightness, flair, and lies, full of erotic flatteries. Sade, my sweet, here I am right by your side, in your arms, lovingly, subversively in bed with you. I am in your face, up your ass, articulating the means of noncriminal pleasure's support.

Duclos's abnormalities and Sade's contradictions, complexity, and realism enable her to be unashamed at the same time that he highlights body parts, events, and products whose expulsive properties signal shame. Sade's erotics, like Bataille's (and Reeder's), is determined by organs of expulsion rather than pleasure. Expulsion—imperious demand, tumultuous release—equals violence, and shame erupts from the body. Bataille asserts the "violence and incongruity of . . . excretory organs," nose, anus, penis, vagina.[25] According to Bataille's translator Allan Stoekl, André Breton "in effect condemns Bataille as an 'excremental philosopher.' "[26] For Bataille, mucus, menstrual blood, and semen, as well as feces, are all excremental.

I exclude myself from your expulsions in which pleasure is forced from the body as waste. Your characters retain their shit, but you never tell me the pleasures of retention, how it produces aroused well-being and soul-and-mind-inseparable-from-body fullness, which is both a sense of capacity to act and the feeling that everything wonderful is possible. Your erotics become elegiac.

Sade, my sweet, my truffle, giving a fuck is a decisive act. That is why "I don't give a fuck" and not "I give a fuck" is a common phrase. Not giving a fuck seems to be an easier position to take, for it is when giving a fuck that people often get in trouble. Sade, my sweet, try a different part of paradise, a different way for you to give a fuck. Join me and Russell in our yellow leather chair, in our dark red bedroom that is the color of blood as the force of a loving eros.

NOTES

This chapter expands on "Giving a Fuck," which I performed at the "Censorship: For Shame" session, College Art Association Conference, Toronto, February 1998.

1. See chapter 3, note 7, for documentation of the influence of Julia Kristeva's model of abjection (presented in *Powers of Horror: An Essay on Abjection*, trans. Leon S. Roudiez [New York: Columbia University Press, 1982]) on feminist art historians, critics, and theorists.

2. Georges Bataille, *Erotism: Death and Sensuality*, trans. Mary Dalwood (San Francisco: City Lights Books, 1986), 109.

3. Kathryn Hixson, editorial, *New Art Examiner* 25, no. 2 (November 1997): 7.

4. Jennifer Reeder, "Speakeasy," *New Art Examiner* 25, no. 2 (November 1997): 17.

5. For example, Reeder pits bad girls against good girls, uses "cultural terrorism" to attack "bourgeois ideology," and wants to "disturb . . . the . . . dominating culture," to "revolt against the dominant culture," to oppose "dominant discourses," and to "be completely outside of the power structure" (ibid.).

6. Marquis de Sade, *The 120 Days of Sodom and Other Writings*, comp. and trans. Austryn Wainhouse and Richard Seaver (New York: Grove Press, 1966), 567, 415.

7. Ibid., 410.

8. Roland Barthes, *A Lover's Discourse: Fragments*, trans. Richard Howard (New York: Hill and Wang, 1978), 175 (originally published as *Fragments d'un discours amoureux* [Paris: Editions du Seuil, 1977]).

9. See ibid., 177, and Nancy Princenthal, "The Arrogance of Pleasure," *Art in America* 85, no. 10 (October 1997): 106–9. In the introduction I discuss Princenthal's article and the issue of pleasure as arrogance.

10. Georges Bataille, "The Use Value of D. A. F. de Sade," in *Visions of Excess: Selected Writings, 1927–1939*, ed. Allan Stoekl, trans. Allen Stoekl with Carl R. Lovitt and Donald M. Leslie Jr. (Minneapolis: University of Minnesota Press, 1985), 101.

11. Bataille, *Erotism*, 171, 18.

12. Sade, *120 Days of Sodom*, 220, 257, 474.

13. Ibid., 492, 387.

14. Ibid., 455.

15. For Duclos's participation in these acts, see ibid., 418, 422.

16. Maurice Lever, *Sade: A Biography*, trans. Arthur Goldhammer (New York: Farrar, Straus, and Giroux, 1993).

17. I feel chastised by Maurice Hénaff's argument in *Sade: The Invention of the Libertine Body*, trans. Xavier Callahan (Minneapolis: University of Minnesota Press, 1999 [first published Paris: Presses Universitaires de France, 1978]). According to his brilliant and entertaining analysis of Sade, I am naively— lyrically, metaphorically, romantically—interested in Sade's body and that of Duclos. For a scholar, that makes me too much like Justine, "the naïf, who believes in the signs," "misreading . . . , misperceiving their function as decoys" (46).

18. Nick Cave and the Bad Seeds, "The Ship Song," on *I Had a Dream, Joe*, Mute Records Limited, 1992, 12Mute148.

19. Sade, *120 Days of Sodom*, 219.

20. Ibid., 219, 266.

21. Ibid., 379.

22. Ibid., 393.

23. Ibid., 401.

24. Ibid., 397.

25. Bataille, "The Use Value of Sade," 99.

26. Allan Stoekl, introduction to *Visions of Excess*, by Bataille, xi.

Fourteen

VAMPIRIC STRATEGIES

A spotlit podium stands onstage. Houselights dim to darkness after the audience is seated.

Frueh speaks miked and offstage: "Theories nuzzle together in my mind, erotic shapes with insufficient form," says the vampire. "Then they build thick muscle and materialize. They take a stand."

Houselights on for introduction.

Tonight's speaker, Dr. Joanna Frueh, is a noted art critic, art historian, and performance artist. In her book *Erotic Faculties* (1996), she begins to build a theory and practice of aesthetic and erotic self-creation. Her lecture continues this development in her focus on the vampire.

Outside the art world, Dr. Frueh is known for her research and fieldwork in the lore and history of vampires. In partnership with adventurer and anthropologist Lily Dawson, Dr. Frueh has made startling discoveries about the past and present existence of vampires. In tonight's lecture, "On the Identification of Vampires," Dr. Frueh will present new material, gathered after Dawson's disappearance in 1988 somewhere along the banks of the Mississippi. Dawson, on her own, had been exploring the

Cahokia Mounds, compiling information on vampires who inhabited the area from 1150 to 1300, the height of Cahokian civilization. Dr. Frueh has asked me to tell you that her lecture is dedicated to Lily Dawson.

Frueh enters and walks to the podium. Her face is whiter than its natural color, her lips are bright pink, and the voluminous satin collar of her navy blue tuxedo, whose jacket is hipbone length and fitted at the waist, spreads wide to reveal an aquamarine-and-diamond necklace and bare skin almost to the waist. She speaks unmiked.

On the Identification of Vampires

We think we know the vampire, for we have a vision of the vampire, as we have a vision of god. Like a deity, the vampire is as much a truth as she is a fiction: for narratives, whether we call them history, legend, or the news, are invented, and the mythos of vampires, like the mythos of gods, is simply a story.

According to some sources, the story of vampires begins in Assyria and Chaldea, where archaeologists have found references to these monsters on tablets. Other research, including my own findings, indicates a beginning that dates before the Eolithic Period, to bands of vampires that came to be called, in the early Christian era, the Order of the Wound and the Fate of Blood. The story of those bands is intricate and includes the wars initiated by hostile Christian sects, especially the Necrites, against the Order of the Wound; the strangulation of pagan blood cults; scribes who were tyrants of knowledge; priests who were sybarites of terror; evidence of unmechanized travel through the air and on the water; and episodes of telepathy. But my focus tonight is on identification rather than history, and with this in mind I will recite a chant, first spoken by the Order of the Wound, that we can hear as a key to vampiric identity. The chant was recorded in the 1300s by nuns in the Convent of the Sanguines, whose ruins still stand near the chateau of Bazoches in Burgundy:
Incise the body
Stroke the organs
So they play the tune of blood
Make your mark
And drink the wisdom
Life is wisdom, wisdom love.[1]

The word *write* derives from a sound, whose linkages of sense, senses, and melody simultaneously mean "incise," "draw," "wound," and "make a mark." The Fate of Blood called themselves writers, people who made their mark on and in the human body, thus touching the soul-and-mind-inseparable-from-body, drinking it in, and making the lifeblood flow.

Based on the chant I recited (known as the Song of the Sanguines), on rituals practiced by the Order of the Wound, and on an oral history about the order that circulates still in disparate regions of the world—through farmers in northern Oregon and octogenarians in the Louisiana bayous, through Icelandic shamans and Chinese intellectuals—we must compose a picture of the vampire that radically alters the popularly painted one. That image, like most of what we accept, represents vision at its most superficial. We see movie vampires, based often on the title character from Bram Stoker's 1897 novel *Dracula*, and think of resuscitated corpses whose sharp, elongated canines, full red lips, and formal dress make the creatures at once civilized and wild. Maybe we don't even see in the vampire a meshing of painful passions but rather merely note the conventions of costume and appearance that have entertained people since 1897 in numerous plays—including dramas, comedies, and musicals—and since 1922 in film, when a rodentlike but still seductive vampire appeared in F. W. Murnau's *Nosferatu*.

The vampire is not an entertainment. That vision of simplistic supernaturalism and evil as a spice has been invented by the Necrites as well as by earlier and later manipulators of culture, politics, and religion. Such arbiters of the taste and thus the state of souls-and-minds-inseparable-from-bodies projected their own living deadness onto the vampire, whose knowledge of blood—the current of life—they transmitted sometimes deliberately, sometimes in innocence, as devotion to death.

Simplistic supernaturalism is anything but miraculous, for in its transcendence of the everyday and its disengagement from nature—*super* means "above," "superior to"—it denies that daily life is full of miracles.

The problem centers on narrative and vision: who tells, who sees, who knows that both *smile* and *miracle* share the Latin cognate *mirari*, "to wonder at."

The vampire's knowing smile, often converted into a cinema sneer, comes from her focus on the miraculous, which, as a simultaneous sensation and concept, existed from the beginning of the Order of the Wound. The vampire's identity has been obscured because she has

wanted not to manipulate the world but rather to know its miraculous currents. The vampire, then, is a visionary, a soul-and-mind-inseparable-from-body that sees into the opacity of the self-evident. We must do the same if we are to unearth the vampire's identity, to learn not only about it but also from it.

To this end, I discuss several topics: fitness, blood, night, sex, and nature. I proceed with the conviction, out of respect for the Order of the Wound and in agreement with it, that poetry is the language of the undead.

Fitness

All sources attribute unusual strength and grace to the vampire. We read that vampires can leap from the ground to the tops of pyramids and sky-scrapers, climb the sides of buildings and mountains if that better suits their purposes, walk with such speed and lightness that they pass through walls and dance into the earth, and lift and hurl an enemy so quickly that witnesses say defense could be only an afterthought. Some accounts also state that vampires fly, using the wind's currents.

Vampirologists ascribe such accomplishments to supernatural vitality, a term that creates the vampire as phantom. I ascribe them to fitness, which has to do with adaptability. Supernaturalism removes the vampire from the flesh, whereas fitness grounds her there. Folklorist Moira Trend's statement in *Vampires of Desert and Sage* is typical: "The vampire's supernatural vitality originates in spirit, not flesh. Indeed, she is not flesh at all. Her flesh is an illusion, she is almost ethereal." Bazoches nun Hélène de la Terre's commentary on the Song of the Sanguines contradicts Trend: "Eros begins in the flesh, they say. Beware the thing that is so little flesh it is like God is said to be, light as an idea. They say, Beware the fleshless thing. It is unfit."

Today's obsession with fitness originates, in part, from a desire for vampiric fitness, adaptability in a time when looking good and feeling good are insufficient achievements in fitness. A statement made by movie star Gloria Disciple, known too for her beauty and fitness book, *Gloria's Disciplines*, epitomizes such inadequacies: "I want to have the best ass you can imagine." This aim is purposeless and passive. Disciple's quip betrays too much caring about others' assessments of aesthetic and erotic pleasure, and it betrays as well a misunderstanding of corporeal exis-

tence: one *is* body, one does not simply *have* a body. She does not know flesh as the body of content. Being glutei, biceps, pectorals, quadriceps—being deliberately aestheticized and eroticized flesh—is a far cry from having a nice ass, a part that may be shapely but that has not been built in earnest in the discipline of eros. Gloria's "disciplines" are mere regimens in fashionable behavior and surface results. The vampire does not maintain fitness solely in order to be admired—though she loves such attention—but rather in order to act. Fitness permits flexibility, enough control to deal with the unpredictability at the heart of existence. Flexibility allows the vampire to walk through walls of confusion, to bound over the architecture of precedent, and to catch an enemy off guard. The vampire may want beautiful buttocks, for the pleasures of narcissism and sex and the necessity of smooth and easy movement; but unlike Disciple's desire, manifested in rigid exercises of food choice, bodily movement, and makeup application, vampiric desire fluidly connects pleasure and necessity. Ultimately, Disciple's "best ass" suggests tight-assed fear of flesh that is experienced—in aging, in big muscle, in the sweaty messes of daily life. Fluidity is freedom of movement. The vampire is loose, the vampire is fluent.

Fluency is both poetry and readiness, and vampiric fitness is the readiness of radiant energy, poetry in motion. Various souls-and-minds-inseparable-from-bodies can demonstrate vampiric fitness. The mountaineer climbs till the wind and cold bloody his cheeks. The sumo wrestler's solid roundness serves as a source of power from which to strike. The bodybuilder speaks of pumping blood into her muscles till she feels sensual, animal, able to trust the erotic logic of instinct and act on it. The practitioner of t'ai chi ch'uan centers her weight for balanced movement.

In each case, the soul-and-mind-inseparable-from-body's actions or appearance are distinctive. Movement has made its mark, for movement is the essence of vampiric fitness. All vampires say, "We travel fast." This is because, as we know from the chi masters, creativity means movement. The vampire acts on the knowledge that creativity and adaptability go hand in hand and that they require change—journeys that may have to be made unexpectedly, even reluctantly, but always in grace. For instance, the old vampire knows that when his soul-and-mind-inseparable-from-body can no longer adapt quickly in this world, he must move into another.

Blood

In this world the vampire is known to love blood. The sight and smell of blood arouse her, and her lust is said to be cruel. Some authorities say the vampire needs blood; others say the craving comes from appreciation, similar to that of fine food. Wilhelm Lippen claims that "the conventional vampire's bloodsucking is a matter of taste rather than necessity, like alcohol or drug addiction. The vampire enjoys drinking blood, and a satanic compulsion to gorge controls her."

Lippen and others operate under misconceptions stemming from their participation in the myth of vampiric evil and from their lack of knowledge about vampiric fitness. In many accounts the vampire is a repulsive monster, despite certain charismatic traits, who must take victims in order to live. Their blood keeps her fit, forever young and attractive; and historical, literary, legendary, contemporary, and news stories propagate belief in such ideas. Examples of grotesque bloodlust, often called vampiric, include Elizabeth Bathory, a seventeenth-century Transylvanian countess whose narcissism drove her to kidnap and kill attractive young virgin women in order to bathe in their blood, thereby maintaining her own beauty; Gilles de Rais, the fifteenth-century French nobleman who killed children and often drank their blood; English mass murderer John George Haigh, executed in 1949, who said he drank a glass of his victims' blood before dissolving their bodies in acid; Dracula, whose victims either die from twin puncture wounds in the neck or become horrors like himself; and Lestat, the blonde hero of Anne Rice's novels, who grows more glowingly gorgeous after he feeds.

Such stories present love of blood as sickness. But vampiric fitness is health, the wedding of pleasure and necessity not simply to survive or to create beauty and maintain youth, but to set the soul-and-mind-inseparable-from-body apart from mediocrity. As Rachel the Rose observes in her recently released autobiography *Interior Canyon*, which reveals her to be a vampire, "Most are mediocre. They aspire to mediocrity. I live to be extraordinary."

Ancient roots of the word *victim* mean "to set apart" and "to be holy." The vampire is her own victim, who needs and enjoys blood not as a gourmand but as a soul-and-mind-inseparable-from-body, who acts on the knowledge that, to quote the Song of the Sanguines, "Life is wisdom,

wisdom love." Blood, since the beginning of the Order of the Wound, has been called the sacred liquid and the elixir of life, and even life itself. Blood is holy, and to sip, suck, breathe, gulp, lick, piss, shit, pump, exchange, and circulate blood is to be alive.

Blood is a diet at once rich and lean, so the vampire does not gorge unless she has fallen into a starving state. Then the gorging is necessary, and it is as much a giving as a taking. For the vampire's victim, rather than ending up dead and drained, is infused with life, is made holy, set apart from the mediocrity of the so-called living, who are really the dead. To become undead is to be the victim of vampiric generosity.

The vampire chooses her victims carefully, for (as was believed in Babylon and Assyria) the dead, whether they know it or not, seek sustenance from the living, sometimes with such greed and ignorance of their own neediness that they can permanently injure the vampire's soul-and-mind-inseparable-from-body.

The mutual transfusion brings on a state, which can last for seconds or several hours, called the trance-fusion, a blood bond whose intensity ebbs till another transfusion occurs but whose existence permeates a vampire's soul-and-mind-inseparable-from-body. Vampire and victim kiss one another to draw blood to the skin, to make the blood flow. Both swoon in trance-fusion, which heals the victim and renews the vampire's belief in life. The vampire takes care of enemies as she does loved ones, and in trance-fusion she absorbs the former and dissolves their sickness in her blood.

She can do this because her blood is wise. The Greeks believed wisdom was centered in blood, and in many stories blood is a heal-all and can tell where to travel in order to cure any ill. This sounds naive to us, who do not believe in the miraculous and who know that blood can carry disease. But we are innocent of wiseblood; the integrity of soul and body eludes us, and blood weds them. The vampire, whose giftedness in wiseblood grows as he ages, embraces this integrity, which Rachel the Rose questions and praises in a poem.

I stand in my garden
The bleeding heart is bleeding me
I am the Rose
The potion drunk
When wisdom teeth cut through the surface

Skindeep That's how I see the world
That thinks Christ's blood is sacred
When the blood of life before was called the moonblood
That I bleed each month and more
 Taboo
Nothing is sacred but the simplistic surface
 Misfit
I am a living legend wronged by disbelief the dead
Who do not know that in vampiric language blood and flowers are the
 same
I am the Rose Taboo

Night

The moonblood ritual, to which Rachel the Rose alludes, was central to
the Order of the Wound. Under the moon—which they called, according
to its phase, the perfect white scar and the opening in the sky—the order
sang songs of blood and sex until each orifice spurted blood and the moon
spit red as well as silvery streaks of light. The vampires named the spurt-
ing "the flowering." They stroked each other's skin and dipped their
fingers into their own and others' orifices. They called the moon's blood
heal-all, as they did their own blood, for they breathed more easily in the
morning. This relief came because the blood kisses smeared on each vam-
pire's skin had penetrated to the soul-and-mind-inseparable-from-body,
kisses covering every pore, like the luminous crimson moonlight.

Vampirologists and novelists who do not know the moonblood ritual
treat moon rays simply as a reanimating force: killed vampires, if left in
moonlight, will come back to life.

Some sources say the moonstruck, the abnormal, the misfits, are
potential or actual vampires. One authority writes, "In some areas of
Virginia anyone with 'strange' skills, such as artistic expression, is
marked as a latent vampire."

Stoker's Dr. Van Helsing, the vampirologist, says Dracula can "come
on moonlight rays as elemental dust."[2] Van Helsing announces this as
part of a list of evils. His comment is typical in transposing powers to
evils. As Hélène de la Terre writes, "Vampires are angels of the night,
substances that sparkle in their darkness." De la Terre knows that angels
are messengers and that vampires are messengers of blood.

The vampire is often a moonwatcher, a poet, an advocate of night walks who, far from making the night unsafe, wants it to be peaceful for both lovers and the lonely, a time for love songs, which are the legacy of the moonblood ritual's blood and sex songs. These ancient songs are the reason that the moon and moonlight, sexual desire, and the hot bloods of passion meet in songs sung by and about moonstruck lovers.

The vampire often approaches her victims in the moonlight, always in the night. All sources agree that it is her element, but they generally treat her as a dark and stealthy monster, who will die in daylight and who stalks her prey. Trend is typical in associating vampires' love of the night with the evil that is blackness. In a racist stereotype that recurs throughout vampire literature, especially nineteenth-century European works, Trend asserts that the "black-skinned vampire is the epitome of darkness." Her fear of erotic flesh becomes embedded in her fear of the black skin that Western civilization has perversely sexualized into a grotesquely sensual allure. However, the black vampire is out of Trend's control, is too much for Western civilization's mutually limiting tropes of primitive/black/sexy and civilized/white/pure.

African American photographer and writer Carla Williams declares that the "specifically erotic image is naked and dark, animalistic and fleshly."[3] In a mid-1850s daguerreotype of a young black woman who is naked and masturbating—defining her "own sexual pleasure" in an "empowering act" from which the viewer "relinquishes control"—Williams discovers part of her own visual history as a maker of nude self-portraits. She concludes her discussion, "I take control of my own representation, I revel in my own skin."[4] Similarly, the vampire delights in her darkness. She takes to the night because it is the inside of the body, the soil in which plants grow, the unconscious where lust and ideas germinate, the earth that protects corpses, the luxurious dirtiness of sex. The vampire stalks because she is animal, but her victims are not prey. The notion that the sun will shrivel her is untrue and comes from the Necrites' and others' belief that because darkness is bad, light is good and will destroy its enemy.

Van Helsing says the vampire "can see in the dark—no small power this, in a world which is one half shut from the light."[5] I say, she provides the light; she is a monster, a misfit, because she can see where others can't, and this power of vision, which is a beauty, frightens them. The vampire sees through half-light and half-truth, like Williams seeing her own body

through a visual history that she herself must interpret. The vampire's night vision identifies her as a creature of the night, but she is not the horror movie's murdering beast. Rather, her animal intellect, which in the past two centuries has often been educated and civilized to despair, makes her the hunter of shadows. In the shadows of day and night she looks for the food of love, which is itself shadowy in its permutations of desire, protectiveness, companionship, and hope. The vampire exists at the crossroads of light and dark, depth and surface, life and death, like Hecate, goddess of the crossroads. There, at the crossroads, she is a shadowy figure, frightening because of her position—at the crucial point where decisions must be made.

The shadowy figure casts a shadow, counter to the popular idea that vampires have no shadow. That idea contributes to the construction of supernatural monstrosity and the vampire as phantom. But a shadow is not a phantom, which is illusory. Just as the vampire casts a shadow, her image reflects in mirrors. Rachel the Rose tells of regularly scrutinizing herself in a mirror until she saw into her soul-and-mind-inseparable-from-body, saw further than any Venus who stared at herself in a mirror over centuries. Many vampires' diaries, which span two hundred years and are kept in a private collection in Reno, Nevada, reveal that they enjoyed looking in mirrors, at themselves and their partners, when they had sex.

Sex

The vampire mythos has given her an erotic reputation. An American vampire film from 1971 is even called *Count Erotica*. The vampire bites victims on the neck and they swoon. She is sexually charismatic, often physically attractive, always seductive, and her allure is usually fatal.

Typically, the "vampire visit" takes place. The vampire is male, the setting a woman's boudoir. A literary example appears in the first vampire novel, James Malcolm Rymer's *Varney the Vampire; or, The Feast of Blood*, published in 1847. Varney, in the height of bloodlust, clutches the "victim's" hair, pulls her head toward him, drags her to the side of the bed, and bites her beautiful throat.[6] Variations on Varney's bedside manner recur from then on in novels and movies. Sometimes the "victim" bleeds a great deal—an excessive symbolization of the deflowered virgin—sometimes only tiny pricks can be found in the neck, and they are visible to the practiced eye alone.

In the mythos, promulgated by *Varney the Vampire*'s descendants, such as Stoker's *Dracula*, Murnau's *Nosferatu* and Werner Herzog's 1979 remake, Tod Browning's 1931 *Dracula* starring Bela Lugosi, and two late 1970s productions, the BBC's *Count Dracula* with Louis Jourdan and a close to $40 million *Dracula* with Frank Langella, the vampire is a demon lover. His long-bladed heart lacks compassion, and he offers what Lippen calls "the taboo love, the forbidden fruit, the sexy kiss of death." The vampire rapes women in the absence of relatives and also seduces his "victims" under their relatives' eyes. A title card in Murnau's *Nosferatu* reads: "Is this your wife? What a beautiful neck."

Lippen claims the "underlying allure of fatal voluptuousness is eternal. That element of the vampire image will keep people returning for more forever." Longing for love is implicit in people's attraction to the vampire, but Lippen is wrong in his belief that the kiss of death is the lure. He writes of forbidden love, which, counter to the popular picture he gives, is not the "sexy kiss of death" but rather the aphrodisiac kiss of life. For only the kiss and fuck of life are truly erotic, opening the victim to "the mental, physical, and feeling states and acts that express what can be the opulence of our daily lives"—what artist Pisces Malone in her essay "Erotic (Dys)Functions" defines as the erotic. The traditional vampire is sensual in appearance, tastes, and actions. Her eyes seduce and hypnotize, and she has voluptuous lips and, overall, an alien because astoundingly radiant beauty. These features account, in part, for her sexual charisma, as they often do with the vampire whose new portrait I am painting. Her radiant energy creates them. But more important it is the vampire's promise of the forbidden territory of love that people sense and that attracts them. Love that draws and gives blood is "obscene," a lust for something different from the holocaust of hearts and the erotics of damage in which people exist without life. The vampire is all heart. That is why a blow to the heart—literalized into the pounded stake of convention—can kill a vampire.

Traditionally, the vampire's sexuality is frightening. The nosferatu, a particular kind of vampire, makes husbands impotent. Most traditional vampires so magnetize their chosen that the rest of life holds no interest for the vampire's sexual object. In contrast, the vampire who is poetry in motion moves her victim to greater participation in life. The vampire is able to effect this change because she does not fear her own body, for it is soul-and-mind-inseparable-from-body, matter in love with its own beauty. And the vampire maintains this attitude throughout her life in

our world, and it accounts for her reputation, among the living, as a seasoned and desirable lover.

The vampire is not a demon lover but a dream lover. Her victims do swoon, as blood flows and flowers during trance-fusion; but unlike their traditional counterparts, these "victims" are in an erotic not a paralytic rapture.

Nature

The vampire can hiss, coo, and curl his voice around a person's ears, like the wind. She can also amplify her voice, so that she magnifies its clarity and richness and its tones that probe the soul-and-mind-inseparable-from-body. In this she is like an echo in the wilderness. Not only are all these qualities often seductive, but they also demonstrate the vampire's ability to shapeshift. It is part of her fitness, her adaptability as an offspring of nature who must find and make her way in culture.

The vampire is multisexual. Some stories feature homosexual and bisexual vampires. Examples are *Dracula and the Boys,* a 1969 movie also titled *Does Dracula Really Suck?;* Sheridan Le Fanu's 1872 short story "Carmilla," about a lesbian vampire; and *Dracula Sucks,* a 1969 play in which the count enjoys both women and men. The vampire shifts the shapes of gender, the quality of sex role and sex object from affliction to aphrodisiac: vampires dominate, penetrate, submit to their aggressive eros, to their penises anywhere the vampires want them; they understand themselves to be full of orifices ready for power-playing in their souls-and-minds-inseparable-from-bodies, ready to let loose the generosity of gender.

The vampire shifts jobs and even professions as she does sexual categories, and she may often move from city to city. She can also shift herself into a person's soul-and-mind-inseparable-from-body. Traditional accounts have perverted this ability into a nasty talent of mental persuasion, and they relate too that she can appear as mist, grow large and turn small at will, vanish altogether, direct atmospheric events, and not only control animals but transform herself into what Trend terms "the most detested animals, such as spiders, locusts, slugs, snails, rats, and wolves." Stoker says that Dracula changes into a vampire bat, and vampirologist Gertrude Sommers writes that "the Wallachians' *murony* assumes many shapes, such as those of a dog, cat, wolf, rat, or flea."

Sources generally label such abilities, which do apply to our recon-structed vampire, supernatural. But the vampire is in partnership with nature. She moves into another soul-and-mind-inseparable-from-body like a shifting wind. She is not a hijacker. Nor does she kill the soul-and-mind-inseparable-from-body that she becomes, for she and it are kin.

This kinship is especially clear in her relationship with the wolf, who, through millennia and cultures, has fit significantly into the vampire's life. Members of the Order of the Wound kept wolves as companions, and the Necrites wrote, "The Wound and the wolf were like one. They roamed together, as a pack, and people said they could not tell the differ-ences between the two." Because the Necrites hated the Fate of Blood, most of what they have written about it cannot be considered accurate. The statement I quote, however, comes from a passage that inveighs against the "shifted shape of species." The Necrites conclude, "Go—hunt, defile, and kill the wolf and vampire."

In many Irish saintly legends, some of which are obscured histories of the vampire, the wolf appears as a gentle, loving animal. Saint Ronan, who worked miracles on behalf of wolves, was accused of being a wolf. Saint Lugaid, another vampire, initiated a yearly feast in celebration of wolves.

The very word for vampire in some languages suggests the vampire's connection with the wolf. Sommers says, "*Vrykolaka, vurkulaka,* or *wukodalak* signifies the vampire for the Bohemians, Russians, Servians, Morlacchians, natives of Montenegro, Crete, of Albania and Hydra, and the Transylvanians. These three words all mean 'wolf-fairy,' and are thought by many vampirologists to derive from the Greek." In Croatian, *vukodlak*, from *vuko*, "wolf," and *blaka*, "hair," means both "vampire" and "werewolf." In many stories, most popularly the werewolf movies starring Lon Chaney, a person becomes a wolf on the night of the full moon, then commits gory murders. Here we find history skewed again, in a misrepresentation of the moonblood ritual. *Fairy,* usually defined as a supernatural being, to vampires means "belonging exquisitely to nature."

Even though Stoker misrepresents the vampire in many ways, he does place Dracula in the heart of nature. Dracula is a wolf-fairy, though not named as such; and he lives, pretty much isolated, in a land of rugged beauty. When Dracula, disguised as a calèche driver, takes lawyer Jonathan Harker to Castle Dracula, snarling wolves surround the car-

riage. Dracula raises his hands, gives a command, and the wolves disperse. In his diary, Harker recalls that when he and his host are together in the castle,

> There seemed a strange stillness over everything; but as I listened I heard as if from down below in the valley the howling of many wolves. The Count's eyes gleamed, and he said:—
> "Listen to them—the children of the night. What music they make!"[7]

The wolves, and Dracula as wolf, belong to the jagged peaks and thick woods of Transylvania—home. It is the bond with home, which is not necessarily a birthplace (human or vampiric) but can be as easily a region where the vampire feels at home, that accounts for the vampire's need to sleep in the earth of home, to carry with her, wherever she moves, an image of home.

This need has given rise to the notion that the vampire literally keeps earth from her homeland in the coffin in which she sleeps.

The vampire does not sleep in a coffin. She sleeps wherever she likes, in a bed or a sleeping bag, with or without a tent, on the ground, by a river, on a mountain, or in the desert. And sometimes, before she goes to sleep, the vampire turns into a bird and flies, in order to survey her whereabouts from a clearer yet more distant viewpoint. In this form she may visit the dead and screech into their ears or sing so sweetly that the dead begin to bleed. The night bird terrified Romans in the later years of the empire. They called it *strix* or in groups *striges,* witches, and believed they sucked sleepers' blood. *Witch* or *sorcerer* is also the meaning of the Turkish word for vampire, which is *uber;* and the Slavonic word for vampire, *upir,* means "he flies away."

Just as the vampire takes to the air, she also takes to water. While traditional sources say the vampire cannot enter or cross running water—because water is said to be the raft of the gods, and vampires have been, for the most part, created evil—many vampires are swimmers, sailors, kayakers, and white-water rafters, who have spent hours in water or fallen into it without harm. Yet another perversion of the vampire as belonging to nature is the idea, prevalent not only in the West but also in China, Malaya, Afghanistan, some regions of the Amazon, and in many other cultures, that garlic will afflict the vampire. Garlic is a lily with white flowers, and the lily has symbolized virginity for both Christians and pagans. If symbolic purity was not enough to lay a vampire to rest,

then the disagreeable odor of garlic that would reek from the vampire's mouth—and it was thought that there it could remain fresh indefinitely—would prevent her from making her particular brand of social call. Actually, the vampire uses garlic as a medicine, for it prevents and cures infections by cleansing the blood.

Garlic has also been used in the death rituals devised by storytellers, both ancient and modern, to kill their own fear of the vampire. John the Necrite, Gertrude Sommers, and Moira Trend, among numerous others, say that after decapitating a vampire, the executioners should stuff garlic in the vampire's mouth.

Such an attempt to kill the vampire is as useless as the driving of a buckthorn, whitethorn, or hawthorn stake through her heart. Thorn is meant to be symbolic of Christ's crown of thorns; like the crucifix, it was fantasized, as a link with god, to be unbearable to the vampire. But the vampire laughs at efforts to turn nature against her. She laughs at those who have placed a red rose on her chest, as she sleeps, to keep her forever sleeping. For the red rose is the heart, and it only enlivens her more. In Rachel the Rose's words, she is the Rose Taboo, hated by the dead; so sometimes she must laugh at them, because their absurdity can be amusing. One such incident took place in the village of Blau near the Bohemian town of Kadam. A vampire pulled the stake from her chest and laughed, thanking villagers for leaving her a branch of life that she could grow into a sword of roses. "Theories flower into muscle," she promised.

Houselights on. Frueh walks off. Ten-minute intermission.

<div align="right">PART II</div>

Houselights off. Still wearing the tuxedo, Frueh enters and sits close to the audience on a simple chair. The vampire's conventional costume, the tuxedo, along with Frueh's words in Part II about fitness, blood, night, sex, and nature, identify her as a vampire. To her right a pink glass lamp incised with a nude woman stands on a small table, which also holds a glass of red wine. Frueh speaks into a mike.

My suit is the pitch blue of the night. My lips are pink like cunt and lush from being kissed and kissing. My eyelids shine like moonlight; so do my satin shoes, and I am stained inside with blood, like you. I body-

build because I like the movements—the feeling, the aesthetics, the discipline—of lifting weights, and I am a narcissist. I like the shape of muscle, and I like to have the muscle to move with power in the world.

Yet I can sit here thinking there's no use for such beauties. Artists I know wonder, What's the point of making art? as if in this ugly, senseless world something of meaning and of beauty has no purpose.

This is the time of raking light, which, though it reveals blemishes, also gives them the spotlight, makes them stars with a scrutiny that relishes their ugliness.

I wish for a darker age, where radiance is the energy and nighttime is the right time for love.

My first night walk without the lights of a city, flashlight, or candle happened not too long ago. The place was Elephant Rocks, a state park with huge boulders, about three hours out of St. Louis. Russell had been climbing the boulders; we had drunk red wine and eaten a lot of bread and cheese at sunset, then left our gear and remaining food to go for a walk. I couldn't see a thing. Russell led. I couldn't even see him. We got lost. I laughed from nervousness. Lost in the dark. Then we found our way.

That night was nothing compared to climbing the Matterhorn, a route on Tucson's Mount Lemmon, when the sun was setting. Russell had climbed it many times. I'd done it once before. The Matterhorn is an easy climb with two pitches, two belay points. Russell went up slowly, and I knew I'd probably end up finishing the climb in the dark. This scared me. I was wearing tights and a tank top, and the wind began to blow hard and cold as I leaned my back against rock at the second belay point. The sky was turning lavender and pink, and the ground, much hidden by pines, was becoming shadow. The lead climber on the Matterhorn is out of sight on the entire second pitch of about 150 feet, and the wind sent our voices away from each other. I shivered now and then and was having trouble with the gear before I set off on the second pitch in the lessening light. Climbing that pitch is like climbing a ladder, but my fear made my movements slow and sloppy. Finally I was at the top with Russell, and it was almost dark with a rappel yet to set up and perform. We went down in the dark, seeing and sensing the dangers of rock and trees and a sloping landing.

Russell's grace, strength, and flexibility in climbing amaze me, as these qualities do when I watch other climbers of disciplined beauty. He

hooks a heel, above his head, onto the rock. He spreads his legs, toes finding holds less than my fingernail in width. He lunges where he cannot see, makes dynamic moves of faith.

One afternoon he said to me, "We will practice agility training." We were hiking to the meeting place of two canyons. Many rocks of varying size lay on our trail, some of which was a steep upgrade. He moved fast and I learned to do the same.

And I have taught him to move the weights. And he has helped me to move heavier ones.

At shivah after the funeral of my mother's mother, I met a woman who was an old friend of my grandparents. Her hair was white and she sparkled. I was in my mid-twenties, and I said to her, "You're beautiful." I asked her age. She said, "Seventy."

The very old who have youthfulness and the very young who have wisdom astound us. They seem miraculous, for each has what seems its opposite, which creates radiant energy and offers a glimpse of balance.

So often things seem out of whack. At the airport recently I asked Russell, "Are we as ugly and absurd as everyone else?" I look at people marked by fear and fragility and glutted with information, which has become false lifeblood. Their skin is lackluster. They look bled dry and still they stand for their sorry lives. This is bloodcurdling, for sometimes I can't tell if I'm any different.

Then I'll remember . . .

Driving through a winding road the first time I was drunk
> drunk on the blood of the grape, called wine
> drunk on the wine of the body, called blood

And Russell and me on an approach to a climb, when a branch cut my leg and it was bleeding and I said, "Lick it," and he did, cooing that the taste was sweet and salty

And him swooning during sex

And saying now and then, "Put on a red dress as sweet as your lips, let me see the red dress flow over your hips"

And biting lips so hard that blood flavors the kiss

And greeting enemies with smiles as warm as for friends

And seeing why his mouth is like a rosebud

> Lay your head in my lap
> Drink your claret
> Clarity is drinking in
> The loved one the Red Sea

Lily drew the Red Sea trickling through a map of glaciers. She called the drawing *Project for Warmth*, because she knew that blood would heat the ice age of our world.

Lily and I were planning our next work when she disappeared. It was to be titled *Blood Stories*. There were to be three volumes: one on the history of moonblood rituals; another on menstruation, birth, and other gynecological experiences; and the third on the world's current need for blood. Each chapter of the last volume was to be titled with an idiom or phrase having to do with blood—blood bank, blood brother, blood cell, blood money, blood count, blood donor, blood feud, blood type, blood pressure, bloodhound, blood clot, blood vessel. The last was to begin with a vision of Hélène de la Terre's made into a song by the Sanguines.

We are all blood vessels, containers full of love
Underground channels, highways for birds to fly
For the bird flies high, rising from its own death
Fresh as desert air scented after rain
With chaparral whose ground leaves cleanse the blood
Phoenix comes from Greek *phoinos* bloodred
Fly the phoenix highway

The wolves, said Dracula, make music. Some of us say it is like ancient music, when all songs, sung to and under the moon, were of the soul-and-mind-inseparable-from-body, and songs of the mind were yet to be conceived. From the desert Russell wrote me, when I was living in a city far away from him, "Tonight is a blue moon," and I saw him standing, staring up, ready to fly. And from the distance between my desk and his, I sang to him "Blue Moon."

To care is hard in the holocaust of hearts, and to move on that caring is harder yet. The expression "I feel like I'm in the dark" applies to this difficulty.

But it is a perfect time for action, because the possibility exists, more than when we think we see the light, of becoming the monsters we are meant to be.

In the dark we see the lack of the absolute. The walls of a room feel permeable, the land by a road away from town both extends forever and has disappeared, the features of a lover's face stretch and contract into shapes at once soothing and disturbing. He is shifting shape, into a perversion of the correct, gentle man he is supposed to be.

Then I heard Russell say, his hand on my shoulder, "My fingers are turning into claws," and he became my wolf, though I was afraid.

Later I remembered part of a poem I had written before ever meeting Russell:

I say Turn into a wolf

I say Start howling now

Later still, when we were living in Tucson, he saw, after days of exhaustion, wolves by our driveway.

Wolves bond with other wolves, and wolves are known for their extraordinary loyalty to their partners.

We once lived between a cemetery and a mental institution, places of darkness, or certainly crossroads: the former of surface and underground, the latter of so-called health and illness. The well-tended grounds for the corpses and society's dysfunctional belied the energies that must have circulated in each site and out into the block between the two, where we lived.

Darknesses exist all around and in us, but often we call things by their wrong names. We say drug deaths are dark, but they are visible. Miseries, bright in the glare of journalism, invade the soul-and-mind-inseparable-from-body, and we call them nightmares.

Night mare

The dark horse that I count on when the light can blind

Black stallion

Children's wish for a partner wild in love

Night mare and black stallion are dreamed by lovers in the dark

And only in the dark can dream lovers exist, like the wolves calling for each other in the night, fur silvered by the moon.

Russell has a future name for me, Silver Sex Lady, and we imagine octogenarian sex. He tells me a story from an acquaintance whose mother had always suffocated his father. When she died he married a woman his age and now they're in their eighties, having the best sex of their lives.

When Russell's entire body sinks into me, like teeth into the tenderest flesh, my muscles flower. They remember engagements on old frontiers, for causes with a history darkened by the future they predict.

And for this continued flowering I must remember many things and keep remembering, all I've said and more:

When I was a child and rode my bike through neighborhood streets and when I and my sister sat in the back of the car, Dad driving over local streets, the oaks arched high and made a nave;

When I was sixteen, my three best friends and I were in the annual high school variety show. We were dressed and made up like "vampires"—slinky, long, black dresses, white faces, eyes darkly rimmed—and we sang (*Frueh sings*)

Leprosy is crawling all over me

There goes my eyeball into your highball

There goes my fingernail into your ginger ale

Kiss me quick, there goes my upper lip

I don't remember any more than that;

When I met Russell, he came in a mist, for I didn't understand him. Not until we went out to dinner did the mist become an atmosphere of blood;

When Russell says, "Sometimes you're six, sometimes six thousand," I see that I am monster-child and monster-god;

When I sat down with Lily over coffee and a greasy spoon breakfast for our first long talk, she told me that she sailed and that she used to rock climb. Russell kayaked and rafted before he learned to climb. And I have been in box canyons with a river at my feet, then my feet in the river, and I have bathed, near a hunters' camp, but out of season, with deer on the opposite shore;

When I take garlic tablets, my skin is clear and my colds are fewer and milder;

When I was at the botanical garden near my parents' home I overheard a couple as I strolled through summer shrubs and flowers with Mom and Dad. The man said, almost in a whisper, "Jimsonweed. Jism weed";

When Lily dreamed, the night before the last time I saw her, she put her arm into a lizard's mouth;

When Russell climbed in Tucson, he would occasionally meet snakes at the base of a climb or on the trail, which was, more often than not, no path but a steep jumble of branches and loose rock and earth. Once he thought the snake he saw was me.

Spotlight on. Frueh walks downstage and faces the audience.

I rewrite the legends, I'm a monster on the loose

I'm flowering, I'm fatal to the stories that abuse

My muscular indictment of rumors of a beast

Who would rather make you suffer than help eros be unleashed

Frueh takes off her jacket—she is naked underneath—and hangs it on the podium. She performs a front double biceps pose. Spotlight out. Frueh takes her jacket, throws it over one shoulder, and walks off.

Frueh speaks miked and offstage.

Approved method of disposal:

Chain it to the grave with wild roses

Transfix with a hawthorn bough

No known remedy

Lemon in its mouth

No known remedy

Stake through the heart

Extract its heart

Pile stones on its grave

No known remedy

No known remedy

No known remedy

NOTES

This chapter is a revision of the performance *Vampiric Strategies* that was presented at NAME Gallery, Chicago, in 1990.

1. Vampire authorities and various sects are invented.
2. Bram Stoker, *Dracula* (1897; reprint, New York: Laurel-Leaf/Dell, 1965), 267.
3. Carla Williams, "The Erotic Image Is Naked and Dark," in *Picturing Us: African American Identity in Photography,* ed. Deborah Willis (New York: New Press, 1994), 133.
4. Ibid., 131, 134.
5. Stoker, *Dracula,* 267.
6. James Malcolm Rymer, *Varney the Vampire; or, The Feast of Blood* (London: F. Lloyd, 1847); available in modern reprints, ed. Devendra P. Varna (New York: Arno, 1970); ed. E. F. Bleiler (New York: Dover, 1972).
7. Stoker, *Dracula,* 26.

Illustrations

Index

Page numbers in italics denote photographs.

abjection, 36–37n28; cult of, 135; erotics
of shame and, 289; feminism and, 133,
133n7, 136; monster/beauty vs., 19; of
mother, 133, 134–36, 145n14; unadul-
terated pleasure vs., 31. *See also* dam-
age, erotics of; shame
acne, 3, 6
advertising: for gyms, 73; for hair color-
ing, 281; hair removal and, 21; narra-
tives of loss and, 15; for perfume,
250–51, 253, 264n11; for personal
style, 269. *See also* commodification
aesthetic/erotic self-creation: and
aesthetic/erotic field, defined, 2; of
Altomare, 93–94; Aphroditean style
and, 269; cultural practices as affect-
ing, 267; as discipline, 262; "GLAM
Manifesto" and, 31–32; individual
vs. community, 29; models of, 11, 20
(*see also* Aphrodite; bodybuilding;
stepmother-stepchild pedagogical
model; vampires); nonproductivity
and, 81; perfection vs., 251; professors
and, 161, 180; as ridiculous, 20, 40;
Sade's characters and, 294–95; self-

love resulting from, 2, 34n1; substitu-
tion for, 223; technology of self and,
248; time and, 81; will to pleasure and
(*see* will to pleasure). *See also* monster/
beauty
aesthetics, 119; control and, 70; humilia-
tion and, 61; lowlife, 290–91, 297n5;
nonproductivity and, 81; postmodern,
281, 291; of power, 101; of power vs.
fragility, 68–69; prosaic, 39, 40–41;
Sadeian, 290–91; as transgressive/
transcendant, 119
Africans, primitivized images of, 115, 261
age: acting one's, enforcement of, 63, 77,
138, 262, 271–72; Blonde Bunny God-
dess cult and, 275, 277; gender and
cross-generational attraction, 232–34;
irrelevance of, 233–34; stepmothers
and, 233
ageism, 4; feminist, 68
agency: abjection as devastating, 136;
aesthetic concentration and, 66; of
Aphrodite, 270; Blonde Bunny God-
dess cult and lack of, 275; corporeal,
5, 15–16, 24n14; display and, 74, 96

representation (*continued*)
 as multivalent and malleable, 89–90,
 100; self-representation, 27–28
reproductivity: blondeness as signifying,
 270, 271–72, 273; joke of female, 274;
 pleasure representations vs., 105,
 123n37; as symbol and embodiment of
 fuckability, 61, 271
Rexroth, Kenneth, 218, 219, 228–29, 237,
 238–39, 240n11
Robinson, Mrs. (Nichols character), 117,
 118, 125n74
rock climbing, 41, 303, 314–15, 318
Rome, ancient: and Aphrodite (Venus),
 39, 41, 255, 263n4; incest in, 230,
 242n50; Lucretia, 118; Lupercalia,
 259–60; women of, 41
Rooks, Noliwe M., 36nn19,25
roses, 236, 252
Rosler, Martha, 5
Rossetti, Dante Gabriel, 129–30, 144n3
Rubens, Peter Paul, 79, 87n57, 236
Rymer, James Malcolm, 308–9

Sacher-Masoch, Leopold von, 152, 210
sacrifice, 27, 277–78, 283n10
Sade, Marquis de: blondes vs. brunettes
 in, 270; contradictions of, 296; Frueh
 and, 293–94, 296, 297, 298n17; influ-
 ence of, 289–90, 292, 296; *Juliette*,
 270, 290; *Justine*, 290; love letters of,
 296; midlife women and, 293, 294;
 The 120 Days of Sodom, 289, 291, 293,
 294–95; and repetitive pleasures, 29;
 and shame, erotics of, 289–90, 296
Sappho, 260, 263–64n4, 266n29
Scapp, Ron, 155, 156
Scherr, Raquel L., 3, 4, 5, 17, 32; the per-
 sonal and, 18, 19
Schneemann, Carolee, 30–31, 101
Schneider, Rebecca, 100, 125n69
scholarship: the personal in, 16–17, 18,
 19; poetry in, 17. *See also* feminism;
 intellectual work; pedagogical theory
Schreiber, Andi Faryl, 98
Schwarzenegger, Arnold, 80, 111
SCUM Manifesto (Solanas), 212
seduction: alienation as lessened by, 159;
 moves of, 158; slowness of consen-
 sual, 158; as term, 180
Segal, Lynne, 68, 121n3
Seid, Roberta, 21, 23, 256–67, 258,
 265n20

self: apologizing for, 207, 209–10; lust
 for, 72, 73, 80, 86n41
self-love, self-creation based on, 2, 34n1
Semmel, Joan, 60
sentimentality, 39; chocolate and, 295; as
 obscenity, erotics of damage and,
 291–92
separation: of professor's mind from
 body, 150, 159, 160, 162–64, 165–67,
 179–80, 181; of student from teacher,
 156–58, 171n18; of student's mind and
 body, 166
sexiness: commitment to, 262; men and
 intelligence and, 152, 170n6; profes-
 sor's body and, 152, 160, 161–62,
 164–65; sexy, as term, 162, 262;
 women and intelligence and, 152, 153,
 162–63. *See also* aesthetic/erotic self-
 creation; eroticism; pleasure
sexual harassment, 149–50, 169–70n1;
 Gallop and, 149–50, 167, 170n2,
 183–84, 186, 188n15; harass, as term,
 167; hostile environment and, 166–67;
 men and, 149, 154, 169–70n1; mind
 separated from body and, 165–67;
 policies on, 182–84, 186, 194; student
 gaze and, 194. *See also* pedagogical
 erotics
sexuality: pedagogy and (*see* consensual
 sexual relations; pedagogical erotics);
 pleasure as lacking in discussion of,
 213; vampires and, 308–10, 315,
 316–17. *See also* eroticism
sexually active midlife woman, 67–68,
 90, 91–92
sexy, as term, 162, 262
shame: Aphrodite and, 255, 259, 265n17;
 bodybuilders and, 72, 108; celibacy
 and, 68; in classroom, 180, 195; denial
 of beauty and, 10; erotics of, 289–90,
 296; female professors and, 164; gaze
 and, 194–95; midlife sexy and erotic
 body and, 67–68, 71; power/pleasure
 obstructed by, 208; Sade and, 289–90,
 296; spectacle and, 26; stepmothers
 and, 228, 238–39, 242n43; unashamed
 vs. shamelessness and, 30, 31, 291;
 younger man and older woman and,
 238–39. *See also* abjection; damage,
 erotics of
shamelessness, 30, 31, 291
Sherman, Cindy, 20, 100, 271
shit, 293, 295, 296, 297

Joanna Frueh is Professor of
Art History at the University of
Nevada, Reno; author of *Erotic
Faculties* (California, 1996) and
Hannah Wilke: A Retrospective
(1989); and coeditor of *Picturing
the Modern Amazon* (2000),
*New Feminist Criticism: Art,
Identity, Action* (1994), and
*Feminist Art Criticism:
An Anthology* (1991).

DESIGNER Nola Burger
COMPOSITOR Impressions Book
and Journal Services, Inc.
TEXT 11/13.75 Fournier
DISPLAY Futura
PRINTER AND BINDER Friesens